T0073167

Foreword

Tim Hunter, Gerald Dobek, and James McGaha are among the greatest observers of the night sky of our time. Tim, who clearly has a visual mind, was for some years the Head of the Department of Medical Imaging at the University of Arizona, but his first love was astronomy, and not only has he set up two magnificent amateur observatories, the 3towers Observatory and Grasslands Observatory both in southern Arizona, but has contributed immensely to the protection of one of our most valuable natural and cultural resources, the dark sky, as co-founder with David Crawford of the International Dark-Sky Association. Jerry, Head of Science and Departmental Head of astronomy at Northwestern Michigan College who makes professional observations of small-amplitude variable stars from his home observatory published (in 2011) an annotated and updated edition of E.E. Barnard's legendary *A Photographic Atlas of Selected Regions of the Milky Way* (Cambridge University Press), thereby making a reasonable facsimile of it available to all those who have ever seen it and despaired of ever owning a copy of the original. James McGaha, a retired Air Force pilot, is Director of the Grasslands Observatory and is a leading practitioner of asteroid and comet astrometry and photometry as well as a contributing author to *Skeptical Inquirer* magazine.

All three of these outstanding observers share a love for the life and work of Edward Emerson Barnard, one of the greatest observational astronomers of all time (his only rivals are the likes of Galileo and William Herschel) whose name is recalled in the eponymous "Barnard's Star," "Barnard's Loop" (in Orion), and the 370 "Barnard Objects" whose visible darkness

make them among the most beautiful and photogenic objects in the night sky. In this magnificent book, they have shared their long fascination with Barnard and especially the dark nebulae cataloged under their name—most of which they have reimaged using more modern techniques than those available to him, while compiling a staggering amount of information about them. Like Barnard's *Atlas*, this is a book for the ages; it will be savored by anyone with an interest in the structure and evolution of the Milky Way who has been intrigued by these impressive and mysterious objects. It is exactly the kind of book that E.E. Barnard, as a young man working at a Photograph Gallery in Nashville whose interest in the night sky was perennial even before he learned the names of the stars and planets, would have given his eye teeth for. In his case, a few rude star charts in a book given to him by a thief as a surety of a loan first introduced himself to the formal knowledge of the heavens. This book, on the other hand, comes as close as anything in text or digital form to comprehending the beauty and variety and sheer ravishment of the heavens themselves. Anyone who opens the book will find it impossible to put down. I enjoyed it immensely. As with all great books, it compels the reader to go beyond its pages to experience directly that which it describes—and in this case, one could no better honor the authors than to go out to some inky-black spot (not so easy to come by these days as for Barnard who, from downtown Nashville, could see the Milky Way and even the gegenschein with the naked eye) and "look up in perfect silence at the stars."

If I may be permitted a personal reflection. Like the authors, I have always had the greatest admiration for Barnard, whose achievements could only be explained, as Tim Hunter points out, as the works of genius. If we did not know of him as much as is known about the lad of Stratford who went to London to seek his fortune on the stage, we might well be inclined to introduce the equivalents of Baconian or Oxfordian or other theories to explain how such rudimentary circumstances could produce the Swan of Avon. In Barnard's case, the documentation is remarkably complete, with an enormous number of documents—including even diaries kept in his early life, and abundant portraits showing him progress through the stages of hardship, success, and setback—kept at Vanderbilt, University of California-Santa Cruz, and the University of Chicago. Instead of seeming like a case of abracadabra or creation ex nihilo, one can track how one step led to the next—and ultimately mountains were climbed. For all that, it is still almost unbelievable.

So if not magic, what? Nothing other than genius could ever have seen him from the impoverished circumstances of his early life as an urchin on the streets of the part of Nashville known as "Varmint Town" to the dizzying

heights of astronomical discovery he achieved. The odds against were long beyond belief. Despite having only two months of formal schooling—and not even having a book about astronomy to pore over until he was nineteen—he was an omnivorous learner, who picked things up wherever he went. It was his good fortune that, in order to support his poor mother and feeble-minded brother (his father died before he was born), he was placed at age nine by sheer chance as a very lowly assistant in a Photograph Gallery, and there learned to refine his innate talent for art (apparently inherited from his mother who made flowers in wax to support herself and her family) and the remarkable technical skills needed to carry out the darkroom magic which led to some of the remarkable discoveries described here.

I first became intrigued by Barnard when, at about ten, I became seriously captivated by the wonders of the night sky and those who studied them best. He, with Galileo, William Herschel, and Percival Lowell, was my great hero, and as I learned more about him, my admiration only grew. In my late twenties (at about the time I began preparing for a professional career in psychiatry), I became interested in the way that different observers saw things in the telescope, especially on the surfaces of planets, and made the surprising discovery that Barnard's long-lost (and possibly even destroyed) drawings of Mars, made with the 36-inch Clark refractor at Lick Observatory in 1892 and 1894 and searched for in vain by the likes of Carl Sagan in the post-Mariner 4 era, had in fact survived. I found that out in 1987, and appreciated fully for the first time just how much remained to be discovered in the history of astronomy. It was the careful study of Barnard's (and other) Mars drawings I embarked on then that led me to write a book, *Planets and Perception* (University of Arizona Press, 1988). Before I had finished that, I had begun to ponder the idea of writing a proper biography of Barnard himself.

It seemed rather daunting, simply because of Barnard's extraordinary range—he observed everything that shone or obscured (with the possible exception of the Moon, to which he gave little attention), and though he was one of the keenest-eyed visual observers who ever lived, he was one of—perhaps the greatest—astronomical photographers during the age of its first flowering (the late-nineteenth and early twentieth century). He was to comets and the Milky Way what Matthew Brady was to Abraham Lincoln or the battlefields of the Civil War, or Ansel Adams to Half-dome or El Capitan. In addition, his life took place against a stirring background of events. He was born in Nashville in 1857, the year of the infamous Dred Scott decision that sent the country hurtling inexorably toward civil war. (The Nashville slave market, still a going concern in his early childhood, was at the corner

of 4th and Charlotte, a close walk from 4th and Cherry where the Photograph Gallery he worked from the age of nine was located.) On his seventh birthday, he heard the cannons during the Battle of Nashville, in which the Confederate army began and the city was placed under Union occupation. As his reputation for astronomy grew (largely owing to his prolific discovery of comets), his career played out against the backdrop of just-founded institutions—Vanderbilt University, Lick Observatory, Yerkes Observatory, Mt. Wilson. Thus writing his life would entail also learning about the leading figures, institutions, astronomical techniques, and discoveries of the whole remarkable period which included the emergence of astrophysics. The vast scope required of Barnard's biography made the whole thing daunting; but it also made it—ultimately—irresistible.

In addition, one of Barnard's achievements was one of the most highly coveted books by anyone who owns a small astronomical library. That book is *A Photographic Atlas of Selected Regions of the Milky Way* (1927), based on the photographs he obtained with the Bruce astrograph of the Yerkes Observatory mostly during a sabbatical at Mount Wilson in 1905. Unfinished at the time of his death, it represented the fruits of 20 years of hard work by one of the most driven and hard-working astronomers of any era—though in the end, like the apples of Tantalus, its completion remained out of reach of Barnard himself. To some extent, it was finished by his niece and assistant Mary Calvert and his boss, the Yerkes director Edwin B. Frost. However, it is distinctively Barnard's in vision and style of thought. What Barnard has achieved here remains *sui generis*, *sub specie aeternitatis*, a monument for all time. His plates express not only their celestial subject matter—the grandest subjects any artist can attempt to remember—but the unique living force of the artist's personality, the distinctive design, pattern, or "inscape" (to use a term coined by Gerard Manley Hopkins, our friend David Levy's favorite poet) of his vision. The texts are worth pondering, and Barnard was capable of a poetic turn of phrase as when (in his earlier *Milky Way and Comet Photographs*) he described the Great Star Clouds in Sagittarius as "like the billowy clouds of a summer afternoon; strong on the side towards the Sun, and melting away into a thin atmosphere on the other side. Forming abruptly at their western edge against a thinly stars strewn space, these star clouds roll backwards toward the east in a broadening mass to fade away into the general sky, beyond the limits of the present picture."[1]

[1] E.E. Barnard, "Photographs of the Milky Way and of Comets made with the six-inch Willard lens and Crocker telescope during the years 1892 to 1895." *Publications of the University of California*, vol. XI (Sacramento, 1913), p. Plate 49.

But above all Barnard's was a strongly visual imagination, and the pictures speak for themselves.

When the authors of the present work asked me to contribute a foreword to the present work, I was honored to do so. The job done—the stage set—I could take this opportunity to pull down my sails and seek safe harbor again. However, as I have begun to write and caught a favoring wind as it were, I have once more become inveigled by the wonderful story—all the difficulties overcome, dramatic incidents, charm and perseverance of Barnard's life. All of that comes back to me as I recall the 3 years or so in which I spent a substantial part of my own life following Barnard's foot-steps and sometimes even getting close to what must have been my thoughts. Writing Barnard's biography has been one of the intellectually most challenging and satisfying things I have done in my life, and the book that emerged from it, *The Immortal Fire Within: The Life and Work of Edward Emerson Barnard* (Cambridge University Press, 1995), remains I think the best thing I have ever done in (and for) astronomy.

Though the *Atlas* is the major focus in the present book, and in some ways was the fulfilment of Barnard's richly creative life, it exists in the context of the entire sweep of Barnard's career. Messrs. Hunter, Dobek, and McGaha have covered Barnard's life, techniques, and achievements with great completeness and mastery. But perhaps I will be allowed, briefly, as his biographer to summarize a few of the highlights that led from his first moments of transport under the night sky, when he looked at the stars and wondered what they were, to the last days of his life when—even when clearly dying—he watched an occultation of Venus by the moon through the window of his sickroom.

I might begin still earlier, but let me begin when Barnard was a young man in his early twenties sweeping the sky for comets from the still-dark skies of his native Nashville. Though the comets were then the prizes he sought, inevitably he was brought into contact with many of the wonders of the background sky across which they moved, and the Milky Way was for him the wonder of wonders. In an 1883 article for the Nashville *Artisan*, he wrote of his experiences comet sweeping and of being often close compan-ion to awe:

> Sweep on through glittering star fields and long for endless night! More nebu-lae, more stars. Here a bright and beautiful star overpowering in its brilliancy, and there close to it a tiny point of light seen with the greatest difficulty, a large star and its companion. How plentiful the stars now appear. Each sweep increases their number. The field is sprinkled with them, and now we sud-denly sweep into myriads and swarms of glittering, sparkling points of bril-liancy—we have entered the milky way. We are in the midst of millions on

millions of suns—we are in the jewel house of the Maker, and our soul mounts up, up to that wonderful Creator, and we adore the hand that scattered the jewels of heaven so lavishly in this one vast region. No pen can describe the wonderful scene that the swinging tube reveals as it sweeps among that vast array of suns.[2]

In his sweeps, Barnard encountered many nebulae. Their nature was one of the great unsolved problems of astronomy of the day. Most were readily distinguished by their fantastic forms, but some were like those famously marked by comet-seeker Charles Messier that, as Barnard put it, appeared as "roundish patches of foggy matter, extremely like comets in appearance." Occasionally he also came across a singularly baffling object, unlike any of these, as on July 17, 1883. While sweeping for comets southwest of the Trifid Nebula (M20) in Sagittarius, he noted a "small triangular hole in the Milky Way, as black as midnight," which he later described as "a most remarkable small inky black hole in a crowded part of the Milky Way … with a bright orange star on its n[orth] p[receding] border and a beautiful little cluster [NGC 6520] following."[3]

This, evidently, was one of the mysterious voids discovered by William Herschel while making the "star gauges" by which he had attempted to plumb the depths of the sidereal universe a century before. Herschel had indeed thought them true voids, and the novelist Thomas Hardy, writing a year before Barnard penned the article just quoted, described them as "impersonal monsters, namely, Immensities… the voids and waste spaces of the sky." Darkness visible, they evoked both beauty and fear, and held the mind with the same kind of irresistible fascination that black holes do for us today—and were, as Hardy put it, places where "our sight plunges quite beyond any twinkle we have yet visited. Those are deep wells for the human mind to let itself into."

Through his long apprenticeship in the Photograph Gallery in Nashville, where he began as a nine-year-old human clock drive, cranking a set of wheels to keep a giant camera, "Jupiter," aimed on the Sun to help shorten the exposure times of portraits, and lasted until he left the Gallery for a position as a Special Fellow and director of the small observatory at Vanderbilt University, Barnard became one of the greatest experts in photography and photographic processes as applied to astronomy in his time. (In addition to learning the techniques of photography, he also found a wife through his place of employment—Rhoda Calvert, 13 years his senior; she was the

[2] William Sheehan, *The Immortal Fire Within: the life and work of Edward Emerson Barnard*. (Cambridge: Cambridge University Press, 1995), p. 50.

[3] Ibid., p. 68.

older sister of the Calvert brothers originally from Morley, Yorkshire, England, who after emigrating to the United States acquired the Photograph Gallery from Van Stavoren. They were married in 1881.)

On the strength of his work with small telescopes and his many comet discoveries, in 1889 Barnard began work as a member of the original small staff of astronomers at Lick Observatory in California. However, as its most junior member, he not given regular time on the Observatory's most coveted instrument—the 36-inch refractor, then the largest in the world—Barnard made sweet uses of adversity. Adapting to long-exposure photography of the night sky a cheap and rather ancient six-inch portrait lens (the "Willard lens") that had been picked up the Lick Director Edward S. Holden for photographing the total eclipse of the Sun of January 1, 1889, Barnard began a remarkable program of wide-field photography of comets and the Milky Way. The first Milky Way photograph was exposed for three hours on stars of Sagittarius on August 1, 1889, and centered on the small triangular hole he had noticed during his comet sweeping years before. The inscrutable details in this and other plates presented at once a revelation and a conundrum. In 1894, he described a particularly striking one to the English barrister and astronomer Arthur Cowper Ranyard as "essentially a region of vacancies. There is a great chasm here in the Milky Way." Another showed the peculiar region centered on Rho Ophiuchi, where a century before William Herschel had exclaimed to his sister Caroline, "Here surely is a hole in the heavens." At the time Barnard—who was cautious and did not allow himself to get swept away—agreed with the Herschels, but Ranyard thought otherwise: "The dark vacant areas or channels … seem to me to be undoubtedly dark structures, or absorbing masses in space, which cut out the light from a nebulous or stellar region beyond them."[4] Ranyard, who died of cancer that same year, proved to be right, but Barnard hesitated. The question nagged at him, however, and solving it became the great intellectual adventure of his life.

Despite Barnard's enormous productivity at Lick (his most famous result, which vaulted him to international fame, was the discovery of the fifth satellite of Jupiter in 1892), he clashed with Director Holden. Recognizing Barnard's unhappiness, the dynamic George Ellery Hale recruited him to Yerkes Observatory in the village of Williams Bay in southern Wisconsin, and Barnard arrived in 1895—even before its new telescope, a 40-inch refractor that "licked the lick"—was available. The change of scene was not an entirely happy one for him. A native of the South, and a lover of sunny California where he and Rhoda had hoped on retirement to

[4] Ibid., p. 274.

repair to a small plot of land they acquired in San Jose where they could build a house and plant oranges, he despaired of the harsh winters, and yet as an obsessive "observaholic," he refused on even the coldest winter nights to sacrifice even a scrap of clear skies. In later years, visitors to the Yerkes Observatory were amazed that he continued to work even when the temperature in the dome was ten or fifteen degrees below zero Fahrenheit, and when they asked him how he kept warm, he replied: "We don't!" One profoundly miserable winter night, when the temperature plunged to -26° Fahrenheit, Barnard was observing with the 40-inch Yerkes refractor; S.A. Mitchell, who was at that time an assistant at the observatory, was working at the 12-inch refractor. At 2 a.m., a haze came over the sky. "We each left [our respective] dome to go down stairs to thaw out," Mitchell later recalled. "Inwardly, I must confess that I hoped it had clouded for good. If he felt the same he did not say so. The haze was only the last traces of moisture being frozen out of the atmosphere for it cleared off an we both went back to work until seven o'clock… [O]h! the torture of working so long at a stretch at such temperature with one's vitality at so low an ebb!"[5] On another equally bitter night, Barnard did stop work and close the dome, even though the stars were still shining brightly. The next morning, he explained that he had done so from worry that the telescope might break or be injured in the extreme cold. Edwin Brant Frost, who succeeded Hale as Observatory director after the latter left for Mount Wilson, knew that Barnard would never abandon work solely with a thought to his own comfort, agreed that this precaution was prudent, and posted a sign that henceforth whenever the temperature in the dome dropped below −25° Fahrenheit work should stop—for the sake of the telescope!"

Though Barnard was an avid user of the 40-inch refractor, his first priority at Yerkes was his Milky Way photography, which he hoped to carry forward with a more suitable instrument than the primitive "Willard lens." He managed to secure a grant from reclusive New York City heiress and astronomy patron Catherine Wolfe Bruce to purchase an astrograph centered on a 10-inch doublet lens by Pittsburgh telescope-maker John Brashear. It was to be mounted with two other telescopes, a 6 ¼-inch doublet and a 5-inch guide scope, on the same bent pier mounting. (Perhaps somewhat to Barnard's chagrin, Miss Bruce provided the money for an even larger astrograph to Max Wolf, Barnard's friend and rival, at the Heidelberg Observatory.) At first, Barnard hoped to employ the telescope at Yerkes, but through hard experience realized that the seeing conditions, especially in

[5] S.A. Mitchell, "With Barnard at Yerkes Observatory and at the Sumatra Eclipse," *Journal of the Tennessee Academy of Science*, 3:1 (1925), p. 25.

winter, would never allow him to get the best results with it. Meanwhile, the ever-restless Hale, endowed by the Carnegie Institution with a 10,000,000 gift and appointed to a committee to help decide the best uses for the money for the promotion of astronomy, was spending most of his time in California, planning to set up a high-altitude solar observatory and a large reflecting telescope on "Wilson's Peak" (elevation 5886 feet) near Pasadena. Hale's reports of conditions there were tantalizing, but at the moment no money could be found to bring Barnard and the Bruce out there, and so Barnard reluctantly went ahead with having the Bruce telescope set up on the grounds at Yerkes (between the 40-inch dome and his home on the shore of Lake Geneva). Though the telescope had not yet been delivered, work on the dome proceeded. Just after Christmas 1903, Barnard wrote to Hale:

> It is very cold and disagreeable here. It has been as low as 20 degrees below zero. It remains cold all the time with tremendous winds.... We got the tinner to come and finish the shutters.... But he has yet to come and do all the soldering.... It is too cold now.[6]

Meanwhile, it became apparent that Hale was not going to return to Williams Bay but instead would remain in California (though still as director of Yerkes) to establish the Mount Wilson solar observatory. Dartmouth-trained spectroscopist Edwin B. Frost would in Hale's absence serve as acting director at Yerkes.

Barnard began intensively lobbying Hale to find a way for him to bring the Bruce telescope there as well. Hale was willing, and at the beginning of February 1904 managed to secure a grant of $1000 from hardware- and steel-pipe millionaire Joseph D. Hooker for a grant of $1000 for the "Hooker expedition" to bring Barnard and the Bruce telescope out west. Two weeks later, the Bruce telescope arrived at Yerkes from the Cleveland telescope-making firm of Warner and Swasey, and since Barnard was now expecting to be off to California as soon as possible, temporarily set it up in the corridor of the Yerkes main building. Continuing the correspondence with Hale, the latter noted that there was at the time only a rugged trail to Mount Wilson, and that therefore Barnard would be better off setting up on nearby Mount Lowe (named after Civil War balloonist, Dry Ice manufacturer, and real-estate speculator, who had established an observatory upon yet another nearby peak, Echo Mountain) which could be reached by railway.

Barnard hoped to ship the telescope out to Mt. Lowe and arrive himself by early May, but now Hale began to hang fire—there were doubts about

[6] Sheehan, *The Immortal Fire Within*, p. 333.

the spring-time seeing conditions, and money problems, as Hale found himself in the uncomfortable position of finding that he did not have money to pay the astronomers' salaries. When he informed Barnard of the situation in March, Barnard was in bed with a bad case of bronchitis, as he always was by the end of a harsh winter of observing in Williams Bay. He did his best to commiserate with Hale's financial struggles, and assured him that he ought not to let his own wishes for the Bruce telescope to interfere in any way. But he promptly added:

> It is needless to say that I am extremely anxious to get a chance at the southern part of the Milky Way from Mt. Lowe…. I looked out the other morning about 3 o'clock … at the Milky Way and that glorious region in Scorpio and Sagittarius was coming up in the low south next, and it made me feel that it would be a great thing….
>
> I am satisfied that you will do all in your power to get the Bruce out there and I hope you will succeed, but as I say if it interferes with your plans for your other work, why let it go.[7]

With the prospects for the Mount Lowe expedition now dimming, Barnard decided to go ahead and mount the Bruce telescope on its brick pier at Yerkes, and begin work there. He encountered various difficulties adjusting the telescope, while the situation in California also disappointed; dust was coming up from the desert and covering the sky with whitish haze, making it seem pointless to take the Bruce telescope out there. However, then conditions improved again, and by fall the trip was on again. Hale was having better luck with the seeing at Mount Wilson, and the financial situation had improved. Hoping to avoid another Midwestern winter, Barnard was more than eager to come out. In early November he informed Hale of trying to get an eight-hour exposure on the Pleiades and a nine-hour exposure on the Milky Way in Cassiopeia. But the results were little better than he had obtained with the Willard lens on Mt. Hamilton. "The night was not transparent," he explained. "We have had very little clear weather this fall until the end of last week which has kept up till now and it is singularly perfect—it is Indian summer in appearance—but the sky is thickish at night and on faint nebulosities it is very poor."[8] A few days later, the weather turned "cold and raw and cloudy, with a miserable north wind." After another unsuccessful attempt at the Pleiades, he decided there was no point to continuing; instead, he hoped to set out for Mount Wilson, noting "I may be on time to get at [the Pleiades]" there. The telescope (except the 10-inch lenses which would travel with Barnard as hand luggage) set out in early December. After seeing Rhoda (suffering from heart problems) off to New York from where she would set sail to England to spend the time Barnard was away with relatives there, Barnard himself set out—to San

[7] Ibid., p. 334.
[8] Ibid., p. 336.

Francisco—Lick—Pasadena—and on January 10, 1905, after a climb of five hours most of it on foot and with the 10-inch lenses fastened on one side of a mule and balanced on the other side, arrived at the summit (the males-only "Monastery," like those in the Levant Hale had read about) safe and sound. The last part of the journey was in fog and rain.

On Mount Wilson with the Bruce

By this time, Hale had already drawn after him several members of the Yerkes staff—Walter S. Adams, Ferdinand Ellerman, and George Willis Ritchey—as well as another transplant from Yerkes, the Snow solar telescope, a horizontal telescope of coelostat design that Hale and Ritchey built at Yerkes in the autumn of 1903 and since shipped to Mt Wilson. Others who came out to Mt. Wilson on a temporary basis while Barnard was there included Charles Greeley Abbot of the Smithsonian Institution, his assistant, Leonard Ross Ingersoll, and Henry Gale, a former football player who was now a University of Chicago physicist interested in sunspot spectra. Adams would later recall fondly those early days at the Monastery:

> Hale had introduced Abbot to the Oriental stories … on the monasteries of the Levant, and our evenings usually started off with a dramatic rendering by Abbot of the tale of the Jew of Constantinople and Solomon's seal which he knew by heart. Occasionally the Smithsonian challenged all comers to a game of duplicate whist, but more often the group would gather around the fireplace for discussions of plans of work or of the state of the world in general. Hale's amazing breadth of interests, his great personal charm, and his stories of important figures in science and international affairs make these evenings stand out in memory.[9]

[9] W,S, Adams, "Early Days at Mt. Wilson—II, *Publications of the Astronomical Society of the Pacific*, 59 (1947), pp. 97–115:pp. 99–100.

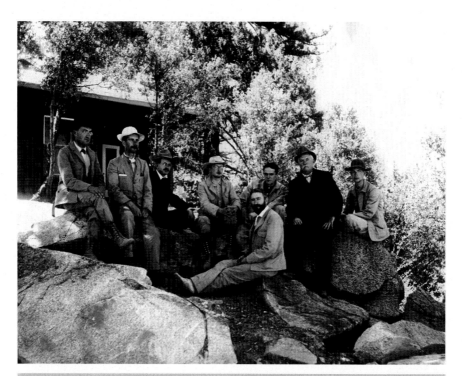

Mt. Wilson group 1905. Seated in front is F. Ellerman; from left to right are Construction Superintendent H.L. Miller, C.G. Abbot, G.E. Hale, L.R. Ingersoll, W.S. Adams, E.E. Barnard, and C. Backus. Credit: Henry E. Huntington Library and Art Gallery.

Now in his glory, with the Pleiades that the struggled to capture from Yerkes still accessible and the Galaxy to explore, Barnard wasted no time, and had soon erected the Bruce telescope in a small wooden structure on a small hillock on the trail midway between the Monastery and the Mt. Wilson Solar Observatory and the Observatory workshop. Within this improvised structure he had mounted together on the cement pier four telescopes—the 10-inch Bruce, a 6 ¼-inch photographic telescope, a 3 ½-inch doublet, and a lantern lens. The very first plates were exposed on the night of January 27.

At first, Barnard was prone to experience night terrors of the kind he had sometimes experienced years earlier when observing Jupiter with his small telescope all alone in Nashville. The Mt. Wilson Solar Observatory was still in the early construction stage, and sometimes, while working in the small Bruce Observatory, he was the only person on the mountain. Moreover, since the small observatory was separated by some distance from the Monastery, which was hidden from view by heavy foliaged spruce trees,

even when others were about he found himself, "essentially isolated from the rest of the mountain," as he later recalled:

> I must confess that at times, especially in the winter months, the loneliness of the night became oppressive, and the dead silence, broken only by the ghastly cry of some stray owl winging its way over the canon, produced an uncanny terror in me, and I could not avoid the dread feeling that I might be prey any moment to a roving mountain lion. The sides of the [Bruce] observatory were about five feet high, so that it would have been an easy thing for a hungry mountain lion to jump over it and feed upon the astronomer. So lonely was I at first that when I entered the Bruce house and shoved the roof back I locked the door and did not open it again until I was forced to go out.[10]

Fortunately, with the coming of spring (and the increasing accessibility of the southern Milky Way), the loneliness and oppression that he had experienced during the winter began to lift. A good part of this had to do with the reawakening of insect life, which "began its notes in the chaparral":

> The dread of the night soon passed away and the door was left open and it became a pleasure to sit and listen to the songs of nature while guiding the telescopes in long exposures, heedless of all beasts of prey. No one knows what a soothing effect these "noises of the night" have on one's nerves in a lonely position like that on Mount Wilson.[11]

Generally, Barnard found the skies at Mt. Wilson much better than at Yerkes—after the drenching rains early in the season, the dust which had been a matter of concern completely settled out, and Barnard began to obtain magnificently deep plates of the southern Milky Way. In all, he would expose some five hundred plates with his three telescope and his lantern lens—from which he later quarried most of the material used in the *Atlas of Selected Regions of the Milky Way*. As usual he worked like a fiend. For many years he had been used to getting by on a few hours of sleep a night, but on Mt. Wilson he often gave up sleep altogether. Adams later recalled:

> Barnard's hours of work would have horrified any medical man. Sleep he considered a sheer waste of time, and for long intervals would forget it altogether. After observing until midnight, he would drink a large quantity of coffee, work the remainder of the night, develop his photographs, and then join the solar observers at breakfast. The morning he would spend in washing his plates, which was done by successive changes of water, since running

[10] E.E. Barnard, unpublished manuscript; Yerkes Observatory Archives.
[11] Ibid.

water was not yet available. On rare occasions he would take a nap in the afternoon, but usually he would spend the time around his telescope. He liked to sing, although far from gifted in the art, but reserved his singing for times when he was feeling particularly cheerful. Accordingly, when we at the Monastery heard various doleful sounds coming down the slope from the direction of the Bruce telescope, we knew that everything was going well and that the seeing was good.[12]

From Yerkes, Frost, on hearing from Barnard of the excellent conditions he was enjoying, wrote, "It is a pleasure to know that you are having such fine weather for work, but I hope you will not overdo, and you will give up some clear nights when you need sleep."[13] Barnard could always be counted upon to ignore such advice. He knew, moreover, that he might never again have such a grand opportunity to explore the star clouds, diffuse nebulae and strange dark regions which he had first recorded with the Willard lens and regarded as vacant spaces but would eventually conclude, after years of study, were clouds of obscuring matter (and, as we know now, interstellar dust). Doubtless Barnard would have loved to stay on Mt. Wilson with Hale, Adams, Ellerman and Ritchey, and escape the unhealthy winters of southern Wisconsin. But as Barnard was the Yerkes Observatory's most celebrated astronomer, Frost would never have agreed to give him up. Moreover, except in photography where he broke new ground, he was a skilled practitioner of the classical methods of astronomy (much of his work at the Yerkes 40-inch involved wielding a micrometer to make precise measures of double stars and the stars of globular clusters in which he hoped to detect proper motions) rather than a pioneer of the astrophysics of the Sun and stars on which Hale had staked the future of the new observatory. So in mid-September 1905, after a stay of eight months, Barnard packed the lenses of the Bruce telescope and his precious plates in the saddlebags of his mule and, escorted down the mountain early one morning by Adams, retraced the journey by train in reverse order to the one that had brought him here.

Publishing the best of these photographs—and analyzing the markings shown on them—henceforth became one of the great goals of Barnard's life, spread over much of the last two decades of it. The funding for what was to be tentatively called *An Atlas of the Milky Way* was provided by a grant of the Carnegie institution of Washington, D.C. in 1907. When he began, Barnard clearly intended to include a large part of the Milky Way accessible from Mount Wilson—hence the title. However, as time passed, the scope of the project was scaled back; the final selection of areas to be

[12] Ibid., pp. 97–98.

[13] E.B. Frost to E.E. Barnard, July 27, 1905; Vanderbilt University Archives.

included was made much later, and it proved that inclusion of only a third or a quarter of the plates needed to compass the original project could be accommodated. Thus, instead of an atlas of the Milky Way, Barnard endeavored to include only the most interesting or representative sections—and the title was modified, by Frost after Barnard's death, to the more precise *A Photographic Atlas of Selected Regions of the Milky Way*. However, even thus scaled back, the work proved to be daunting. Barnard toiled at it in desultory fashion for 16 years until his death—and even then it was still unfinished.

This was perhaps an inevitable result for someone pursuing as many lines of work as Barnard did while at the same time attempting to uphold almost unachievable standards of perfection. And no sooner did he begin planning the *Atlas* than he began to run into difficulties. The first and most serious was trying to honor a binding commitment to previous work. In 1895, he had agreed (quite enthusiastically) to produce a collection of Milky Way and Comet photographs taken with the Willard lens at Lick. These were pioneering work, highly significant and in the case of comets, at least, full of time-dependent phenomena such as tail-detachment events which represented the only record of them available. Barnard knew their importance, and so did his colleagues and supporters, who raised a substantial sum in subscriptions and grants in order to reproduce them, in his words, in a first class manner. But at that moment Barnard was "fallen on evil days." Barnard and much of the rest of the staff had been engaged for some time in what can only be described as internecine warfare with the Director Edward S. Holden. From this distance, it is apparent that the strife owed at least as much to Barnard's rather neurotic personality—seeded in the insecurity and hardship of his early life of deprivation—as to Holden's rather stiff and autocratic West Point manner. In any case, at almost the very moment that Barnard promised to put the Milky Way and Comet photographs in order, he departed Lick for Yerkes, and needless to say was soon absorbed in the researches favored at the new institution. The Milky Way and Comet photographs were cast aside for several years—possibly Barnard himself had managed to put them out of mind. But they represented an obligation he could not evade. Finally, in 1902, with Barnard just returned from a long (and unsuccessful) eclipse expedition to Sumatra, a new Lick Director, W.W. Campbell, reminded him of the project and offered to provide whatever support he could (including financial) toward its completion. The project briefly (if feebly) was stirred again, but once more faltered. The main problem was Barnard's perfectionism. He was simply unable to satisfy himself with the quality and uniformity of any of the methods of reproduction available. Collotype, photogravure, halftone all were tried. All failed.

There was another hiatus until 1907, when Campbell began to press again. Barnard committed to finish by the end of the year, or else "every cent of the money, dollar for dollar … will be returned to California, and I shall once more be free from worry in that direction." He added, "To me the whole thing has been a most bitter disappointment. It has caused many an illness from worry on it."[14]

The worry continued, and was only compounded with the Carnegie grant for publication of the Bruce photographs. Clearly the commitment to the old project had now become a millstone around his neck. At Christmas 1907, fighting off bronchitis in order to finish a remarkable series of observations with the 40-inch of the edgewise rings of Saturn, he confided to his old Lick colleague John M. Schaeberle his near-despair over the Milky Way and Comet Photographs. "It has been a heart rending affair, and I have finally given it up," he wrote. "The pictures already made are many of them full of errors and I don't propose to do anything with them. Life is short and uncertain, and I can't stand the strain any longer… I would rather die than to have a faulty work go out. I have therefore decided to give up any more efforts, and to put the money out of my hands, as I do not want to die with anything in my possession that does not belong to me."[15]

Barnard was as good as his word. He wrote a check to Lick Observatory for the entire amount he had collected in 1895, together with the printed sheets of the Milky Way reproductions he had already finished in his abortive attempts to produce something satisfactory, and explained to Campbell from the sickbed to which the Saturn observations had reduced him:

> My sole desire in the matter has been to put in the hands of astronomers a trustworthy set of reproductions of these Milky Way and comet photographs. I have no desire to get out a volume simply for the sake of the volume. Recognizing at last the hopelessness of bringing out these pictures to my satisfaction, and feeling of late the uncertainty of life, I have finally decided, while it is within my power (but not without much pain and disappointment) to close up the matter and to abandon the work to its fate.[16]

Campbell, however, refused to let the matter drop, and with extraordinary patience and tact eventually managed to see it through. In the end, Barnard was (briefly) able to satisfy himself with the quality of reproductions by the (previously rejected) Chicago Photogravure Company, and finally, ending a struggle of almost two decades, the *Milky Way and Comet Photographs* appeared in an edition of 1000 copies. It appeared as volume 11 of the *Publications of the Lick Observatory* (University of California Press, 1913)

[14] Sheehan, *The Immortal Fire Within*, p. 352.

[15] Ibid.

[16] Ibid., p. 353.

(Though the publication date is given as 1913, Barnard did not actually finish the Introduction until December 16, 1913, and the actual printed copies did not appear until the following September.)

The long and often bitter struggle was over, with Campbell, who had had to exercise extraordinary patience and restraint in nurturing it along, having previously accounted for the unprecedented delays to the Comptroller of the University of California:

> Astronomical subjects are extremely difficult to reproduce satisfactorily, and Barnard's temperament is such that discouragements led him to put the subject entirely aside for two or three years at a time. Shortly after I became Director [in 1901] I insisted that he go on with the work, partly because the photographs were the first great successes in their lines, and partly to show our good faith with private contributors. Barnard's entire freedom from business ability has made the administrative questions difficult, but the scientific merits of the subject have been sufficient to preserve my patience.[17]

<div align="center">***</div>

At last Barnard could begin to turn his attention to the *Atlas*, though it had to compete for his attention with work still in hand—of which the most significant strain was the work on the dark markings of the Milky Way. In 1907, he had still clung to the idea that they were vacancies. However, "one beautiful transparent moonless night" in the summer of 1913, he was photographing the southern Milky Way with the Bruce telescope (now at Yerkes) when he experienced an epiphany as to their nature:

> I was star struck with the presence of a group of tiny cumulous clouds scattered over the rich star-clouds of Sagittarius. They were remarkable for their smallness and definite outlines—some not being larger than the moon [i.e., half a degree across]. Against the bright background they appeared as conspicuous and black as drops of ink. They were in every way like the black spots shown on photographs of the Milky Way, some of which I was at that moment photographing. The phenomenon was impressive and full of suggestion. One could not resist the impression that many of the small spots in the Milky Way are due to a cause similar to that of the small black clouds mentioned above—that is, to more or less opaque masses between us and the Milky Way. I have never seen this peculiarity so strongly marked from clouds at night, because the clouds have always been too large to produce the effect.[18]

Those might not have been the good old days in many respects. However, in one respect they were enviable: there were no city lights in Williams Bay,

[17] Ibid., p. 354.

[18] E.E. Barnard, "Some of the Dark Markings on the Sky and What They Suggest," *Astrophysical Journal*, 43 (1916), 1–8:4.

and the Chicago light dome that has made sensitive observations at the site impossible did not yet exist. Under these conditions, the clouds appeared perfectly black and darker than the star- and Milky Way-lit sky. (Nowadays, they would of course appear brighter, due to reflection of artificial lights, and the effect that made such a strong impression on Barnard would have been lost.)

Around this time Barnard began somewhat haphazardly to jot down in his atrociously bad handwriting various scattered notes and comments which later served as the basis of what became the Introduction to the *Atlas*. Meanwhile, Frost—who though not the demon researcher that Hale had been and that, later, Otto Struve would be—was a genuinely humane and understanding person, had been thinking about how to spare Barnard the frustration he had experienced with the *Milky Way and Comet Photographs*. He persuaded Barnard that direct photographic prints would most faithfully reproduce the details of the original negatives. And so Barnard selected fifty of his best negatives, and then painstakingly made a second negative from each from which the prints could be made by a commercial photography firm (Copelin & Son in Chicago). During 1915, 1916, and 1917, Barnard traveled often to Chicago to inspect the prints—35,700 in all, making up a limited edition of 700 copies. The descriptions were written after Barnard had made a careful study of the prints and negatives, but progress was uneven—mainly, as Frost noted, "of Professor Barnard's well-known eagerness to observe the heavens whenever the sky was clear," which "left him little time for the remainder of the preparation of the work for publication."[19]

In addition, Barnard suffered a serious crisis of health. In February 1914, he noticed that he was tiring more easily, thirsty much of the time, and passing copious amounts of urine (which made life extremely difficult for someone who was often required to guide a telescope while exposing a photographic plate for several hours without a break). He tried to push through, but on March 8, 1914, took to his bed; when, three nights later, he observed the nearly total eclipse of the Moon, it was from his bedroom window. The physicians were called in, and at once diagnosed diabetes mellitus. The diagnosis was easy, but in those days before insulin, the treatment was obscure, and outlook for the diabetic patient bleak. Barnard's physicians agreed with the prescription by Sir William Osler in his influential textbook of medicine. "Sources of worry should be avoided," Osler had directed, "and the patient should lead an even, quiet life, if possible in an equable climate." On medical advice, Barnard's doctors ordered him to

[19] E.B. Frost, Introduction to E.E. Barnard, *A Photographic Atlas of Selected Regions of the Milky Way*, E.B. Frost and M.R. Calvert, eds. (Washington, D.C.: Carnegie Institution, 1927), p. xi.

forego observations with the 40-inch telescope, and, as Frost noted, bore his banishment from the great telescope "manfully." However, he added, it was "almost impossible for Mr. Barnard to keep away from the Bruce photographic telescope when the sky was clear and the moon did not interfere." He spent from December 1914 to March 1915 in California, and on his return had recovered his health to the point where he was once more able to resume work at the great telescope—though for the rest of his life he would continue in the grips of a desperate struggle with the vitality-sapping, wasting disease.

Despite his struggles, those years were productive ones, with the *Atlas* was only occasionally his principal concern since as Frost noted, "the reduction and publication of current observations had, with him, the right of way."[20] Clearing the vast backlog of work, and the publication of the Milky Way plates, simply had to wait.

In May 1916, he discovered the star informally referred to by the Yerkes staff as "Gilpin" (after a character whose horse runs away with him in a poem by William Cowper) and now known as "Barnard's Star"—a red dwarf star that was then (and is still) that with the greatest proper motion of any known and, because of its relative proximity to us (6.0 light years away), a regular staple of science fiction stories ever since. (It provides a way station for interstellar travelers in Douglas Adams' *Hitchhiker's Guide to the Galaxy* series and Arthur C. Clarke's *The Garden of Rama*, and is a setting of Kim Stanley Robinson's *Icehenge*, among others.)

During a brief rebound of his health in the fall of 1917, Barnard traveled with Frost to scout three potential observing sites along the path of totality of the forthcoming eclipse of June 8, 1918, and observed from the site chosen as the most promising—Green River, Wyoming—for the eclipse. A poignant moment came the night after the eclipse, when Barnard savored the childlike joy of standing in awe beneath the sky upon independently discovering Nova Aquilae, the brightest nova of the twentieth century. On attaining to its maximum brightness two days later, Barnard caught it on its rising above Castle Rock, and described it as "very white and very much brighter than Vega. It twinkles very much—low altitude. It must be as bright as Sirius."

His most important work concerned the dark markings of the Milky Way, and his still-evolving ideas about them were carefully documented in a series of crucial papers published in the *Astrophysical Journal* in 1913, 1915, 1916, and 1919—the last including his famous catalog of 182 dark objects.

[20] Ibid.

Another highlight of these twilit years was the visit to Yerkes on May 6, 1921, of the Berlin professor Albert Einstein. In a group photograph taken in the Yerkes dome, Barnard appears a few places to Einstein's right; a gaunt and unsmiling figure with sunken eyes and hollow cheeks, a grizzled mariner steering off a coast of stormy seas. Just ten days later tragedy struck: Rhoda, long in poor health, suffered a stroke. Five days later she was dead. They had married forty years earlier, during Barnard's years of struggle as a young man employed at the Photograph Gallery in Nashville and searching (successfully) for comets with a small telescope at night. Now, he wrote to astronomer Frederick Slocum of the Van Vleck Observatory, "I am sad beyond measure. She loved me and cared for me more than I knew or could appreciate, but it all comes back to me now and I am heartbroken." To W.H. Wright at Lick he wrote, "I have felt so unhappy and broken in spirit, that it seemed impossible to write… I am thinking of Mrs. Barnard all the time."[21] Even the dream of growing oranges in California had to be given up; it was simply unthinkable without Rhoda.

After Rhoda's death, Barnard soldiered on, only too keenly aware that his own days were numbered. Finally, toward the end of 1922, he finished the first draft of the descriptions of the photographs for the *Atlas*. He hoped soon to turn to the rest, but he was now running out of time. On December 16, 1922—his sixty-fifth birthday—he traveled to Chicago for a meeting of a local astronomical club. The next night he tried to examine Nova Persei of 1901 with the 40-inch, but was unable to get any kind of image; the object glass was completely coated with frost. The next night he was assigned to the instrument was December 23; the sky was overcast. On Christmas morning he was at Frost's house with the rest of the staff for about an hour, but excused himself early, due to distress from an acute inflammation of the bladder. The next day Frost drove to Milwaukee to consult his oculist. By the time he returned he found that Barnard was laid up in bed. A physician, Dr. McDonald, was called out, and succeeded in relieving Barnard's distress by means of a catheter, but recognized that the real problem was an enlargement of the prostate, for which the remedy was surgery. In Barnard's case, because of the diabetes, this was ruled out. Nevertheless, the catheter had cleared up the bladder inflammation within a week, and Barnard improved to the point where he was, Frost noted, "getting sleep and rest and [dressing up] to go down to breakfast, and [doing quite a little writing for his Atlas]."[22]

[21] Sheehan, *The Immortal Fire Within*, p. 413.

22 Ibid., p. 415.

Barnard never again returned to the great telescope. His last astronomical observation, of an occultation of Venus by the Moon, was made through his bedroom window on the morning of January 13, 1923. He and Mary Calvert worked a few hours every afternoon on the Atlas, and he tried to keep up his correspondence. On the day after the occultation, he wrote to the Lick Observatory Director W.W. Campbell, "I am sick in bed... My greatest unhappiness [is] that I can do no observing at all." A week later he told Wright, "I am sitting up this morning... My strength is returning but my main trouble is unchanged.... In the meantime I am subject to the catheter with the forlorn hope that things will come all right again... It is distressing to be away from my observations."[23]

At the beginning of February, a Chicago specialist in metabolic diseases, Dr. Rollin Turner Woodyatt, was called out to Williams Bay, and after examining Barnard expressed the hope that he could be taken to Presbyterian Hospital in Chicago, placed on a strict diet and given the new treatment for diabetes—insulin. In this way, he hoped, it might be possible to bring things to the point where an operation could by attempted. But it was too late. Barnard was by then suffering from other complications, including congestive heart failure. The end was near. He told Mary Calvert that "he didn't mind dying, but was sorry not to finish his work."[24] Almost to the very end, the *Atlas* nagged at him.

After about noon on Monday, February 5, his consciousness began to cloud up, and he was no longer coherent. He was attended through the night by Calvert, Oliver J. Lee of the Yerkes staff and Lee's wife. Drs. Woodyatt and McDonald were also at his bedside, and the following day Barnard received the new insulin treatment—but it was too late. His vital functions were now rapidly failing, and at 4 p.m. the doctors decided that nothing more could be done and gave him a hypodermic injection of morphine. His pulse ceased at 8 p.m. Frost, recording the time, added: "*ad astra*"—to the stars.

To which he might well have added—as the light of Barnard's life went out—to the dark nebulae.

23 Ibid., p. 416.
24 Ibid.

But enough from me. Now, dear reader, it is time to turn the page and commence reading—and studying—and enjoying this remarkable book, in which "the immortal fire" of Barnard's spirit truly lives again.

Flagstaff, AZ, USA William Sheehan
January 11, 2023

Preface

The Barnard Objects have fascinated professional and amateur astronomers for over 100 years. Edward Emerson Barnard (more commonly known as EE Barnard) was a leading pioneer in the development of astrophotography. He recognized that guided long exposures (up to 15 + hours) produced revolutionary astronomical photographs and data not otherwise attainable. While Barnard was one of the most experienced, hard-working, and productive visual observers in history, his seminal work with photography contributed to the eventual demise of visual professional astronomy.

Barnard was particularly fascinated by regions of nebulosity both bright and dark (areas where there was absence or diminution of the number of stars). Nebulae are common throughout the Milky Way. Barnard was not the first person to recognize dark nebulae or even to photograph them, but he along with his friend and colleague Max Wolf (1863-1932) of Heidelberg University were among the first to understand dark areas were not holes in the Milky Way but were areas where material obscured background stars. Barnard's extensive photography of the Milky Way coupled with his intense study of dark nebulae finally convinced him they were not holes in the sky as believed by William Herschel but areas of obscuring material.

Barnard noted that long exposures revealed some stars in dark regions, and the longer the exposure the more stars were revealed. He also felt small dark nebular bodies which look like tiny black ink dots were silhouetted against brighter background starry regions like the visual effect of small earth clouds being silhouetted against the bright Milky Way observed from an exceptionally dark sky site. He observed that some dark nebular areas

had sharp margins along a part of their periphery while other portions imperceptibly blended with the starry background. This suggested some type of obscuring material in front of and partially or totally obscured bright background material.

Barnard and Wolf finally concluded dark nebulae are obscuring clouds of gas and dust, though uncertain as to the exact composition of such clouds. Today, our understanding of both bright and dark nebulae is considerably advanced over that of a century ago during Barnard's time. We remain quite far from fully characterizing these complex regions which consist of varying mixtures of molecular gas (mainly hydrogen), ionized gas (mainly hydrogen), dust (simple carbon and silicate compounds), ices (frozen water and gases), and complex organic compounds.

Nebulae of all types are fascinating objects. They range in size from mere arc seconds to many degrees. Some are bright from the effects of light from nearby luminous stars reflected off dust, gas, and ice particles. Others are regions of energized gas emitting radiation in portions of the electromagnetic spectrum, and others are dark from the obscuring effects of gas and dust. Many have a mixture of bright and dark regions. Most of the bright nebulae are gorgeous visual objects and many more of them also are photographic gems either in black and white or in color.

Barnard observed and photographed objects throughout the sky visible from the northern hemisphere. In the later part of his career, his attention was most focused on examining the Milky Way. He produced a personal list of selected dark nebulae now known as Barnard Objects which were collected and codified in a 1927 posthumous publication *A Photographic Atlas of Selected Regions of the Milky Way* edited by Edwin B Frost, Director of Yerkes Observatory, and Mary R Calvert, Barnard's niece and assistant. This publication was based on Barnard's work and followed upon his initial list of 182 dark nebulae published in 1919 (*Astrophysical Journal*, January 1919; 49:1-23). Earlier he had published "Photographs of the Milky Way and Comets," Volume 11 of the *Publications of the Lick Observatory* (1913). This was based on his photography of the Milky Way from 1892 to 1895 using Lick Observatory's Crocker Astrograph.

Barnard's images were obtained with black and white photographic plates. Successful professional color astrophotography did not take place until 1959 when Super Anscochrome film was introduced. The first amateur color astrophotographs were published in *Sky & Telescope* in 1963 and 1964. Nowadays, film is no longer used for most everyday photography and rarely used for astronomical imaging. In astronomy film has been replaced by digital imaging with CCD and CMOS chips. Amateur astronomers produce thousands of stunning color astrophotographs daily, many of which are the same objects Barnard first imaged more than 100 years ago.

The classic Barnard Objects numbering 1-370 are favorite objects for amateurs to optically observe as well as photograph. In 2014, I started a project to image all the Barnard Objects in color using a variety of instruments at the Grasslands Observatory (http://www.3towers.com) in Southeastern Arizona. This project continues with most of the objects having been imaged, mainly with wide-field techniques but some with more detailed imaging due to their unique features or small size. The goals for this project were to present all the Barnard Objects on the Grasslands Observatory website and to write a book illustrating all the objects.

The more I contemplated the book project and researched Barnard and his legacy, I realized a picture book with hundreds of images was not practical or particularly useful. After much thought, the present book has evolved with the important work from co-authors Jerry Dobek and James McGaha. Chapter 1 is a general introduction to Barnard and his work. Chapter 2 defines nebulae and looks at them from multiple points of view. That dovetails into Chapter 3 which lists and discusses many of the most important astronomical catalogs in common use. Chapter 4 is an in-depth discussion of EE Barnard's work with dark nebulae.

Visual observations of the larger and brighter Barnard Objects are discussed in Chapter 5 which leads to Chapter 6 that gives a detailed discussion of our color imaging techniques for the Barnard Objects. In Chapter 7, selected plates from *A Photographic Atlas of Selected Regions of the Milky Way* are presented with selected modern color images of the objects Barnard noted on those plates. Jerry Dobek has extensive experience with Barnard's work and photography which was demonstrated by Jerry's 2011 republication of the *Photographic Atlas* (Cambridge University Press, Cambridge, UK). The original 1927 *Atlas* did not contain Barnard Objects having numbers from 176 to 200. Barnard had preliminarily marked nebular locations for such "missing" objects which Jerry has "found" and listed in Chapter 8 along with our color images of these missing objects.

Chapter 9 provides an overview of the Barnard Objects as they are found today. We have also provided a glossary of common terms, a general bibliography for Barnard Objects and nebulae as well as a current table of all the Barnard Objects.

I hope you find the book interesting and informative if not scholarly. If it fails in this regard, the blame is mine. No matter what, I hope you appreciate EE Barnard for the astronomical giant he was, and I hope you realize how much fun I had collating all this material. Please give credit for the highlights of the book to my co-authors and reserve its shortcomings to me.

Tucson, AZ, USA Tim B. Hunter

Acknowledgements

The authors were helped with this project by too many persons to name individually if we were to be fair to everyone. We can mention a few persons who have gone way beyond the ordinary to assist us, hoping we have not forgotten someone important.

Dean Salman was invaluable in setting up the Grasslands Observatory for remote operation. His friendship and expertise are much appreciated. Dr. Peter Mack of Astronomical Consultants & Equipment, Inc. has provided us many years of support for our operation often driving to the observatory in the middle of the night to assist with a repair at no small inconvenience to himself. That is greatly appreciated.

Frank Lopez of Stellar Vision and Dean Koenig of Starizona have provided us with endless advice on equipment and building setup. Frank has also made some middle of the night trips to help us in need. Dr. Richard Buchroeder helped us with optical questions and supplied the proper references for the lenses used in Barnard's time.

A book is only successful if behind the scenes there are skilled copy editors and indexers who actually put a book together. These persons usually remain unidentified but are much needed and valued.

Tim B. Hunter
James E. McGaha

In addition to those previously mentioned, Gerald Dobek wishes to thank Dr. Tim Hunter. Tim has been a very good friend for many years, and he is the one who took the initiative and lead on this book. I would also like to thank my mother, Winifred May Dobek (Née Johnson), who was my inspiration and drive to becoming an astrophysicist. And lastly, to my Kim.

Gerald O. Dobek

Contents

About the Authors

Tim B. Hunter obtained a BA from DePauw University in 1966, an MD from Northwestern University in 1968, a BS from the University of Arizona in 1980, and an MSc degree from Swinburne University (Melbourne) in 2006. Currently, Dr. Hunter is Professor Emeritus in the Department of Medical Imaging in the College of Medicine at the University of Arizona and was Head of the department from 2008 to 2011. He was on the Arizona Medical Board (AMB) from 1997 to 2006.

Dr. Hunter has been an amateur astronomer since 1950, and he is the owner of two observatories, the 3towers Observatory and the Grasslands Observatory (http://www.3towers.com). He is also a prime example of someone whose hobby has run amok, spending more time and money on it than common sense would dictate. He has been the President of the Tucson Amateur Astronomy Association, Inc. (TAAA) and a member of the TAAA since 1975. He is a past Chair of the Board of Trustees of the Planetary Science Institute (PSI). Since 1986, Dr. Hunter has been interested in the growing problem of light pollution. In 1987, he and Dr. David Crawford founded the International Dark-Sky Association, Inc. (IDA). IDA is a nonprofit corporation devoted to promoting quality outdoor lighting and combatting the effects of light pollution. Since 2007, Dr. Hunter has written a weekly "Sky Spy" column for the *Caliente* Section of the *Arizona Daily Star*.

Gerald O. Dobek obtained two BS degrees in Mathematics from Trinity College and Ferris State University, an MSc Honours in Astronomy from the University of Western Sydney, and a DSc in Astronmy/Astrophysics from James Cook University. Jerry is currently the Head of Sciences and Department Head of Astronomy at Northwestern Michigan College, Traverse City, Michigan, where he teaches Astronomy. As a professional astronomer, he researches small amplitude variable stars using his private observatory at his home in Traverse City, Michigan. Jerry also continues to research dark nebulous material in the Milky Way. In 2011, he republished Edward Emerson Barnard's A Photographic Atlas of Selected Regions of the Milky Way (Cambridge University Press) adding update information and a mosaic of the fifty plates contained within the Atlas. Jerry holds membership in numerous astronomy and science organisations: Royal Astronomical Society (RAS), American Astronomical Society (AAS), American Association for the Advancement of Science (AAAS), the American Association of Variable Star Observers (AAVSO), The Astronomical Society of the Pacific (ASP), and is a founding member of the IDA. Along with being an advid observational astronomer, Jerry also enjoys writiing and playing music on his twelve and six string guitars.

James E. McGaha obtained a BS in Management and Physics from Georgia Tech University, an MA in Management and Psychology from Webster University, and a MS in Astronomy and Astrophysics from the University of Arizona. He is currently a retired Air Force pilot and is a skeptic lecturer. He is the Director of the Grasslands Observatory (www.3towers.com) and specializes in asteroid and comet astrometry and photometry. He has made over 2900 Minor Planet Electronic Circulars (MPEC) publications and discovered 63 comets. He is a contributing author for *Skeptical Inquirer* magazine. He is a Fellow of the Royal Astronomical Society (FRAS).

Chapter 1

Introduction

Dark nebulae are common throughout the Milky Way. Edward Emerson (EE) Barnard (1857–1923) is credited for the first comprehensive study of these regions and for advancing the concept dark nebulae are not holes in the Milky Way but obscuring interstellar matter (Barnard 1913b, 1919b). His work on dark nebulae was complemented by his friend, colleague, and sometimes competitor Max Wolf (1863–1932) of Heidelberg, Germany. This book's focus is Barnard's photographic work, particularly his study of dark nebulae and his famous catalog of "Barnard Objects."

Barnard was a driven man as superbly described by William Sheehan in his wonderful biography of Barnard – *The Immortal Fire Within*: *The Life and Work of Edward Emerson Barnard*, Cambridge University Press, 1995. Barnard was born in Nashville, Tennessee, on December 16, 1857, into an impoverished family. He had no formal schooling and started working in early childhood at a photography studio in Nashville. He performed menial demanding tasks at first, but due to his hard work, eagerness, and dependability, he gradually gained experience and was given much responsibility learning photographic skills that would serve him well the rest of his life.

Barnard started his astronomy career as a youthful amateur astronomer searching for comets. His early comet discoveries in 1881 and 1882 with modest optical equipment led to employment as an astronomer at the newly

The original version of the chapter has been revised. A correction to this chapter can be found at https://doi.org/10.1007/978-3-031-31485-8_10

T. B. Hunter et al., *The Barnard Objects: Then and Now*, The Patrick Moore Practical Astronomy Series, https://doi.org/10.1007/978-3-031-31485-8_1

founded Vanderbilt University where he received some formal education. He gained enough international acclaim that he was offered employment in 1887 at the new world leading Lick Observatory on Mount Hamilton in Northern California near San Francisco. His many discoveries and observations at Lick Observatory including his Milky Way and comet photography led to his employment at the new Yerkes Observatory in Wisconsin in 1895 where he stayed for the rest of his extraordinary life.

Even though Barnard is now most appreciated for his pioneering astrophotography, he was one of the greatest visual observers in history. In the 1880's while he was working at the photography studio in Nashville, Barnard visually discovered 5 comets and gained his first astronomical recognition. His comet discoveries allowed him to purchase his first house in Nashville, TN (Sheehan 1995). On September 9, 1892, using the Lick 36-inch refractor Barnard visually discovered Amalthea, the fifth moon of Jupiter. He was the first to notice gaseous emissions from a nova showing that it was a stellar explosion. Barnard recognized the gegenschein in 1883 not realizing there had been formal publications about it by Theodor Brorsen (1819–1895) in 1854 and TW Backhouse (1842–1920) in 1876 (Barnard 1888; Olson 2021). Barnard visually studied the gegenschein his entire career publishing several seminal papers about his observations which remain relevant more than 100 years later (Barnard 1919b) (Fig. 1.1).

Barnard is credited with calling modern attention to the Rosette Nebula, first observing it January 23, 1883. Portions of the Rosette Nebula had also been noted by many previous observers including John Flamsteed (1646–1719), William Herschel (1738–1822), John Herschel (1792–1871), and Lewis Swift (1820–1913). In 1884 Barnard first observed NGC 6822 (now known as Barnard's Galaxy) using a 5-inch refractor, and in 1885 he found the California Nebula (NGC 1499), an emission nebula in Perseus, using the 6-inch Cooke Telescope at Vanderbilt University (Teets 2020).

Barnard visually found the nebulosity associated with 15 Monocerotis in 1888 with the 12-inch refractor at Lick Observatory and later photographed this complex nebulous region containing the open cluster NGC 2264 (Christmas Tree Cluster) and the Cone Nebula (Barnard 1895a, b). Barnard is also credited with the first visual description of the "spokes in Saturn's rings," though he did not describe them as such, and they were only confirmed by Voyager spacecraft images decades later.

Barnard was such an avid observer that he discovered many other objects, often galaxies or galaxy groupings, that he classified as nebulae. In his lifetime it was not appreciated that many of the faint smudges he observed were galaxies, "island universes," quite distinct from the more ordinary nebulous regions in the Milky Way.

Barnard's range of discoveries was extensive. Gottlieb (2020) examined Barnard's scanned Lick Observatory logs from May 1888 through October

Fig. 1.1 All-sky image from the Grasslands Observatory (http://www. GrasslandsObservatory.com) on the morning of October 24, 2022 (UT). Gegenschein (G), Jupiter (J), Altair (A), Vega (V), and Deneb (D) are noted. The summer Milky Way is setting in the west (W). There is horizonal sky glow from Tucson, Arizona (right), Nogales, Arizona, Sonora, Mexico (bottom), and Sierra Vista, Arizona (left)

1890 and "…found a treasure trove of uncredited deep-sky discoveries that have lain hidden in his personal logbooks from more than 130 years." In the process of examining these logbooks Gottlieb documented "50 unknown discoveries during [Barnard's] first 2 ½ years at Lick. These include every category of deep-sky object: galaxies, globular and open clusters, and reflection and emission nebulae. Later visual observers rediscovered a few of these objects, but most remained unknown until photographic surveys of the second half of the twentieth century." Why were these observations not published by Barnard? No one knows, but Gottlieb speculates Barnard's passion at that time was sweeping for comets, so he spent a limited amount of time on other observations and publications. Gottlieb also speculates that "when the Lick Historical Project processes Barnard's later notebooks…it will uncover dozens of additional discoveries."

Barnard visually observed comets his entire life, first actively searching for them as an amateur astronomer, and then later studying them in depth visually and photographically as a professional astronomer. During his professional lifetime, he continued to be a leading visual observer of

comets. Barnard was by far the most prolific and accomplished comet photographer in his lifetime. The first photographic discovery of a comet was made by Barnard on October 12, 1892, when a 4 hour 20-minute photograph of the Milky Way near Altair using the 6-inch Willard Lens of the Crocker Observatory at Lick Observatory showed a "narrow hazy streak… about 18 minutes long." Subsequent visual observation with the Lick Observatory 12-inch refractor the following night showed this was a new comet (Barnard 1892).

Barnard produced a very large body of important visual observations of Mars, Jupiter, Saturn, comets, nebulae, double stars, and globular clusters. Many of his observations are still cited today. Given his incredible visual talents, it is somewhat ironic that his pioneering photography helped spell the end of visual professional astronomy.

In addition to being noted for his comet photography, Barnard also had many other photographic accomplishments. Barnard's Loop describes the large arc of nebulosity encircling a portion of Orion. This was first photographed in 1888 by WH Pickering (1858–1939). Barnard called attention to it and described its extended length on photographs of Orion taken in 1894 with exposures of 2-hours and 1 hour 15-minutes using a 1 ½-inch diameter lens with a 3 ½-inch focus (Barnard 1894). Barnard also took numerous photographs of the Horsehead Nebula (IC 434) and was the first to emphasize its appearance and suggest it was caused by obscuring matter (Barnard 1913b) (Fig. 1.2).

Barnard's first wide-field astrophotographs were made in 1889 at Lick Observatory lick observatory (Fig. 1.3). He initially used a 1-inch Voigtlander lens but felt it was too small for Milky Way photography and by July 1889 had switched to what he called the "Willard" lens. This lens had originally been made by Charles F Unser in New York City.

Unser made portrait lenses for stock dealers like Willard & Company. Such lenses were designed for making portraits during the **wet-plate period of photography** from approximately 1851 to 1890. The best portrait lenses were Petzval lenses, which were developed by Joseph Petzval (1807–1891) in 1840. The Petzval design was the first lens design based on optical laws and consisted of a front doublet lens separated from a back doublet lens by an aperture stop in between (Fig. 1.4a). The first Petzval lenses were built by the Voigtlander company of Austria and were widely used as "portrait" lenses as they could be made with large apertures and focal lengths as short as f/3.6.

Nicephore Niepce (1765–1833) is generally credited with producing the first recognizable photograph in 1827. See Table 1.1 **(History of Photography)**. His process was very slow and impractical for commercial use. The first successful commercial photographic process was invented by

Fig. 1.2 IC 434 (Horsehead Nebula; Barnard 33) as photographed by EE Barnard on February 7, 1913, with the 10-inch Bruce Telescope at Yerkes Observatory using a 4-hour 33-minute exposure (Barnard 1913b). This image is a 4× enlargement of a selected region from the original photographic plate and is a "negative" image where blacks and whites are reversed

Louis Daguerre (1787–1851) in 1839 in which a positive image is formed directly on a silvered copper plate made light sensitive with surface coating of iodine vapors.

Daguerreotypes produced an excellent one-of-kind positive image, but they could not be easily replicated. In 1841 Henry Fox Talbot (1800–1877) patented his **calotype process**. The calotype process could produce an unlimited number of prints from a single negative. Even though calotypes could be much more easily duplicated than daguerreotypes, they did not produce as sharp an image as daguerreotypes and did not enjoy the commercial success of the daguerreotype.

The next photographic advance was the **wet-plate or collodion process** invented in 1851 by Frederick Scott Archer (1813–1857). It had been theorized earlier by Gustave Le Gray (1820–1884). Wet plates produced a negative image on a transparent glass plate. This process while slow by later photographic methods, was 20 times faster than the daguerreotype process, replacing daguerreotypes as the leading commercial photographic medium.

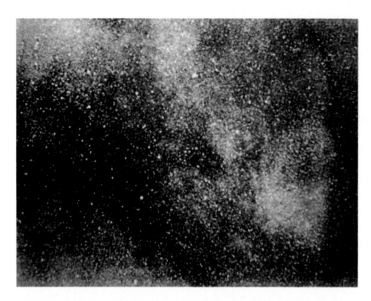

Fig. 1.3 August 1, 1889. Barnard's first long exposure Milky Way image with good results, a 3 hours 7-minute exposure with the Lick Observatory Willard lens strapped to the observatory's 6.5-inch equatorial refractor. The image shows the region of what we believe is Barnard 289. (Barnard 1890)

Fig. 1.4 Common lens designs used by Barnard. (**a**) Petzval lens. This was the lens configuration of the Willard lens on the Crocker Astrograph at Lick Observatory. (**b**) Medieval configuration for a Magic Lantern. The Magic Lanterns in Barnard's time used an arc lamp or early electric light bulb to illuminate photographic plates or film transparences with a simple projection lens. Such a lens could be adapted for wide field astrophotography. (Drawings by Debra Bowles)

Table 1.1 History of photography

Camera Obscura in use	500 BCE – to present.
Discovery of silver nitrate darkening in sunlight	1717. Johann Heinrich Schulze (1687–1727) discovers sunlight and not heat from the Sun darkens substances mixed with silver nitrate. He obtains remarkable shadows of objects, but these first "photographs" are not permanent.
First permanent photograph	1827. Nicephore Niepce exposes a sheet of metal film with chemicals spread on it. Needed multiple hour exposure probably using a camera obscura.
Daguerreotype process	1839. Louis Daguerre (1787–1851) introduces the first widely used commercial photographic process. A positive image is formed directly on a silvered copper plate made light sensitive with surface coating of iodine vapors.
Photographic fixation	1839. John Herschel (1792–1871) proposes sodium hyposulfite as a fixating agent which stops rapid fading of photographs and allows an extended life span for photographs.
Introduction of the first photographic portrait objective lens.	1840. Joseph Petzval designs the first lens based on optical laws, consisting of a front doublet lens separated by a back doublet lens with an aperture stop in between.
Calotype process	1841. Negative and positive process patented by Henry Fox Talbot. It uses a paper negative to make prints. These are less durable and less sharp than daguerreotypes. Because a negative is produced, the calotype process can be easily used to make an unlimited number of positive prints unlike the daguerreotype process.
First photographic lantern slides	1848. Ernst Wilhelm (William) Langenheim (1806–1874) and his brother Friedrich (Frederick) Langenheim (1809–1879) introduce photographic lantern slides, glass negatives and positives.
Wet Plate (collodion) process	1851. Frederick Scott Archer (1813–1867) introduces the wet plate process in which a mixture of collodion and silver salts is spread on sheets of glass. This is cheaper than the daguerreotype process and was a negative/positive process allowing unlimited positive prints. Photographic sensitivity was greatly increased allowing for far easier portrait photography. The wet plate process replaced daguerreotypes and was commercially widespread until replaced by the dry plate process in the late 1880's.

(continued)

Table 1.1 (continued)

First Color Photograph	1861. James Clerk Maxwell (1831–1879) introduces the concept of color photography by combining images through red, green, and blue filters to produce a final color photograph. Thomas Sutton (1819–1875) created the first single lens reflex camera in 1861 and was the photographer for Maxwell's color photography.
Dry plate photography	1871. Introduced by Richard Leach Maddox (1816–1902), a glass plate is coated with a gelatin emulsion of silver bromide. It could be stored until exposure and processed in the darkroom later when convenient. The wet plate process while an improvement over the daguerreotype process required immediate darkroom preparation of the photographic plate and immediate development of the plate after exposure necessitating photographers traveling with both camera and darkroom.
Hardening of photographic emulsion.	1873. Charles Harper Bennett (1840–1927) improves the dry plate process by finding a method to harden the emulsion. In 1878 he discovers prolonged heating increases the sensitivity of the emulsion enabling images as fast as 1/25th second, paving the way for snapshot photography of everyday scenes.
Seed Dry Plate	1879. Miles Ainscoe Seed (1843–1902) introduces a practical dry plate ("Seed Dry Plate"). These plates were easy to transport and quickly became popular. The M.A. Seed Dry Plate Company was incorporated in July 1883 and was purchased by Eastman Kodak in 1902.
Kodak sells first commercial camera	1880's. George Eastman (1854–1932) creates a flexible roll film that did not require the constant change of photographic plates. His first camera held 100 film exposures. It contained a single lens with a fixed focus. The camera was sent back to the factory for film processing and prints to be made. This was the first affordable camera for the average person to own.
Early motion picture systems	1889–1900. Thomas Edison (1847–1931) introduces the Kinetoscope in 1891. Motion picture invention is attributed to Edison, but its creation was the work of multiple inventors, some of whom worked for Edison.

(continued)

Table 1.1 (continued)

Cinematograph system	1895. First practical projected motion picture system. It was introduced by Auguste (1862–1954) and Louis Lumiere (1864–1948) and was the first projection system that allowed a motion picture to be seen by more than one person at a time.
Introduction of the Brownie camera by Kodak	1900. It becomes very popular due to its ease of use with simple roll film.
Autochrome Lumiere	1907. The Lumiere brothers introduce the first commercially successful color photographic process. It was an additive color mosaic screen process and the principal color photography method until subtractive color film was introduced in the late 1930s.
35 mm film format	1924. Oskar Barnack (1879–1936) reduces the camera size and weight for a Leitz Camera product which was named the Leica. The 35 mm (24 × 36 mm) format came into common use in the late 1940's.
Kodachrome introduced	1935.
Instant photographic images	1938. Polaroid introduces the Model 95 camera with a secret chemical process to develop film in the camera in less than a minute.
First 35 mm pentaprism single lens reflex (SLR) camera.	1949. Contax produces the first 35 mm pentaprism SLR which allows easy eye-level viewing. This design quicky becomes the camera of choice for photographers.
Introduction of smart cameras	Late 1970's, Compact point and shoot cameras were introduced that calculated shutter speed, aperture, and focus.
Introduction of digital cameras	Early 1990's. 1991. First digital SLR camera. Digital imaging replaces most film photography by 2005–2010.
Kodak stops selling Kodachrome.	2009.
Kodak files Chap. 11 bankruptcy protection.	2012.
Kodak emerges from bankruptcy.	2013. Orients its main business focus away from film.

Daguerreotypes and wet plate photographs were mostly employed for portraits. Portrait cameras used large, wide multi-inch lenses to gather as much light as possible for the long exposures needed. These portrait lenses had shallow depths of field which was an advantage as the background was blurred enhancing the portrait itself. Barnard would find such lenses useful for wide-field astrophotography; they collected a large amount of light and could produce a reasonably focused image over a large glass plate. He wrote "[t]he main advantage of the portrait lens lies in its grasp of wide areas of the sky and its rapidity of action—this last result being due to its relatively short focus. The wide field makes it specially suitable for the delineation of the large structural details of the Milky Way; for the discovery and study of the great nebulous regions of the sky; for the investigation of meteors and the determination of their distances; and especially for the faithful portrayal of the rapid changes that take place in the forms and structures of comets' tails" (Barnard 1905).

The wet plate process allowed paper prints to be easily made from a developed and dried negative glass plate. Unfortunately, the wet plate process had a significant disadvantage. The plate had to be sensitized immediately prior to exposure, and it had to be processed while its coating was still moist. This required the photographer to have a darkroom immediately available to first sensitize a plate for use and then immediately after taking a photograph to develop the plate. Wet plates had a very short lifetime. They could not be made and then stored. They had to be immediately exposed and developed after exposure. Photographers had to travel with a portable darkroom drawn by a horse or a mule if they wanted to do photography outside their studio.

In 1871 Richard Leach Maddox (1816–1902) developed the idea of suspending silver bromide in a gelatin emulsion which was applied to a glass plate, producing a so-called "dry plate". **Dry plates** coated with gelatin containing silver salts could be stored ready for use when needed, and they could be processed later when convenient. This eliminated the need for a portable darkroom.

In 1873 Charles Harper Bennett (1840–1927) developed a method of hardening the dry plate emulsion making it less resistant to scratches. In 1878 he discovered he could greatly increase plate sensitivity by prolonged heating. In 1879 George Eastman developed an industrial method to coat glass plates with photographic emulsion and opened the Eastman Film and Dry Plate Company, which later evolved into the Eastman Kodak Corporation.

The dry plate photographic process quicky superseded the wet plate collodion process. Dry plate photography marks the beginning of the modern era of photography. It also allowed for photography to become a dominant force in astronomical research. Long exposure photographs became possible.

In 1883 Andrew Ainslie Common (1841–1903) took photographs of M42 using his 36-inch reflector and dry plates showing stars fainter than could be seen visually through large telescopes. See Table 1.2 (**History of Astrophotography**).

Table 1.2 History of astrophotography

1839	John Herschel (1792–1871) popularizes the term *photography* (writing with light) which was first suggested by Johann Heinrich von Madler (1794–1894).
1839	Louis Daguerre (1787–1851) attempts daguerreotype of the Moon with long exposure resulting in blurred image.
1840	First successful photograph of the Moon by John William Draper (1811–1882). Twenty-minute daguerreotype image using a 5-inch reflecting telescope.
1842	Gian Alessandro Majocchi (1795–1854) obtains photographs of a partial phase of a solar eclipse on a daguerreotype while attempting to image the total eclipse of July 8, 1842.
1843	Daguerreotypes of the solar spectrum by John Willian Draper.
1845	Daguerreotype of the Sun by Leon Foucault (1819–1868) and Hippolyte Fizeau (1819–1896).
1849–1852	John Adams Whipple (1822–1891) takes daguerreotype of the Moon on the Harvard Observatory 15-inch refractor in 1849. This wins him a gold medal at the Crystal Palace exposition in London in 1851.
1850	Daguerreotype of Vega by William Cranch Bond (1789–1859) father, George Phillips Bond (1825–1865) son, and John Adams Whipple on July 16–17 with Harvard College Observatory 15-inch refractor. Whipple obtains first known image of a double star (Castor).
1851	Corona of the Sun successfully photographed (daguerreotype) during the solar eclipse of July 28, 1851, by Johann Julius Friedrich Berkowski under the direction of August Ludwig Busch (1804–1855), Director of the Konigsberg Observatory. 84-second exposure with a small refractor.
1849–1852	William Cranch Bond and John Whipple Adams obtain further daguerreotypes of the Moon with the 15-inch Harvard College Observatory refractor.
1852	Wet plate collodion images of the Moon by Warren de la Rue (1815–1889) using 13-inch refractor. The wet plate collodion process used much shorter exposures than the daguerreotype process with far better detailed images of the Moon.
1854	Joseph Bancroft Reade (1801–1870) photographs the Sun with the wet plate collodion process obtaining images resolved enough to show a mottled appearance to the photosphere.

(continued)

Table 1.2 (continued)

1857	First photograph of a double star (Mizar, Alcor) by George Phillips Bond (1825–1865) using the wet plate collodion process and the Harvard College Observatory 15-inch refractor.
1858	George Philip Bonds shows photography can be used to measure the brightness of stars and planets.
1860	Angelo Secchi (1818–1878) captures 4 photographs of the total eclipse of the Sun July 18, 1860, in Desierto de Las Palmas, a remote area of southeastern Spain. His images clearly show the prominences and the corona. Warren de la Rue also obtains successful photographs of the same eclipse.
1870	Louis M Rutherford (1816–1892) obtains first successful photographs of the Sun's surface (granulations) and sunspot details.
1871	Dry plate process introduced by Richard Leach Maddox (1816–1902). Dry plates could be stored for later use and stored after exposure for later developing. The dry plate process made astrophotography more convenient and long exposure images possible.
1872	Henry Draper (1837–1882, son of John William Draper) takes the first photograph of a star spectrum (Vega, alpha Lyrae).
1873	Henry Draper takes spectrum of the Sun. He later photographs spectra of many bright stars, the Moon, Jupiter, and Venus using his 11-inch Clark refractor and a quartz prism located close to the photographic plate.
1870–1890	Herman Carl Vogel (1841–1907) uses spectroscopic photography to determine the rotation period of the Sun. He establishes a program of photographing and analyzing stellar spectra at the Astrophysical Observatory in Potsdam. In 1889 he discovers the light from Algol alternates from blue shifts to red shifts over a period of 3 days coinciding with Algol's period of brightness variation proving that Algol is an eclipsing binary system.
1873	Edward Walter Maunder (1851–1928) installs a photoheliograph at the Greenwich Observatory to photograph the Sun daily.
1874	Pierre Jules Cesar Janssen (Jules Janssen) (1824–1907) successfully records the Transit of Venus in Japan using his "photographic revolver" which he invented in 1873. It takes 180 images at the rate of one frame per second and is a precursor of the motion picture camera.
1876	William Huggins (1824–1910) and his wife Margaret Lindsay Huggins (1848–1915) use dry plate photography to record spectra. The Huggins with help from William Allen Miller (1817–1870) photograph spectra of all the first and second magnitude stars from 1876–1886.
1879	Andrew Ainslie Common (1841–1903) successfully photographs Jupiter using his 36-inch (910 mm) reflector.

(continued)

Table 1.2 (continued)

1880	Henry Draper takes first photograph of the Orion Nebula using his 11-inch Clark refractor.
1881	The Great Comet of 1881 (Comet Tebbutt, 1881 III, 1881b) is photographed by Jules Janssen on July 1 using a half-meter aperture telescope with a 1.60-meter focal length and extra sensitive gelatino-bromide silver plates exposed for 30 minutes. Henry Draper and Ainslie Common photograph this comet and William Huggins obtains a photograph of its spectrum.
1882	Edward C Pickering (1846–1919), director of Harvard College Observatory, starts the world's first photographic sky survey. It runs from 1882 to 1992 and contains over 500,000 images. Pickering starts a spectral program at Harvard College Observatory using objective prisms obtaining several spectra on a single plate.
1882	David Gill (1843–1914) photographs the Great Comet of 1882 (C/1882 R1, 1882 II and 1882b) at the Cape Observatory in South Africa.
1883	Andrew Ainslie Common uses dry plate photography to image M42 showing stars too faint to be seen visually. He uses his 36-inch reflecting telescope with a silver coated glass mirror at his Ealing (England) Observatory.
1885–1886	Paul Henry (1848–1905) and his brother Prosper Henry (1849–1903) produce the first accepted successful planetary photographs with images of Jupiter and Saturn obtained with the Paris Observatory 13-inch f/10 photographic refractor which they had built. On photographic plates taken November 16, 1885, they discover the Maia Nebula (NGC 1432) in the Pleiades (M45).
1887	Amedee Mouchez (1821–1892) proposes the Carte du Ciel. The project's goal is to photograph the entire sky with 18 observatories agreeing to cooperate using a standard photographic telescope design based on the 13-inch refractor at the Paris Observatory developed by the Henry Brothers. Different observatories around the world were assigned to survey specific declination zones. The project ran off and on for many years and was only partially successful and never fully completed.
1888/1890	William Henry Pickering (1858–1939) obtains successful photographs of Mars using the 38 cm and 32 cm refractors at Pic du Midi Observatory.
1890's	Edward Singleton Holden (1846–1914) obtains high resolution photographs of the Moon using the Lick Observatory 36-inch telescope.
1891	George Ellery Hale (1868–1938) obtains first spectral image of a solar prominence using a spectroheliograph which he invented.

(continued)

Table 1.2 (continued)

1892	Max Wolf (1863–1932) obtains first photographic discovery of an asteroid.
1892	EE Barnard obtains first photographic discovery of a comet.
1892–1895	EE Barnard (1857–1923) obtains epoch making photographs of the Milk Way. These were officially published in 1913 along with images of selected comets obtained in the same time span (Barnard 1913a, b).
1896	Edward Crossley (1841–1905) of Halifax, United Kingdom, donates his 36-inch reflector (formerly the AA Common reflector) to Lick Observatory. Lick Observatory Directory James E Keeler (1857–1900) starts photographic survey of nebulae (galaxies, and nebular regions) at Lick Observatory. These are the best long focal length, long exposure photographs of celestial objects until George Willis Ritchey (1864–1945) Ritchey's starts photography in 1909 with the 60-inch f/5 reflector at Mount Wilson Observatory.
1893, 1899	Isaac Roberts (1829–1904) publishes two separate volumes of ***Photographs of Stars, Star Clusters and Nebulae*** based on his series of photographs from 1885–1897 mainly using a 20-inch f/5 reflector mounting the photographic plates at prime focus. This was the first popular large format celestial photography of the deep sky. His December 29, 1888, photograph of the Great Nebula in Andromeda (M31) revealed the nebula had a spiral structure. His January 25, 1900, photograph of the Horsehead Nebula (IC 434) is one of earliest images to show its configuration.
1896–1900	***Cape Photographic Durchmusterung*** published by David Dill and Jacobus Kapteyn (1851–1922) using the 13-inch photographic refractor at the Cape of Good Hope Observatory, South Africa. This is the first complete photographic survey of the southern skies.
1903	Jules Janssen publishes his ***Atlas de Photographie solaires*** with more than 6000 solar pictures.
1913	EE Barnard publishes ***Photographs of the Milky Way and of Comets*** using images obtained from 1892–1895 from the Crocker Astrograph at Lick Observatory.
1914	Publication of the first edition of the ***Franklin-Adams Charts***, 206 photographic plates covering the entire sky on a uniform basis. This was done with a 10-inch f/4.5 lens giving very good images over a field 15 × 15 degrees with a scale of 20 mm to the degree and reaching a limiting magnitude of 16–17. The project was started and funded by the astronomer John Franklin-Adams (1843–1912) who died prior to its publication by the Royal Astronomical Society.

(continued)

Table 1.2 (continued)

1924	Edwin Hubble (1889–1953) identifies Cepheid variables on photographs of the Great Andromeda Galaxy (M31) taken with the Hooker 100-inch telescope at Mt. Wilson Observatory. This demonstrated M31 was a separate galaxy from the Milky Way and paved the way for the modern view the Universe is filled with innumerable galaxies.
1927	Edwin B Frost (1866–1935) and Mary R Calvert (1884–1974) edit and complete Barnard's *Atlas of Selected Regions of the Milky Way* after his death in 1923.
1940	Kodak develops the 103a spectroscopic film series. Each film is sensitive to a different portion of the electromagnetic spectrum. These films have low reciprocity failure.
1958–2000	The National Geographic-Palomar Observatory Sky Survey (NGS-POSS) with nearly 2000 photographic plates is completed. The follow-up POSS-II survey was performed in the 1980s and 1990s. Several southern hemisphere surveys were performed from the early 1970's to 2000 to complement the Palomar Sky Survey.
1959	"Fast" color films introduced allowing practical color astrophotography.
1969	Invention of the Charge Coupled Device (CCD) by Willard Sterling Boyle (1924–2011) and George Elwood Smith (1930–) at the AT&T Bell Laboratories as a form of computer memory. It was later developed into an imaging device by Michael Francis Tompsett (1939–) and others.
1974	First CCD image of the Moon.
1976	First CCD images of Jupiter, Saturn, and Uranus.
1970–1990	Photographic hypersensitization is introduced. It employs various techniques-film baking, gas phase hypersensitization with nitrogen or hydrogen gas, and cold camera use.
1981	Kodak introduces ultra-fine-grained 2415 Technical Pan Film. This film could be developed for maximum dynamic range for planetary work or be hypersensitized for extended exposures of deep-sky objects.
1984	John B Marling obtains United States Patent 4,473,636 "Process and apparatus for photographic film sensitization."
1990	Introduction of digital cameras. Digital imaging replaces most professional film astrophotography by 2000.

The Willard portrait lens used by Barnard for his Milky Way and comet photography at Lick Observatory was obtained by Edward Holden (1846–1914), Director of Lick Observatory, after the January 1, 1889, total eclipse of the Sun which was visible in northern California. William Ireland, an

amateur astronomer, had obtained excellent photographs of the eclipse using a large "Willard" portrait lens of 6-inch aperture and 31-inch focal length he had borrowed from William Shew, a photographer in San Francisco. Shew had used it for making "fashionable portraits (especially in the later sixties)" (Barnard 1913a). Holden purchased the lens from Shew for the Lick Observatory with funds provided by CF Crocker (1854–1897), an important railroad leader and philanthropist in northern California.

Barnard experimented with the Willard lens for astronomical photography and found it to be much superior to the small Voigtlander lens he had previously used. The Willard lens was given to John Brashear (1840–1920), a noted instrument maker and optician, who refigured the lens greatly improving the definition of star images.

The early Milky Way and comet images by Barnard were made with the Willard lens in a wooden camera box strapped onto the Lick 6 ½ equatorial refractor as a guiding telescope. Later, the lens and its wooden box were transferred to an equatorial mounting made by Brashear and fastened to a flat iron plate attached to the upper end of the declination axis on the mounting. The mounting was also paid for by CF Crocker, and the photographic instrument was then named the **Crocker Astrograph** (Barnard 1913a). The telescope was guided by Barnard using a 2.4-inch refractor fastened to the wooden box (Barnard 1913a).

Barnard also sometimes used a small **"magic" lantern lens** for photographing large areas of the sky (Fig. 1.4b). The magic lantern (*laterna magica*) was the forerunner of 35 mm slide projectors and computer screen projectors. Christiaan Huygens (1629–1695) is credited with being the inventor of the magic lantern concept. In its earliest form a concave mirror behind a candle or oil lamp directed light to the other side of the candle through a small rectangular piece of glass (lantern slide) bearing an image. The light was focused onto a wall or screen by a lens at the front of the lantern. The pictures on the slides were initially painted on the glass.

Later photographic lantern slides (hyalotypes) were introduced by the Langenheim brothers in 1848. The lenses used for these early projectors were called magic lantern lenses. The lens used by Barnard for such ultra-wide field photography was 1 ½ inches in diameter with an approximate 4–5-inch focus producing an image scale of 10 degrees to 1-inch on the photographic plate. The long dark and bright nebulous region (Barnard 40 and IC4592) about Nu Scorpii (Jabbah) was discovered on a plate using such a lens (Barnard 1895b).

Barnard's work at Lick Observatory with the Willard Lens and the Crocker Astrograph was the first extensive photographic study of the Milky Way. Barnard recognized larger lenses with longer focal lengths or

photographic cameras attached to large telescopes produced more detailed images of small astronomical objects and gave fainter limiting magnitudes. However, he felt they could not adequately delineate the large wide field structure of the Milky Way.

"It seems desirable to give a brief description of the photographs of the Milky Way made by me [Barnard} at the Lick Observatory in 1889...It was intended to show as far as possible by photography, the wonderful and complex structure of the Milky Way...One very important feature, and one which must not be overlooked, is that these are the only photographs ever made, here or elsewhere, which show all the true Milky Way...The photography...of the true Milky Way must be confined to instruments of medium dimensions-with large apertures and small focal lengths-until our plates can be made much more sensitive, or the exposures extended through several nights...In the photographs made with the six-inch portrait lens, besides myriads of stars, there are shown, for the first time, the vast and wonderful cloud forms, with all their remarkable structure of lanes, holes and black gaps and sprays of stars (Barnard 1890)." The plate scale for Barnard's work with the Willard lens was 1-inch = 1.8 degrees.

In 1897 Catherine Wolf Bruce (1816–1900), an important philanthropist and a noted patron of astronomy, gave the University of Chicago (the owner of Yerkes Observatory) $7000 for the purchase of a 10-inch photographic telescope for Barnard's wide-field photographic work. By that time, Barnard had left Lick Observatory in California and was now at Yerkes Observatory in Williams Bay, Wisconsin. After several delays and modifications, the Yerkes Bruce instrument and observatory for it were finally completed and placed in position in April 1904.

The **Bruce Medal** (officially the Catherine Wolfe Bruce Gold Medal) of the Astronomical Society of the Pacific is named in Catherine Bruce's honor. It was established by Bruce in 1898 to be given to a recipient in recognition of a lifetime of outstanding achievements and contributions to astrophysics. The Bruce Medal is one of the most prestigious awards in astronomy.

The *Bruce Telescope at Yerkes Observatory* was the smallest "Bruce Telescope" in existence at that time. Catherine Wolf Bruce gave $50,000 to Harvard Observatory in 1889 at the request of Edward Pickering (1846–1919), who wanted to build the largest astrograph in existence. Bruce's donation financed the building of a 24-inch photographic telescope with its doublet lens made by Alvan Clark & Sons of Cambridge, MA. The lens was completed in 1893 and the Bruce Telescope was installed in Cambridge, MA in 1893. In 1895 it was moved to the Harvard Boyden Station high-altitude observatory (8000 feet) in Arequipa, Peru where it played a leading

role in astronomical photography and discovery for many years. The *Harvard Bruce Telescope* was moved to Boyden Station in Bloemfontein, South Africa in 1927 and used until 1950 when it was decommissioned. This telescope took nearly 30,000 photographic plates during its lifetime. The telescope's doublet lens was lost for years but rediscovered and is now on display as part of the Harvard Collection of Historical Scientific Instruments.

Max Wolf on a trip to the United States met Catherine Bruce and received a $10,000 donation for construction of a research instrument to be used by Wolf. With this money, Wolf designed and ordered a 16-inch double refractor from John Brashear. This instrument is known as the Bruce doublet-astrograph. It has parallel 16-inch lenses and a fast f/5 focal ratio. The *Bruce doublet-astrograph* began operation in 1900 at the Landessternwarte Heidelberg-Königstuhl near Heidelberg, Germany. Its photographic plates produced wide field images 6 × 8 degrees and was used by Wolf for the study of minor planets, comets, and nebulae, as well as proper motion of stars. This instrument helped Wolf along with Barnard to confirm the presence of dark clouds of interstellar matter in the Milky Way. The *Heidelberg Bruce Telescope* is still in operation.

The Yerkes Bruce Telescope system consisted of a 5-inch guiding telescope and two photographic doublet telescopes of 10 and 6 ¼ -inches bound together on the same mount, a specialized mount built by the Warner & Swasey Company of Cleveland. The pier was bent to form the polar axis allowing the telescope to swing freely in all position of the instrument (Fig. 1.5).The 10-inch doublet lens of a modified Petzval design was figured by John Brashear. It had a focal length of 50 inches which "…gave exquisite definition over a field of some 7 degrees in width and could by averaging be made to cover at least 9 degrees of fairly good definition" (Barnard 1905).

The 6 ¼ -inch telescope was constructed with a used Voigtlander lens of 31-inch focal length. There was also purchased a new 4-inch Voigtlander lens with a short focal length of 7.9-inches. These focal lengths were for the photographic focus of the telescopes; the photographic plates available were most sensitive to the blue portion of the visible spectrum. The visual focus tended to be longer where the green-yellow portion of the spectrum came to focus, the point at which visual observing was the most sensitive.

In use the Yerkes Bruce Photographic Telescope consisted of three optical tubes bound together rigidly on the same mount – the 5-inch visual telescope for guiding, and the 10-inch and 6 ¼-inch photographic telescopes (Barnard 1905).The 10-inch telescope used 12-inch square photographic plates, and the 6 ¼-inch telescope used 8 × 10-inch photographic

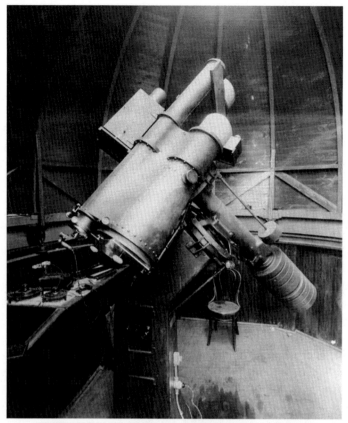

THE BRUCE PHOTOGRAPHIC TELESCOPE IN ITS DOME AT THE YERKES OBSERVATORY

Fig. 1.5 Bruce Telescope in its dome at Yerkes Observatory. (Permission granted for use of image by Gerald Orin Dobek)

plates. The Yerkes Bruce Photographic Telescope was used by Barnard for the rest of his career. It was situated in its own small observatory building at Yerkes, and in a special housing in 1905 when the telescope was temporarily transported to Mount Wilson in Southern California to take advantage of Mount Wilson's 6000-foot altitude and its southern latitude compared to that of Yerkes Observatory in Wisconsin. This allowed Barnard to complete an extensive photographic survey in 1905 of portions of the Milky Way in Sagittarius and Scorpius not attainable from the latitude of Yerkes Observatory.

The use of two photographic telescopes, the 10-inch and the 6 ¼-inch of differing optical configurations was deliberate "...so that an independent series of pictures of the same region could be secured on a very different

scale. Photographs with these, at the same time that they mutually verified each other, would have other values peculiar to themselves" (Barnard 1905). In other words, images from the smaller instrument were a good backup to support any unusual photographic finding from the larger instrument.

Barnard published his initial list of 182 dark nebulae in 1919 (*Astrophysical Journal*, January 1919a; 49:1–23). He gave the nebulae number designations from 1–175 with 44a, 67a, 83a, 84a, 117a, 119a, and 131a bringing the total objects to 182. After Barnard's death, this 1919 work was used as the basis for an expanded work *A Photographic Atlas of Selected Regions of the Milky Way* (1927) edited by Edwin B Frost, Director of Yerkes Observatory, and Mary R Calvert, Barnard's niece and assistant (Fig. 1.6). An excellent reprinting of this book was done in 2011 (Cambridge University Press, Cambridge, UK) by one of the authors (GD). An online version of the Barnard's 1927 book is available from the Georgia Institute of Technology at: https://exhibit-archive.library.gatech.edu/barnard/intro.html.

Barnard visually observed or took astrophotographs every night possible only interrupting his intense routine due to bad weather, occasional illness, a rare vacation, or for a professional trip out of town. Even though he was often up the entire night observing, he was usually in his office at his desk early in the morning. He developed all his photographic plates, guided all

Fig. 1.6 (a) Edwin Brant Frost (1866–1935), Director of Yerkes Observatory, Williams Bay, WI, (1905–1932). University of Chicago Photographic Archive, [apf6–00248], Hanna Holborn Gray Special Collections Research Center, University of Chicago Library. (b) Mary Ross Calvert (1884–1974), Barnard's niece. She was a computer at Yerkes Observatory and shown here operating the Kenwood 12-inch refractor telescope on February 23, 1916. University of Chicago Photographic Archive, [apf6–01280], Hanna Holborn Gray Special Collections Research Center, University of Chicago Library

his exposures, and worked until a few days prior to his terminal illness in early 1923. During his career he exposed 3500 plates of the Milky Way at Yerkes and 500 at Mt. Wilson (Teets 2020).

Barnard died in Williams Bay, Wisconsin, the home of Yerkes Observatory, and was buried in Nashville, Tennessee. Edwin Frost wrote a long, wonderful obituary of Barnard greatly mourning his passing (Frost 1923). Max Wolf, his dear friend, also greatly mourned Barnard's passing. Barnard was one of the last and probably the greatest of visual observers. He was also the leading astrophotographer of his time.

References

Barnard EE. Observations of the zodiacal counterglow. Astron J. 1888;7(168):186–7.

Barnard EE. On the photographs of the Milky Way made at the Lick Observatory in 1889. Publ Astron Soc Pac. 1890;2:240–4.

Barnard EE. Photographic discovery and visual observations of a comet. Astron J. 1892;12:102.

Barnard EE. The great photographic nebula of Orion, encircling the belt and theta nebula. Pop Astron. 1894;2:151–4.

Barnard EE. Photographs of the milky way near 15 Monoceros and near ε Cygni. Astrophys J. 1895a;2:58–9.

Barnard EE. Celestial photographs with a "magic lantern" lens. Astrophys J. 1895b;2:351–3.

Barnard EE. The Bruce photographic telescope of the Yerkes Observatory. Astrophys J. 1905;21:35–48.

Barnard EE. Photographs of the milky way and Comets. Publ Lick Observatory. 1913a;11:1–46.

Barnard EE. Dark regions in the sky suggesting an obscuration of light. Astrophys J. 1913b;38:496–501.

Barnard EE. On the dark markings of the sky with a catalogue of 182 such objects. Astrophys J. 1919a;49:1–23.

Barnard EE. The gegenschein and its possible origin. Pop Astron. 1919b;27:109–12.

Frost EB. Edward Emerson Barnard. Astrophys J. 1923;LVIII(#1):1–35.

Gottlieb S. The lost discoveries of E.E. Barnard. Sky Telescope. 2020;140:34–40.

Olson, Don. Who discovered the Gegenschein? Sky Telescope 2021; 142 (4): 34–40.

Sheehan W. The immortal fire within: the life and work of Edward Emerson Barnard. Cambridge University Press; 1995. ISBN 0 521 44489 6

Teets, Billy. Edward Emerson Barnard-Nashville astronomer Extraordinaire. A brief look at the life and accomplishments of one of Nashville's own. PDF presented at Osher Lifelong Learning Institute Friday, November 13, 2020.

Chapter 2

Nebulae: An Overview

1 Introduction

The word nebula comes from Latin meaning mist or cloud. In the days of professional visual astronomy up until the end of the nineteenth century, a nebula was any poorly defined indistinct object that was not obviously stellar but bright enough to stand out against the dark background sky. Most of the nebulae discovered by visual observers were later found to be galaxies.

Barnard visually discovered scores of nebulae some of which are now known as Barnard Objects, dark nebulae, which are the subject of this book. Dark nebulous regions are common in the Milky Way and had been noted in passing by many observers prior to Barnard. It was through the photographic efforts of Barnard and Max Wolfe that these were recognized as important areas of study.

Some of Barnard's visual nebular discoveries are important bright nebulous regions, such as the California Nebula (NGC 1499) and the Rosette Nebula as opposed to dark nebulae for which he is noted. Most of Barnard's faint nebular discoveries were bright enough to be noted by him but otherwise not particularly interesting and not worth his effort to study further as he was enmeshed in so many projects. Most of his nebular discoveries are in fact galaxies, but that was not appreciated by him or others at that time.

The original version of the chapter has been revised. A correction to this chapter can be found at https://doi.org/10.1007/978-3-031-31485-8_10

T. B. Hunter et al., *The Barnard Objects: Then and Now*, The Patrick Moore Practical Astronomy Series, https://doi.org/10.1007/978-3-031-31485-8_2

In Barnard's lifetime it was not realized there were countless galaxies separate from the Milky Way.

By the mid 1880's Barnard and others realized there were distinct but usually poorly defined areas that had an amorphous cloud-like appearance on astrophotographs. Some were bright, others were dark, and many contained a mixture of bright and dark regions. These "nebulae" are now known to represent interstellar clouds of hydrogen, helium, other mostly ionized gases, and dust particles. The term nebula is no longer applied to galaxies.

The nebulae discussed here all lie within the Milky Way, and the nebulae of interest to us are reasonably close compared with most of the Milky Way. Other galaxies contain nebulae, some far larger and brighter than any found in the Milky Way. These will not be discussed here other than to note the same processes and descriptions applied to the nebulae in the Milky Way can be assumed to apply to those in other galaxies.

The nebulae we observe in the Milky Way are vast in size but usually far less dense than any vacuum created on Earth. *Bright nebulae* are visible from fluorescence caused by hot stars or reflectance of light off particles in the nebulae. *Dark nebulae* are visible as silhouettes against bright star forming regions or bright nebular regions.

There are several ways to classify and describe nebulae. These classifications are somewhat self-evident and overlap. The broadest classification is between bright and dark nebulae as noted above. Nebulae can also be classified as *diffuse nebulae* or *well-defined nebulae*. Except for small planetary nebulae and small well-defined dark nebulae, so called Bok globules, almost all nebulae are extended with no well-defined boundaries. Diffuse nebulae are sometimes classified as *emission nebulae*, *reflection nebulae*, or *dark nebulae*. There are also "nebulae" which are HII regions, planetary nebulae, and supernova remnants. While all these entities are nebulous in appearance and contain gas and dust, they have vastly different origins and somewhat different compositions.

In this chapter we first discuss classical diffuse nebulae – emission, reflection, and dark nebulae. Then we look at other nebular regions which are distinctly different than the classic nebulae, but they are important to note and important to study, though they will not be a focus of this book.

2 Diffuse Nebulae

2.1 *Emission and Reflection Nebulae*

Emission nebulae are bright nebulous regions emitting light with a characteristic emission line spectrum. Emission nebulae originate near hot luminous stars of spectral types O and B. These stars emit large amounts of

ultraviolet radiation which can ionize nearby interstellar atoms. The main component of emission nebulae is ionized hydrogen, a mixture of free protons and electrons. HI is the symbol for neutral un-ionized hydrogen existing as a single hydrogen atom H. HII represents an ionized hydrogen atom or proton.

Recombination takes place when a free electron combines with a proton to form a hydrogen atom. The electron is usually captured in a high energy orbit. The electron then cascades downward through the atom's energy levels toward the ground state emitting photons in the process. Large regions of emission nebulosity are usually called HII regions as the predominant light emitted from them is the spectral line at 656.3 nm (H-alpha line) from a hydrogen electron going from excitation state n = 3 to n = 2 (in the Balmer Series) after it has been captured by a proton and is cascading down the atom's energy levels. This line is in the far-red portion of the visible spectrum, and HII regions are known for their red coloration.

The process taking place in HII regions is fluorescence. High-energy ultraviolet photons emitted by very hot stars are absorbed, and the absorbed energy is re-emitted as lower-energy photons of visible light. A similar but much more complex process takes place in fluorescent lights. In HII regions there are a series of discrete wavelengths emitted by the hydrogen and other elements present, the most dominant emission being that of the H-alpha line at 656.3 nm (Freedman and Kaufmann III 2002).

HII regions are common throughout the Milky Way. They are also very common in spiral and irregular galaxies (Fig. 2.1). These regions are typically large, low-density clouds of partially ionized gas in which star formation has recently taken place or is taking place. Most of the gas is hydrogen, but there is a modest amount of helium, small amounts of other gases, and tiny amounts of various silicon, iron, and other compounds forming "dust."

HI regions are often associated with cold, somewhat denser interstellar nebular regions known as giant molecular clouds in which hydrogen exists in molecular form H_2. Star formation only takes places in molecular clouds through gravitational collapse of dust and gas with resultant heating and eventual nuclear reactions in the core of what becomes a protostar and then a young star. These then give off enormous amounts of ultraviolet radiation that ionize nearby atomic and molecular gas forming an HII region in a localized area of the molecular cloud.

The first recognized HII region and the closest large HII region is the Orion Nebula complex consisting of M42 and M43, though NGC 1977, the Running Man Nebula, may be part of the general complex (Fig. 2.2). The Orion Nebula is probably the brightest nebula in the sky and is visible to the naked eye even in mildly light polluted skies. It is approximately 437 +/− 19 parsecs from the Sun (Hirota et al. 2007). It is estimated to be 24 light

years across and has a mass about 2000 times that of the Sun. It is probably the most intensely studied region in the sky since it is known to contain many stellar protoplanetary disks and brown dwarfs. The star forming regions are estimated to range from less than a million years in age to ten million years. There are intense areas of turbulent motion in its gas, and there are photo-ionizing effects of massive, hot stars in the nebula. At the center of the Orion Nebula are four, hot massive stars known as the Trapezium. The Orion Nebula is surrounded by the much larger Orion

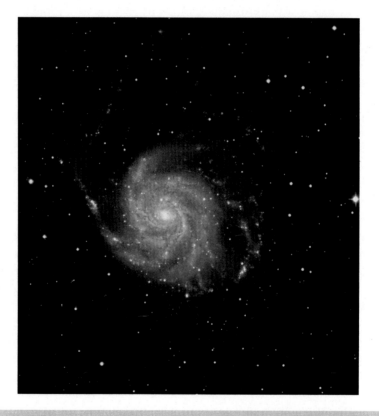

Fig. 2.1 (**a**) M101 (NGC 5457), a classic spiral galaxy with many HII regions spread throughout its spiral arms. PlaneWave CDK24 24-inch f/6.5 telescope, Finger Lakes Instrumentation Proline 9000 CCD, Cousins-Johnson B, V, and R images combined with luminous images for final color image. (© Tim B Hunter, 3towers, LLC, 2022. All Rights Reserved). (**b**) M82 (NGC 3304) with marked regions of H-alpha emission spread throughout the galaxy from presumed recent very active star formation and probable supernova bursts. PlaneWave CDK24 24-inch f/6.5 telescope, Finger Lakes Instrumentation Proline 9000 CCD, Cousins-Johnson B, V, and R images combined with luminous images for final color image. (© Tim B Hunter, 3towers, LLC, 2022. All Rights Reserved). (Unless otherwise noted, all astronomical images are oriented with north at top and east to the left)

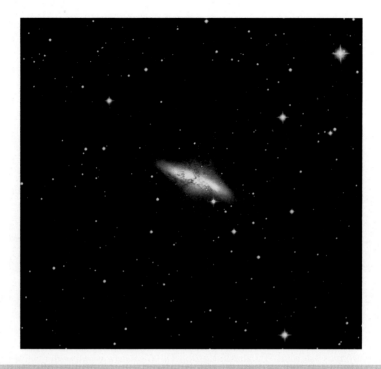

Fig. 2.1 (continued)

molecular cloud complex which measures hundreds of light years across and spans the entire constellation of Orion.

The Orion Nebula often photographs as mainly red from its H-alpha emission. When observed visually, especially in large telescopes, it has a distinctive greenish tint. This is caused by doubly ionized oxygen OIII emitting at 500.7 and 495.5 nm which produces a green-turquoise-cyan appearance for most people and is at a spectral location to which the eye is particularly sensitive.

These OIII lines are known as "forbidden lines", because they are not seen on Earth where there is dense gas compared to the near vacuum of the Orion Nebula. In the case of an oxygen atom excited by collision with a rapidly moving electron or ion, the oxygen atom emits various wavelengths as its electrons cascade down to lower energy levels. Transitions between certain energy levels are very unlikely and termed forbidden. These are metastable levels where electrons can be stuck for some time prior to falling to a lower level. This does not occur in the dense gas on Earth as the atoms collide so frequently with each other an electron in a metastable level is almost immediately excited back up to a higher level. In emission nebulae

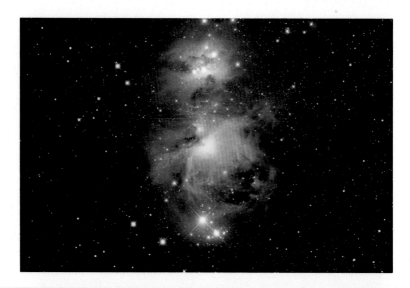

Fig. 2.2 Orion Nebular Complex (M42, NGC 1976), M43 (NGC 1982), NGC 1977 (Running Man Nebula), and NGC 1980. M42 and M43 are mainly emission nebulae. NGC 1977 (top) is a complex mixture of reflection, emission, and dark nebulosity. NGC 1980 is the open cluster at bottom. The linear streaks going north of M43 are geosynchronous satellites. Takahashi Epsilon 180 f/2.8 astrograph with Canon EOS Ra camera. (© Tim B Hunter, 3towers, LLC, 2022. All Rights Reserved)

an atom can go for an hour or more between collisions, enough time for some electrons in a metastable level to transition to a lower level and emit a "forbidden" line. In fact, the presence of forbidden lines in emission nebulae demonstrate these nebulae have low density (Seeds 2003).

There are also regions of blue-violet coloration in the Orion Nebula which is produced by reflection of light off dust and gas particles. The Running Man Nebula (NGC 1977) is considered a "sibling" of the Orion Nebula lying about 30 arcminutes north of it. It is estimated to be roughly at 414 parsecs distance. The Running Man Nebula has a milder radiation field with lower stellar densities than the Orion Nebula and several young stellar objects (YSO) with ages of 2 million years or less (Kim et al. 2017). It is an excellent example of a mainly reflection nebula contrasting with the emissions of the Orion Nebula (Fig. 2.3).

Reflection nebulae are clouds of interstellar gas and dust that reflect light of nearby stars. They are often associated with areas of emission nebulosity with the regions of reflection nebulosity receiving insufficient radiation to ionize the gas in the nebula. The microscopic particles making up the dust in the nebulosity are very small with diameters ranging from 0.2 μm to 50 μm. They preferentially scatter blue and violet light giving reflection nebulosity a blue or blue violet color (Seeds 2003). The dust particles are

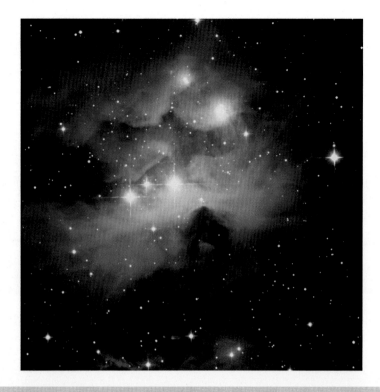

Fig. 2.3 Running Man Nebula (NGC 1977). This lies 30 arcminutes north of the Orion Nebula and is mainly a reflection nebula with its blue and violet colors. It also has complex dark lanes. PlaneWave CDK24 24-inch f/6.5 telescope, Finger Lakes Instrumentation Proline 9000 CCD, Cousins-Johnson B, V, and R images combined with luminous images for final color image. (© Tim B Hunter, 3towers, LLC, 2022. All Rights Reserved)

thought to represent carbon compounds with iron and nickel also present. Some of the particles will line up with the galactic magnetic field and cause the scattered light to show mild polarization.

The Pleiades are a stunning example of a reflection nebula (Fig. 7.3). It is an open cluster containing middle-aged hot B-type stars. These hot blue luminous stars formed within the last 100 million years. However, its hottest stars are not hot enough to ionize the gas surrounding the stars in the cluster (Seeds 2003). The gas and dust surrounding the Pleiades may not have originated with the stars. They may be merely passing through it.

IC 2118 (Witch Head Nebula) is a large, faint nebula reflecting the light from nearby bright Rigel in Orion (Fig. 2.4). Its blue color comes from the blue dominant emission of Rigel as well as its dust particles reflecting blue light better than red light. The sky is blue similarly, because the molecules

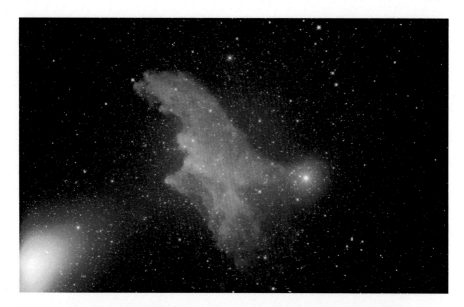

Fig. 2.4 IC 2118 (Witch Head Nebula). This is a large area of relatively faint reflection nebulosity which reflects the light of bright Rigel. The streaks in the lower left-hand corner of the image are internal telescope/camera reflections from Rigel which is just out of the field of view. Takahashi Epsilon 180 f/2.8 astrograph with Canon EOS Ra camera. (© Tim B Hunter, 3towers, LLC, 2022. All Rights Reserved)

of oxygen and nitrogen in the atmosphere scatter blue light more efficiently than red light. The Trifid Nebula (M20, NGC 6514) is an excellent example of mixed emission and reflection nebulosity (Fig. 7.10d). It is a large star-forming region with ionization of much of its gas to produce emission nebulosity. Some portions of its gas have not been ionized, and the dust in this area scatters and reflects blue light from the hot young stars in its interior.

2.2 Dark Nebulae

Dark nebulae, particularly those discovered or photographed by Barnard, are the main subject of this book. They are discussed in much more detail in other chapters but are noted here because of the overlapping association of emission, reflection, and dark nebulae. All these nebular regions are giant gas clouds which contain mostly hydrogen and helium with a scattering of many other materials, much of which is in the form of microscopic dust grains. How we perceive such regions depends on our point of view with respect to the nebular region and how much if any active star-formation is

present. It is not at all unusual for an area of nebulosity to demonstrate emission, reflection, and dark regions. A classic example of this is an extended area around the star Alnitak in Orion's Belt (Fig. 2.5).

Dark nebulae are opaque in varying degrees to visible light. Their opacity is caused by the microscopic dust they contain which absorbs and scatters light. In fact, reflection nebulae and dark nebulae are proof that gaseous nebulous regions in the Milky Way also contain dust particles. These particles reflect blue light more efficiently than red light causing the blue color

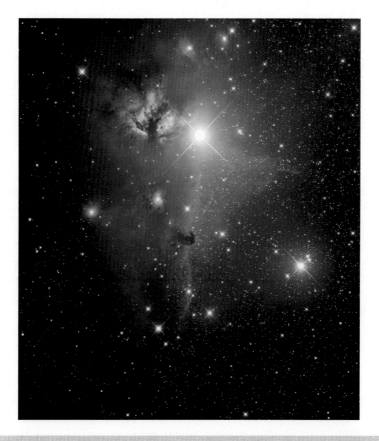

Fig. 2.5 Alnitak and environs. Alnitak is the bright star above the center of the image. Red emission nebulosity IC 434 surrounds the dark Horsehead Nebula (Barnard 33). The Flame Nebula (NGC 2024) is just to the left (east) of Alnitak and is a mixture of emission and dark nebulosity. To the left (east) of the Horsehead Nebula is blue reflection nebulosity scattered about, the largest portion of which is NGC 2023 northeast of the Horsehead nebula. Takahashi Epsilon 180 f/2.8 astrograph with Canon EOS Ra camera. (© Tim B Hunter, 3towers, LLC, 2022. All Rights Reserved).

of reflection nebulae, and they can absorb enough visible light to create regions of dark nebulosity. Dark nebulae are cold with temperatures between 10 Kelvin to 100 Kelvin. They are cold enough for molecular hydrogen H_2 to form, and they contain about 10^4 to 10^9 particles (atoms, molecules, and dust grains) per cubic centimeter, which is very tenuous compared to the Earth's atmosphere (Freedman and Kaufmann III 2002). Even so, they are so large (many light years across) they contain enormous masses of material and have sufficient depth to absorb star light behind them.

Most dark nebulae are irregular and diffuse in form. A few of them, like Barnard 86, are well defined, seemingly a hole in the sky (Fig. 7.9c–f). There is a special class of small, concentrated well-defined dark nebulae, the Bok globules, which in many cases are regions of active star-formation. These are an important area of current research and are discussed extensively in Chap. 9 which looks at the modern picture of the Barnard Objects.

3 Planetary Nebulae

A planetary nebula (PN) is a special type of emission nebula. It is an expanding glowing shell of gas thrown off by a low-mass star (0.8–8 solar masses) at the end of its life (Hynes, 1991; Kwok, 2001). The name planetary nebula is a misnomer. It arose from these nebulae simulating round or irregularly shaped planets when observed visually through early telescopes prior to astrophotography and spectroscopy showing their true nebular composition. They have no connection to planets, but their name has remained in use.

The *Hertzsprung-Russell diagram (HR diagram, H-R diagram, or HRD)* is a plot of stars showing their luminosity (absolute magnitude) versus their temperature (spectral type or color) (Fig. 2.6). This was created independently by Ejnar Hertzsprung (1873–1967) in 1911 and Henry Norris Russell (1877–1957) in 1913. Most stars when plotted on an HR diagram are on the *main sequence* which runs diagonally from the upper left where there are giant stars which are hot and very luminous to the lower right where there are cool dwarf stars. A star's position on the main sequence is mainly determined by its mass.

Stars on the main sequence "burn" (convert) hydrogen into helium in their cores through a complex nuclear process, the details of which depend on the star's mass. The result is conversion of all the hydrogen into helium at which point the star nears the end of its life. A star of the Sun's mass has enough hydrogen to last for billions of years, while a massive star like Rigel

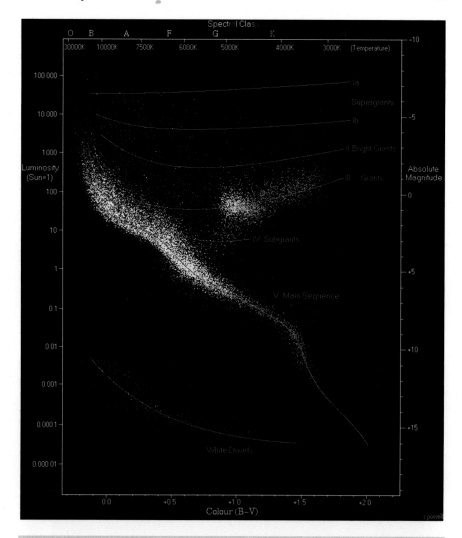

Fig. 2.6 Hertzsprung-Russell diagram plotting the luminosity (absolute magnitude) of a star against its color (spectral class or color as defined by its B-V value). (© Richard Powell: https://upload.wikimedia.org/wikipedia/commons/6/6b/HRDiagram.png)

(Beta Orionis) with more than 15 times the mass of the Sun exhausts its nuclear fuels in only a few million years ending its life as a spectacular supernova. The Sun will end its life forming a quiet planetary nebula and then evolve into a white dwarf.

When hydrogen burning in a star's core ceases, the aging star swells up to become a red giant with a compressed core and a bloated atmosphere. It goes through a complex cycle of swelling and contraction depending on its mass, and a low mass star like the Sun expels its outer layers into space. These ejected

layers form a glowing emission nebula around the star known as a planetary nebula which can have a very complex shape and mixed colors (Fig. 2.7).

There are two major stages to the stellar winds that produce a planetary nebula. The aging red giant star first gently blows away its outer layers producing low-excitation gas that is difficult to see. This exposes the very hot interior of the star around which there is often very hot coronal gas with temperature up to 1,000,000 Kelvin which is later ejected as a high-speed wind that overtakes and compress the slowing moving initial gas outburst. The slow-moving gas is excited, partially ionized, and heated as the high-

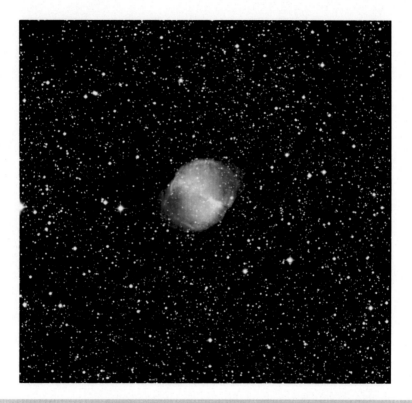

Fig. 2.7 Examples of planetary nebulae. (**a**) M27 (NGC 6853) Dumbbell Nebula. PlaneWave CDK24 24-inch f/6.5 telescope, Finger Lakes Instrumentation Proline 9000 CCD, Cousins-Johnson B, V, and R images combined with luminous images for final color image. (© Tim B Hunter, 3towers, LLC, 2022. All Rights Reserved). (**b**) NGC 7293 (Helix Nebula). PlaneWave CDK24 24-inch f/6.5 telescope, Finger Lakes Instrumentation Proline 9000 CCD, Cousins-Johnson B, V, and R images combined with luminous images for final color image. (© Tim B Hunter, 3towers, LLC, 2022. All Rights Reserved). (**c**) M57 (NGC 6720) Ring Nebula. PlaneWave CDK24 24-inch f/6.5 telescope, Finger Lakes Instrumentation Proline 9000 CCD, Cousins-Johnson B, V, and R images combined with luminous images for final color image. (© Tim B Hunter, 3towers, LLC, 2022. All Rights Reserved)

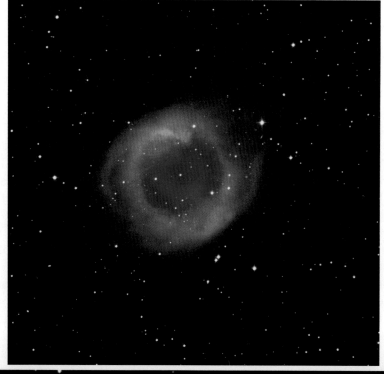

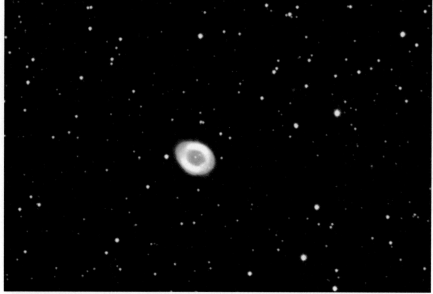

Fig. 2.7 (continued)

speed gas plows into it plus the intense ultraviolet radiation from the exposed core of the parent star further excites the gases to glow (Seeds 2003). The gases in the nebula itself are heated to 10–25,000 Kelvin.

Planetary nebulae have very complex shapes, the cause of which is not fully understood. The irregular throwing off of gas from the dying star may be one cause. There may be planets about the star, and many planetary nebulae are thought to form in binary systems. Magnetic fields may also play a role in their formation.

Planetary nebulae range in size from 0.5 to 6 light years in diameter. Their spectra have emission lines showing they are composed of low density hot, excited gas expanding around 10–20 kilometers/sec (Seeds 2003). The underlying exposed stellar core eventually evolves into a white dwarf star. The planetary nebular gas can be emitted in several waves over many years, but a planetary nebula is a short-lived phenomenon with a life of up to 30–70,000 years. By that time most of the gas has cooled and dispersed into the interstellar medium.

Planetary nebulae are thought to be powerful tracers of the Milky Way's star-forming history. They should be very common in the Milky Way, but their known numbers are considerably less than what should be seen. That is, only about 3000 planetary nebulae have been catalogued even though some authors suggest we should see more than 20,000 in the Milky Way's disk alone (Parker et al. 2006). They are also observed in other galaxies and are an important contributor to the interstellar medium.

4 Supernova Remnants

Low mass stars end their lives with a gentle bang producing planetary nebulae. Massive stars do not go gently into the night at the end of their lives. They first consume the hydrogen in their cores and then ignite hydrogen in shells around the core. As this is taking place, the star expands becoming a giant or a supergiant star and often undergoes episodes of expansion and contraction throwing off significant amounts of mass into the interstellar medium.

At some point the star's core contracts enough and becomes hot enough to fuse helium in the core and then in a shell outside the core (Seeds 2003). Carbon and oxygen are produced in this way in the core. If the star still has more than 4 solar masses of material when its carbon oxygen core contracts, it can reach 600 million Kelvin in the core igniting more nuclear fusions leading to the production of heavier elements like neon. This pattern of core ignition followed by shell ignition continues with the star developing a complex multi-layered structure at its center.

Heavier elements are produced in this way until iron is reached. Iron has the most tightly bound nucleus, and no nuclear reaction starting with iron will produce a more tightly bound nucleus. Up until this point, when a new element or isotope was produced, it had a more tightly bound nucleus releasing energy into the system for further nuclear reactions. Once iron is produced in the core, there is no more energy resulting from nuclear fusion, leaving the core to contract from gravitational forces which is countered by increasing temperature in the core as it tries to contract. The shells around the core may still be fusing lighter elements into heavier elements giving off energy. When the mass of iron in the core exceeds 2 solar masses, there is not enough energy available to keep the core from suddenly collapsing (Seeds 2003). The iron core collapse takes place in less than a second triggering a massive star destroying "explosion," a supernova, as material rebounds outward from the sudden core collapse. The core itself collapses into either a black hole or a neutron star. The star's outer layers are ejected into the interstellar medium at speeds of 10–20,000 kilometers/sec producing the brilliant burst of visible light and other radiation making up a supernova.

Supernovas are rare events. The last known supernova in the Milky Way was in 1604, though there was a supernova in February 1987 in the Large Magellanic Cloud, a satellite galaxy of the Milky Way. Modern computerized supernova surveys cover thousands of galaxies daily with many astronomical transient discoveries, often supernovae, reported every day (TNS 2022). A supernova at its height may be as luminous as the galaxy which contains it. Its brightness fades over several days to weeks, and after a few months all that remains is the expanding luminous shell of hot gas, its ejected outer layers, a *supernova remnant*. Supernova explosions are the prime method heavier elements are produced and spread through the interstellar medium.

A supernova remnant (SNR) may contain as much as one-fifth of the mass of its parent star. When a supernova remnant is young, such as M1 the Crab Nebula, it is relatively small and bright (Fig. 2.8a). As a remnant expands, it collides with the interstellar medium producing complex effects. Older remnants are larger and often have a delicate appearance, such as the Veil Nebular complex in Cygnus (Fig. 2.8b). Supernova remnants often emit X-ray and radio wave photons. Many produce synchrotron radiation, photons emitted by electrons spiraling through a magnetic field. This radiation is spread over a variety of wavelengths. Some supernova remnants are invisible in the visual portion of the spectrum and are only detected by their radio and X-ray emissions.

A white dwarf star is a stellar core remnant composed of electron-degenerate matter, which is a complex mix of electrons, protons, neutrons, and other quantum particles pressed together into a very dense undefined state. White dwarves are the final evolutionary state of stars whose mass is not high enough to form a neutron star or black hole. The composition of the white dwarf depends on the mass of its progenitor star. In any case, the material in a white dwarf no longer undergoes nuclear fusion and its emission is from residual thermal energy. White dwarves are extremely dense and resist further gravitational collapse because of pressure from the

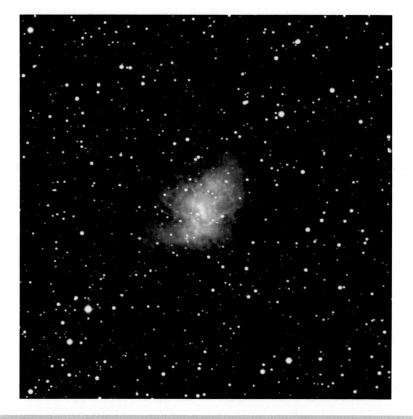

Fig. 2.8 Supernova remnants. (**a**) M1 (NGC 1952) the Crab Nebula. There is a radio pulsar at the center of the expanding shell of luminous gas known as the Crab Nebula. This is thought to have been produced by a supernova explosion in 1054 recorded by Chinese observers as well as possibly recorded on some Native American petroglyphs in North America. PlaneWave CDK24 24-inch f/6.5 telescope, Finger Lakes Instrumentation Proline 9000 CCD, Cousins-Johnson B, V, and R images combined with luminous images for final color image. (© Tim B Hunter, 3towers, LLC, 2022. All Rights Reserved). (**b**) Veil Nebula complex consisting of NGC 6960, 6992, 6974, 6979, and 6995. Takahashi Epsilon 180 f/2.8 astrograph with Canon EOS Ra camera. (© Tim B Hunter, 3towers, LLC, 2022. All Rights Reserved)

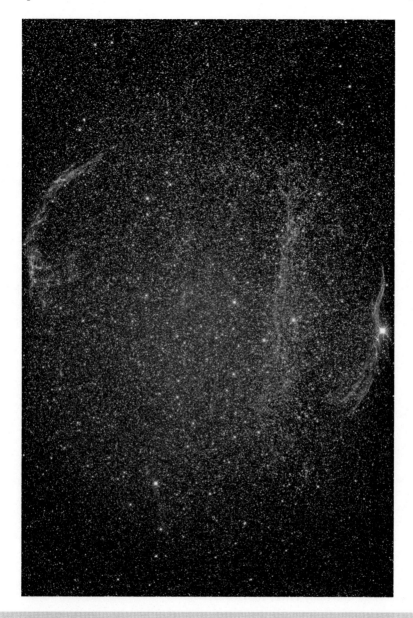

Fig. 2.8 (continued)

electron degenerate mass. Most will slowly radiate away their energy over billions of years and gradually fade away.

White dwarves are not uncommon, and they will be the end stage for many stars in the Milky Way. Many white dwarves are part of binary or multiple star system. In a few instances white dwarves are in a close enough

binary system for the white dwarf to accrete mass from its companion. If a white dwarf accretes enough mass, it may reach the *Chandrasekhar limit*, approximately 1.44 times the mass of the Sun, at which point gravitational collapse overcomes the electron degeneracy pressure producing sudden stellar collapse resulting in a supernova explosion and a supernova remnant as material rebounds outward from the collapsed star.

Thus, there are two main ways for supernovas to occur, either by core collapse of a massive star, or by a white dwarf star accreting mass from a companion star and exceeding the Chandrasekar limit. Supernovas are an extremely complex topic beyond the purview of this book. There are many classifications for them which are based on their spectral characteristics and the assumed mechanism for their formation. They along with planetary nebulae are discussed here for complete listing of the various types of nebulae found in the Milky Way and other galaxies. There are several prominent supernova remnants in the Milky Way like the Crab Nebula, the Veil Nebula complex, Tycho (the remnant of SN 1572 observed by Tycho Brahe), and Kepler (the remnant of SN 1604 observed by Johannes Kepler). The youngest known supernova remnant in the Milky Way is G1.9 + 0.3 which lies in Sagittarius near the Galactic Center. It has been observed both by NASA's Chandra X-ray Observatory and the VLA Radio Observatory (Stone et al. 2021).

References

Freedman RA, Kaufmann WJ III. Universe. 6th ed. New York: W.H, Freeman and Company; 2002.

Hirota T, Bushimata T, Choi YK, Honma M, Imai H, et al. Distance to Orion KL measured with VERA. Publ Astron Soc Jpn. 2007;59:897–903.

Hynes SJ. Planetary nebulae. A practical guide and handbook for amateur astronomers. Richmond: Willman-Bell, Inc; 1991.

Kim JS, Fang M, Clarke CJ, Facchini S, Pascucci I, Apai D, Bally J. Young stellar object & photoevaporating protoplanetary disks in the Orion's sibling NGC 1977. Mem SA It. 2017;88:790–2.

Kwok S. Cosmic butterflies. The colorful mysteries of planetary nebulae. Cambridge: Cambridge University Press; 2001.

Parker QA, Acker A, Frew DJ, Hartley M, Peyaud AE, et al. The Macquarie/AAO/Strasbourg Hα planetary nebula catalogue. Mon Not R Astron Soc. 2006;373:79–94. https://doi.org/10.1111/j.1365-2966.2006.10950.x.

Seeds MA. Foundations of astronomy. 7th ed. Pacific Grove: Thomson. Brooks/Cole; 2003.

Stone AG, Johnson HT, Blondin JM, Watson RA, Borkowski KJ, et al. Type Ia supernova models: asymmetric remnants and supernova remnant G1.9+0.3. Astrophys J. 2021;923:233. https://doi.org/10.3847/1538-4357/ac300f.

Transient Name Server (TNS). 2022.: TNS – Getting started | Transient Name Server (wis-tns.org)

Chapter 3

Astronomical Catalogs: An Overview

1 Introduction

A *catalog* is a list of items in alphabetic, numeric, or some other systematic order. A variant spelling is *catalogue* which is particularly popular in the astronomical world where there are many catalogs of astronomical objects. Very often the authors of these catalogs prefer to use the variant spelling catalogue. For the purposes of this book, either term is considered appropriate, and they are used interchangeably taking care to accurately reflect the spelling used by the authors of a particular work discussed or cited in the book.

Atlas was the Titan who was forced by Zeus to support the heavens on his shoulders as punishment for his part in the revolt of the Titans against the gods. A more common meaning for atlas is a bound collection of maps and informative tables. Star catalogs and star maps have been known since ancient times, most of which have been lost, though portions of their data or references to them appear in later work.

Hipparchus (circa 190-cicra 120 BC) completed a star catalog in 129 BC in which he compared his data to that of Timocharis (circa 290 BC) discovering the longitude of the stars Timocharis listed had changed leading Hipparchus to determine the first value for the precession of the equinoxes. Ptolemy (circa 90-circa 186 AD) published a star catalog as part of his

© The Author(s), under exclusive license to Springer Nature 41
Switzerland AG 2023
T. B. Hunter et al., *The Barnard Objects: Then and Now*, The Patrick Moore
Practical Astronomy Series, https://doi.org/10.1007/978-3-031-31485-8_3

Almagest listing 1022 stars visible from Alexandria, Egypt. Ptolemy's catalog was based mostly on that of Hipparchus.

Al-Sufi (903–986), a Persian astronomer, published his ***Book of Fixed Stars*** in 964. In this work he updated and corrected data from the ***Almagest***. Ulugh Beg (1394–1449) of Samarkand, Uzbekistan, patronized astronomical and mathematical work by Muslim astronomers who published ***Zij-i Sultani*** in 1437 which updated star positions from the Almagest. ***Zij-i Sultani*** was not superseded until the thousand-star catalog of Tycho Brahe (1546–1601) came into common use in the early seventeenth century. Johannes Kepler (1571–1630) published the ***Rudolphine Tables*** in 1627 which was a star catalog and planetary tables based on the observational data of Tycho Brahe. The tables were named in memory of Rudolf II (1552–1612), Holy Roman Emperor, in whose employment Brahe and Kepler had begun the work which led to the tables.

The standard for star atlases was set in 1603 when Johann Bayer (1572–1625) published ***Uranometria***. It was the first atlas to cover the entire sky. Its name derives from Urania, muse of the heavens. ***Uranometria*** consists of 51 star maps engraved on copper by the artist Alexander Mair (circa 1562–1617). There are two hemisphere illustrations and "...charts for each of Ptolemy's 48 classical constellations plus a map showing the far southern sky with a dozen newer constellations-Apus, Chamaeleon, Dorado, Grus, Hydrus, Indus, Musca, Pavo, Phoenix, Triangulum Australe, Tucana, and Volans. Altogether about 2000 stars are displayed" (Ashbrook 1984). Little is known about Bayer other than he was a lawyer in Augsburg, Bavaria. He also introduced the Greek letter designations for the brighter stars in each constellation which is still used today.

Previous celestial maps were oriented as though the viewer were looking down upon the celestial sphere from outside. This showed the human figures making up some of the constellations from behind. Mair, the engraver for Uranometria, retained this convention for many of the figures, but he showed the stars as seen from the Earth. Later atlases used the convention of viewing the constellation figures and their stars as viewed from the Earth looking up.

The main subject of this book is the Barnard Objects, those dark nebular regions described and studied by EE Barnard throughout his career culminating in the 1927 posthumous publication of ***A Photographic Atlas of Selected Regions of the Milky Way*** edited by Edwin B Frost and Mary R Calvert. In that work and in many of his publications Barnard refers to various astronomical catalogs, including the Messier Objects and the NGC and IC Objects as well as the ***Bonner Durchmusterung*** (B.D.). While these catalogs are familiar to most astronomers, there are many other catalogs of

important objects that are commonly cited in both amateur and professional publications, often using an abbreviation without citing their full name or their source and importance. This chapter provides an overview of astronomical catalogs in common use with emphasis on those catalogs that pertain to Barnard and his areas of study. This discussion will not be all encompassing or in-depth. It will give the reader a start to understanding the purpose and usefulness of many of the astronomical catalogs in everyday use.

2 Star Names and Star Catalogues

Most of the several hundred brighter naked eye stars carry several different names from the very familiar to the very obscure. This is well summarized on Jim Kaler's stars website at: http://stars.astro.illinois.edu/sow/starname.html. Many of these star names are ancient coming down to us from myth and legend as summarized most famously in the *Almagest* by Ptolemy. Others star names are of more recent historical origin. Some have been formally adopted by the International Astronomical Union (IAU).

The most familiar star names are popular names derived from ancient Greek or Latin that describe a position or other unique characteristic of a particular star. The largest number of names in common everyday use are Arabic star names from the Middle Ages when Arabian astronomers adopted Greek constellations from Ptolemy and applied their own Arabic names to stars. These names then came to us from Arabic texts that were translated back into Latin. In the process many of the original Middle Age Arabic names became changed, lost, or corrupted. Nevertheless, most of these somewhat contrived names have made their way into common usage. "Examples of ancient Greek, Latin, and Middle Age Arabic for star names include Sirius (searing or scorching in ancient Greek), Polaris (pole star in Latin), Deneb (tail in Arabic) in Cygnus the Swan, and Denebola (lion's tail in Arabic) in Leo the Lion" (Hunter 2023).

Bayer's system used the Greek alphabet to name stars in order of brightness with the brightest star in a constellation named alpha, the second brightest star beta, the third brightest star gamma, and so forth. The lowercase Greek letter is appended to the Latin possessive form of the constellation name like α Lyrae for Vega, the brightest star in Lyra the Lyre. Vega can also have its named spelled out as Alpha Lyrae. The names Bayer assigned to many stars remain in common use today. The brightness order for the stars in each constellation sometimes do not line up with the names assigned by Bayer, because some beta stars are brighter than the alpha stars in a few

constellations. Bayer had to devise names using upper case and lower-case Roman letters after he exhausted the twenty-four letters in the Greek alphabet.

In 1712 John Flamsteed (1646–1719), the first Astronomer Royal, published his great star catalog *Historia Coelestis Britannica* and later introduced an enlarged and revised edition containing 2866 star positions in 1725 (Jones 1991). In this work he introduced his numbering system for stars in which bright "first magnitude" stars were given their known proper names, like Vega and Sirius, and then Greek and Latin letter names as proposed by Bayer. After that, all the remaining brighter stars in constellations were given any historical name they might have had. The dimmer stars that had not received a name up to that point were assigned Flamsteed numbers starting with 1 being the western most otherwise unnamed star in the constellation. Like Bayer names, Flamsteed numbers are still used today. These represent dimmer stars that otherwise do not have a historical proper name or a Greek/Latin letter name.

Abbe Nicholas Louis de la Caille (1713–62) [usually known as Nicholas Lacaille] published his *On the Nebulous Stars of the Southern Sky* in 1781 as an appendix to Messier's catalog in the almanac *Connaissance des Temps* for 1784 which was published 3 years ahead of its almanac date. In the *Nebulous Stars of the Southern Sky* Lacaille described 42 nebulae, 33 of which today are considered true deep sky objects (SEDS, Lacaille Catalog). Lacaille is known for mapping stars in the Southern Hemisphere and naming new constellations. From 1750–54 he led an exhibition to the Cape of Good Hope where using a half-inch refractor he determined the position of 9800 stars between the south celestial pole and the tropic of Capricorn. This great catalog *Coelum Australe Austriaei Stelliferum* was published partly in 1763 and not completed until 1847 (Lacaille, biography). Many of these stars are still referred to by his catalog numbers. Lacaille was the first astronomer to accurately and systematically measure a large number of stars in the Southern Hemisphere. Edmund Halley (1656–1742), the second Astronomer Royal succeeding John Flamsteed in 1720, had produced the first catalog of the southern sky from Saint Helena in 1676–1677 using a large sextant with telescopic sights. This resulted in his *Catalogus Stellarum Australium* which included a map of the southern sky and descriptions of 341 stars.

While in South Africa, Lacaille also carefully observed the Moon, Venus, and Mars working closely in cooperation with Jerome Lalande (1732–1807) making similar observations in Europe leading to the calculation of more accurate distances for these planets. Lacaille is credited for naming 14 out of the present modern 88 constellation.

2.1 Bonner Durchmusterung (B.D. or BD)

Bonner Durchmusterung (German for Bonn sampling) is an astrometric star catalogue and atlas of the sky compiled from the north celestial pole to just south of the celestial equator by the Bonn Observatory in Germany using visual observations made with a 7.7 cm diameter 65 cm focal length refractor. It was completed and published in its entirety in 1863 and was later periodically updated. The project was initiated by Friedrich Argelander (1799–1875) and mainly carried out by his assistants. When first published it had positions and apparent magnitudes of approximately 324,188 stars down to magnitude 9–10.

BD soon became the standard star catalog and atlas for professional astronomers from the time of its publication to well into the twentieth century. Its strength lay in its large number of stars listed with minimal errors, star magnitudes accurate to 0.1 magnitude, star right ascension accurate to 0.1 second of time, and star declination accurate to 0.1 arc minute (Ashbrook 1984). BD star numbers were commonly used by Barnard and are still sometimes used today. BD and its southern equivalent the **Cordoba Durchmusterung** were the last great star atlases to be compiled prior to photography superseding visual observations in astronomy.

2.2 Cordoba Durchmusterung (CD)

The **Cordoba Durchmusterung (CD)** star catalog was produced at the National Observatory of Argentina at Cordoba using a Clark 12.5 cm refractor with a focal length of 168 cm. Its final volume was published in 1932. CD gives positions and apparent magnitudes of 613,959 stars from −22 to −89 declination being the southern sky equivalent of the **Bonner Durchmusterung**. The project was started by John M Thome (1843–1908) who became director of the observatory in 1885. He made most of the observations, though he did not live to see the completed work. The catalog had a visual limiting magnitude of below 10 (HathiTrust Digital Library 2022).

2.3 Cape Photographic Durchmusterung (CPD)

Sir David Gill (1843–1914), a Scottish astronomer, spent much of his career in South Africa. He was Her Majesty's Astronomer at the Royal Observatory

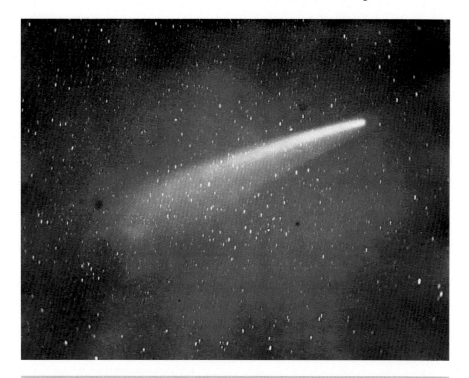

Fig. 3.1 Great Comet of 1882 (C/1882 R1, 1882 II and 1882b) as photographed by Sir David Gill. He wrote "I have obtained photographs of the Great Comet of this year by attaching to the declination-axis-counterpoise of the 6-in. Grubb Equatorial an ordinary camera with a rapid portrait-lens by Dallmeyer of about 2 ½ inches aperture and 11 inches focal length" (Gill 1882). He tracked on the comet's nucleus. This image is probably his Photograph 3 which was obtained on October 21, 1882, with a 40-minute exposure

at Cape of Good Hope from 1879 to 1906. He was a pioneer in astrophotography and obtained one of the first comet photographs, that of the Great Comet of 1882 (C/1882 R1, 1882 II and 1882b) at the Cape Observatory (Fig. 3.1). He started an ambitious project using a 13-inch photographic refractor with a 10-inch guide refractor to conduct a photographic survey of the Southern Hemisphere stars producing approximately 6000 plates of southern stars from declination −18 to −90.

Jacobus Kapteyn (1851–1922) at the University of Groningen in the Netherlands developed a special instrument to measure stars on photographic plates and collaborated with Gill to measure his plates. Their resulting work of Gill and Kapteyn is the *Cape Photographic Durchmusterung* published in three volumes from 1896–1900. This catalog lists the positions and magnitudes for 454,875 stars in the Southern Hemisphere and goes as

faint as magnitude 9.5. Unlike the BD and CD which were compiled from visual observations, the CPD is one of the first successful photographic surveys.

2.4 Modern Stellar Catalogs

Carte du Ciel was an international star mapping project initiated in 1887 by Admiral Amedee Mouchez (1821–1892), Director of the Paris Observatory. He was so impressed by the success of the 13-inch astrograph built by Paul Henry (1848–1905) and his brother Prosper Henry (1849–1903) that he proposed an *Astrographic Catalogue* in which the entire sky was to be photographed to 11th magnitude and a fainter survey (*Carte due Ciel*) to 14th magnitude using an astrographic setup based on the design of the Henry's instrument at the Paris Observatory.

Different observatories around the world were assigned to survey specific declination zones. The entire project was only partially successful and never fully completed. The instrument built by the Henry's had a useful field of view of 2 degrees square requiring 20,000 photographs to cover the sky twice. This entailed an enormous amount of work to take the plates and then to reduce the data as astrophotography was in its infancy and accurate fast plate measuring techniques had not yet been developed (Ashbrook 2003; Jones 2000).

Henry Draper Catalogue (HD) was published between 1918 and 1924 giving spectroscopic classifications for 225,300 stars. It has been updated and expanded since that time. The catalogue is named after Henry Draper (1837–1882), a noted amateur astronomer and astrophotographer whose widow Mary Anna Draper (1839–1914) donated the money to finance the catalogue. Henry Draper made the first photograph of a star's spectrum when he showed distinct spectral lines in Vega in 1872. The catalogue covers the entire sky down to photographic magnitude 9 and became a standard astronomy reference due to extensive listing of stellar positions, stellar magnitudes, and stellar spectra. The catalog was initially compiled by Annie Jump Cannon (1863–1941) and coworkers at Harvard College Observatory under the direction of Edward Pickering (1846–1919). The catalog remains popular today and HD catalogue numbers are a common way used to identify stars.

The *Smithsonian Astrophysical Observatory (SAO) Star Catalog* was compiled in 1966 from several astrometric catalogs. It serially numbers over 250,000 stars and contains stars down to about 9th magnitude. It overlaps the Henry Draper Catalogue and includes only those stars for which accu-

rate proper motion data is available. Like the Henry Draper Catalogue the SAO Catalog remains popular and is in common use today.

The *Bright Star Catalogue (BS, SBC)* serially numbers 9000 naked eye stars. It was first published in 1930 as the *Yale Catalog of Bright Stars* and revised in 1983. The catalog contains stars down to visual magnitude 7.1 with stellar coordinates, stellar proper motion, stellar photometric data, and stellar spectral types.

The largest catalog based on photographic plates is the United States Naval Observatory-B1.0 (*USNO-B1.0*) and its successors. Its data was obtained from scans of more than 7000 Schmidt telescope plates from various sky surveys during the last 60 years. It provides all sky coverage down to V = 21 magnitude with more than 1 billion objects listed.

The *Guide Star Catalog (GSC)* is an online catalog that appears in many commercial sky atlas software programs. This was produced for positioning and identifying stars for use as guide stars by the Hubble Space Telescope (HST). The first version **GSC-1** used digitized photographic plates from Palomar and UK Schmidt photographic surveys. It was published in 1989 and contained about 20 million stars to as faint as 15th magnitude. The latest version **GSC-II** was published in 2008. It contains revised, more accurate information for nearly a billion stars out to magnitude 21. Non-stellar objects and binary stars are excluded to cause less confusion for the HST fine guidance sensors. This is the first all sky star catalog developed specifically for navigation in space.

Astrometric satellite star catalogs have been developed from data produced by the European Space Agency astrometric satellites *Hipparcos* and *Gaia*. These catalogs are online digital data releases noted for the breadth of their data and for their precise parallax measurements, particularly the data releases for Gaia. The *Hipparcos Catalogue*, *Tycho-1*, and *Tycho-2* are based on data from Hipparcos. The *Gaia data releases* are ongoing. The enormity and accuracy of this data provides a wealth of information about the structure of the Milky Way and will be the standard by which star catalogues are based in the future.

There are many other star catalogs which are too numerous to mention here. Several catalogs list double stars, nearby stars within 20 parsecs (65 light years) of the Earth, trigonometric star parallaxes, and carbon stars. There are catalogs for stellar proper motion and catalogs listing variable stars. For example, the *International Variable Star Index (VSX)* is a globally accessible clearing house for the latest information on variable stars, both established and suspected (AAVSO 2022).

2.5 Star Names Today

Star names remain a confusing and complex business. This is not much of a problem with the very brightest first magnitude and second magnitude stars as they are mostly known by their historical proper names. Unfortunately, third and fourth magnitude stars, though bright enough to be seen in most suburban skies, are sometimes listed by their proper name, sometimes listed by their Bayer assigned Greek letter name; or, they may be faint enough to be listed by a Flamsteed number, an HD number, an SAO number, or some other catalog designation. Their naming is not consistent from one source to another which is very distracting and irritating, to say the least, for the amateur astronomer trying to observe one of these stars (Hunter 2023).

3 General Non-stellar Catalogs

3.1 Messier Objects

Charles Messier (1730–1817) bridged the transition from purely observational astronomy with small telescopes and little instruments to astronomical research involving larger telescopes, better optics, and the introduction of instruments for measuring star positions and star spectra.

Messier's career spanned the time of the French monarchy through the French Revolution and the Napoleonic Wars. Messier was mainly interested in discovering comets. Between 1760 and 1798 he discovered 13 comets, and he made his now-famous list of objects so others would not confuse them with comets. Jones (1991) notes "... it is an odd turn of fate which has led to his fame resting upon a catalogue of objects he was really trying to avoid while the successful 'ferret of comets' has no comet which bears his name."

Messier's list of non-stellar nebulous objects was not the first, but it became the most accurate and largest until the work of William and Caroline Herschel later in the eighteenth and early nineteenth centuries. Messier first published a list of 45 objects in 1771 and an extended catalog of 103 objects in 1781 for the 1784 issue of the *Connaissance des Temps*. Another seven were added to the Messier Objects list by modern authors as they were described by Messier in his writings but did not appear on his published list (Mallas and Kreimer 1997; Jones 1991).

Many of the objects in Messier's list have been credited to him as being their discoverer, though several were observed previously, and more than twenty of the 103 objects in the final catalog of 1774 were discovered by his colleague Pierre Mechain (1744–1804) who generally passed on his observations to Messier (Jones 1991). Mechain, interestingly, became the Director of the Paris Observatory in 1799. He, unfortunately, died of yellow fever in Spain in 1804 while doing survey work. His survey work along with that of his associate Jean Baptiste Joseph Delambre (1749–1822) was an important component for the measurement of the metric system's unit of length the meter.

All the Messier Objects are important subjects for astronomical research except for M40 and M73 which are asterisms and mistaken for nebulosity either by Messier or other observers. There is controversy concerning M102 which may be a duplicate observation of M101 by Mechain. Excluding M102, the Messier Objects can be categorized as (Jones 1991): 2 asterisms, 4 planetary nebulae, 27 galactic (open) clusters, 39 galaxies, 1 supernova remnant, 7 gaseous nebulae, and 29 globular clusters.

3.2 New General Catalogue (NGC) and Index Catalogues (IC)

William Herschel (1738–1822) working with his sister Caroline (1750–1848) compiled three lists of nebulae and clusters totaling more than 2500 entries. Later, John Herschel (1792–1871) took up his father's work discovering an additional 525 objects. Another 1700 objects were added by John Herschel from his observations in South Africa from 1834–1838. He combined all the previous lists into the *General Catalogue* of some 5000 entries published in 1864 (Jones 1991).

The *New General Catalogue of Nebulae and Clusters, Being the Catalogue of Sir John Herschel, Revised, Corrected and Enlarged*, more commonly known as the New General Catalogue or NGC was compiled by John Louis Emil Dreyer (1852–1926) from the earlier work of John Herschel and first published in 1888. The catalog as originally published contained the positions and descriptions of 7840 objects for the epoch 1860. Draper later added two supplements, the *Index Catalogs (IC)* in 1895 and 1908.

All the Messier Objects are included in the NGC except for the asterism M40 and the Pleiades M45. Traditionally, a Messier Object is listed by its M number and/or its common name, such as M42 the Orion Nebula. Its New General Catalogue designation (NGC 1976) is usually given second if at all. This mainly results from the Messier Objects being the brightest and

most well-known deep sky objects, though it is far easier to remember a Messier designation than an NGC designation.

The NGC and IC catalogs had considerable errors and have been updated and revised many times by several authors (Sulentic and Tiff 1973; Sinnott 1998; Steinicke 2010; NGC/IC Project 2022). Data compiled by Frommert (2022) in July 2007 gave the following statistics for the NGC, and IC catalogs (which include the Messier Objects except M40 and M45):

Galaxies	NGC-6029	IC-3971
Diffuse Nebula or Supernova Remnants	NGC-144	IC-97
Planetary Nebulae	NGC-94	IC-35
Open Clusters	NGC-684	IC-38
Globular Clusters	NGC-115	IC-8

Frommert based his work on **NGC 2000.0** by Roger Sinnott. Frommert also noted there were 51 total listings in the two catalogs that were part of another object, usually galaxies. There are a total of 593 duplications in the catalogs, and 321 objects not found. There are also 1047 stellar objects if you include M45 and M40. Despite these defects, the Messier, NGC, and IC catalogs remain the everyday standard catalogs of non-stellar objects for both amateur and professional astronomers.

4 The National Geographic Palomar Sky Survey (POSS, POSS I); Southern Sky Survey; ESO Surveys

The most significant sky survey in the twentieth century and arguably in the history of astronomy was the Palomar Sky Survey. It was the basis for most of the specialized astronomical catalogs discussed in this chapter, and it was the forerunner of the large surveys of the late twentieth century and early twenty-first century, such as *2MASS*, the *Sloan Digital Sky Survey*, and the *Vera C Rubin Observatory*.

The **National Geographic Society - Palomar Sky Survey (NGS-POSS)** was completed by the end of 1958. It is also called the First Palomar Sky Survey (POSS I). 936 pairs of photographic plates were taken using the 48-inch (1.22 m) aperture Oschin Schmidt Telescope at Mount Palomar Observatory in southern California. The survey used 14-inch square photographic plates that covered about 6 degrees of the sky per side. Each region was photographed twice, once using Kodak 103a-E plates which were red sensitive, and once with Kodak 103a-O plates which were blue sensitive. The survey extended from the north celestial pole to approximately

−30-degrees south declination. Its limiting magnitude varied but is said to be 22nd magnitude on average. The Whiteoak Southern Extension was added in 1962 with 100 red plates only extending the sky down to a declination of −42 degrees.

The First Palomar Sky Survey (POSS I) was followed later by a second extensive survey from Mount Palomar (POSS II) performed in the 1980's and 1990's with faster films and an upgrade to the Oschin Schmidt Telescope. A Southern Sky Survey from Siding Springs Observatory in New South Wales, Australia used the 1.24-meter UK Schmidt Telescope (UKST) which went in operation in 1973. The UKST is very similar to the Oschin telescope at Palomar, and it took corresponding 606 blue/green Kodak IIIa-J-plates from 1974–1987 for the *SRC-J (UK Science Research Council) Survey.* These were correlated into what is sometimes called the *Southern Sky Atlas*.

Several European Southern Observatory (ESO) photographic surveys were also performed of the southern sky to complement and expand on the work performed at Palomar and the earlier southern sky work at Siding Springs Observatory. The *ESO(B) Atlas (Quick Blue Survey)* used the ESO 1 meter Schmidt telescope at La Silla, Chile, to photograph 606 fields from −90 to −20 degrees declination using unsensitized Kodak IIa-O plates with a 2 mm GG385 filter to give a bandpass similar to the Johnson B color. The field size and scale were like those in the Palomar Sky Survey. This atlas was completed in 1979.

The *ESO Red Survey* ran from 1978–1990. The ESO-Schmidt telescope at Ls Silla, Chile, produced 606 photographic red plates of the sky from −15 degrees declination to −90 degrees declination. The *ESO/SRC Atlas of the Southern Sky* is a catalog containing the coordinates of the plate centers and observation dates of the plates composing the ESO(B) Survey, the ESO Red Survey, and the SRC-J Survey.

Photographic sky surveys ended around 2000. Since then, sky surveys of any kind have used digital imaging. The thousands of photographic plates from the Palomar Sky Survey and its iterations as well as from the several southern sky surveys remain invaluable and have been digitally scanned and made available in various digital formats. These digital files are used daily by professional and amateur astronomers. In addition, there are many digital file collections obtained by scanning photographic plates at major observatories around the world.

The photographic plates from the Palomar and UK Schmidt telescopes were digitized to produce the *Digitized Sky Survey (DSS)* which was then processed and calibrated to produce the *Guide Star Catalog* as discussed above. The DSS is a valuable resource used daily by amateur and

professional astronomers. It is readily available in an updated form as the *ESO Online Digitized Sky Survey* (ESO 2022).

SkyMapper Southern Sky Survey is an ongoing project at Siding Springs Observatory using a 1.35-meter modified f/4.8 Cassegrain telescope. It uses a unique large digital camera designed and constructed by in-house Australian National University engineers to take rapid wide-field survey images of the southern sky through a variety of specially designed glass filters. SkyMapper started in March 2014 and generates approximately 100 megabytes of data per second during every clear night of survey operations (SkyMapper 2022).

5 Galaxy Catalogs

Galaxies by far are the most common nonstellar object. Except appearing near the Milky Way, galaxies are more numerous on long exposure astrophotographs than stars. Most of the galaxies appear as faint background smudges, and it is hard to distinguish between a dim star, a faint galaxy, or a smudge produced by a film or digital imaging defect. Appearing through and near the Milky Way galaxies are almost completely obscured by the stars, gas, and dust in the Milky Way. Even with modest equipment it is possible to image any portion of the sky away from the Milky Way to find many galaxies that have no assigned name or designation. There are simply too many galaxies. There are, however, several catalogs of galaxies that are important for both historical reasons and for their common use in professional astronomy. A few of the most prominent of the "primary galaxy catalogs" are noted here (Primary Galaxy Catalogs, 2022).

5.1 Shapley-Ames Catalog (SA)

Harlow Shapley (1885–1972) and Adelaide Ames (1900–1932) published *A Survey of External Galaxies Brighter Than the Thirteenth Magnitude* in 1932 (Shapley and Ames 1932). It was a systematic photometric catalog of bright galaxies containing a total of 1249 objects. To compile the catalog Shapley and Ames selected objects by examining plates from the *Harvard Sky Patrol* (Ingrao and Menzel 1967). The sky patrol plates from both the Northern and Southern Hemispheres had such wide fields and small scales that most galaxies appeared sufficiently stellar for photographic photometric purposes. Most of the galaxies noted and catalogued were between 10th

and 13th magnitudes. Only 13 of the 1249 objects appearing in the catalog were not listed in the NGC and IC catalogs. This catalog was one of the earliest most useful catalogs of exclusively galaxies. It remains cited frequently today and was revised in 1967 by Sandage and Tammann, the **Revised Shapley-Ames Catalog (RSA)**. Sadly, Ames was killed in a boating accident shortly after the cataloged was published.

5.2 LEDA; Catalogue of Principal Galaxies (PGC)

The *Lyon-Meudon Extragalactic Database* (*LEDA*) is a database of galaxies created in 1983 at the Lyon Observatory in France. This evolved into the *Catalogue of Principal Galaxies (PGC)* published in 1989. It later became *HyperLEDA* or *PGC2003* containing information on over 3 million objects, 1 million are galaxies which are brighter than ~18 magnitude (Paturel et al. 2003). The galaxies were obtained either from digitized sky surveys or direct CCD images.

The PGC is probably the most frequently encountered catalog of galaxies after the NGC/IC catalogs (Fig. 3.2). It is not unusual for numerous PGC, UGC, and CGCG galaxies to be encountered in fields imaged by amateur astronomers.

5.3 UGC-Uppsala General Catalog of Galaxies

The **UGC** is a complete listing of galaxies down to as small as 1.0 arcminute and/or to a limiting apparent magnitude of 14.5 on the blue prints of the Palomar Observatory Sky Survey (POSS). Unfortunately, galaxy coverage is limited to north of declination −2 degrees. The catalog contains considerable information about each galaxy. The galaxies are numbered and listed in order of their right ascension epoch 1950.0. There are 12,939 galaxies listed. More information about the UGC and a searchable table for the UGC is on the NASA HEASARC website.

5.4 Catalogue of Galaxies and of Clusters of Galaxies (CGCG)

This catalog was published by Fritz Zwicky and Charles T Kowal in six volumes from 1961–1968. It was a programmed survey of POSS for galax-

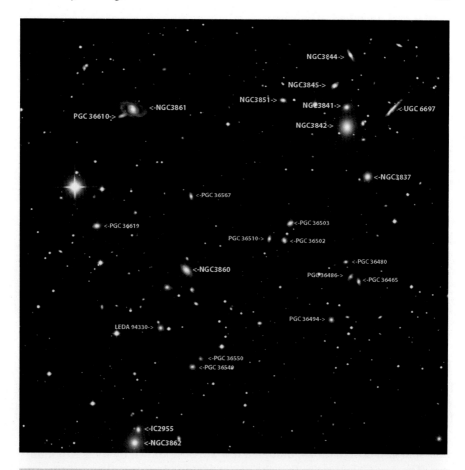

Fig. 3.2 Leo Galaxy Cluster (Abell 1367) with many of the galaxies labeled showing various galaxy naming conventions, the most numerous being PGC galaxies (north up, east left). PlaneWave CDK24 24-inch f/6.5 telescope with Finger Lakes Instrumentation Proline KAF9000 CCD and Cousins-Johnson B, V, R filter images coupled with luminous images to produce a final color image. (© Tim B Hunter, 3towers, LLC, 2022. All Rights Reserved)

ies brighter than magnitude = < 15.7 covering the northern celestial hemisphere with an additional circular strip between declinations zero and −3 degrees. "Altogether 31,350 galaxies and 9700 clusters of galaxies were surveyed and included in the catalogue" (Zwicky and Kowal 2022). Compact galaxies in the Zwicky-Kowal catalog are sometimes called *Zwicky galaxies*.

5.5 Morphological Catalogue of Galaxies (MCG); VV Galaxies

This is a Russian catalog of ~30,000 galaxies compiled by Boris Vorontsov-Velyaminov, VP Arkhipova, and AA Krasnogorskaya from POSS plates. It was published in 6 volumes from 1962 to 1974 and listed the positions, magnitudes, and sizes for about 29,000 galaxies to limiting magnitude of ~15. Vorontsov-Velyaminov was also the author of an earlier work *The Atlas and Catalogue of Interacting Galaxies* (1959). The 1959 publication listed 355 galaxies from VV1 through VV355. A 1977 publication by Vorontsov-Velyaminov showed photographs of 1500 interacting galaxies most of which had been recognized and described earlier in the MCG. The VV listing was extended from VV356 through VV852. VV853 to VV2014 were later added to the catalog in a 2001 publication.

5.6 Atlas of Peculiar Galaxies (Arp Galaxies)

Halton Arp (1927–2013) published his *Atlas of Peculiar Galaxies* in 1966. The atlas contains 338 unusual galaxies astronomers could use to study the processes that distort spiral and elliptical galaxies. The galaxies in the atlas were sorted on their appearance ranging from spiral galaxies with low surface brightness to galaxy groups and galaxy chains (Arp 1966; Hunter, Grasslands Observatory). Most of the Arp Galaxies are better known by their standard designations, though a few are best known by their Arp numbers. The Arp Galaxies are favorite observing and imaging objects for amateur astronomers.

Arp pointed out examples of two or more distorted galaxies with dissimilar redshifts but appearing to be physically connected. He felt the commonly accepted idea that a galaxy's redshift was reflective of its distance was not correct. This was not accepted by the mainstream astronomical community, and he was somewhat shunned professionally in the latter part of his career. Because of this controversy, Arp became well known in the amateur astronomy community. He was a very engaging person and a popular speaker. Arp was an outstanding researcher, and many in both the amateur and professional astronomy community felt he was unfairly treated (Kanipe and Webb 2006). Most of the peculiar galaxies he noted now are interpreted as galaxy mergers or non-interacting line of sight overlap of two otherwise unrelated galaxies.

5.7 Abell Catalogue

In 1957 George Abell (1927–1983) completed his PhD thesis *The Distribution of Rich Clusters of Galaxies* at the California Institute of Technology. He presented a catalog "… of 2712 rich clusters of galaxies found on the National Geographic Society—Palomar Observatory Sky Survey. From the catalogue, 1682 clusters are selected which meet specific criteria for inclusion in a homogenous statistical sample" (Abell 1957).

Abell's initial work only covered the sky down to declination −27 degrees. A southern survey was started in the 1970's by Abell and completed in 1989 by Harold G Corwin and Ronald P Olowin after Abell's untimely death from a heart attack in 1983 (Olowin 1989). The southern data were "…collected from the ESO/SRC southern sky survey, using the UK 1.2-m Schmidt Telescope IIIa-J plates and films…" (Olowin 1989). The data was reduced similarly to the northern data published by Abell in 1958. A revised northern catalog was completed and a further 1361 southern clusters were added to produce a final catalog of 4073 rich galaxy clusters. The larger and brighter Abell clusters are of interest to amateur astronomers as challenging objects for viewing or imaging (Fig. 3.2).

6 Star Cluster Catalogs

Star clusters are divided into two main categories, open or galactic clusters, and globular clusters. These are really two distinct entities. Open clusters are found in the Milky Way's disk often in association with nebulous regions, molecular clouds, and active star formation. They range in age from a few million years up to a couple of billion years, though generally they are relatively young. Open clusters tend to dissipate. The motion of individual stars scatters the cluster as they move through space with galaxy rotation and with interactions from gas, dust, and other stars in the Milky Way. In an open cluster there are not enough stars, and they are not grouped close enough together for gravity to prevent the eventual dissipation of the cluster. Open clusters contain a few hundred to a few thousand stars spread over 3–20 light years region. There is some dispute about the term galactic cluster being synonymous with open cluster, some arguing that other galaxies have open clusters, and it is better to drop the use of galactic cluster when referring to open clusters in the Milky Way (Archinal and Hynes 2003).

Globular clusters on the other hand are tight formations of hundreds of thousands of stars and are quite old, roughly 13 billion years of age. They lie in a vast halo around the Milky Way. The stars in globular clusters are tightly bound by gravity. The size, density, and number of stars in globular clusters vary somewhat, but they typically contain at least 100,000 stars spread over a radius of approximately 10 parsecs (32 light years). Nearly all galaxies contain halos of globular clusters, some larger galaxies containing many thousands of globular clusters. The number of known Milky Way globular clusters is under 200. This is considered a gross undercount of the actual number of globular clusters associated with the Milky Way. There are probably many undiscovered globular clusters in the galactic bulge, and many are no doubt hidden by the gas and dust of the Milky Way, particularly those lying on the other side of the Milky Way from the Solar System.

The best overview of star clusters and an excellent modern listing of most known Milky Way clusters is found in Archinal 2003. This book also gives an excellent review of the many cluster catalogs that have been produced up to the modern era with computerized telescopes and digital imaging. The specific catalogs discussed below were selected due to their common use, popularity, or historical interest realizing many important catalogs noted by Archinal and others are not discussed here, such as the catalogs of G Alter (**Alter**), MV Dolidze (**Do** or **DoDz**), IR King (**King**), BE Markarian (**Mrk**), J Ruprecht (**Ru**), Harlow Shapley, Jurgen Stock (**St**), Sidney van den Bergh (**vdB, vdB-HA, BH**), Clyde Tombaugh (**TOM**), RJ Trumpler (**Tr**), and the Berkeley Open Cluster Catalogue (**Be**) (SEDS 2022).

6.1 A Catalogue of Star Clusters Shown on Franklin-Adams Chart Plates -Melotte Catalogue (Mel)

P.J. Melotte (1880–1961) in 1915 published a list of 245 clusters based on his studying the photographic charts in the *Franklin-Adams Chart* (Melotte 1915). The first edition of the *Chart* was published by the Royal Astronomical Society in 1914. It consisted of 206 photographic prints covering the entire sky on a uniform basis. The original plates were obtained with a 10-inch f/4.5 lens giving very good images over a field 15 × 15 degrees with a scale of 20 mm to the degree and reaching a limiting magnitude of 16–17. The project was started by the astronomer John Franklin-Adams (1843–1912) who died prior to its publication. A second edition was published in 1922, and a third edition was published in 1936 (Photographic Committee 1936).

Archinal and Hynes (2003) notes many of Melotte's clusters both open and globular were already identified in the NGC and IC catalogs. Melotte

13 and 14 are the Double Cluster (NGC 869 and NGC 884) and Melotte 22 is the Pleiades (M45). Melotte's list contains only 10 newly discovered clusters, the most prominent of which is Melotte 111, the Coma Star Cluster, which has been known since ancient times (Archinal and Hynes 2003). Even so, the Melotte Catalogue continues in common use and many Melotte objects are favorite observing targets of amateurs.

6.2 Collinder Catalogue (Cr)

Per Collinder (1890–1974), a Swedish astronomer, published a catalog of 471 open clusters in 1931 (Collinder 1931). Some errors were present in the catalog, and a modern interpretation of its contents shows 452 open clusters, 11 globular clusters, 6 asterisms, 1 moving group of stars (Cr 285, the Ursa Major Moving Group), and 1 stellar association (Cr 302, the Upper Scorpius Association). Collinder's work started as part of his PhD thesis. He based the catalog on his and Knut Lundmark's (1889–1958) visual observations and an extensive collection of plates, charts, and literature. Much of his work was based on the Franklin-Adams charts and literature.

6.3 Lund Catalogue of Open Cluster Data (Lund)

The Lund Catalogue was compiled by Gosta Lynga of Lund Observatory, Lund, Sweden, from data collected in the literature. The fifth edition was published in 1987, and the catalogue is now being distributed on the CDS and NASA data centers (Lynga 1987). It is a main source for open cluster data used by Archinal and Hynes in their massive work *Star Clusters* (Archinal and Hynes 2003). In the Lund Catalogue more than 1000 open clusters are listed with an identification name and positional data. "For most of them, angular diameters and some descriptional parameters are also available. Almost 500 clusters are studied well enough to have estimates of distance, age and effects of interstellar reddening" (Lynga 1987). In approximately 100 clusters there is data on stellar abundances or radial velocity determinations.

6.4 Globular-Cluster Catalog (Arp) and Others

Arp's catalog was published in 1965 as part of a review paper that appeared in *Star and Stellar Systems*, Volume 5, general editor GP Kuiper, editors A

Blaauw and M Schmidt. The catalog lists 119 globular clusters giving their NGC number or other designation, position in equatorial and galactic coordinates, and many other important features of each object (Arp 1965). While this catalog is often cited, most globular clusters of interest to amateurs are those found in the Messier and NGC lists.

The Palomar Globulars (**Pal**) were discovered in the 1950's on the plates of the first Palomar Observatory Sky Survey. These 15 globular clusters were found by Edwin Hubble, Walter Baade, Fritz Zwicky, Halton Arp, and George Abell when examining the POSS plates. Some Palomar Globulars are moderate size and nearby but obscured by dust, and others are far away in the extreme outer halo of the Milky Way. The Palomar Globulars produce a very challenging list of objects for observing or imaging (Adventures in Deep Space 2022).

The Terzan globular clusters (**Terzan 1–11**) were discovered by Agop Terzan in 1967–1971 through photographic observations in the far-red portion of the spectrum (6400 angstroms) and in the infrared portion of the spectrum (8100 angstroms) at the Newtonian focus of the 193 cm (76-inches) f/15 telescope at the Haute Provence Observatory in southeastern France. Terzan was studying the central portion of the Milky Way (Terzan 1971). His original list included 12 objects, but he later noted Terzan 11 was a rediscovery of Terzan 5, and he renamed Terzan 12 to Terzan 11. These are faint challenging objects, but advanced amateurs have had success in viewing and imaging them (Wilson, Adventures in Deep Space).

7 Planetary Nebulae Catalogs

7.1 Catalogue of Galactic Planetary Nebulae (PK)

A good bibliography of planetary nebulae and summary of planetary nebulae catalogs is found in Appendix A in SJ Hynes *Planetary Nebulae* (1991). The *Catalogue of Galactic Planetary Nebulae* by L Perek and L Kohoutek was published in 1967. It was compiled from photographic plates take by L Perek using the 66 cm (26-inch) Schmidt telescope at the Tonantzintla Observatory in San Andres Cholula, Puebla, Mexico and from plates taken at the Mount Wilson 60-inch reflector and the Mount Palomar 48-inch Schmidt telescope. All the plates were taken on Kodak 103aE emulsion through a red filter. An updated version of the Catalogue was published by

Kohoutek in 2001. This lists 1510 planetary nebulae with their Perek-Kohoutek (**PK**) number, their other designations, and 2000 coordinates.

7.2 Catalog of Planetary Nebulae (Abell)

George Abell was an indefatigable researcher. He listed 86 objects from the original POSS1 plates as planetary nebulae. He noted AG Wilson first identified about half of the objects, and the rest were found by RG Harrington, R Minkowski, and himself (Abell 1966). He did note one or two of the objects may not be actual planetary nebulae. Many of these objects are observing challenges, and a complete listing of them with notes can be found on the Adventures in Deep Space website.

7.3 PLNEBULAE – Galactic Planetary Nebulae Catalog (PN or PNG)

This catalog is on the NASA High Energy Astrophysics Science Archive Research Center (HEASARC) website. It a 1992 version of the **Strasbourg-ESO Catalog of Galactic Planetary Nebulae** (Acker et al. 1992). The catalog lists 1143 true and probable planetary nebulae and another 347 objects whose status is uncertain. In the online catalog the planetary nebulae are given the designation PN, while the nebulae as listed in the 1992 ESO publication are given the designation PNG.

8 Emission, Dark, and Reflection Nebulae Catalogs

Nebulae, particularly dark nebular regions as first described by Barnard are the main subject of this book. As discussed in Chap. 2 there are several ways to classify non-planetary nebulae. One of the most common ways is to break them into three groups – a) bright nebulae, either emission or reflection or mixed, b) dark nebulae, and c) mixed bright and dark nebulae. It is unusual for a dark nebula to be completely opaque and not have any region of associated bright nebulosity. There are two major catalogs for dark nebulae – Barnard's catalog and Lynds **Catalogue of Dark Nebulae** (**LDN**). These along with **Lynds Catalogue of Bright Nebulae** (**LBN**) are examined in detail in Chap. 9 where the modern view of Barnard Objects is discussed

along with noting newer catalogs for dark nebulae based on microwave, radio wave, and infrared observations of the Milky Way.

8.1 Catalog of Bright Diffuse Galactic Nebulae (Ced)

Sven Cederblad produced a catalog of 330 bright diffuse galactic nebulae in 1946 as part of his PhD thesis at Lund University. He was looking at the spatial distribution and geometrical properties of bright galactic nebulae with investigation into interstellar absorption of light. His work is "…a nearly complete compilation of [all] the knowledge about bright galactic nebulae [known in]…1945" (VizieR Cederblad). While Cederblad's list is somewhat outdated, it is frequently cited as the nebulae he noted are the largest and brightest in the Milky Way.

8.2 Minkowski Emission Nebulae (Mi or M1)

Rudolph Minkowski (1895–1976) then of Mount Wilson Observatory produced a table of 80 mostly newly found "emission nebulae" while searching objective-prism survey plates obtained by WC Miller with a 10-inch telescope. These showed Hα emission with little or no continuous spectra. Minkowski noted "…most of the 80 objects…have been…classified as planetary nebulae on the basis of their appearance on direct photographs obtained at the Newtonian focus of the 60-inch or the 100-inch telescope [at Mount Wilson Observatory]…The remaining objects have been designated planetary nebulae because their spectra are unmistakably like those of planetary nebulae, showing strong forbidden lines with little or no continuous spectrum" (Minkowski 1946).

Minkowski also listed "…20 diffuse nebulosities with emission, and 3 peculiar galaxies…Some of the objects are relatively bright and easily found, but many which are faint and strongly reddened cannot be identified without the aid of charts…" While Minkowski's list mainly consists of planetary nebulae, it is generally placed in the category of diffuse nebulae, and Minkowski objects designations are occasionally found in popular atlases and observing programs. His work has generally been succeeded by later catalogs and by the Palomar Sky Atlas which he headed. Minkowski was one of the giants of twentieth century astronomy. He is particularly known for his work with Walter Baade (1893–1960) on supernovae.

8.3 Sharpless Catalogue of HII Regions (SH2 or Sh2)

Stewart Sharpless (1926–2013) at the U.S. Naval Observatory published a catalog of 313 HII regions north of declination −27 degrees (Sharpless 1959). This was an update to his Part I publication in 1953 of HII regions based on a series of 48-inch Palomar Schmidt telescope plates between galactic longitudes 315° and 105° and extending on either side of the galactic circle. He updated and extended his work to the entire sky north of declination −27 degrees based on prints in the Palomar Sky Survey after they became available. He attempted to exclude reflection nebulae based on a comparison of the red and blue photographs in the Palomar atlas.

Sharpless objects are some of the finest HII regions in the sky with wonderful emission nebulae. They are sometimes labeled Sh-1 for objects described in his first catalog. It is best to ignore his first catalog and use the information from his 1959 publication. These are the Sharpless-2 objects, usually listed as Sh2 or SH2, though as with many other designations in astronomy, there is considerable variation in how observers and authors attach designations for common objects.

8.4 Gum Nebulae; RCW Catalog

Colin S Gum (1924–1960), an Australian astronomer, conducted a photographic survey for diffuse emission nebulosities (HII regions) in the Southern Milky Way and published his survey in 1955 (Gum 1955). His catalog lists positions and dimensions of 85 physically separate HII regions with details of the stars exciting the nebulae and their distance moduli when available. A major part of his paper was contained in a thesis he presented as a requirement of the degree of Doctor of Philosophy in the Australian National University, Canberra. The survey had been started by CW Allen for CSIRO (Commonwealth Scientific and Industrial Research Organization) at the Mount Stromlo Observatory in 1950 and extended by Gum starting in late 1951.

For most of the program an f/1 100 mm Schmidt camera was used with 22 mm diameter disks of film punched from 35 mm roll film. The field of view was 11° in diameter with the focal plane scale 35 arcminutes per mm. A combination of absorption filters was used with Kodak 103a-E or Super-XX emulsions. A detailed and interesting discussion of his photographic techniques is provided by Gum in his 1955 paper. Gum's work is most remembered for the large HII regions he described, the most famous of which is Gum 12 (sometimes called the Gum Nebula) an emission region

extending across 36 degrees in Vela and Puppis. In 1959 Gum was appointed Head of the Observational Optical Astronomy program at the University of Sydney. Tragically, he died in a skiing accident at Zermatt, Switzerland in 1960.

In 1960 AW Rodgers, CT Campbell, and JB Whiteoak published the *Atlas of Ha Emission in the Southern Milky Way* (Rodgers et al. 1960). This resulted from a survey program started in 1957 by Bart Bok (1906–1983) for detection of southern sky HII regions using a "Meinel-Pearson 8-inch f/1 flat field Schmidt [telescope]." They felt "…that in this survey we have reached fainter limiting emission measures in a given region of the sky than did Gum, primarily because of the increase in resolution of our camera." The subsequent catalog published after their 1960 article lists 182 HII regions broken up into two groups, those greater than 4 arcminutes in diameter and those less than 4 arcminutes in diameter. This catalog includes many regions listed by Gum and is considered an extension of Gum's work. There is moderate overlap with Sharpless Catalogue-2, though Sharpless covered the northern sky, and Gum and RCW covered mainly the southern sky.

8.5 Van den Berg Catalog of Reflection Nebulae (vdB)

Sidney van den Berg (1929-), a Dutch Canadian astronomer and former director of the Dominion Astrophysical Observatory in British Columbia, published a study of reflection nebulae in 1966 (Van den Bergh 1966). He used prints from the Palomar Sky Survey to identify all stars with a BD or CD designation that were associated with reflection nebulosity. About 500,000 stars were investigated with 500 BD and CD stars found associated with reflection nebulosity.

In most cases the reflection nebulosity was only visible on the blue prints of the Sky Survey. "A total of 170 BD and CD stars were found to be associated with reflection nebulosity which was bright enough to be visible on both the red and the blue prints of the Palomar Sky Survey" (Van den Bergh 1966). Van den Berg produced a table on all reflection nebulae found to be associated with BD or CD stars north of declination −33 degrees. The table contains 158 stars associated with reflection nebulosity along with other data. The brighter vdB reflection nebulae are interesting visual targets, and all are subjects for astrophotography. *Astronomy* magazine provides a good summary listing of the 158 van den Berg reflection nebulae with their van den Berg classifications as very bright (VBR), bright (BR), moderate (M), faint (F), and very faint (vF) (Astronomy, van den berg reflection nebulae).

The Cygnus X Region: V. Catalogue and Distances of Optically Visible HII Regions (DWB)

The Cygnus X Region is a diffuse radio source in Cygnus named in 1952 by JH Piddington and HC Minnett to distinguish it from the radio galaxy Cygnus-A (Dickel et al. 1969). The radio emissions from Cygnus X are from clouds of ionized interstellar gas. This is one of the richest known regions of star formation in the Galaxy. The emission from most of the "… sources are thermal and the positions of the radio sources agree well with those of the optically visible HII regions" (Dickel et al. 1969). Cygnus X is an approximate 5 × 5-degree area near Gamma Cygni (Sadr) (Fig. 3.3). HR Dickel, H Wendker, and JH Biertz in 1969 catalogued 90 optically visible HII regions for which they had radio data and estimated distances derived from interstellar reddening data.

8.6 Atlas of Galactic Nebulae (GN)

The well-known German amateur astronomer Hans Vehrenberg (1910–1991) and the German professional astronomer Thorsten Neckel (1937–2020) of the Max Planck Institute for Astronomy created the *Atlas of Galactic Nebulae* published in three parts from 1985–1990. It was a large three volume 462-page work with high quality images of emission and reflection nebulae listed by a GN designation. There are 1547 objects whose images were taken from the POSS and ESO/SERC Southern Sky Survey as well as a few images from the Calar Alto Observatory in Spain and from the La Silla Observatory in Chile (Steinicke 2022). This was an important publication coming just prior to the modern era of digital imaging.

9 Conclusions

There are seemingly innumerable catalogs and atlases of astronomical objects. The more common ones have been briefly discussed in this chapter. The ones noted most resemble or complement Barnard's 1927 *Atlas* and help put his great work in perspective. Barnard stated in his 1927 *Atlas* "My principal aim in presenting these photographs has been to give pictures of some of the most interesting portions of the Milky Way in such form that they may be studied for a better understanding of its general structure. They are not intended as star charts. Such photographic charts have already been made by Wolf and Palisa (Table 3.1) and by Franklin-Adams. They are

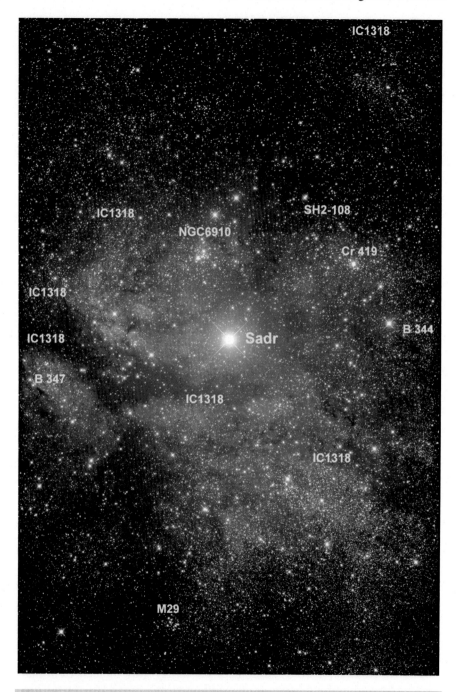

Fig. 3.3 Central Cygnus showing Gamma Cygnus (Sadr) and surrounding emission (IC 1318, SH2–108) and dark nebulae (B 347 and B 344) (north up, east left). Image obtained with Takahashi Epsilon 180 f/2.8 astrograph and Canon EOS Ra camera. (© Tim B Hunter, 3towers, LLC, 2022. All Rights Reserved)

Table 3.1 Common astronomical atlases, catalogs, and surveys

Catalog or Atlas	Objects listed	Approximate date	Number of listings	Comments
Uranometria	Stellar atlas	1603	51 star maps covering the entire sky; 2000 stars	First all sky atlas
Historia Coelestis Britannica	Stellar atlas	1725	2866 star positions	John Flamsteed's stellar catalog
On the Nebulous Stars of the Southern Sky	Abbe Nicholas Louis de la Caille's stellar catalogue	1763; 1847	42 "nebulae" and 9800 stars	First comprehensive study of the Southern Hemisphere skies; A century earlier Edmund Halley published a sky map and description of 341 southern stars
Messier	Deep Sky	1784	103–109	First, most comprehensive deep sky catalog
NGC; IC	Deep Sky	1888–1908	7840 + 4149	Correlation and extension of work originally done by William and Carolyn Herschel and John Herschel
Bonner Durchmusterung (BD)	Stellar	1863 with periodic updates	324,188 stars with accurate positions and magnitude	Precise comprehensive work. The basis for many subsequent catalogs. Still referred to today
Cordova Durchmusterung (CD)	Stellar	1885–1932	613,959 stars with accurate positions and magnitudes	Considered the southern sky equivalent to the BD

(continued)

Table 3.1 (continued)

Catalog or Atlas	Objects listed	Approximate date	Number of listings	Comments
Carte du Ciel	First photographic sky survey; based on 13-inch Henry astrograph at Paris Observatory	1887- Observatories around the world were assigned fields to photograph with equipment analogous to the Henry astrograph	Several thousand photographic plates from observatories around the world	Never fully completed
Cape Photographic Durchmusterung	An extension of the BD into the southern hemisphere but using photographic plates not visual observations	1896–1900	Positions and magnitudes of 454, 875 stars in the Southern Hemisphere.	The photographic plates were obtained at the Royal Observatory at the Cape of Good Hope by David Gill using a 13-inch photographic refractor
Photographische Sternkarten	Stellar atlas of the sky visible in Europe assembled by Johann Palisa (1848–1925) of Vienna in cooperation with Max Wolf of Heidelberg (GAVO, Wolf-Palisa Survey)	~1900–1916	210 large photographic prints from plates obtained at Heidelberg by Max Wolf using the 40 cm (16-inch) Bruce Telescope. Each print covered 50 square degrees and reached 14th magnitude	This was assembled to aid the visual discovery of asteroids

Franklin-Adams Charts	First completed systematic photographic survey of the entire sky in uniform fashion	1914; 1922	206 photographic prints obtained with 10-inch f/4.5 lens covering 15 × 15-degree field of view	Most important photographic sky survey in the first half of the twentieth century. The basis for many subsequent catalogs
Henry Draper Catalogue (HD)	Stellar with spectroscopic classification	1918–1924	225,300 stars listed with position, magnitude, and spectroscopic classification	A standard catalog in daily use today
Barnard Objects	Dark Nebulae	1919 and 1927	~352 dark nebulae	First great catalog of dark nebulae and one of the first photographic catalogs
Shapley-Ames	Galaxies	1932	1249 galaxies to limiting magnitude 13	One of the earliest and most useful galaxy catalogs
Bright Star Catalogue (BS, BSC)	Catalog of naked eye stars	1930; 1983	9000 naked eye stars down to magnitude 7.1	Lists the stellar coordinates, proper motion, photometric data, and stellar spectral type
National Geographic-Palomar Sky Survey (POSS 1)	Covered entire sky to declination −23 degrees with photographic plates through red and blue filters obtained from the Palomar Observatory 48-inch Oschin Schmidt Telescope	POSS 1 completed in 1958	897 plates in two colors	Extensive photographic survey that set the standard for subsequent photographic and digital surveys. Its work is still used extensively today

(continued)

Table 3.1 (continued)

Catalog or Atlas	Objects listed	Approximate date	Number of listings	Comments
POSS 2 and Southern Sky Surveys	The northern sky was photographic again with better plates and updated 48-inch Oschin Schmidt Telescope	2000		Its work complements POSS 1 and the southern sky surveys
Multiple Southern Sky Surveys	These were an extension of the Palomar Sky Survey into the southern sky using similar photographic techniques and similar telescopes	1958–2000		These surveys complemented the Palomar Sky Surveys and along with the Palomar Sky Surveys led to Digitized Sky Survey freely available on the internet
Smithsonian Astrophysical Observatory Star Catalog (SAO)	Stellar information derived from multiple sources	1966	250,000 stars	Overlaps Henry Draper Catalogue and only lists stars for which there is proper motion data. Important catalog in daily use today
The Cygnus X Region. V. Catalogue of Optically Visible HII Regions (DWB)	Optically Visible HII Regions in Cygnus X	1969	90 HII regions	Compiled by HR Dickel, H Wendker, and JH Bieritz

Atlas of Galactic Nebulae (AGN)	Nebulae excluding Planetary Nebulae	1985–1990	Three volume book with 462 pages, now on DVD	1547 objects, mainly emission and reflection nebulae collected from POSS and ESO/SERC Southern Sky Survey
USNO-B1.0	All sky catalog	2003-	Data from scans of 7435 Schmidt plates taken from various sky surveys	Covers the entire sky down to V magnitude 21 listing more than a billion objects
Guide Star Catalog	All sky catalog	1989–2008	Data taken from photographic surveys as well as from the Hipparchus mission listing over 1 billion stars down to magnitude 21	This is the first all sky star catalog developed specifically for navigation in space.

See discussion in text. Also see SEDS List of Common Deep Sky Catalogs https://www.messier.seds.org/xtra/supp/cats.html and List of astronomical catalogues: List of astronomical catalogues – Wikipedia

probably more useful for the identification of individual stars. But these do not give us a true picture of the parts of the sky shown, for there are structures and forms that cannot well be depicted in ordinary charts [like Franklin-Adams]…These photographs [in *A Photographic Atlas of Selected Regions of the Milky Way*] may, therefore, be considered as supplementary to the regular charts in that they show the details of clouds, nebulosities…" Barnard succinctly outlined why his atlas was appropriate and was complementary to other atlases and catalogs. Likewise, most of the atlases and catalogs discussed above cover a distinct object or area of study and complement other works.

It is unfortunate Barnard was not able to complete his work on dark nebulae. His catalog is incomplete, and it is evident from his writings he wanted to add more objects. This is discussed in further detail in Chap. 8. His catalog does suffer from a scattered, thrown together appearance with no specific definition for object inclusion. Also, his numbering system is undefined. No doubt he worked on his dark nebulae catalog intermittently when time permitted coming back to it off and on after considerable time lapses which added to its jumbled appearance.

Professional and amateur astronomers are casual in how they designate or name a common astronomical object. There is little consistency from one source to another. This can be quite confusing for someone trying to look up an article or an image about a star or deep sky object. If you want to read about Meissa, do you look it up with that name? Or do you call it Lambda Orionis? How about Porrima versus Gamma Virginis or is it Γ or γ Virginis? Amazingly, there is little consistency in this regard, and it is rare for the star to be listed by more than one of its names in each source. This is not too much of a problem with bright stars mostly known by their common names, but fainter stars with both a common name and a Bayer Greek letter name can be real challenges to look up.

There is a similar problem with deep sky objects. Brighter more popular Messier or NGC objects are usually easy to reference. But those objects which are fainter or more challenging and which have several designations can be cited in any number of ways depending on the source. For example, how do you search for a paper or image of the Horsehead Nebula? Do you use its popular name Horsehead Nebula, or its NGC/IC name IC 434 (or is it IC434 without the space?), or its Barnard designation B 33 or B33 without the space?

Unless you have the original publication for an astronomical catalog or atlas, it is most difficult to accurately determine when it was published and what it contains. Common web encyclopedia entries usually give good overviews but are often very inaccurate with specific details such as the

number of entries to the catalog or its publication date, and the web entries frequently list references hard to access.

Even more amazing is the almost universal lack of photographic details concerning the instrument, specific photographic plate, and exposure times for a historical astrophotograph found on the web. For example, the image of the Great Comet of 1882 by David Gill (Fig. 3.1) is widely available on the web and is in the public domain. Yet, one must go to Gill's 1882 *MNRAS* article to guess as to which date the picture was obtained and with what exposure. He does list his equipment for imaging the comet, but he does not list the specific brand of photographic plate he used.

Table 3.1 provides an overview of the most important astronomical sky atlases, catalogs, and surveys from 1604 to 2008. The Franklin-Adams plates and prints, the Palomar Sky survey plates and prints, and the southern sky surveys performed to complement the Palomar northern plates and prints are the basis for almost all the other more specialized astronomical catalogs in use. The Hipparcos mission produced the first large space-based data set of precise stellar measurements. It is now being complemented and superseded by the Gaia mission. There are also important Earth based surveys like the Sloan Digital Sky Survey, SkyMapper, Catalina Sky Survey, Pan-STARRs, and the upcoming Vera C Rubin Observatory (Sky & Telescope, Astronomical Sky Surveys). These surveys are following in the footsteps of Franklin-Adams, Barnard, and Palisa-Wolf who first applied photographic imaging for specialized surveys and catalogs more than 100 years ago.

References and General Bibliography

Abell GO. The distribution of rich clusters of galaxies. California Institute of Technology; 1957. PDF: Abell_GO_1957.pdf (caltech.edu).

Abell GO. The distribution of rich clusters of galaxies. Astrophys J Suppl Ser. 1958;3:211–88. https://doi.org/10.1086/190036.

Abell GO. Properties of some old planetary nebulae. Astrophys J. 1966;144:259–80.

Acker A, Ochsenbein F, Stenholm B, Tylenda R, Marcout J, Schohn C. Strasbourg-ESO catalogue of galactic planetary nebulae. Parts I. European Southern Observatory; 1992.

Adventures in Deep Space. The Palomar Globulars. 2022: The Palomar Globulars (astronomy-mall.com).

Adventures in Deep Space. The Abell Planetaries: The Abell Planetaries (astronomy-mall.com).

American Association of Variable Star Observers (AAVSO). 2022: Home I aavso.

Archinal BA, Hynes SJ. Star clusters. Richmond: Willmann-Bell; 2003.

Arp H. Globular Cluster Catalog. 1965. Review paper on globular clusters. See VizieR online data Catalog: Globular-Cluster Catalog (Arp 1965): https://ui.adsabs.harvard.edu/abs/1996yCat.7013....0A/abstract.

Arp H. Atlas of Peculiar Galaxies. California Institute of Technology, Pasadena, CA; 1966. Atlas_of_Peculiar_Galaxies.pdf.

Ashbrook J. In: Robinson LJ, editor. The Astronomical Scrapbook. Cambridge, MA\ Cambridge, UK: Sky Publishing Corporation\Cambridge University Press; 1984.

Astronomy magazine. The van den Berg catalog. van_den_bergh_catalog.pdf (astronomy.com).

Barnard EE. A Photographic atlas of selected regions of the Milky Way. In: Frost EB, Calvert MR, editors. . Washington: Carnegie Institution of Washington; 1927. Online Version at Georgia Institute of Technology: Barnard's Photographic Atlas of Selected Regions of the Milky Way (gatech.edu).

Barnard EE. A Photographic atlas of selected regions of the Milky Way. In: Edwin B Frost, Mary R Calvert, editors, reprinted under the direction of Gerald Orin Dobek. Cambridge: Cambridge University Press; 2011.

California Institute of Technology (CalTech). National Geographic Society Palomar Observatory Sky Atlas (PDF); 1954.

Cederblad S. Catalog of bright diffuse Galactic nebulae: VII/231. VizieR: VizieR VII/231 (unistra.fr).

Collinder P. On structural properties of open galactic clusters and their spatial distribution. Summary. Ann Obs Lund. 1931;2:B62.

Dickel HR, Wendker H, Bieritz JH. The Cygnus X region. V. Catalogue and distances of optically visible HII regions. Astron Astrophys. 1969;1:270–80.

ESO online Digitized Sky Survey. 2022. https://archive.eso.org/dss/dss.

Frommert H. The interactive NGC catalog online. 2022: The Interactive NGC Catalog Online (seds.org).

GAVO. Wolf-Palisa Survey. https://dc.zah.uni-heidelberg.de/lswscans/res/positions/wpshow/form.

Gill D. On photographs of the great comet (b) 1882. Mon Not R Astron Soc. 1882;42:53–4.

Gum CS. A survey of southern HII regions. Mem R Astron Soc. 1955;67:21–177.

HathiTrust Digital Library. Cordoba Durchmusterung, volume III; 2022. https://babel.hathitrust.org/cgi/pt?id=mdp.39015033090963&view=1up&seq=1&skin=2021.

Hunter TB. The sky at night: easy enjoyment from your backyard. Tucson, Arizona: University of Arizona Press; 2023.

Hunter TB. Grasslands observatory: table of arp galaxies: https://www.3towers.com/Grasslands_Content/ArpGalaxies/ArpGalaxiesTable.html.

Hynes SJ. Planetary nebulae. A practical guide and handbook for amateur astronomers. Willman-Bell, Inc, Richmond; 1991.

Ingrao HC, Menzel DH. New Sky Patrol Program at Harvard College Observatory. Report No. 1. December 15, 1967: https://articles.adsabs.harvard.edu/pdf/1967phae.proj.2635I.

Jones KG. Messier's nebulae and star clusters. 2nd ed. Cambridge: Cambridge University Press; 1991.

Jones D. The scientific value of the Carte du Ciel. *A&G* 2000; 41(Issue 5) 16–20.

Kanipe J, Webb D. The Arp Atlas of peculiar galaxies: a chronicle and observer's guide. Willmann-Bell Inc; 2006. ISBN 978-0-943396-76-7

Lacaille N. Biography: Nicholas Louis de Lacaille (1713–62) (archive.org).

Lacaille N. Nichola Louis de la Caill'e Original Catalog. SEDS: Lacaille's Original Catalog (seds.org).

Lynds B, editor. Dark nebulae, globules, and protostars. Tucson: University of Arizona Press; 1970.

Lynga G. Catalogue of open cluster data. 5th ed. Distributed through the CDS and NASA data centres; 1987.

Mallas JH, Kreimer E. The Messier album. Cambridge: Sky Publishing Corporation; 1978. Fourth printing 1997.

Melotte PJ. A catalogue of star clusters shown on Franklin-Adams chart plates. Mon Not R Astron Soc. 1915;60:175–86.

Minkowski R. New emission nebulae. Publ Astron Soc Pac. 1946;58:305–9.

NASA's HEASARC: Archive. Access to the catalogs and astronomical archives of the HEASARC: https://heasarc.gsfc.nasa.gov/docs/archive.html.

Olowin RP. The all-sky Abell rich cluster catalogue: preparation and uncertainties. In: Flin P, Duerbeck HW, editors. Morphological cosmology, Lecture notes in Physics, vol. 332. Berlin, Heidelberg: Springer; 1989. https://doi.org/10.1007/3-540-51223-3_113.

Paturel G, Petit C, Prugniel P, Theureau G, Rosseau J, Brouty M, Dubois P, Cambresy L. HYPERLEDA. I. Identification and designation of galaxies. Astron Astrophys. 2003;412:45–55. https://doi.org/10.1051/0004-6361:20031411.

Perek L, Kohoutek L. Catalogue of galactic planetary nebulae. Publication House Czechoslovak Academy of Sciences, Prague; 1967. Version 2000 by L Kohoutek, Hamburg-Berfedorf, 2001: https://astronomy.com/-/media/Files/PDF/web%20extras/2013/06/Perek-Kohoutek%20Catalog.pdf.

Photographic Committee of the Royal Astronomical Society. The Franklin-Adams chart. Mon Not R Astron Soc. 1936;97:89–94.

PLNEBULAE. Galactic planetary nebulae catalog. HEASARC: PLNEBULAE – Galactic Planetary Nebulae Catalog (nasa.gov).

Primary Galaxy Catalogs. 2022. https://ned.ipac.caltech.edu/level5/CATALOGS/pgc.html.

Ridpath I. Star tales. James Clarke & Co.; 1988.

Rodgers AW, Campbell CT, Whiteoak JB. A catalogue of ha-emission regions in the southern milky way. Mon Not R Astron Soc. 1960;121:103–10.

Sandage AR, Tamman GA. A revised Shapley-Ames catalogue; 1981: https://ned.ipac.caltech.edu/level5/Shapley_Ames/frames.html.

SEDS. List of Common Deep Sky Catalogs. 2022. https://www.messier.seds.org/xtra/supp/cats.html.

Shapley H, Ames A. A survey of the external galaxies brighter than the thirteenth magnitude. Ann Harvard College Obs. 1932;88(#2):41–76.

Sharpless S. A catalogue of HII regions. Astrophys J Suppl Ser. 1959;4:257–79.

Sinnott RW. Ngc 2000.0: The Complete New General Catalogue and Index Catalogues of Nebulae and Star Clusters by Jl.L.E. Dreyer. Cambridge: Sky Publishing Corporation; 1988.

Sky & Telescope. Astronomical Sky Surveys. https://skyandtelescope.org/sky-and-telescope-magazine/astronomical-sky-surveys/.

SkyMapper. Southern Sky Survey. 2022. https://skymapper.anu.edu.au/.

Star catalogue. 2022. https://en.wikipedia.org/wiki/Star_catalogue.

Steinicke W. Observing and cataloguing nebulae and star clusters. Cambridge: Cambridge University Press; 2010.

Steinicke W. Hans Vehrenberg, Thorsten Neckel. Atlas of Galactic Nebulae (DVD). 2022. http://www.klima-luft.de/steinicke/Artikel/Atlas%20of%20Galactic%20 Nebulae.pdf.

Sulentic JW, Tiff WG. The revised new general catalogue of nonstellar astronomical objects. Tucson: The University of Arizona Press; 1973.

Terzan A. Four new star clusters in the direction of the central are of the galaxy. Astron Astrophys. 1971;12:477–81.

The NGC/IC Project. 2022. https://ngcicproject.observers.org/.

Van den Bergh S. A study of reflection nebulae. Astron J. 1966;71(10):990–8.

Vorontsov-Velyaminov BA. The Atlas and catalogue of interacting galaxies (Moscow, 1959). PDF: The Atlas and Catalogue of Interacting Galaxies (caltech.edu).

Vorontsov-Velyaminov BA, Noskova RI, Arkhipova VP. The catalogue of interacting galaxies by Vorontsov-Velyaminov. Astron Astrophys Trans. 2001;20(5):717–959. https://doi.org/10.1080/10556790108208213.

Wilson B. Obscure Globular Clusters of the Milky Way: Terzan Clusters and the Faintest Globular UKS-1. An Observational and Imaging Success. Adventures in Deep Space: Obscure Globulars (astronomy-mall.com).

Zwicky F, Kowal CT. Catalogue of galaxies and of clusters of galaxies. Volume VI. CaltechAUTHORS. 2022. https://authors.library.caltech.edu/37997/1/ Volume%206.pdf.

Chapter 4

Barnard and His Photography

1 Barnard the Photographer

Barnard's experience working at a portrait studio in Nashville, Tennessee, from early childhood gave him photographic skills he used and enhanced the rest of his life. He was a photographer's photographer. He could do it all-take photographs (portraits, landscapes, eclipses, the Moon, comets, the Milky Way, and occasional planets and deep sky objects), develop his own photographic plates, and work closely with professional printers and engravers to obtain the best print reproductions of his photographs.

Barnard knew lenses and telescopes. He was an expert on darkroom procedures. Throughout his career many of his papers discussed the fine points of darkroom technique going so far as to recommend plates, developing solutions, plate fixation procedures, and methods for plate varnishing and preservation. He took all his own astrographs and developed all his own plates. He never used an assistant.

When you read Barnard's descriptions of his photographic methods and his darkroom techniques, you know immediately you are in the presence of a genius. This is particularly evident for those who are familiar with film and used a darkroom. I (tbh) grew up in the era of film photography in the 1950's and 1960's even prior to color astrophotography. In junior high school I was given a darkroom kit with solutions, trays, and a print box. This was set up in a dark corner of our basement. If I used the darkroom during the day, I

T. B. Hunter et al., *The Barnard Objects: Then and Now*, The Patrick Moore Practical Astronomy Series, https://doi.org/10.1007/978-3-031-31485-8_4

had to put cardboard over the basement windows to keep out light. My results were mediocre, but I can feel the photographer and darkroom expertise in Barnard's writings. Later, when I attempted film astrophotography with a telephoto lens eventually graduating to telescopic astrophotography, I completely experienced the joys and mostly the frustrations of astrophotography so well described by Barnard in his many articles.

2 Visual Observing Versus Photography

Barnard is either the greatest visual observer in history or near the top alongside Charles Messier, William Herschel, John Herschel, and Galileo. Even so, he strongly believed that one saw the sky "poorly" prior to photography of the heavens. He summed up his view this way:

> Before the application of photography to the study of the heavens, one saw the sky but poorly indeed, and in the light of the revelations of the photographic plate today, one is almost tempted to say that he did not see the heavens at all, so vastly has photography enlightened us to the actual appearance of the sky and its citizens…And, what is of immense advantage, it permanently records what it sees, so that the exact appearance of a nebula may be preserved for future reference perhaps hundreds of years hence, while the view obtained by the eye is as evanescent as the fleeting glimpse of the object itself. Even though the observer should make a careful drawing it is too often worthless, and misleading, for reference with other drawings, made later on; for the astronomer is seldom or never an artist…The photographic plate, not only with an accuracy far beyond that of the most skillful artist but with an eye almost infinitely more sensitive, sees the faintest details of a comet or a nebula and records them with a faithfulness unheard of before (Barnard 1908).

3 Astrophotography – Plates, Prints, Darkroom Techniques, Emulsions

All astrophotography whether professional or amateur was black and white until the 1960's when fast color films were introduced. The present discussion concerning Barnard's photographic techniques applies to black and white imaging. When we discuss color imaging of the Barnard Objects and other astronomical bodies, this is in the context of modern digital imaging. Color film photography is complex with quite involved darkroom procedures, similar to but more elaborate than those for black and white photography. Color film is still being used for commercial photography and

popular photography, though it has generally been succeeded by digital color imaging. Color film and color plates are not used in professional astronomy.

Astronomers in the early days of astrophotography, even Barnard, were somewhat inconsistent in their use of photographic terms. Herein when we speak of *photographic plates*, unless otherwise noted, we mean a glass plate with an emulsion on one side. The plates in Barnard's time were not totally flat. "All commercial plates are more or less curved. It is the custom to put the emulsion on the concave side. This improves the flatness of the field…" (Barnard 1909). The plate was put into the camera plate holder with the emulsion facing the camera lens or the telescope objective lens or mirror.

Professional astronomers used glass photographic plates from the earliest days of photography until digital imaging replaced photographic plates in the early 2000s. George Eastman created the first flexible roll film in the 1880's, and the Brownie camera was introduced by Eastman Kodak in 1900. Roll film on a spool was smaller and much easier to handle than large glass plates, and it soon became the standard photographic medium for the public. Even so, professional astronomers preferred large glass plates for astrophotography rather than strip film.

Photographic emulsions contain various silver salts (usually silver halides) and other additives that are chemically altered if exposed to light. When an image is focused on the emulsion by a camera lens for the proper exposure duration, the silver salts are altered in proportion to the amount of light they receive. The emulsion has a "latent image" that only becomes visible once the plate is developed. Those areas receiving light precipitate tiny micron sized grains of black metallic silver onto the plate in proportion to the amount of light they receive after the plate is placed in a selected chemical bath (the developer) for the proper amount of time. The more silver grains precipitated, the darker that portion of the developed plate. Those areas receiving little or no light during the photographic exposure precipitate little or no silver grains after plate development leaving that section of the plate clear or white.

A photographic plate (and later photographic roll film) must be prepared in darkness, so the silver halide emulsion is not permanently overexposed by stray light. Such a ruined plate when developed is totally black. Dry plates introduced in 1871 were the first photographic plates that could be manufactured and stored for later use if they were kept in a light free container. Once exposed, the plate could again be stored in a dark container until developed in a darkroom.

Anyone growing up in the film era and having experience in darkroom procedures immediately recognizes Barnard as a darkroom master from his

writings. Darkrooms were a necessity from the earliest days of photography. Photographers and darkroom assistants became quite facile handling photographic plates, prints, and films in total darkness. The earliest plates and even some of the films used in the twentieth century were insensitive to red light, enabling a dim red light to be present in the darkroom to assist the photographer in his or her task producing enough dim illumination to see what one was doing and to watch the image appear on a plate or print as it was being developed.

The *typical darkroom procedure* for plates and film from the earliest days of photography up to the present era consists of three basic steps: (1) Remove the exposed plate from its container or plate holder and immerse it in the developing solution (the developer) for the proper time. Developing solutions chemically reduce the silver halides to the metallic silver. (2) After developing the plate, wash it thoroughly to remove developer solution so excess development and chemical destruction of the plate does not take place. The washing solution could be simple water or a more complex stop bath solution to better halt the action of the developer. (3) Place the plate in a fixator, a solution to give permanence to the developed image. A photographic plate that has been exposed, developed, and washed will show an image, but that image quickly fades with time. Plate fixation was introduced by John Herschel in 1839 when he proposed sodium hyposulfite (hypo or fixator) as fixating agent.

There were many nuances in photographic darkroom techniques with which Barnard was familiar and often wrote about. The composition of the developing solution, its temperature, and the development time were of critical importance. Any change in one of these factors could enhance or detract from the end result. Usually, there was a trade off in factors. If you increased the developing time or changed the solution to increase plate sensitivity, you decreased the resolution of the resulting image. It had a grainer appearance. As plates and films evolved and became more specialized for general photography and astrophotography, special developing and fixation solutions were introduced for a specific film.

Plate washing and fixation could be altered in many ways as well, though they were usually less important as long as the plate had proper fixation: "The preservation of original astronomical negatives is of vital importance. There are three things that tend to the injury or total destruction of dry plate negatives:

1. Deterioration due to the atmosphere.
2. Deterioration due to insufficient fixing in the hypo [fixator].
3. Deterioration due to insufficient washing.

The most harmful of these, and the one for which there seems to be no remedy is insufficient fixing. The want of complete washing, when detected

in time, can be remedied by rewashing, if the negative has not been varnished. The effect of atmospheric deterioration is slow. It can be prevented by varnishing the negative…The varnish also produces a hard surface which protects the negative from ordinary rubbing or scratching" (Barnard 1919a).

A developed photographic plate has a "negative" image on the plate, an image where normal black and white relationships are reversed, stars appearing black, and the sky background appearing white (Fig. 1.1, Fig. 4.1a). When such a photographic plate is "printed", the print is a "positive" image, blacks, whites, and gray shades having a normal relationship, stars white dots and the sky background black. The term *negative* denotes a negative image on a glass plate or on a sheet or roll of film.

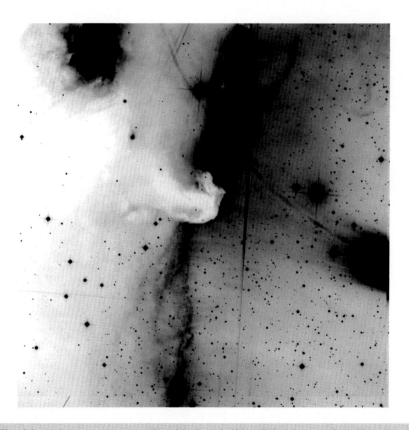

Fig. 4.1 (a) Long exposure modern black and white digital image of the Horsehead Nebula (Barnard 33, IC 434) displayed as a "negative" image with reversal of normal black and white relationships. PlaneWave CKD24 24-inch f/6.5 telescope with Finger Lakes Instrumentation Proline KAF9000 CCD at the Grasslands Observatory (http://www.GrasslandsObservatory.com). (© Tim B Hunter, 3towers, LLC, 2022. All Rights Reserved). **(b)** Same image as Fig. 4.1a but with a normal black and white display, a "positive" print. (© Tim B Hunter, 3towers, LLC, 2022. All Rights Reserved)

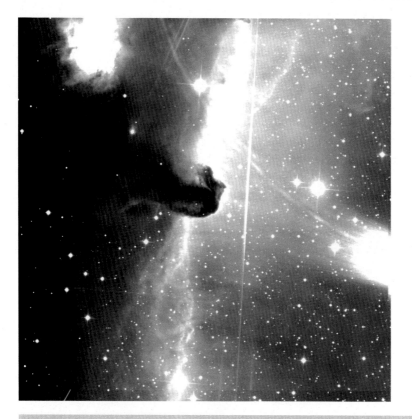

Fig. 4.1 (continued)

Photographic prints are made in the darkroom often using a print box that holds the negative in place while light from a lamp in the box shines through the negative onto another glass plate or onto a stiff sheet of paper (print paper) coated with photographic emulsion. When this second plate or print paper is developed, there is a "positive" image. An enlarger may be used instead of a print box to produce an enlarged version of the original negative image or a portion of the image. The negative to be "enlarged" and printed is placed in the enlarger's plate or film holder. Light from the enlarger's lamp shines through the negative and is projected onto the print paper for the proper length of time. It is then developed in routine fashion resulting in an enlarged positive print of the original negative.

In general, the term *print* means positive image on a sheet of stiff (photographic print) paper. Barnard often made positive plates and paper prints but was bedeviled his entire career by trying to make accurate prints from his plates for large scale reproduction in journals and books.

4 Barnard's Astrophotography – Comets and the Milky Way

Barnard was an accomplished solar eclipse photographer and traveled around the world on several eclipse expeditions, some of which were unsuccessful due to poor weather conditions. Eclipse photography came into its own by the time of the January 1, 1889, total solar eclipse visible from Northern California (Fig. 4.2). Barnard noted "This was by far the most successful eclipse, photographically, of any that had yet been observed, and forever set aside as worthless the crude and wholly unreliable free-hand sketches and drawings previously depended upon" (Barnard 1898).

Barnard was an early proponent of using photography for astronomical measurement, even though he used a filar micrometer visually his entire career measuring double stars, select stars in globular clusters, and satellites of the planets. Even so, he noted: "The Pleiades, the cluster of Perseus, Praesepe in Cancer, etc., have all been measured with the micrometer, the

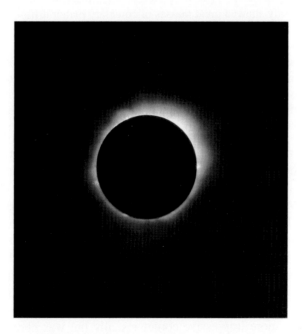

Fig. 4.2 Total solar eclipse of January 1, 1889. Lantern slide image of totality by EE Barnard from Bartlett Springs, California. This was probably taken with a 3 ¼ -inch telescope objective lens stopped down to 1.75 inches with a focal length of 49-inches adapted to a long wooden camera box with a 5 × 7-inch plate holder. A Seed No. 26 plate was used with an exposure from 1–4 seconds

heliometer and by photography. The comparisons have shown that photography has many advantages over the older methods, and the results are possibly even more accurate" (Barnard 1898).

Max Wolf, Barnard's friend and occasional rival, was noted for his photographic asteroid discoveries. "The first of these photographic discoveries of asteroids was made by Dr. Max Wolf in 1892. They are now found wholesale in this manner by photography (Barnard 1898)." While Barnard is credited in 1892 with the first photographic discovery of a comet, his comet discoveries were mainly visual, and he directed his comet photographic efforts to wide field imaging of their tails noting fascinating daily changes in the tails of many comets, phenomena often not evident or much appreciated by visual observations.

> The photographs of Brooks comet of 1893 [modern designation C/1893 U1, or 1893c] also secured with the Willard lens [at Lick Observatory], showed such an extraordinary condition of change and distortion in the tail as to suggest some outside influence, such as the probable collision of the tail with some resisting medium…The long series of photographs obtained of this comet frequently showed great masses of cometary matter drifting away into space…all of these wonderful phenomena would have been unknown to astronomers had it not been for these photographs, and the comet, instead of proving to be one of the most remarkable on record, would have passed without special notice. Though these phenomena were so conspicuously shown, scarcely any trace of the disturbance was visible with the telescope. On account of the apparent insignificance of the comet visually, no photographs were made of it elsewhere during its active period (Barnard 1898) (Fig. 4.3).

Another unremarkable comet visually but photographically stunning was Comet Morehouse [modern designation C/1908 R1 (Morehouse)] discovered by the astronomer Daniel Walter Morehouse (1876–1941) September 1, 1908. Dr. Morehouse was an accomplished professional astronomer and later became President of Drake University in Des Moines, Iowa. Comet Morehouse was unimpressive visually but had stunning daily changes in its tail with disconnection of the tail from the head of the comet (Fig. 4.4).

Barnard assiduously photographed Comet Morehouse on a nightly basis weather permitting producing a remarkable series of photographs documenting the extraordinary changes in the comet's tail. Comet Halley in 1910 was a far more impressive comet visually but was photographically less interesting than Comet Morehouse. "The quiescent condition of the [Halley] tail and its slow photographic action, may perhaps be explained by the absence of cyanogen in the tail, as shown by the spectrograms taken of the comet by Professor Frost and Mr. Parkhurst. This element was a strong characteristic of the tail of Morehouse's comet, which was one of the most

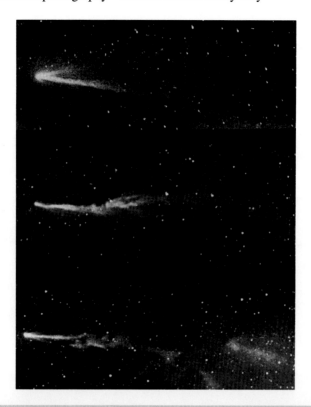

Fig. 4.3 Brooks comet of 1893 [C/1893 U1 (Brooks)] photographed by EE Barnard on October 21/23, 1893, at Lick Observatory using the Willard Lens and Crocker Astrograph

extraordinary freak comets known. Its apparent feeble light was remarkably strong photographically" (Barnard 1910).

Barnard rarely commented on what specific photographic plates he used. He never mentions making his own plates, so it is assumed he used commercial dry plates. In 1890 he notes "…the dark part of the moon, when the moon's age is 2.9 days, can be photographed with the [Lick] twelve-inch Equatorial with a Seed 26 plate in twenty-seconds-the complete outline of the dark part just showing with this exposure" (Barnard 1890).

In 1879 Miles Ainscoe Seed (1843–1902) introduced his dry plate ("Seed Dry Plate"). His commercial plates were easy to transport and quickly became popular. The M.A. Seed Dry Plate Company was incorporated in July 1883 and was purchased by Eastman Kodak in 1902. According to *The Art of Negative Making* (M.A. Seed 1890) the Seed 26x was the most extensively used plate. "For general portrait work it cannot be surpassed… The 26x plate has a wider latitude than any other portrait plate in the world.

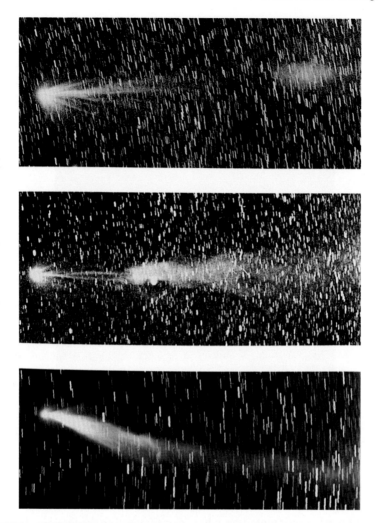

Fig. 4.4 Comet Morehouse [C/1908 R1 (Morehouse)] photographed by EE Barnard with the Yerkes Observatory Bruce Telescope on September 30–October 2, 1908, showing rapid changes in its tail

It requires ¼ more exposure than the Gilt Edge 27…" These plates were sensitive to blue, indigo, and violet and ultraviolet portions of the spectrum. "The ordinary photographic plate is not sensitive to …color…The result is, that the Red, Orange, Yellow, or Green have no action on the plate at all…" Therefore, a dim red "safety" light could be used in a darkroom to assist the photographer in developing his or her Seed Dry plates.

Barnard photographed Giacobini's comet 1905c [modern designation C/1905 X1 (Giacobini)] and Daniel's comet 1907d [modern designation C/1907 L2 (Daniel)] with Seed 27 Gilt Edge plates (Fig. 4.5a and b). He photographed Comet Morehouse and regions of Comet Halley with Lumiere

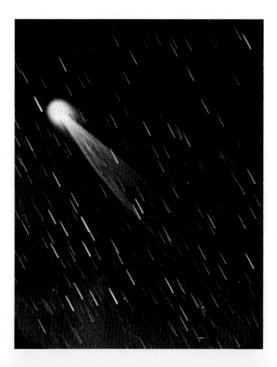

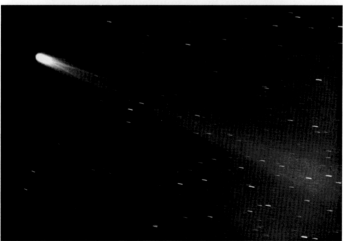

Fig. 4.5 (**a**) Giacobini's Comet of 1905 [C/1905 X1 (Giacobini)] photographed by EE Barnard sometime December 29, 1905, using the Yerkes Observatory Bruce Telescope, 2-hour 38-minute exposure. (**b**) Daniel's Comet [C/1907 L2 (Daniel)] photographed by Barnard with the Yerkes Bruce Telescope on August 8, 1907

Sigma plates. Lumiere plates were manufactured by the Lumiere brothers August and Louis, though they are more well known for introducing in 1895 the first projection system allowing a motion picture to be viewed by more than one person at a time. They also introduced Autochrome Lumiere in 1907, the first commercially successful color photographic process.

Gustav Cramer (1838–1914) began manufacturing dry plates around 1880 and with his three sons incorporated in 1898 as G. Cramer Dry Plate Company, St. Louis. The Cramer Lightening Plate was also used by Barnard. All these plates were sensitive in the blue portion of the spectrum and were insensitive to the green, yellow, and red portions of the visible spectrum. Thus, a comet that was visually spectacular usually had a prominent "dust tail" which is mostly yellow and red. An unusually prominent "ion tail" looks green or blue as it emits light mainly in the blue and green portions of the spectrum. If the dust tail were not very spectacular, and the ion tail was particularly intense in the "actinic" (blue/ultraviolet) portion of the spectrum, it would photograph well like Comet Morehouse but be a dud visually as noted by Barnard.

Comet Halley showed no cyanogen in its tail, while it was prominent in Comet Morehouse. Cyanogen chemically is $(CN)_2$, a toxic, colorless gas at room temperature. When prominent in the ion tail in comets, it emits light in the near ultraviolet portion of the spectrum to which the photographic plates used by Barnard were sensitive.

The brightest and most interesting comets are best seen in twilight since they become most active when they are close to the Sun. Concerning twilight photography Barnard wrote: "Serious injury to, or total loss of, important comet plates may occur by beginning the exposure too early in the evening or prolonging it too late in the morning. Such plates, which cannot be properly developed, would otherwise, with a few minutes less exposure, have made satisfactory negatives…The safest plan would be not to begin or continue the exposure while there is any sky illumination. This is seldom practicable, however, in the case of a bright comet which is never very far from the sunset or sunrise points…On account of its greater sensitiveness the Lumiere Sigma plate is recommended [for comet photography]. Unfortunately this plate has been rather frequently defective in having small round transparent and opaque spots. It is also more subject to 'chemical fog' than the Cramer or Seed. Otherwise it is a beautiful and very rapid plate. When the comet is brightest I would recommend Seed 27 Gilt Edge plates on account of their general freedom from defects and finer grain…The focus of the lens should be carefully determined. This is done by the aid of star trails and does not require that the camera be mounted…A 'dew cap' some

eight of ten inches long (not long enough to cut off any of the field) will be valuable not only in case of dew forming, but also to cut off outside sky illumination which would otherwise tend to fog the plate" (Barnard 1909).

Barnard's classic *magnum opus* on comet photography was his 1913 Lick Observatory publication *Photographs of the Milky Way and Comets* (Barnard 1913a, b). This remarkable treatise summarizes Barnard's best photographic work at Lick Observatory from 1892 to 1895. It took many years to publish it as Barnard was always dissatisfied with how his plates looked when printed for publication. This agonizing effort is wonderfully described by Sheehan (1995) in his magnificent biography of Barnard.

Barnard's 1913 comet publication contained considerable description of his telescopic instruments (the six-inch Willard Lens and Crocker Telescope) and his photographic techniques. In the publication he presented one plate with four photographs of the Moon under different conditions, including the total lunar eclipse of September 3, 1895. Another plate showed the total eclipse of the Sun of January 1, 1889. The real substance of the publication were 88 plates demonstrating Barnard's skill in photographing star clouds, bright and dark nebulae associated with the Milky. Thirty-nine plates show Barnard's remarkable wide field comet photography with detailed comments on comet morphology and comet photography.

5 Barnard and Dark Nebulae

Barnard devoted much of his professional effort toward photographing, cataloging, and trying to understand what we now call dark nebulae. These are discussed in depth in his 1913 Lick publication and in his seminal 1919 publication in the *Astrophysical Journal (APJ)* "On the dark markings of the sky with a catalogue of 182 such subjects."

Barnard's thinking about the nature of dark nebulae evolved over his career from viewing them as holes in the sky where no stars existed to their representing obscuring matter blocking out the light from more distant stars. He (along with Max Wolf) is credited for introducing this concept to the professional astronomical community through his visual and photographic observations and publications. Barnard wrote in a 1913 *Astrophysical Journal* article: "The so-called "black holes" in the Milky Way are of very great interest. Some of them are so definite that, possibly, they suggest not vacancies, but rather some kind of obscuring body lying in the Milky Way, or between us and it, which cuts out the light from the stars. This explanation seems to become more and more plausible the more we know of these objects."

In a 1916 article in the *Journal of the Royal Astronomical Society of Canada* Barnard further noted: "I have shown that in certain cases a nebula may be opaque, or partly so. This is strikingly evident in the case of the great nebula about ν Scorpii and the one about ρ Ophiuchi (see Fig. 7.5a and b)...In the case of the first of these nebulae it was shown that parts of it seemed to transmit the light of the stars behind it, and other parts-especially the darker or more obscure portions-seemed to cut out the light of the stars entirely (Fig. 4.6). That they are due to the interposition of masses of dark nebulosity seems more than probable, especially as long-exposure photographs frequently show feeble traces of nebulosity in these starless spots... All that is needed to make these dark bodies visible is a luminous region behind them...An excellent example of how such a thing may be possible is shown by a phenomenon that presented itself to me one beautiful transparent moonless night in the summer of 1913, while I was photographing the southern Milky Way with a Bruce telescope. I was struck with the presence of a group of tiny cumulus clouds scattered over rich star-clouds of Sagittarius. They were remarkable for their smallness and definite outlines-some not being larger than the moon. Against the bright background they appeared as conspicuous and black as drops of ink. They were in every way like the black spots shown on photographs of the Milky Way, some of which I was at that moment photographing. One could not resist the impression that many of the black spots in the Milky Way are due to a cause similar to that of the small black clouds mentioned above-that is, to more or less opaque masses between us and the Milky Way."

Barnard was not the first to observe dark areas or to suggest dark regions in the sky are obscuring matter. William Herschel (1738–1822) noted in a 1785 publication an unusual vacant space in Scorpius which was later felt by many writers to be the same as the "ink spot" observed by Barnard and now known as Barnard 86. However, others feel the complex nebulous region around Rho Ophiuchus near M80 and now known as Barnard 42 represents the dark area noted by Herschel (Steinicke 2016) (Fig. 7.5a and b). In his 2016 paper Steinicke lists in Table 4 "Herschel Catalogue of Dark Nebulae" 17 vacant spaces located near or in the Milky Way observed by Herschel which can be identified in modern catalogs (Barnard and Lynds).

In general, Herschel felt these vacant areas were true voids in stellar distribution, though he did wonder if there may be some areas of obscuring matter that changed the color of fainter, more distant stars which he found to be generally red, presumably due to other colors being absorbed or diverted by matter in space. In 1847 William Struve (1793–1864) speculated there is absorbing material in space. Jacobus Kapteyn (1851–1922) worried that interstellar absorption of starlight would complicate his efforts

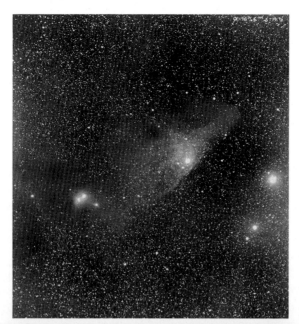

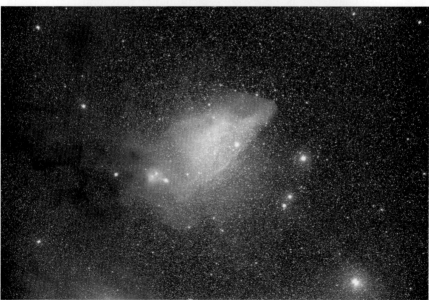

Fig. 4.6 (**a**) Plate 12 Region of Nu Scorpii from Barnard EE *A Photographic Atlas of Selected Regions of the Milky Way* edited by Edwin B Frost and Mary R Calvert, reprinted under the direction of Gerald Orin Dobek, 2011, Cambridge University Press, Cambridge, UK. (**b**) 200 mm f/2 telephoto lens image by James E McGaha and Tim Hunter with Canon EOS modified camera, ISO 1600, nine 180-second exposures median combined obtained to resemble Plate 12 Region of Nu Scorpii from Barnard EE *A Photographic Atlas of Selected Regions of the Milky Way* edited by Edwin B Frost and Mary R Calvert, reprinted under the direction of Gerald Orin Dobek, 2011, Cambridge University Press, Cambridge, UK. (© Tim B Hunter, 3towers, LLC, 2022. All Rights Reserved)

for accurate determination of stellar brightness and his effort to characterize the structure of the Milky Way (Belkora 2003).

Barnard in his 1919 *Astrophysical Journal* article cataloging 182 dark objects concluded: "I do not think it is necessary to urge the fact that there are obscuring masses of matter in space. This has been quite definitely proved in my former papers on this subject...I did not at first believe in these dark obscuring masses...The increase of evidence, however, from my own photographs convinced me later, especially after investigating some of them visually, that many of these markings were not simply due to an actual want of stars, but were really obscuring bodies nearer to us than the distant stars. In this way it has fallen to my lot to prove this fact. I think there is sufficient proof now to make this certain...Among the first to look upon these dark places as real matter was Mr. A. C. Ranyard [1845–1894]...For some time I have hoped to make a catalogue of the dark markings shown on my photographs of the sky...With this idea in view I have collected a number of these objects shown on my negatives to form the following catalogue...This catalogue is necessarily incomplete; it is constantly being added to. Later, a more complete list will be printed."

Barnard's 1919 article was his formal introduction of the Barnard Objects and his famous catalog of these dark markings. Barnard planned further publication of this work, but his health had deteriorated so that he was not able to update the catalogue and publish it in a more completed and expanded form.

Frost and Calvert reprinted Barnard's 1919 list in the *1927 Photographic Atlas* and included a second list which Barnard had started before his death. The positions of the dark nebulae for this second catalogue were determined by Mary Calvert, and this list was begun with #201 and ending at #370. Thus, there are no Barnard Objects having numbers from 176 to 200. These "missing" Barnard Objects are the subject of Chap. 8.

Frost and Calvert omitted #s 52, 131a, and 172 from Barnard's original list feeling they had been mistakenly listed by Barnard twice. However, Dobek in his *2011 Photographic Atlas* added these objects back stating: "This omission may have been in error." The fields in which these objects are situated are some of the most crowded in the sky. It would have been easy for Barnard to have mistakenly duplicated a listing; or, just as easily, Frost and Calvert could have mistakenly overlooked objects which Barnard had correctly listed. Dobek favors the latter interpretation, which we will use here. Thus, Barnard's published catalogue consists of 352 dark objects.

By the time of Barnard's death, it was generally accepted the dark nebulae he studied in the Milky Way were concentrated regions of obscuring matter probably consisting of gases, ices, and dust. What was in question was whether there was a more generalized distribution of lesser concentra-

tions of obscuring matter in the Milky Way. Robert J Trumpler (1886–1956) noted the brightness of more distant open clusters was less than expected and showed this extinction of light was most probably due to interstellar dust throughout the Milky Way. This is now an accepted concept.

It is also well known that dark nebulous regions are quite common in many galaxies, being especially evident in those spiral galaxies we view edge on (Fig. 4.7). Barnard even noted this phenomenon in his 1916 article in the *Journal of the Royal Astronomical Society of Canada*, though it was not appreciated at the time such island universes existed beyond our own Milky Way. He stated: "Another beautiful example of this kind is shown in photographs of the very elongated nebula 24 Comae (N.G.C. 4565), which seems to be an object similar to the great nebula of Andromeda, with its edge toward us, where the darker outer periphery of the nebula is seen cutting across the brighter central region as a black irregular streak."

Fig. 4.7 NGC 4565 a large spiral galaxy viewed along its orbital plane (edge on). Note the complex lanes of dark material running through the galaxy. These are similar to the dark lanes found in the Milky Way. PlaneWave CKD24 24-inch f/6.5 telescope with Finger Lakes Instrumentation Proline KAF9000 CCD and Cousins-Johnson B, V, R filter images coupled with luminous images to produce a final color image. (© Tim B Hunter, 3towers, LLC, 2022. All Rights Reserved)

6 Barnard's Star

Occasionally, Barnard used a blink comparator to investigate plates taken of the same region at different times, sometimes several years apart. Scanning of plates in this manner had been used by astronomers for many years to look for variable stars, asteroids, comets, novae, and other transient phenomena. When Barnard compared a plate taken in May 1916 at Yerkes Observatory with one of the same fields taken with the "Willard" lens in August 1894 at Lick Observatory, he discovered a star in Ophiuchus with a proper motion of 10.3 arcseconds per year, the fastest motion for any star known (Frost 1923). Subsequent investigation of the star by Barnard and others at Yerkes Observatory and elsewhere showed the star was 6.1 light years away, the nearest star after the Alpha Centauri system. This star is now known as Barnard's star.

7 Honors and Awards

Barnard's Star, Barnard's Loop, Barnard's Galaxy (NGC6822), and his Barnard Objects are the most well-known subjects named for Barnard. In addition, there is Barnard a lunar crater on the eastern limb of the Moon and Barnard a Martian crater, several comets are named after him, and there is asteroid 819 Barnardiana discovered in 1916 by his friend Max Wolf. Vanderbilt University Barnard Hall is named after Barnard. There are several university Barnard Halls, most of which were named after other Barnards not EE Barnard. The Barnard Astronomical Society of Chattanooga, Tennessee founded in 1923 is named after EE Barnard as is Mount Barnard in California. Mount Barnard has an elevation of 13,990 feet (4264 meters) and is located on the Sierra Crest in both Sequoia National Park and the John Muir Wilderness. It was first ascended by WL Hunter, John Hunter, William Hunter, and C Mulholland on September 25, 1892, who named the peak in honor of Barnard.

Barnard was quite famous during his lifetime first receiving widespread attention when he discovered Amalthea, the fifth moon of Jupiter in 1892. Surprisingly, he never formally suggested a name for the moon, and its name was put forth by Camille Flammarion (1842–1925), though not formally adopted by the International Astronomical Union (IAU) until 1976. Barnard received several important awards during his lifetime, including the Catherine Wolfe Bruce Gold Metal in 1917, the Lalande Prize of the French Academy of Sciences in 1892 (along with his friend Max Wolf), the Gold

Medal of the Royal Astronomical Society in 1897, and the Prix Jules Janssen, the highest award of the Societe astronomique de France, in 1906. He was made a member of the American Philosophical Society in 1903, and he became an Associate Fellow of the American Academy of Arts and Sciences in 1892.

Though Barnard never had much formal schooling, he did complete most of a bachelor's degree at Vanderbilt University, and he was awarded an honorary Master of Arts Degree from the University of the Pacific in 1890. In addition, he was awarded an honorary Doctor of Science Degree from Vanderbilt University in 1893, the only one the university has ever awarded. He also received a Doctor of Laws degree from Queen's University in Kingston, Ontario.

8 Astronomical Glass Plate Collections

Barnard exposed at least 4000 glass plates during his career, most of which are unavailable for study and are de facto unusable as they have not been digitized and are hidden away in storage. Many professional observatories have large glass plate collections, some with plates well over 100 years old. The Harvard College Observatory plate collection contains more than 500,000 plates, and Lowell Observatory has a collection of over 50,000 glass plates. The Lick Observatory photographic plate collection contains about 150,000 plates, having among other things Barnard's Milky Way and comet plates, Keeler's Crossley plates of spiral nebulae, ES Holden's moon plates, David Todd's 1882 transit of Venus plates, and eclipse coronas plates (Lick 2021).

One estimate is there are over seven million astronomical photographic plates worldwide, only a small fraction of which have been digitized and made available for study (Levine 2021). Most are stored in less-than-ideal conditions, often in rotting boxes stacked irregularly in a basement or warehouse facility. Even worse, there may be no good records as to which plates are stored where. The logbooks for the plates are often housed in a similarly haphazard fashion.

There is a growing urgency to digitize as many of these photographic plates as possible and make them available digitally for scientific study by the wider astronomical community. The original photographic plates are fragile and degrade with time. The glass plates may be as thin as 1/16th inch even for plates as large as 14-inches square (Levine 2021). The emulsions on the plates are easily scratched and susceptible to damage from moisture, mold, and separation from the glass as noted by Barnard in 1919. Plates

stored in envelopes often have deposits on the plates, and the associated logs were often on acidic paper that is degrading.

These plates and their records are a lost legacy that ought to be preserved (Schaefer 2003). They provide a unique window into the sky at the time they were exposed and can help to extend our view of the sky back more than 100 years beyond digital images. It is not unusual for such plates to hold pre-discovery observations of solar system bodies, such as Pluto, many comets, and asteroids. Previously unknown novae and supernovae also turn up on old plates. Barnard's star is a prime example of a pre-discovery stellar observation on an older photographic plate.

There is widespread understanding in the astronomical community about the value of their glass plate collections and the necessity for digitizing and organizing as many plates as feasible. Much effort is now being devoted to this task which is quite expensive and time consuming. Funds are being raised to implement digitization of glass plate collections at many observatories, and many persons have freely volunteered considerable time and expertise in these efforts. Not only should the plates be properly digitized and be made available to the wider community, but associated logbooks and other notes should also be properly cataloged and digitized. Additionally, it would be ideal for the original plates to be stored in an organized, safe fashion in a modern facility.

The Maria Mitchell Observatory (MMO) astronomical plate collection totals 8000+ photographic plates obtained with its 7.5-inch Cooke/Clark refractor during 8 decades of research. The digitized files are available for scientific research on request (Maria Mitchell Association 2021; Schaefer 2003).

Lowell Observatory has a long-term program to digitize the Lowell plate collection using commercial flatbed scanners. The scanners can give a spatial resolution of 5–10 microns with 12 to 15 bits of photometric depth. The digital data will be made available over the World Wide Web. Lowell Observatory recently completed a modern archival storage facility to ensure the long-term survival of the original plates (Levine 2021).

Harvard University has the Digital Access to a Sky Century @ Harvard (DASCH) project to scan most of its 500,000 glass plate negatives, producing full photometry results for the entire sky (Harvard 2021). These plates span the range between the 1880's to the 1990's.

The Mount Wilson Archive contains greater than 150,000 images of the Sun acquired over more than 100 years. The glass and acetate negatives are stored in Pasadena, CA, at the offices of the Observatories of the Carnegie Institution of Washington. Much of this data is available online (Mount Wilson Archive 2021). There are also an estimated 250,000 glass photo-

graphic plates of the night sky stored in the Mount Wilson plate vault. Unfortunately, most have not been digitized, but individual plates can be retrieved and examined for special projects.

In 2008 many of Yerkes Observatory records were transferred from the observatory at Williams Bay, WI, to the Special Collections Research Center of the University of Chicago. More than 2000 photographs (glass plate negatives, lantern slides, and prints) have been digitized and are available online at http://photoarchive.lib.uchicago.edu/. There are still 175,000 astronomical glass plates at Yerkes Observatory. These images were taken over a period of 120 years. While this collection contains Barnard's work at Yerkes, most of the plates in the collection were taken with the 24-inch Ritchey reflector at Yerkes starting in 1901 or at the McDonald Observatory in western Texas. The University of Chicago Library is partnering with the Department of Astronomy and Astrophysics to determine how to best scan these plates (University of Chicago Library 2021; Dickinson 2021).

The National Geographic Society – Palomar Sky Survey (NGS-POSS) was completed by the end of 1958. It is also called the First Palomar Sky Survey (POSS I). 936 pairs of photographic plates were taken using the 48-inch (1.22 m) aperture Oschin Schmidt Telescope at Mount Palomar Observatory in southern California. The survey used 14-inch square photographic plates that covered about 6 degrees of the sky per side. Each region was photographed twice, once using Kodak 103a-E plates which are red sensitive, and once with Kodak 103a-O plates which are blue sensitive. The survey extended from the north celestial pole to approximately −30-degrees south declination.

A Southern Sky Survey was carried out by the United Kingdom Schmidt Telescope (UKST) at Siding Springs Observatory in Australia. This telescope is similar to the Palomar Oschin Schmidt Telescope and carried out its photographic plate survey of the southern sky from the early 1970's to after 2000. In the early 1980's the 48-inch (1.22 m) aperture Palomar Oschin Schmidt Telescope was upgraded allowing it to carry out a Second Sky Survey (POSS II) which was completed in 2000. It consisted of 897 fields from the north celestial pole to the equator and complemented the Southern Sky Survey. The Southern Sky Survey and POSS II had improved image quality relative to POSS-I and used three different spectroscopic Kodak plates – blue (llla-J, most sensitive at 480 nm), red (llla-F, most sensitive at 650 nm), and near infrared (IVN, most sensitive at 850 nm). The Palomar Digital Sky Survey (DPOSS) is based on the digitization of POSS II which was done at the Space Telescope Science Institute (STScI) and then calibrated and catalogued by the DPOSS team (DPOSS 2021). These images and other digitized images are available online at the STScI Digitized Sky Survey site (STScI 2021).

The German Astrophysical Virtual Observatory (GAVO) is a service of the Center for Astronomy of Heidelberg University. GAVO has an extensive collection of data available for downloading including astronomical logbooks and astronomical plates which include: "Scans of plates kept at Landessternwarte Heidelberg-Königstuhl. They were obtained at location, at the German-Spanish Astronomical Center (Calar Alto Observatory), Spain, and at La Silla, Chile. The plates cover a time span between 1880 and 1999. Specifically, HDAP [Heidelberg Digitized Astronomical Plates] is essentially complete for the plates taken with the Bruce telescope, the Walz reflector, and Wolf's Doppelastrograph at both the original location in Heidelberg and its later home on Königstuhl." (GAVO).

Other German astronomical observatories also have extensive glass plate collections. According to Archives of Photographic Plates for Astronomical USE (APPLAUSE): "There are about 850,000 plates in the archives of Hamburger Sternwarte, Dr. Karl Remeis-Sternwarte Bamberg, and Leibniz-Institut für Astrophysik Potsdam (AIP). The plates are digitized with high-resolution flatbed scanners. In addition, the corresponding plate envelopes and observation logbooks are digitized, and further metadata are entered into the database" (APPLAUSE 2021). This work is available online and is funded by the German government. Hopefully, more funding of this type will become available to more observatories around the world. It would be ideal for all the photographic plates taken by major observatories since the 1880's be digitized and available through the internet.

References and General Bibliography

APPLAUSE. Archives of Photographic Plates for Astronomical USE. 2021: https://www.plate-archive.org/applause/.

Barnard EE. Note on photographing the dark part of the moon. Publ Astron Soc Pac. 1890;2:138.

Barnard EE. The Bruce photographic telescope of the Yerkes Observatory. Astrophys J. 1905;21:35–48.

Barnard EE. Some of the results of astronomical photography pertaining specially to work with a portrait lens. Pop Astron. 1908;16:286–98.

Barnard EE. Suggestions in respect to photographing comets with special reference to Halley's comet Pop Astron December 1909; 17 (10): 597–609.

Barnard EE. Photographic observations of Halley's comet. Pop Astron. 1910;18(6):321–3.

Barnard EE. Photographs of the milky way and comets. Publ Lick Observatory. 1913a;11

Barnard EE. Dark regions in the sky suggesting an obscuration of light. Astrophys J. 1913b;38:496–501.

Barnard EE. Some of the dark markings of the sky and what they suggest. JRASC. 1916;10:241–9.

Barnard EE. On the varnishing of astronomical negative. Pop Astron. 1919a;27:487–8.

Barnard EE. On the dark markings of the sky with a catalogue of 182 such objects. Astrophys J. 1919b;49:1–23.

Barnard EE. A Photographic Atlas of Selected Regions of the Milky Way. In: Edwin B Frost, Mary R Calvert, editors, reprinted under the direction of Gerald Orin Dobek. Cambridge: Cambridge University Press; 2011.

Mount Barnard: Mount Barnard : Climbing, Hiking & Mountaineering : SummitPost.

Barnard EE. The development of photography in astronomy. Pop Astron. 1898;6(#8):425–55.

Belkora L. Minding the Heavens. The story of our discovery of the milky way. Philadelphia\Bristol: Institute of Physics Publishing; 2003.

Dickinson D. Universe today. Low-cost approach to scanning historic glass plates yields an astronomical surprise (January 25, 2021.): https://www.universetoday.com/149644/low-cost-approach-to-scanning-historic-glass-plates-yields-an-astronomical-surprise/.

Frost EB. Edward Emerson Barnard. Astrophys J. 1923;LVIII(#1):1–35.

German Astronomical Virtual Observatory (GAVO). Full plate access to Heidelberg Digitized Astronomical Plates (uni-heidelberg.de).

Harvard University. Astronomical photographic plate collection; 2021. DASCH Project: https://platestacks.cfa.harvard.edu/dasch-project.

Levine S. Digitizing the Lowell plate collection. Lowell Obs. 2021;123(#3):4–5.

Lick Observatory. The lick observatory historical collections; 2021. http://collections.ucolick.org/archives_on_line/about.html.

M.A. Seed Dry Plate Co. St. Louis. The art of negative making. Circa; 1890.

Maria Mitchell Association. 2021. https://www.mariamitchell.org/astronomical-plates-collection.

New York Public Library. An introduction to photographic processes. https://www.nypl.org/collections/nypl-recommendations/guides/photographic-processes.

Palomar Digital Sky Survey (DPOSS). 2021: https://sites.astro.caltech.edu/~george/dposs/dposs_pop.html.

Schaefer BE. Old Astrophotos: Averting a lost legacy. Sky Telescope. 2003;105:42–6.

Sheehan W. The immortal fire within: the life and work of Edward Emerson Barnard. Cambridge University Press; 1995. ISBN 0 521 44489 6

Sloan Digital Sky Survey/Sky Server. The Palomar Observatory Sky Survey (sdss.org).

Steinicke W. William Herschel's 'hole in the sky' and the discovery of dark nebulae. J Astron Hist Herit. 2016;19(3):305–26.

STScI Digitized Sky Survey. 2021: https://archive.stsci.edu/cgi-bin/dss_form.

The Mount Wilson Archive. Mt. Wilson solar photographic archive digitization project. 2021. https://www.astro.ucla.edu/~ulrich/MW_SPADP/index.html.

University of Chicago Library. Mining historical glass slides for astronomical data. 2021. https://www.lib.uchicago.edu/about/news/mining-historical-glass-slides-for-astronomical-data/.

Chapter 5

Visual Observation of the Barnard Objects

1 Introduction

Dark nebulae can be challenging to observe. Instead of seeing something brighter than the dark sky background, you are looking for something dark, usually only visible as it contrasts with a brighter background star field or a bright nebulous region. Visually, many dark nebulae look like holes in the sky. They are not visible unless the Milky Way itself is easily visible which means you must have a clear, transparent sky, free from much light pollution, and without the Moon being present (Banard 2011). One good way to judge your sky quality regarding darkness and light pollution is the Bortle Scale (Table 5.1) (Bortle 2008).

Many observers use a sky quality meter (SQM) to judge the darkness of the sky. These come in various designs (Unihedron 2022). In the simplest case, one points a small handheld meter at the zenith avoiding the Milky Way, press a button for a few seconds to take a reading, and then note the sky brightness reading on the SQM screen. Astronomers generally judge the brightness of the background sky using a unit of *magnitude per square arc-second* which is a measurement of surface brightness (Flanders 2017). Table 5.1 presents a simplified overview of the Bortle Scale, and Table 5.2 gives an overview of sky brightness as measured by an SQM.

The original version of the chapter has been revised. A correction to this chapter can be found at https://doi.org/10.1007/978-3-031-31485-8_10

Table 5.1 The bortle dark-sky scale[a]

Class 1: Excellent dark-sky site

Naked eye limiting magnitude is 7.6–8.0. The zodiacal light, gegenschein, and zodiacal band are all visible. The zodiacal band spans the entire sky. M33 is an obvious naked eye object with direct vision. The brightest regions of the Milky Way cast shadows. Airglow is readily evident. Such skies are quite rare, most often in remote locations.

Class 2: Typical truly dark site

Airglow weakly apparent along the horizon. M33 evident with direct vision. The summer Milky Way is bright and quite structured. Zodiacal light casts weak shadows with a distinct yellow color. Small Barnard clouds are visible as dark holes in the starry background.

Class 3: Rural sky

Some light pollution is evident along the horizon. Clouds along the horizon are illuminated but may appear dark overhead. The Milky Way still appears bright and very complex. M33 can be seen with averted vision. Zodiacal light remains bright in spring and autumn.

Class 4: Rural/suburban transition

Winter Milky Way is still visible but not dramatic. Fairly obvious light pollution domes are evident in several directions. Zodiacal light is still evident but does not extend halfway up to the zenith. M33 visible with averted vision if higher than 50-degree altitude. Milky Way still impressive at high altitude above the horizon. Naked eye limiting magnitude is 6–6.5.

Class 5: Suburban sky

Only hints of zodiacal light can be seen on the best spring and autumn nights. The Milky Way is weak near the horizon and even looks washed out overhead. Lights are visible in many directions. Over most of the sky clouds are brighter than the sky itself. The naked eye limiting magnitude is 5.6–6,0.

Class 6: Bright suburban sky

Zodiacal light not visible. Milky Way can only be glimpsed toward the zenith. The sky near the horizon is grayish white from light pollution. Clouds in the sky are bright. M31 is only moderately apparent to the naked eye. Binoculars are needed to see M33. Naked-eye limit is about 5.5.

Class 7: Suburban/urban transition

Entire sky has a vague grayish white hue with bright light sources visible in all directions. The Milky Way is not visible. M44 or M31 may be seen with unaided eye with effort. Even moderated sized telescopes show the brightest Messier Objects as pale ghosts of their true selves.

Class 8: City sky

The sky glow is orange, and you can read newspaper headlines without trouble. Only the brightest Messier Objects are detectable with a modest-size telescope. Some of the fainter constellations are difficult to discern.

(continued)

Table 5.1 (continued)

Class 9: Inner city

The sky is brightly lit. Many familiar constellations are difficult to discern. Dim constellations such as Cancer or Pisces are not visible. The only celestial objects that provide pleasing telescopic views are the Moon, planets, double stars, and brighter star clusters.

[a]Adapted and simplified from Bortle (2008). It should be noted that naked eye limiting magnitude is dependent on one's visual acuity and atmospheric seeing can be important for telescopic observations. A site with excellent seeing may give better photographic and visual results than a somewhat darker site with poor seeing

Table 5.2 Sky Quality Meter (SQM) readings versus sky brightness[a]

17.0	Bright urban sky
18.0	Good urban sky, poor suburban sky
19.0	Fairly good suburban sky
20.0	Very good suburban sky
21.0	Typical rural sky
22.0	Ideal dark-sky site
Full Moon	18.0 – in otherwise dark sky
Half Moon	20.5 – in otherwise dark sky
Measured or estimated sky darkness at major observatories[b]	
Mount Wilson observatory	19.8
Palomar Mountain	21.5
Mount Lemmon (near Tucson, AZ)	21.5
Lowell Observatory (Mars Hill)	20.5
Van Vleck Observatory (Connecticut)	18.5
David Dunlap Observatory (Toronto)	18.4
Haute Provence (Southern France)	21.8
Siding Springs observatory	21.9+

[a]Adapted from Flanders (2017). Units are magnitude per square arcsecond
[b]Work by Brian Skiff as presented by Lodriguss (2022)

If you plan to observe dark nebulae without any visual electronic enhancement (image intensifier, CCD or CMOS video camera and projector), you must be fully dark adapted prior to looking for most dark nebulae. The darkness of the sky obviously determines one's visual limiting magnitude with naked eye, binocular, or telescope observing. However, one's age, health, and visual acuity also affect limiting magnitude.

Seeing is sometimes a very important factor for observing. Good seeing is obviously necessary for observing the Moon, planets, and double stars, but it is unappreciated as being an important factor for deep sky observing.

It may well be that a site with excellent seeing can give better visual observing of deep sky objects (non-stellar objects like galaxies, clusters, and nebulae) than a somewhat darker site with poor seeing. Likewise, the quality of one's optical devices also is a factor on how well you can observe faint, challenging objects. Persistence always helps. "The standard observing rule is if you think you see the object at least <u>three times</u>, then you probably Really Did See It…" (Mitchell 2018).

1.1 Sky Darkness and the Contrast Illusion

It is not known if there is a direct relationship between the stellar limiting magnitude for a given night and site and the limiting magnitude for faint extended deep sky objects. Some persons have the experience of being able to see very faint stars on a given evening but not seeing deep sky objects as well as might be expected. This may represent the effects of seeing as noted above. A night with good transparency (darkness) may suffer from poor seeing, and small faint objects are so blurred that they blend into the background and become invisible. A site with steady seeing may allow better visualization of faint objects than one that is intrinsically better (higher altitude and less light pollution) but with poorer seeing (Grasslands Observatory website n.d.; Hunter & McGaha n.d.)

Pilots are taught that one's dark adaptation begins to fall off above 5000-foot altitude. Yet, skies should grow darker with increasing altitude, since there is less absorption of starlight by the atmosphere and less atmosphere to scatter light pollution. What is the ideal altitude for visual observing without supplemental oxygen? It may be as low as 7000 feet. No doubt the skies grow darker with increasing altitude, but your ability to perceive fainter objects may be significantly diminished by relative oxygen deprivation to your brain and retina. This varies from person to person, depending on one's age, general state of health, specific health of your eyes, and one's experience (Flanders 2017).

One factor not to use in estimating sky darkness is how "black" the sky appears. A pitch-black sky does not translate into a dark sky. In fact, the darkest skies often have a faint greenish background from airglow. Our own observatory lies at a very dark site at 5000-foot altitude (Grasslands Observatory: http://www.GrasslandsObservatory.com). When we arrive at the observatory after dark for an evening's observing, the sky seems inky black with the Milky Way boldly standing out. However, a couple hours later when we are thoroughly dark adapted, the sky has a faint greenish glow. The Milky Way blends imperceptibly with the rest of the sky. The Gengenschein is discernible, and our visual stellar limiting magnitudes are higher, yet the sky does not seem as dark.

What is taking place is the Contrast Effect or Contrast Illusion. When you are not dark adapted, your pupil is more contracted, and your eye/brain

system perceives more contrast. This is easy to demonstrate. Notice how difficult it is to walk into a movie theater after the lights have been turned off and the film started. The screen is brilliant, almost blinding you; you cannot see the aisle to find your seat. After a few minutes, the screen is no longer painful to look at, and you can easily look around the theater and recognize friends a few rows away.

Try an experiment. When you are at a dark site and ready to quit observing, notice how much contrast the Milky Way has and how the sky may have a slight greenish or reddish glow. Now walk over and open your car door and flood the area with some white light. Notice how the sky background immediately turns black, and the Milky Way suddenly stands out against the black sky. You obviously can't be seeing as faint, but the sky seems darker. In a similar fashion, notice how black the sky seems when you are driving along and looking at constellations through the car window.

These examples show the Contrast Illusion at work. To avoid the insidious nature of this effect, you must be very careful in describing a dark sky. To prove one site is darker than another, you must objectively compare the two by carefully observing selected objects and judging them on reproducible criteria, such as the faintest stars visible with the naked eye or the quality of viewing selected dark sky objects, like dark nebulae, from one site compared to the other. Realize conditions change from night to night and choosing between sites may take some nights of observing prior to your understanding the relative merits of each site. Also, convenience often trumps quality. A moderate quality site, like your backyard used frequently, is much more useful than a first-class site used rarely.

1.2 Opacity

Barnard never assigned a darkness scale or "opacity" to his objects. He only commented indirectly on their relative darkness compared to the background sky or other nearby dark objects. Lynds in describing her catalog of dark nebulae introduced the term "opacity" for dark nebular regions. This was based on their photographic appearance, though the same concept can be roughly applied to visual observing. Her opacity scale is 1–6 with 6 being the darkest (Lynds 1962). It has been generally accepted and used by all those observing, photographing, or writing about dark nebulae.

If there is a bright starry background like in the center of the Milky Way or strong emission nebular background like in M8 the Lagoon Nebula, small dark areas are easily discernible with high opacity of 5 or 6. If there is a faint background, even a very dark nebular region may not be very distinguishable and only have an opacity of 1 or 2.

1.3 Observing Barnard Objects

To observe most Barnard Objects, your sky should be reasonably dark, probably at least 20.0 to 20.5 magnitude per square arcsecond. Many of the personal observations described in this chapter and most of the images in this book were made at the Grasslands Observatory in southeast Arizona (http://www.GrasslandsObservatory.com). This is a Class 2 or Class 3 Bortle site with SQM readings averaging 21.5 magnitude per square arcsecond. It is difficult to set hard and fast rules for any type of observing. Determination, experience, and perseverance sometimes count more than equipment quality or sky quality so give dark nebulae observing a try. There are multiple observing books, articles, and websites devoted to deep sky objects. Some of these are listed in the References Section at the end of the chapter. Those by Cooke, Higgins, King, Machin, McHenry, Mitchell, and Wilds are especially focused on observing dark nebulae (Cooke 2012; Higgins 1987; King 2015; King 2016; Machin, n.d.; McHenry, n.d.; Whitman 2006; Wilds 2017).

The brightest and largest dark nebulae can be seen with the naked eye or binoculars, but they all require a good dark sky and dark adaptation. A rich field telescope, such as a 6-inch f/4 Newtonian reflector or a 4-inch f/6 refractor, with wide-angle long focal length eyepieces will give marvelous views of the Milky Way star clusters, bright nebulae, and large dark nebulae. Many of the more popular Barnard Objects and other dark nebulae are withing the range of a rich field telescope or an 8–10-inch telescope for the moderately faint objects.

The smallest and faintest objects are particularly challenging and are best viewed with moderate to large telescopes in the 12–20-inch range or larger. One interesting suggestion is to observe with a range of powers as it is unpredictable what eyepiece telescope combination will be best for a given object (Cooke 2012). This also holds true for the use of a nebular filter or a light pollution reducing filter. Filters increase contrast but dim an image. It is unpredictable as to how a given filter will change the visual appearance of a dark region. An extensive discussion of filters for imaging and observing is in Chap. 6.

The only exception for predicting the usefulness of nebular filters is the hydrogen-beta (H-beta) filter which was specifically designed for viewing the Horsehead Nebula (Barnard 33) and the California Nebula (NGC 1499) (Figs. 2.5, 4.1, and 5.1). It blocks all light except the 486 nm H-beta wavelength and seems to bring out these two nebular regions better for many observers, though it is fair to say the Horsehead Nebula, in particular, is a difficult object for viewing even with the largest of telescopes under very dark sky conditions. The Horsehead Nebula probably has an opacity of 4,

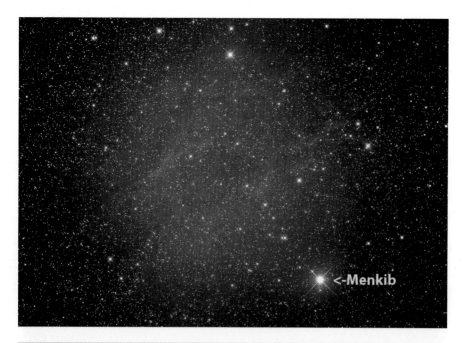

Fig. 5.1 The California Nebula (NGC 1499), emission nebulosity discovered by Barnard. Said to be best observed with a H-Beta nebular filter. Takahashi Epsilon 180 f/2.8 astrograph with Canon EOS Ra camera (cropped and enlarged image). (© Tim B Hunter, 3towers, LLC, 2022. All Rights Reserved)

but it is silhouetted against the faint emission nebulosity IC 434 background making its observation difficult. The H-Beta filter allows the background 496 nm emission from IC 434 to be better contrasted against the Horsehead's dark nebulosity making its observation easier.

On the night of November 4, 1913, with good seeing and fair transparency Barnard examined the Horsehead Nebula with the 40-inch Yerkes refractor using 460-power. He noted "The outlines of the spot-so sharp and clear in photographs of this region-could not be made out with any definiteness. The view showed that the spot is certainly not clear sky, for the field was dull, apparently indicating the presence of some material substance at this point. To me the observation would confirm the supposition of an obscuring medium at this point" (Barnard 1913).

It is fun to speculate what Barnard would have seen if he had had a H-Beta filter available for viewing the Horsehead Nebula with the great Yerkes 40-inch telescope. Interestingly, no image of the Horsehead Nebula (B 33) appears in Barnard's 1927 **Atlas**. This may be due to the posthumous publication of Barnard's work by Frost and Calvert, and it may represent Barnard's earlier disposition not to include it to save space and effort, since

he had so well discussed and illustrated it in his 1913 article. In fact, in his 1919 article introducing his catalog of dark markings he states in the "Notes on the Catalogue" for #33 (Horsehead Nebula) "See *Astrophysical Journal*, 38, 496, 1913, Plate XX" (Barnard 1919). Barnard never called it the Horsehead Nebula, and its notoriety came much later. To him, it was an interesting region that he had already discussed. It is lost in history how the object acquired its familiar name.

Some large dark nebulae have smaller darker patches within them with separate designations. The Pipe Nebula is a large dark area in Ophiuchus noted by Barnard with a stem consisting of Barnard 57, 65–67, and a bowl Barnard 59 (Figs. 5.2 and 7.7). The entire Pipe Nebula is large enough to be seen under the right conditions with the naked eye or low power binoculars. At times, the individual small Barnard Objects may be distinguished from the larger entity but that usually requires telescopic observation. The very

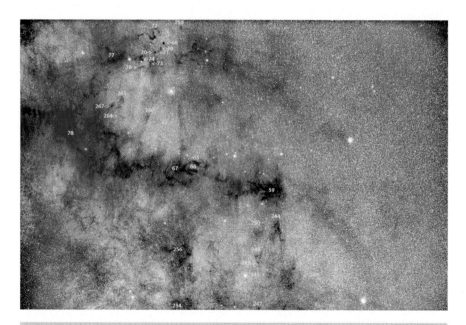

Fig. 5.2 (**a**) The Pipe Nebula and environs with individual Barnard Objects marked. This image was obtained by combining multiple exposures using a 200 mm f/2 lens with a Canon EOS Ra camera. The field of view and orientation of the image was designed to be like Plate 18 Region in Ophiuchus and Scorpius from Barnard's 1927 *Atlas*. Image by James McGaha and Tim Hunter. (© Tim B Hunter, 3towers, LLC, 2022. All Rights Reserved). (**b**) Plate 18 from Barnard EE. *A Photographic Atlas of Selected Regions of the Milky Way* edited by Edwin B Frost and Mary R Calvert, reprinted under the direction of Gerald Orin Dobek, 2011, Cambridge University Press, Cambridge, UK. Permission granted for use of image by Gerald Orin Dobek

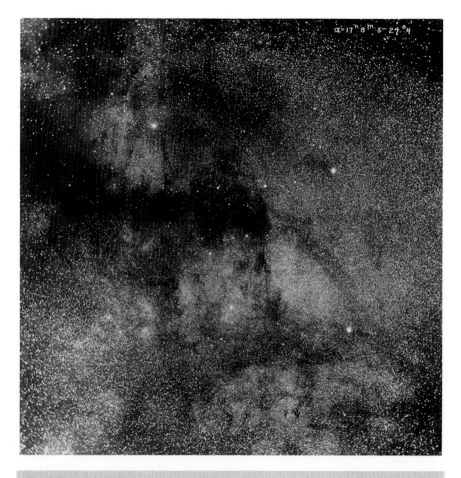

Fig. 5.2 (continued)

smallest dark nebular areas now known as Bok globules are most challeng-
ing and require good sky conditions and large telescopes for their
observation.

Cooke (2012) feels Barnard's list of dark nebulae remains the first and
foremost reference for anyone interested in dark nebulae. The Barnard
Objects lie in the densest portions of the Milky Way in or close to the bright-
est regions of the galactic plane. There is more nebulosity in this area to
begin with, and there are more stars to contrast with the darker portions of
the Milky Way nebulosity. Cooke does feel approximately one-third of the
Barnard Objects are not observable under any conditions and remain strictly
photographic objects.

2 Barnard's Observations of Dark Nebulae

Barnard was an indefatigable observer. He combined his incredible energy, visual acuity, and observing experience with his world leading knowledge of photography to compile a long list of discoveries. It is estimated he published over 900 papers during his lifetime many of which listed new visual or photographic discoveries.

According to Steinicke (2022) Barnard discovered 18 new NGC and 171 new IC objects. Many were found visually with his personal 5-inch Byrne refractor in Nashville or the 6-inch Cooke refractor at Vanderbilt Observatory. He also had many visual observations and discoveries of NGC and IC objects at Lick Observatory using its 12-inch and 36-inch Clark refractors. He spent many hours observing with the 40-inch Clark refractor at Yerkes Observatory, but it is difficult to ascertain how many discoveries he made with that telescope versus follow-up observations of photographic and visual discoveries made with other instruments. Many of his later discoveries were either made or confirmed by his extensive photographic efforts beginning at Lick Observatory and continuing at Yerkes Observatory until the end of his life.

No doubt there are countless other unpublished visual discoveries of Barnard's waiting to be found (Gottlieb 2020). Barnard noted many nebulous areas on his comet searches, and unless they were unusual or particularly interesting, he merely logged them in his observing book and continued with his observations. Most of these nebulae are galaxies and many were later found by other observers or by Barnard or others through photographic surveys. Barnard also noted that his visual observations were often improved or better understood by later photography of the same regions, particularly regarding his study of bright and dark nebulous regions like Rho Ophiuchi (Barnard 1906; Barnard 1910).

One of Barnard's most famous and earliest discoveries is now known as Barnard 86 or Barnard's Ink Spot (Fig. 7.9c–f). He called it "A small triangular hole in the milky-way [sic], perfectly black, some 2′ diameter, very much like a jet black nebula" (Barnard 1884). It is readily visible in a moderate sized telescope and should be a target for any visual observer. Barnard 92 is also a good visual telescopic target. Barnard said the regions [around Barnard 92 and 93] "…impress one as being actual holes" (Barnard 1906) (Fig. 7.10b–c).

Barnard described two general classes of dark nebulae apparent to the naked eye. "Those lying north of the southern part of Ophiuchus are purely black and give the appearance of empty space beyond, seen through rifts or holes in a dense sheeting of stars. I think this description will essentially cover these peculiar features elsewhere outside of Scorpio and Ophiuchus" (Barnard 1906).

In Ophiuchus and Scorpio in a region bounded by approximately 16 hours to 18-hours right ascension and declination -20 to −45 degrees, he found the vacant regions different. "Here occur vacancies within vacancies; that is there are vast regions almost entirely free from stars, in surrounding region thick with small stars. These regions seem veiled over with some sort of material in which occur blacker spaces…In this, apparently, occur rifts and openings giving a clearer view of space" (Barnard 1906).

Barnard also described other peculiarities in this region saying a description is difficult and apt to be misleading, but the photographs of this area should be carefully examined. "The most striking thing however, is their dissimilarity to the ordinary blank spaces elsewhere in the Milky Way (Barnard 1906)." Barnard was particularly enamored of the region of Theta Ophiuchi as well as the region of 58 Ophiuchi, and the area surrounding Rho Ophiuchi (Figs. 5.3 and 7.5a).

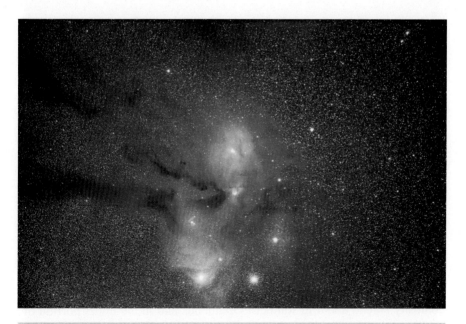

Fig. 5.3 (**a**) Region of Rho Ophiuchi (center) with Antares at bottom center, M4 to the right of Antares and considerable bright and dark nebulosity throughout the region. This image was obtained by combining multiple exposures using a 200 mm f/2 lens with a Canon EOS Ra camera. The field of view and orientation of the image was designed to be similar to Plate 13 Region of the Great Nebula of Rho Ophiuchi from Barnard's 1927 *Atlas*. Image by James McGaha and Tim Hunter. (© Tim B Hunter, 3towers, LLC, 2022. All Rights Reserved). (**b**) Plate 13 Region of the Great Nebula of Rho Ophiuchi from Barnard EE. *A Photographic Atlas of Selected Regions of the Milky Way* edited by Edwin B Frost and Mary R Calvert, reprinted under the direction of Gerald Orin Dobek, 2011, Cambridge University Press, Cambridge, UK. (Permission granted for use of image by Gerald Orin Dobek)

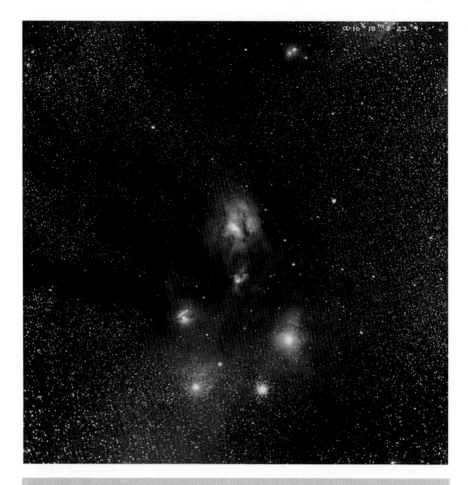

Fig. 5.3 (continued)

He called the nebula around Rho Ophiuchi "…the most puzzling region that I know of in the sky" (Barnard 1906). In referring to the remarkable nebulosity spread about in southern Ophiuchus and in the upper portion of Scorpius, Barnard noted nebulosities in this region were first found by him in Nashville, TN, while comet seeking as early as 1883, and later at Lick Observatory with the "comet seeker" [6.5 refractor at Lick] and the 12-inch refractor at Lick. However, he did admit "their remarkable appearance was not fully known until they were shown by my photographs of that region in 1893" (Barnard 1906).

Barnard was also intrigued by the small Sagittarius star cloud (Fig. 5.4a and b): "In Sagittarius is a small star cloud which is conspicuously noticeable to the naked eye. The photographs show this cloud to be specially remarkable for two black holes in its upper part [Barnard 92 and Barnard

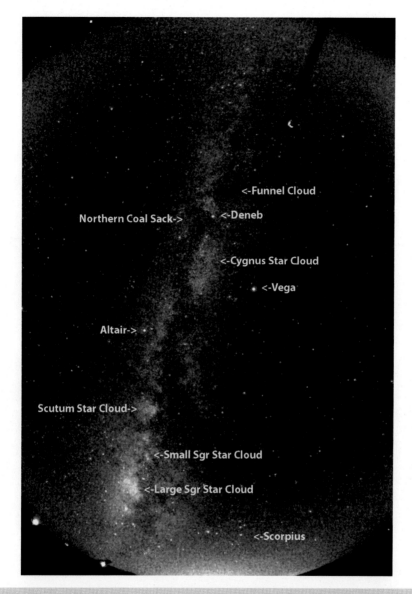

Fig. 5.4 (**a**) All sky camera view of the summer Milky Way from the Grasslands Observatory in Southern Arizona. This shows the Great Rift of the Milky Way and major star clouds. (© Tim B Hunter, 3towers, LLC, 2022. All Rights Reserved). (**b**) Setting summer Milky Way. The Dark Horse Nebula (Prancing Horse) is outlined with asterisks. The large and small Sagittarius star clouds are marked. (© Tim B Hunter, 3towers, LLC, 2022. All Rights Reserved). (**c**)The summer Milky Way and Great Rift (*) from a suburban location with considerable light pollution (a Bortle Class 5 or 6 sky with a SQM reading of ~19.6). This wide-angle view was taken in the foothills of the Catalina Mountains north of Tucson, AZ, approximately 4 miles north of the city center. Note the large sky glow on the right from Tucson. (© Tim B Hunter, 3towers, LLC, 2022. All Rights Reserved)

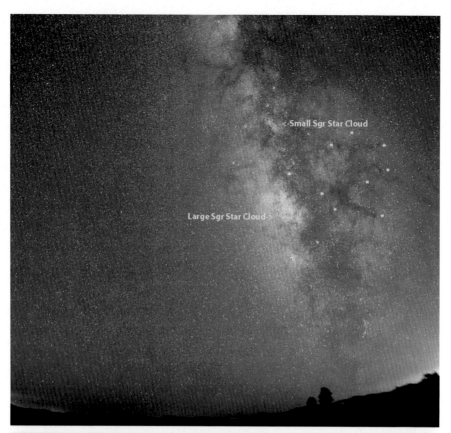

Fig. 5.4 (continued)

93]…" (Barnard 1906) (Fig. 7.10a–c). This star cloud should be observed with the naked eye and binoculars, and then a modest sized or larger telescope used to see both Barnard 92 "Black Hole in Small Star Cloud in Sagittarius" and Barnard 93.

Barnard observed Barnard 92 with the 40-inch refractor at Yerkes on the night of July 27, 1913, a very favorable night for transparency and seeing. The field of view of the telescope only encompassed one-third of the object (Barnard did not note what eyepiece and power he observed with). After careful observation he states "…one would not question for a moment that a real object-dusky looking, but very feebly brighter than the sky-occupies the place of the spot" (Barnard 1913). It was this observation among others that helped convince Barnard his dark nebulae were not holes in the sky.

2.1 The Great Rift of the Milky Way

The Great Rift or Dark River of the Milky Way is a large, irregular band of dark clouds and lanes that somewhat divides the Milky Way along about 1/3 of its length. The Rift starts with the Northern Coal Sack or Cygnus Rift just south of Deneb and extends through Cygnus, Aquila, the western part of Ophiuchus and into Sagittarius (Fig. 5.4a–c and 9.8). It is composed of a series of large, overlapping dust clouds between us and the Sagittarius Arm of the Milky Way (see Fig. 9.6).

At a dark site the Great Rift is a wonderous region for naked eye and binocular observing. The Funnel Cloud, a dark region north of Deneb, and the Northern Coalsack (Cygnus Rift) south and east of Deneb are readily evident to the naked eye. Further south is the main portion of the Great Rift going through the western portion of Aquila and into Scutum and then on to Sagittarius while reaching up into Ophiuchus. The Scutum Star Cloud, the Small Sagittarius Star Cloud, and the Large Sagittarius Star Cloud are visible to the naked eye. These star clouds are discussed further in Chap. 9.

It is worth noting the Milky Way, particularly the summer Milky Way, is brighter than you would guess and is visible with some effort from bright suburban skies (Fig. 5.4c). It is worth trying for, particularly the Great Rift with its dark bands contrasting with the stars of the Milky Way.

Barnard often viewed the Great Rift and wrote extensively about its star clouds. He also photographed many objects in and alongside the Great Rift. Plates 26–29 in his 1927 *Atlas* were photographs of the "Great Star Clouds" in Sagittarius or regions immediately bordering them. Plate 31 shows the Small Star Cloud in Sagittarius, and Plates 36 and 37 show the Great Star Cloud in Scutum. Plate 44 is centered on Gamma Cygnus (Sadr) (Fig. 3.3).

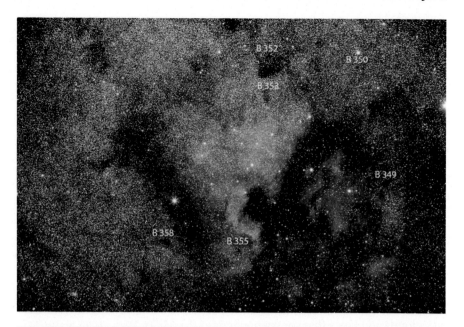

Fig. 5.5 Region of the North America Nebula with Barnard Objects labeled. See also Fig. 7.13. This image was obtained by James McGaha with a Takahashi Epsilon 130 f/2.8 astrograph and a Canon 20 Da camera. (© Tim B Hunter, 3towers, LLC, 2022. All Rights Reserved)

Plate 45 is centered near Deneb, and Plate 46 is the Region of the North America Nebula which is just east and slightly south of Deneb (Figs. 5.5 and 7.13). The North America Nebula is visible to the naked eye, not the nebulosity per se, but the stars having a configuration resembling North America. Several small Barnard Objects are in or contiguous to the North American Nebula, but they are challenging objects best sought with a moderate to large telescope for viewing.

The Galactic Dark Horse Nebula or Prancing Horse is a large collection of dark nebulae in the southern portion of the Great Rift. It is roughly a 10-degree area in Ophiuchus west of the Large Sagittarius Star Cloud. It looks like a prancing horse and depending on the orientation of the Milky Way, it also looks like a horse standing on hind legs (Fig. 5.4b). A good portion of the Dark Horse Nebula is shown on Plate 20 from Barnard's 1927 *Atlas* with the Pipe Nebula forming the hind end and hind legs of the horse (Fig. 5.2). This is a good region for naked eye and binocular viewing.

The Cygnus Star Cloud sits between Sadr and Albireo in the southern part of Cygnus (Fig. 5.4a) . A portion of this area was photographed on Barnard's Plate 43 showing the large dark area Barnard 44 (Barnard's Fish

on Platter), which is potentially visible to the unaided eye and visible in binoculars (Fig. 7.12).

3 Other Observations of Dark Nebulae

Many of the Barnard Objects were discovered visually or photographically independent of Barnard. The Reverend TE Espin observing with a 17 ¼ -inch reflector at the Wolsingham Observatory at Tow Law, England, on the night of January 16, 1898, noted a void or cloud in the sky while sweeping for red stars and stars with remarkable spectra (Espin Rev 1898). Subsequent observations of the same region on January 24th and January 25th showed "…the blotting out of the stars was very marked, and the object seemed more remarkable than ever." This was soon followed up by other observers who saw it with a 6-inch refractor (Espin Rev 1898). The coordinates for the object discovered correspond to Barnard 20, which Barnard credited to Espin and described as "…north of a small group of faint stars and is 6′ or 8′ in diameter in a somewhat larger vacant space" (Barnard 1927) (Fig. 9.16).

WS Franks (1851–1935) in 1930 reported on his *Visual Observations of Dark Nebulae.*" He used the 6 1/8th inch f/13.3 Cooke refractor at the Brockhurst Observatory in East Grinstead, Sussex, England mainly with a Kellner eyepiece of 1-inch focus giving a field of 36 arcminutes at 81x. His working list was the Barnard Objects. The objects he attempted to view was pruned considerably as Franks felt 120 of the Barnard Objects were "…only mere spots of small diameter; these are generally too small to be detected in the telescope. Moreover, though on the photographs they are sharply defined, yet to the eye they are very diffuse and sometimes unrecognizable" (Franks 1930).

Franks observing from England limited his observations to above 28⁰ south declination. Also, since two-thirds of the Barnard Objects are between 16–19 hours right ascension, many are grouped closely together, and many objects, though observable, had to be missed due to limitations in his observing time. Franks made his observations on very clear Moon free nights when the Milky Way was conspicuous. Each object was observed on two nights for consistency, and the observations commenced in August 1929 and ended in December 1929. He observed 42 Barnard Objects in total providing interesting descriptions for those observed (Table 5.3).

Franks was the astronomer-in-charge at FJ Hanbury's private observatory at Brockhurst from 1909 until his death in 1935. He worked on double stars, red stars, diffuse nebulae, and dark nebulae. The observatory lay across the road from the family home of Sir Patrick Moore (1923–2012), the noted

Table 5.3 Barnard Objects Observed with the 6 1/8th in Cooke refractor at Brockhurst Observatory, Sussex, in 1930 by WS Franks[a]

Barnard object	Abbreviated notes from Franks
40	A dusky cloud, about $\frac{1}{4}^0$ diameter, peculiar dingy tint…
41	Very large dense cloud…too large for 36′…not a star seen
42	An obscure spot in a dark gap
44	A very long, broad, dark lane…not very easy to follow
45	Two parallel dark lanes, about 2^0 long and $\frac{3}{4}^0$ apart…
78	A large vacant region in Ophiuchus…visible to naked eye
86	A feeble dingy cloud in oval ring of stars…touching the cluster N.G.C. 6520
88	…one of several dark gaps between the masses of bright nebulosity in … M8
92	A dusky oval spot
95	A peculiar dark lane, about 1^0 long, of a nondescript dingy hue
97	An oblong dense patch, larger than field of view
100	A dark streak
101	A similar streak…and forming an elbow with B100.
318	A long very narrow lane…between…M11 and Barnard 112. Distinctly seen
112	A diffuse dark spot, $\frac{1}{4}^0$ [south] of M11. Pretty readily seen.
320	Irregular patchiness in field, around a 7.5 mag. star
323	A pretty dark patch, about $\frac{1}{4}^0$ diameter, surrounded by many stars
324	Very peculiar, crooked, dark lane, in shape resembling the letter J
135	A dusky patch, about $\frac{1}{4}^0$ diameter
136	Another dark spot
141	Roundish spot in rather bare region
330	Dark patch, about $\frac{1}{2}^0$ diameter
333	Dark area of irregular markings
142	Large and irregular, surround by rich area.
143	Large curved dark marking, somewhat the shape of a horseshoe
339	Large, irregularly dark region
340	Curious angular marking
341	Narrow dark line…Distinctly seen
144	Long vacant region…very few stars in it, but densely crowded all around.
145	Curious triangular dusky marking…Quite distinct.
343	Dusky oval cloud, about 15′ diameter.
345	Dusky curve
346	Another curved marking
348	Peculiar large curved dusky lane

(continued)

Table 5.3 (continued)

Barnard object	Abbreviated notes from Franks
349	Small curved dusky marking, rather faint
150	Long curved dark marking
351	Dusky lane
352	Large dense patch
353	Small but distinct dusky spot
354	A crooked irregular dusky lane about 1^0 long
356	Pretty large but irregular dusky patch
357	Dense dark space, nearly filling field of 36′ diameter.

[a] Adapted from Franks WS. Visual Observations of Dark Nebulae. *MNRAS* 1930; 90: 326–329. The objects are listed in order by right ascension beginning at 16 hours and ending at 6 hours

British astronomer and founding editor of the series of books of which this is one. Moore had known Franks in the 1930's and was a frequent visitor to the observatory. The observatory was owned by the wealthy industrialist FJ Hanbury (1855–1938). Franks was free to use the observatory as he wished as long as he entertained Hanbury's guests by showing them celestial objects with the Cooke refractor (Shears 2022). When Franks died after a cycling accident from which he never recovered, Hanbury asked 14-year-old Moore to be the director of the observatory. This lasted until early 1939 when Hanbury died, and the observatory was sold. Moore always felt Franks was an important dear friend and a wonderful influence (Moore 2002).

Higgins in 1987 put together a list of 24 of the best summer dark nebulae for observing (Table 5.4). He described them as ranging from the very easy to moderately difficult. Several of these are also Barnard Objects observed by Franks and most of them are on the Astronomical League's Dark Nebulae Observing Program list of either required or optional objects (see below). Summer is the best time to see the Milky Way, though summer thunderstorms may limit one's viewing. Higgins' list of summer Barnard Objects for viewing is excellent and highly recommend.

The Texas Star Party Advanced Observing Program in 2018 put together by Larry Mitchell was dedicated to Barnard (Mitchell 2018). A considerable list of objects associated with Barnard in one way or other was presented for observers to try at the star party. In introducing the list Mitchell noted "This years Advanced Listing of Barnard Objects puts you, the observer, in direct competition with one of the best visual observers of all time. He did it with

Table 5.4 Recommended Summer Viewing List of Barnard Objects[a]

Object	Constellation	Opacity	Size
B 244	Ophiuchus	5	30 × 20′
B 250	Ophiuchus	5	15′
B 64	Ophiuchus	5	20′
B 70	Ophiuchus	4	4′
B 72	Ophiuchus	6	30 × 3′
B 74	Ophiuchus	5	15 × 10′
B 289	Sagittarius	5	7 × 35′
B 85	Sagittarius	6	<1′
B 86	Sagittarius	6	4′
B 88	Sagittarius	5	2.7 × 0.5′
B 89	Sagittarius	6	2 × 0.5′
B 87	Sagittarius	5	12′
B 92	Sagittarius	6	12 × 6′
B 93	Sagittarius	5	12 × 6′
B 337	Aquila		
B 340	Aquila		
B 142	Aquila		
B 143	Aquila		
B 145	Cygnus	4	35 × 6′
B 356	Cygnus	4	24′
B 363	Cygnus	5	40 × 7′
B 169	Cepheus	5	60′
B 170	Cepheus	5	26 × 4′
B 171	Cepheus	5	19′

[a]From Higgins (1987) in order of right ascension from 17 hours to 22 hours. See standard sky atlas for specific object coordinates. The opacity scale is 1–6 with 6 being the darkest (Lynds BT. Catalogue of dark nebulae. *ApJ* 1962; S7: 1–52)

refractors…What can you do with your enhanced coated mirrors?" In Mitchell's list of 40 deep sky objects plus 7 solar system objects associated with Barnard were 8 dark nebulae (B 68, B 86, B 90, B 92, B 93, B 98, B 133, and B 352). Franks had included B 86, B 92, and B 352 on his list of observed Barnard Objects, and Higgins had included B 86, B92, and B 93.

Astronomical sketching is challenging and beyond the skills of the authors of this book. Many amateur and professional astronomers produce wonderful drawings of astronomical objects, including dark nebulae. Dark nebulae may be one of the more challenging objects for sketching as they are often difficult to observe, and it takes real skill to show an accurate representation of what they look like to the observer. Bartels has a large collec-

tion of astronomical drawings of many objects (Bartels 2022). He has observed and published drawings of more than 170 Barnard Objects plus many other drawings of Lynds dark nebulae and other dark nebulae. His drawings and his list of objects observed are a great example of what one can accomplish observing dark nebulae.

4 Astronomical League Dark Nebula Observing Program

The Astronomical League has a Dark Nebula Observing Program which is an excellent source of information for observing many of the Barnard Objects as well as other dark nebulae like Lynds dark nebulae (Machin, Astronomical League). Some of the objects listed are visible with the naked eye or with small telescopes. Most require tripod-mounted binoculars or a 4–6-inch rich field telescope. Some of the smaller optional more difficult nebulae in the program will require an 8-inch or larger telescope. All require good dark skies with the Milky Way readily visible.

It is best to review the League's website for information about its splendid Dark Nebulae Observing Program in addition to its many other fine observing programs. To receive a certificate from the League for completing any of its programs, you must be a member of the Astronomical League and follow the guidelines for submitting your observations. For the Dark Nebulae Program there is a list of 35 required objects that must be observed or imaged and properly recorded, and there is a list of an additional 105 dark nebulae from which you must choose 35 nebulae for observing or imaging for completion of the program and receiving a certificate from the League (https://www.astroleague.org/al/obsclubs/DarkNebulaeClub).

4.1 Naked Eye Objects

The first object on the list of required objects for observing dark nebulae is the Great Rift (Fig. 5.4a–c) The grandeur of the Milky Way and its Great Rift are best appreciated by naked eye viewing. Other naked eye dark nebulae worth trying for are Barnard 144 (Barnard's Fish on the Platter), Barnard 44 which is a large irregular lane, Barnard 78 (the bowl of the Pipe Nebula), and the stem of the Pipe Nebula. The latter contains B 59, B 66, B 67, and B 65 embedded in it (Fig. 5.2 and 7.7). They are smaller and darker than the larger background nebulosity and probably only viewable telescopically.

Two other naked eye dark nebulae of interest are the Northern Coalsack or Cygnus Rift and the Funnel Cloud, east and a little north of Deneb (Fig. 5.4a). The Funnel Cloud is also known as LG3 (Le Gentil 3) after the French astronomer Guillaume Le Gentil (1725–1792) who was the first to note it. He was a fine observer and astronomer but, unfortunately, is best known for his ill-fated attempts to view Transits of Venus in 1761 and in 1769 from India. He left France in 1760 for India and through an incredible series of misfortunes and travails about southeast Asia, missed viewing both transits. He finally arrived back home in Paris in 1771 finding that he had been declared legally dead and replaced in the Royal Academy of Sciences. His wife had remarried, and his relatives had plundered his estate. After much litigation and the intervention of the King of France, he recovered his seat in the academy. He later remarried and finished out a successful career.

4.2 Binocular and Telescopic Objects

About one-half of the required objects for observing dark nebulae are considered binocular objects (Machin, Astronomical League). A few are observable both with the naked eye or low power binoculars or with binoculars and a rich field telescope. Good objects for binocular viewing are B 142/B 143 which form Barnard's "E" Cloud (Fig. 5.6). Barnard 34 is just west of M37 making it is easier to find in binoculars (Figs. 6.3 and 7.4). Barnard 144 is also a good object for binocular viewing (Fig. 7.12d). Barnard 64 is west of M9 and is said to cause darkening of M9 (Fig. 5.7). Barnard 275 is at the west edge of M6, and Barnard 278 is on the east end of M6, though Barnard 278 is not on the Astronomical League observing lists for dark nebulae (Fig. 5.8). Barnard 103 is on the northwest side of the Scutum Star Cloud. Barnard 111 is a large dark area with other Barnard Objects within it, and Barnard 119a is a large area east of Barnard 111 (Fig. 9.9). Barnard 111 may also be visible to the naked eye.

Most of the rest of the dark nebulae on the list of required objects and on the list of optional objects require telescopic viewing, though some like Barnard 138 (140 × 140′) or Barnard 228 (Lupus Dark Cloud) (310 × 80′) are quite large and best viewed in higher power mounted binoculars or a good rich field telescope (Fig. 9.26). Many are small dark patches and will be challenging like Barnard 33 the Horsehead Nebula. Some optional objects are well known and are on many popular observing lists like Barnard 72 the Snake Nebula or Barnard 87 the Parrot's Head Nebula. In any event, they are all doable under the right sky conditions with the right instrument. Give them a try.

5 How to Best Observe Dark Nebulae-Techniques and Equipment

The following recommendations are based on many years of observing, mainly at the Grasslands Observatory in Southeastern Arizona. The most important concept is to recognize you need to obtain the best possible contrast of dark nebulosity against its background. You cannot change the nebulosity or its background, but you can take steps to maximize the intrinsic contrast present for each dark object you wish to observe. First, as noted you must have a dark sky free of the Moon-ideally a Bortle Class 1–3 or better sky, 21.1–21.5 magnitude/arcsecond skies, though many dark nebular regions are observable in Bortle Class 4 or 5 skies. Good seeing always improves one's observing, and if possible, choose a site with consistently good seeing.

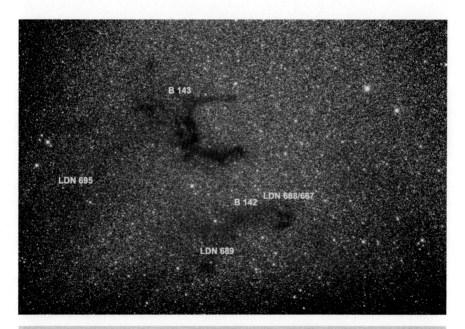

Fig. 5.6 (**a**) Barnard 143 and 142 (Barnard's E Cloud) with other dark nebulae. Takahashi Epsilon 180 f/2.8 astrograph with Canon EOS Ra camera. (© Tim B Hunter, 3towers, LLC, 2022. All Rights Reserved). (**b**) Barnard 143 as imaged with ASA 20-inch f/3.6 astrograph and Finger Lakes Instrumentation Proline KAF9000 CCD, combining luminous images with images through Cousins-Johnson B, V, and R filters. This image shows the dusty nature of the object and that it obscures background stars and does not represent a hole in the sky. (© Tim B Hunter, 3towers, LLC, 2022. All Rights Reserved)

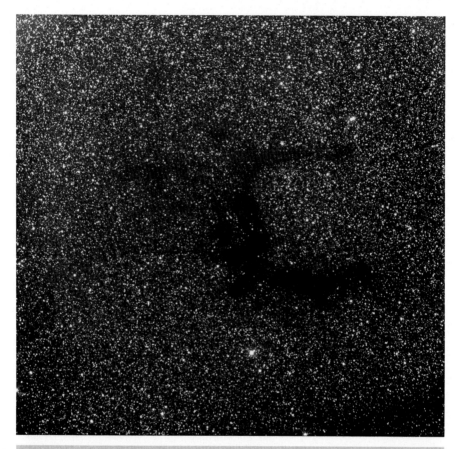

Fig. 5.6 (continued)

You need the highest contrast optics you can get, usually an APO/achromat ED triplet 100–180 mm f/4-f/7 refractor. These are expensive and hard to obtain, but they will give you the highest contrast possible and are ideal for objects requiring high contrast and good definition. No matter the telescope, use high contrast eyepieces with wide 80–120-degree apparent fields of view. The eyepiece telescope combination should give an exit pupil of 2.5–3 mm which gives the best visual contrast.

The *entrance pupil* is the aperture through which light enters the telescope. The *exit pupil* is a small circle of light just behind the eyepiece of a telescope or binoculars through which all the light rays pass. It is an image of the telescope's aperture, and its size equals the aperture divided by the magnifying power (MacRobert 2006).

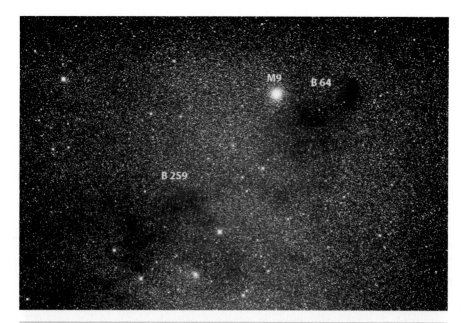

Fig. 5.7 M9 and nearby Barnard 64 and Barnard 259. Takahashi Epsilon 180 f/2.8 astrograph with Canon 60 Da camera. (© Tim B Hunter, 3towers, LLC, 2022. All Rights Reserved)

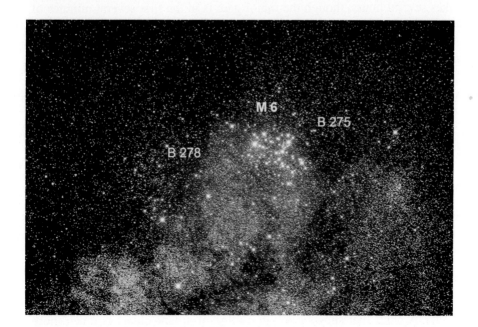

Fig. 5.8 M6 and nearby Barnard 275 and Barnard 278. Takahashi Epsilon 180 f/2.8 astrograph with Canon EOS Ra camera. (© Tim B Hunter, 3towers, LLC, 2022. All Rights Reserved)

Seven millimeters is the maximum pupil size most persons can obtain, and this is only if you are under the age of thirty. Older adults usually cannot obtain a pupil size larger than ~4–5 mm. At 3–4 mm the pupil is wide enough to admit maximum light using the best part of the eye's lens for focusing and providing the best visual contrast. An exit pupil of a telescope or binoculars too large to completely fit into your pupil means you lose some of the instrument's light (MacRobert 2006).

Light pollution reducing or nebular filters may enhance observation of selected dark nebulae and emission nebulae. This is particularly true of the H-beta filter designed for observing the Horsehead Nebula (Barnard 33) and the California Nebula (NGC 1499) as discussed above. Some of the dark nebulae have faint emission nebular backgrounds which might be enhanced by a nebular filter increasing contrast between the background and the dark object itself.

One should be fully dark adapted to see the faintest objects. Dark adaptation is a complex subject with importance for amateur astronomers but also having relevance in many other fields including ophthalmologic medicine, optometry, aviation, and policing (Science Direct 2022). In the amateur astronomy community, it is generally stated one is fully or nearly fully dark adapted after 20 minutes in dark conditions. Low level red lighting is said to disturb dark adaptation the least. It is also known that full dark adaptation takes several hours, though the major gain is in the first several minutes of being in dark conditions. As a practical matter, if you are away from all lights, at least white or bluish light for 10–15 minutes, you should be reasonably adapted for observing faint celestial objects.

To find a dark object you need a very good star field guide, preferably using digital setting circles or direct pointing on your telescope to easily center the object in the field of view. Whatever guide you use, either a printed atlas or a digital atlas, its field should be adjusted to 2 to 4 times larger than your eyepiece field of view so you can be certain you have the correct field and not waste time looking for a dark object in the wrong place.

For binocular viewing 12 × 50 APO binoculars are recommended. They are expensive so use what you can afford. Generally, 12 × 50 binoculars with good optics give the best combination of ease of use (light enough to hand hold), contrast, and field of view. Larger binoculars like 20 × 80 are too heavy to hold steady by hand and need a tripod that is easy to move about the sky but sturdy enough to give an image without vibrations.

Lastly, be careful of not being fooled by dark patches of the sky. There many of them not noted on charts and not carrying any formal name (Fig. 8.14f). A chart that shows a rough outline of a dark object is much more

helpful than one that simply marks the location of an object without indicating its relative size and orientation.

If you can follow these recommendations to the extent your resources and time permit, you will have many hours of observational enjoyment not only of dark nebulae but also of bright nebulae, star clusters, galaxies, and even the Moon and planets.

References

Barnard EE. New Nebulae. Small black hole in the milky-way. Duplicity of β¹ Capricorni. Astron Nachr. 1884;108:369.

Barnard EE. On the vacant regions of the sky. Pop Astron. 1906;14(#10):140.

Barnard EE. On a great nebulous region and on the question of absorbing matter in space and the transparency of the nebulae. Astrophys J. 1910;31:8–14.

Barnard EE. Dark regions in the sky suggesting an obscuration of light. Astrophys J. 1913;38:496–501.

Barnard EE. In: Frost EB, Calvert MR, editors. A Photographic atlas of selected regions of the Milky Way. Washington: Carnegie Institution of Washington; 1927. Online Version at Georgia Institute of Technology: Barnard's Photographic Atlas of Selected Regions of the Milky Way (gatech.edu).

Barnard EE. On the dark markings of the sky with a catalogue of 182 such objects. Astrophys J. 1919;XLIX(#1):1–28.

Barnard EE. A Photographic atlas of selected regions of the Milky Way. In: Edwin B Frost, Mary R Calvert, editors, reprinted under the direction of Gerald Orin Dobek. Cambridge: Cambridge University Press; 2011.

Bartels M. Sketches of dark nebulae; 2022.: Astronomical Sketches of Dark Nebulae (bbastrodesigns.com).

Bortle JE. Gauging light pollution: the Bortle dark-sky scale. Sky Telescope, July 18, 2008.: https://skyandtelescope.org/astronomy-resources/light-pollution-and-astronomy-the-bortle-dark-sky-scale/.

Cooke A. Dark Nebulae, Dark Lanes, and Dust Belts. New York: Springer; 2012.

Espin Rev TE. A remarkable object in Perseus. Mon Not R Astron Soc. 1898;58:334–5.

Flanders T. Astronomy, hiking, and travel. Urban and suburban stargazing. 2017. Surface Brightness: https://tonyflanders.wordpress.com/surface-brightness/

Franks WS. Visual observations of dark nebulae. Mon Not R Astron Soc. 1930;90:326–9.

Gottlieb S. The lost discoveries of E.E. Barnard. Sky Telescope. 2020:34–40.

Grasslands Observatory website: http://3towers.com

Higgins D. A Viewing Guide to E.E. Barnard's Dark Nebulae. Deep Sky. 1987:19–23.

Hunter TB, McGaha J. Sky darkness and the contrast illusion: grasslands observatory, Essays: https://www.3towers.com/Essays/SkyDarknessContrast/Contrast01.html.

King B. Dive into Scutum's Dark Nebulae. Sky Telescope July 15, 2015.: Dive Into Scutum's Dark Nebulae – Sky & Telescope – Sky & Telescope (skyandtelescope.org).

King B. Paddle the Milky Way's Dark River. Sky Telescope July 13, 2016: https://skyandtelescope.org/observing/a-trip-down-the-great-rift/.

Lodriguss L. AstroPix. The Brightness of the Night Sky. 2022.: https://www.astropix. com/html/observing/skybrite.html

Lynds BT. Catalogue of dark nebulae. ApJ 1962; S7: 1–52

Machin K. Dark Nebulae Observing Program. The Astronomical League: Dark Nebula Observing Program | The Astronomical League (astroleague.org).

MacRobert A. A pupil primer: how big should a telescope's exit pupil be? Sky Telescope July 17, 2006.: https://skyandtelescope.org/astronomy-equipment/a-- pupil-primer/#:~:text=The%20exit%20pupil%20is%20a,wall%20or%20the%20 daytime%20sky.

McHenry L.. E. E. Barnard and his Dark Nebula PDF: https://www.stellar-journeys.org/ EE%20Barnard%20and%20His%20Dark%20Nebula.pdf.

Mitchell L. Texas star party-advanced observing program-2018. https://texasstarparty. org/wp-content/uploads/2018/04/tspcluba_s.pdf.

Moore P. William Sadler Franks, 1851–1935. J Br Astron Assoc. 2002;112(5):247–53.

Science Direct. Dark adaptation. 2022. https://www.sciencedirect.com/topics/ agricultural-and-biological-sciences/dark-adaptation.

Shears J. William Sadler Franks and the Brockhurst Observatory. 2022.: https://arxiv. org/ftp/arxiv/papers/1311/1311.6790.pdf.

Steinicke W. Edward Emerson Barnard. 2022. http://www.klima-luft.de/steinicke/ ngcic/persons/barnard.htm.

Unihedron. 2022.: Unihedron.

Whitman A. Seeking Summer's Dark Nebulae. Sky & Telescope, July 16, 2006.: Seeking Summer's Dark Nebulae – Sky & Telescope – Sky & Telescope (skyandte- lescope.org).

Wilds RP. Bright and dark nebulae: an observers guide to understanding the clouds of the Milky Way Galaxy. CreateSpace; 2017.

Chapter 6

Modern Imaging of the Barnard Objects

1 Film Astrophotography

1.1 Barnard the Master Astrophotographer

Barnard was a master astrophotographer and did more than any other individual for establishing photography as an essential tool for astronomy. His active astrophotographic career spanned the interval from approximately 1885–1922. His wide-field astrophotography and his comet photography were unmatched during his lifetime, and he contributed greatly to eclipse and planetary photography. He did occasional deep sky photography but to a lesser extent than many others.

Barnard's expertise was all encompassing. He was an acclaimed visual observer, and he knew the sky better than any other observer. He was a skilled photographer, and, moreover, he knew about photographic plates and darkroom techniques. His extensive writings on the photographic process greatly advanced professional astrophotography.

Astrophotography began in 1840 with John William Draper's first successful photograph of the Moon. Widespread use of photography as an essential tool of professional astronomy was not possible until dry plate photography became available in the 1880s (see Table I and 2 in Chap. 1). In fact, in 1883 Andrew Ainslie Common used dry plate photography to

© The Author(s), under exclusive license to Springer Nature Switzerland AG 2023
T. B. Hunter et al., *The Barnard Objects: Then and Now*, The Patrick Moore Practical Astronomy Series, https://doi.org/10.1007/978-3-031-31485-8_6

image M42 with his 36-inch reflecting telescope revealing stars too faint to be seen visually.

Unfortunately, Barnard, Wolf, and other astrophotography pioneers did not document their photographic technique with respect to plates used and darkroom procedures as much as we would like. Barnard did make use of Seed Dry Plates which were first introduced by Miles Ainscoe Seed in the early 1880s ("Seed Dry Plate"). These plates were easy to transport and quickly became popular. The M.A. Seed Dry Plate Company was incorporated in July 1883 and was purchased by Eastman Kodak in 1902 which became the dominant photographic company in the twentieth century and by the 1930's accounted for most astrophotographic plates. Barnard also used the Cramer Lightning Plate. Gustav Cramer began manufacturing dry plates around 1880 and with his three sons incorporated his company in 1898 as G. Cramer Dry Plate Company, St. Louis.

Almost all the photographic plates used for astrophotography until the 1940's were very insensitive compared to films and plates introduced later and were mainly sensitive to blue and ultraviolet portions of the spectrum. As noted by an M.A. Seed manual: "The ordinary photographic plate is… in fact [sensitive to]…the blue, indigo, and violet; and also to the ultraviolet. The result is, that the Red, Orange, Yellow, or Green have no action on the plate at all, and hence are represented as Black." (M.A Seed 1890).

This was a significant problem for landscape photography as most landscapes are filled with green, yellow, and orange objects. A photograph of a landscape showing only the effects of blue and ultraviolet produced mostly dull and uninteresting results. The orthochromatic plate was introduced by Seed to overcome this problem: "The Orthochromatic plate is the result of the addition of certain dye stuffs into the sensitive coating, which makes the plate capable of being impressed by other colors, viz., the yellow and green" (M.A Seed 1890). Even so, the Seed plates were still much more sensitive to blue end of the spectrum necessitating a colored screen, a light filter to absorb selectively the blue portions of the spectrum to balance the overall color sensitivity of the orthochromatic plates. These techniques did reduce plate sensitivity but was not too much of a problem as most landscape photography was performed in bright sunlight so longer exposures could be tolerated as there is no motion in most landscape photography.

Professional astronomers were quite cognizant of the lack of sensitivity of their photographic plates to the yellow, green, and red portions of the spectrum. William Huggins (1824–1910) and his wife Margaret Lindsay Huggins (1848–1915) used dry plate photography to record stellar spectra as early as 1876. Barnard recognized as early as 1893 that comet photography sometimes showed considerably different results than visual

observations. His work with Brooks comet of 1893, Comet Morehouse in 1908, and Comet Halley in 1910 convinced him that his photographs were showing a blue spectral sensitivity not apparent to the eye (see Chap. 4). His visual observations of specific M13 stars and stars in M3, M5, M15, and M92 "…produces a most remarkable difference between their photographic and visual images... Of course the simple explanation …is that these stars, so bright photographically and so faint visually are shining with a much bluer light than the stars which make up the main body of the cluster. This is an interesting fact, and would seem to be an important one." (Barnard 1900).

When Barnard compared a photograph of M13 taken in 1900 with the Potsdam 13-inch astrographic telescope with M13 as viewed in the Yerkes 40-inch telescope, he noted some of the stars in M13 were "…very much bluer than the rest..." In smaller telescopes there was not enough light to distinguish between star colors in M13. The great Yerkes refractor enabled Barnard to see some of the blue stars evident on photographs. When M13 was photographed with the Yerkes 40-inch telescope and a yellow filter to suppress the blue light, the photographic result was like viewing M13 visually with smaller telescopes. Barnard also noted there were a considerable number of stars that were prominent on the Yerkes image of M13 through a yellow filter, indicating they were yellow stars (Barnard 1900, 1909, 1914).

A recent example showing how the plates Barnard used had poor red sensitivity is shown in Fig. 6.1. Figure 6.1a is a digitized version of Barnard's Plate 49- Region in Cepheus cropped around the large nebulous region IC 1396 to correspond with the color digital image in Fig. 6.1b. In Fig. 6.1b the bright star at the top is Erakis, Herschel's Garnet Star (Mu Cephei). This star is marked with a white arrow in Fig. 6.1a. This star is unremarkable on Barnard's plate, and, in fact, it is not listed in the table accompanying the image.

A normally prepared silver halide emulsion is sensitive to ultraviolet and blue light. An orthochromatic emulsion as discussed above has some sensitivity to green and yellow light as well, meaning it can produce more accurate black and white landscape images and be developed in the darkroom with a red safety light. Hermann Wilhelm Vogel (1834–1896), a German photochemist and photographer, is credited with the discovery of several dyes which when added to photographic emulsions increased their sensitivity to various parts of the spectrum related to the wavelengths of light the dyes absorbed.

This discovery made the use of orthochromatic films possible and allowed for later development of practical commercial color photography. It also led to the introduction of panchromatic black and white emulsions in

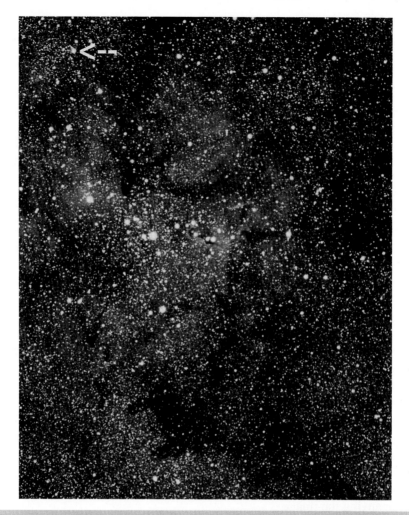

Fig. 6.1 (**a**) Digitized version of Plate 49-Region in Cepheus from *A Photographic Atlas of Selected Regions of the Milky Way* edited by Edwin B Frost and Mary R Calvert, reprinted under the direction of Gerald Orin Dobek, 2011, Cambridge University Press, Cambridge, UK. Permission granted for use of image by Gerald Orin Dobek. The image has been cropped to the same region as in Fig. 6.1b which is a modern digital color image centered around IC 1396. In the present image Mu Cephei is marked with a white arrow. Note how bright and red/orange Mu Cephei appears in Fig. 6.1b. (**b**) Modern color digital image of IC 1396 and environs with major objects labeled. The bright red/orange star is Herschel's Garnet Star (Mu Cephei; Erakis) which is unremarkable on Barnard's plate shown in Fig. 6.1a. Takahashi Epsilon 180 f/2.8 astrograph with Canon EOS Ra camera. (© Tim B Hunter, 3towers, LLC, 2022. All Rights Reserved)

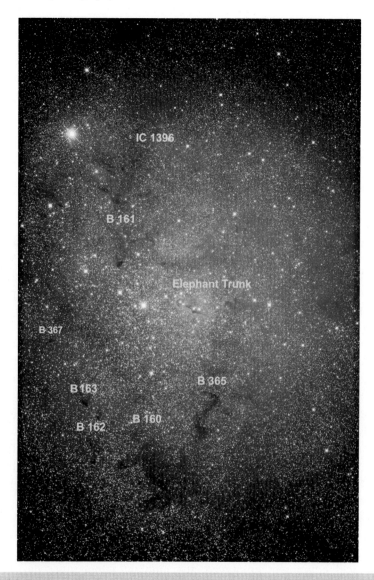

Fig. 6.1 (continued)

the early 1900's. These were sensitive in varying degrees across the spectrum from ultraviolet to red, rendering more accurate black and white photography. Unfortunately, panchromatic films and plates were more expensive than traditional emulsions, had a shorter shelf life, and had to be developed in total darkness. Panchromatic emulsions did not have great sensitivity and were mostly impractical for long astronomical exposures.

Kodak, the main supplier of motion picture film, introduced Kodak Panchromatic Cine Film in 1922 and by 1930 stopped suppling orthochromatic cine film and produced only panchromatic cine film. Kodak's experience with improving the spectral range of its films led to applications for astronomical photography. In 1940 Kodak developed the 103a spectroscopic film series. Each film in the series was designed to be sensitive to a different portion of the spectrum. These films also had low reciprocity failure.

1.2 Reciprocity Failure

The concept of film reciprocity was introduced in 1862 by RW Bunsen (1811–1899) and HE Roscoe (1833–1915) who experimentally showed the exposure time necessary for a set amount of darkening on a photographic image was inversely proportional to the amount of light striking the photographic plate (Wallis and Provin 1988). Reciprocity for photographic plates and films is only true over a very narrow short exposure range. It works well for a rapid few seconds or less exposures in bright light, but it soon became evident to astrophotographers the Bunsen-Roscoe Law of Reciprocity was not true for most astronomical images requiring long exposures. In most astrophotography a small amount of light is striking the photographic surface over many minutes or hours. Most photographic emulsions become less and less sensitive as the exposure is lengthened, so-called low intensity reciprocity failure (LIRF). There is also high intensity reciprocity failure (HIRF) where reciprocity breaks down with very high levels of light and very short exposures, usually less than a millisecond. This rarely applies to astrophotography or general photography.

Low intensity reciprocity failure meant there were diminishing returns for long astronomical exposures after a certain exposure length which depended on a very complex set of factors, the photographic emulsion, the astronomical equipment employed, the ambient temperature during the exposure, and the plate developing technique in the darkroom. For example, one might produce a good image of the Pleiades with a 5-minute exposure on a 200-mm telephoto lens using a fast color film. A 7 ½ minute exposure with the same film and lens might produce a slightly improved image, while a 10-minute exposure might be no better than the 7 ½- minute exposure, and a 15-minute exposure may produce worse results due to increased noise with film fogging.

Professional and amateur astronomers and researchers at Eastman Kodak worked on many techniques to overcome or lessen film reciprocity failure,

including cooled emulsion photography, and various photographic film hypersensitization techniques, like baking plates in nitrogen or hydrogen gas. Kodak's introduction of the 103a series of emulsions helped combat low intensity reciprocity failure. The films in this series of emulsions had both lessened reciprocity failure and different sensitivities peaking in different portions of the spectrum allowing astronomers to select the emulsion with the best spectral response for the specific object being photographed.

In the 1970's Kodak introduced the IIIa emulsions designed specifically for astronomical use and long exposures. In 1981 Kodak introduced ultra-fine-grained 2415 Technical Pan Film which could specifically be processed in the dark room for maximum dynamic range for planetary work or be hypersensitized for extended exposure of faint astronomical objects.

By the 1980's very sensitive photographic emulsions with low reciprocity failure were widely available for long exposure astrophotography. Professional astronomers mainly used the astronomical plates developed by Kodak, while amateur astronomers could use off the shelf commercial film with high sensitivity for short few-minute exposures or hypersensitized black and white or color films for longer exposures.

Exquisite results were produced with these films and techniques. Useful color photographs of brighter deep-sky objects could be obtained with exposures ranging from 1–3 minutes with good astronomical optical systems. Hunter and Knauss 1988 used hypersensitized SR-V Konica 3200 color film on the night of March 19/20, 1988, to perform a photographic Messier Marathon obtaining recognizable images of 84 Messier Objects in one night (Fig. 6.2).

2 Digital Imaging

Just as film was reaching its zenith for astronomical use in the 1990's and early 2000's, digital imaging with charge-coupled device (CCD) chips and later complementary metal-oxide sensor (CMOS) chips became practical. These electronic devices have excellent image reciprocity over extremely wide dynamic ranges eliminating one of the main problems with film astrophotography. They also offer easy computer manipulation of astronomical images, such as unsharp masking, addition of multiple short exposures, contrast and brightness stretching, color enhancement, all of which theoretically could be performed in the darkroom with films and plates but with extreme difficulty. In addition, the digital data from modern electronic chips allows precise photometric measurements of star brightness far exceeding the ability of photographic emulsions to be used for stellar photometry. By

2010 film and photographic plate imaging for astronomical use was replaced by ever evolving digital imaging techniques.

One disadvantage of modern digital imaging is the small size of the imaging chip (~3–40 mm square) compared to large photographic plates (up to 14-inches square). Large astronomical photographic plates are no longer being manufactured. Fortunately, digital single lens reflex cameras (DSLRs) now offer chips equivalent in size to previous 35 mm film (24 × 36 mm) and with costs similar to previous film 35 mm single lens reflex cameras. More sophisticated digital cameras with CCD and CMOS chips of various sizes are now in widespread use for astronomical imaging. In advanced professional astronomy large electronic chips can be placed in a mosaic lattice to gain wider fields of view. These are still very expensive and used mainly for advanced professional work or for space missions.

Fig. 6.2 (a) M13 on the night of March 19/20, 1988, as part of Photographic Messier Marathon (Hunter and Knauss 1988). Twenty-four-inch f/5 reflector at the Grasslands Observatory, hypersensitized Konica SR-V 3200 film, 2-minute exposure. (© Tim B Hunter, 3towers, LLC, 2022. All Rights Reserved). (b) Modern digital image of M13 with Canon EOS Ra camera at ISO 1600, 400-second exposure (6.66-minutes), Takahashi Epsilon 180 f/2.8 astrograph, image cropped and enlarged for comparison with Fig. 6.1a. (© Tim B Hunter, 3towers, LLC, 2022. All Rights Reserved)

Fig. 6.2 (continued)

2.1 Film Speed; Bayer Array; Digital ISO

Film speed represents the sensitivity of a given film or photographic plate to light. A very sensitive film is said to be fast, while an insensitive film is said to be slow. Photographic emulsions after development deposit micron sized metallic silver grains and/or dyes (in the case of color emulsion) onto the photographic plate or film base. Generally, fast films have larger grains with less spatial resolution than slower films with finer grains with more resolution. The current standard measurement for film speed is the ISO standard, which replaced the earlier American Standards Association (now named ANSI) ASA scale and the German DIN system.

Films with an ISO 100 or greater generally were sensitive enough for many astrophotographic applications. For example, Kodak 103a-F spectroscopic 35 mm film was specifically designed for the 450–680 nm portion of the spectrum (most of the visible spectrum). Experiments by WE Pennell in 1975 (Pennell 2022) showed this film was slightly faster than Kodak Tri-X film, one of Kodak's first high-speed black and white films introduced in

sheets in 1940 and in 35 mm and 120 format in 1954. Tri-X was listed as ASA 200 (roughly ISO 200) but could be pushed to ASA 400 (roughly ISO 400) or beyond by special darkroom development. Kodak 103a-F was grainy but did not suffer as much from reciprocity failure and had better sensitivity to hydrogen alpha emission than Kodak Tri-X.

One of the most noted astrophotographers in the film era was Edward Kreimer whose magnificent black and white photographs were displayed in the classic book *The Messier Album* (Mallas and Kreimer 1978, 1997). He used a low-temperature camera to cool Tri-X film to minus 109° F and could obtain images of 19th magnitude stars in 8–10-minute exposures with a 12 ½ f/7 reflector. He also employed special darkroom techniques to enhance his images. ISO 1000 – 3200 was often preferred by astrophotographers for long exposures of faint objects, particularly with a film known for its low reciprocity failure or with a film that had been hypersensitized (Hunter and Knauss 1988).

Digital single lens reflex cameras are quite common and have replaced film single lens reflex cameras with the digital chip, either reduced in size (APS-C) or full frame 24 × 36 mm, acting in place of the 35 mm film strip. Mirrorless digital cameras have also been introduced. In this case the sensor is closer to the lens mount allowing for lenses with improved performance. The newest DSLR or mirrorless systems often have an electronic viewfinder (EVF) or LCD screen on the back of the camera letting one see exactly the field and focus. The AstroPix website has a superb overview of imaging cameras for amateur astronomers and an extensive table of Nikon and Canon camera models detailing some of their specifications and their date of introduction (Lodriguss 2021).

Special DSLR cameras have been introduced specifically for astrophotography. They are often mirrorless systems and have different filters embedded in the camera in front of the imaging chip compared to standard "daylight" DSLRs. These astrophotography cameras usually have a limited production run and may not be useful for routine daytime photography. They typically have been designed to be more sensitive to the hydrogen alpha emission line at 656.3 nm in the far-red portion of the visible spectrum to accentuate emission nebulosity and regions of star formation.

Some of the DSLR cameras specifically modified for astronomical use are the Canon 20 Da, the Canon 60 Da, The Canon EOS Ra, and the Nikon D810a. These cameras are a wonderful compromise between a less expensive off the shelf simple digital camera on the one hand and a dedicated monochromatic high quantum efficiency CCD or CMOS camera specifically designed for astronomical research on the other hand. The latter cameras have greater quantum efficiency (QE) and good reciprocity over a very

large exposure range from seconds to several hours. They are intended to be used with standardized professional astronomical filter systems for astronomical research, such as photometry and astrometry. They also cost a factor of 5 to 10 times more than an advanced DSLR camera designed for astrophotography and are mostly used at the prime focus of large, long focal length telescopes.

The DSLR cameras intended for standard photography or specifically designed for astrophotography are *single shot color (SSC) cameras* producing a final color image as opposed to most CCD or CMOS professional astronomical cameras which produce a monochromatic (black and white) image obtained through a particular filter. There are single shot color digital cameras designed for use at the focal plane of longer focal length telescopes like the more common monochromatic systems. Such single shot color cameras and their monochrome counterparts usually have larger pixels in their chips which provides mores sensitivity but limits their best use to systems with focal lengths beyond 2000 mm and are not usually applicable for use with a telephoto lens.

All single shot color cameras with a CCD or CMOS chip use a **Bayer Array** with an individual red, green, or blue filter on each pixel to synthesize color information from a grayscale sensor. This Color Filter Array (CFA) was invented in 1974 by Bryce E Bayer (1929–2021), a Kodak engineer. Out of each four-pixel groups two will be green, one red, and one blue. Human perception is most sensitive to brightness (luminance) information in the green portion of the spectrum. By emphasizing information from the "green" pixels there is more perceived definition in the final image. The final color displayed for each pixel is determined by a complex mathematical algorithm using information from the color of pixels surrounding it (Lodriguss 2021). There are many proprietary modifications of the traditional Bayer array. It is fair to say without the Bayer array or its modification modern color imaging would not be possible.

Astronomical digital single lens reflex cameras are most used with telephoto lenses or with smaller wide-field telescopes, such as 80–200 mm diameter refractors, or specially designed short focal length reflecting telescopes 4–14 inches in diameter. Many of the images in this book were obtained with a Canon EOS Ra camera attached to a Takahashi Epsilon 180 f/2.8 astrograph (diameter 180 mm, focal length 504 mm). For exposures longer than a few seconds the camera lens/telescope combination must be guided on the sky using an appropriate properly polar aligned equatorial mount.

Film sensitivity is judged by its ISO listing. Digital Single lens reflex camera sensitivity is more difficult to judge. These cameras have an ISO

setting which usually ranges from 100 to 64,000, sometimes even higher. One can set such a camera in automatic mode where the exposure, ISO, and even the focus is performed automatically. Automatic mode rarely works for astronomical imaging which requires manual focusing and manual exposure setting. The ISO is also manually chosen by the observer. Changing the ISO setting usually does not change the sensor sensitivity.

Changing the ISO setting may increase the sensor gain or simply increase linear digital scaling of the image. This depends on the camera and its chip. Most astrophotographers using DSLRs experiment with their camera taking a series of short exposures at each ISO setting and then adjusting all the RAW image files to obtain the same image brightness using the exposure control setting. In this manner, one can see which ISO gives the least noisy image. Our personal experience with Canon 20 Da, Canon 60 Da, and Canon EOS Ra cameras is an ISO setting of 800–1600 gives the best results. Some cameras may be "ISO-less or "ISO invariant" where ISO is simply a digital scale setting.

An interesting question is whether film ISO is equivalent to ISO on a digital camera. The best answer to that question is: "who knows?" Our own experience is they are in the same range with respect to limiting star magnitude or reflection (blue) nebulosity density. What we achieved with 1–3-minutes exposures on high-speed sensitized film in the ISO 400-3200 range is roughly equivalent to what we obtain using a Canon 20 Da, Canon 60 Da, or Canon EOS Ra camera at the same ISO using the same or similar optical equipment. The film ISO standard is based on film density under very specific exposure and development conditions. As noted above, DSLR ISO is much less well defined and very dependent on the camera and imaging chip.

2.2 Noise

There are several sources of noise in every image, and a detailed discussion of noise is beyond the purview of this book other than to make a few summary remarks (Wright, April 2018). One always wants to get the greatest signal to noise (S/N) ratio for any image, but there are many hurdles and compromises along the way. The S/N ratio is increased by increasing the signal, usually through longer exposures or through adding together multiple shorter exposures. Adding together several images works, because the signal is constant and reinforced, while the noise is random and averaged out.

There are many ways of adding images. For a specific pixel x, y location in the final image, one common method is to average the pixel value at that location for all the images being combined. Another common method is to use the median value instead of the average value. Other more complex methods of combining images may be used having their advantages and disadvantages. Modern computers with digital images make this relatively simple, though similar techniques can be used in the darkroom for photographic plates, obviously requiring considerably more work.

The S/N is a function of the square root $\sqrt{}$ of the signal. If the signal increases by a factor of 2 the S/N ratio increases by a factor of the square root of 2 or ~ 1.41. To achieve an image with stars a magnitude fainter (2.512 times fainter per increase in magnitude achieved), you would have to increase the exposure approximately $(2.521)^2$ or roughly 6.3 times. While reciprocity failure is not a problem with modern digital imaging systems, sky background fog from natural sky glow, the Moon, or light pollution will limit the length of an exposure beyond which the increasing background noise decreases the S/N ratio and longer exposures are not useful. In this case the addition of multiple shorter exposures must be used.

Noise is random from one image to the next, but there are conditions which predictably increase the noise and there are procedures that can predictably decrease noise. Traditional film astronomical photography has two main sources of noise, film grain, and "shot noise." Shot noise, quantum mottle, results from the random striking of photon on the emulsion with noise increasing for shorter exposures and less sensitive film. These sources of noise can be theoretically reduced by choosing a film with less grain and taking longer exposures, though there are complex tradeoffs between less sensitivity with finer grain film and film reciprocity failure with more sensitive film and longer exposures.

For electronic images there remains shot noise as always. Short exposures have more relative noise, quantum mottle, than longer exposures. As always, the more photons the better. More photons are obtained with a more sensitive system, a longer exposure, or stacking of many shorter exposures. An annoying source of noise is dark current in which a sensor accumulates signal from thermal energy, heat in the chip. To reduce this noise one can cool the camera, stack many frames, and subtract a *dark frame*. High quality astronomical CCD and CMOS cameras have cooling systems to reduce the imaging chip temperature by 50 °C or more. Some professional cameras even have liquid cooling systems with liquid nitrogen as a coolant. DSLR cameras have no cooling systems and may have increased noise if the ambient temperature is high. Fortunately, modern CMOS chips in the current DSLR cameras have good tolerance for high ambient temperatures and relatively low dark current and read out noise.

Dark frames for high end CCD and CMOS astronomical cameras are obtained by taking exposures with the objective lens or mirror covered or with the camera shutter closed so no light meets the imaging chip. Usually, multiple dark frames of different exposures are taken, and a master dark frame is often made to represent most of the expected dark noise for one's application. This frame is mathematically subtracted from the exposure frames to remove most of the dark current noise. *Bias frames* and *flat field images* are also used in modern digital imaging applications to reduce noise and improve the cosmetic appearance of a final image. Their discussion is beyond this book, but many sources are available to help one with digital image processing, such as Gendler (2013).

Dark current per se does not exist for film emulsion, but the equivalent of it occurs when an emulsion is subjected to high or low temperatures outside its expected range. The temperature for the developer solution in the darkroom is especially critical. If the development temperature is not exact, the film may be underdeveloped giving poor sensitivity and a fainter image or be overdeveloped with fogging and significant loss of sharpness with increased grain.

All electronic devices have an associated read noise. As each image pixel is read out random electrons are lost or gained causing the readout signal to vary a bit. For high signals (bright objects) this is of little consequence. For low signals (faint objects) this can be significant. Since the read noise and dark current in modern CMOS chips is much improved over earlier designs, it is best to experiment with camera exposure and ISO settings for one's own observing conditions (Wright, September 2018).

3 Modern Color Imaging of the Barnard Objects

3.1 Color Photography

3.1.1 Additive Color

James Clerk Maxwell (1831–1879) introduced the concept of color photography in 1861 when he combined images through red, green, and blue filters to produce a final color image. The photographer for Maxwell was Thomas Sutton (1819–1875) who also created the first single lens reflex camera in 1861. Prior to that time photographic portraits and other scenes were sometimes hand colored. Even today, modern digital techniques allow amazing life-like coloration of old black and white photographs and motion pictures.

The French physicist Louis Ducos du Hauron (1837–1920) developed a trichrome process of color photography in 1869 in which a scene was separately photographed through green, orange, and violet filters. Then, each of the resulting negatives were printed on thin sheets of bichromate gelatin containing carbon pigments of red, blue, and yellow, the complementary colors of the negatives. When these positive transparencies were superimposed, a color photograph resulted. This system worked well but never became practical. Other additive color photographic processes were introduced in the late 1800, such as the Kromogram developed in 1897 by Frederic Eugene Ives (1856–1937) and the Joly Process introduced in 1894 by Dr. John Joly (1857–1933) of Dublin (Science+Media Museum 2020).

In 1907 the Lumiere Brothers Auguste (1862–1954) and Louis (1864–1948) introduced the first commercially successful color photographic process. They had earlier in 1895 introduced the first practical projected motion pictures system. The Autochrome Lumiere process was an additive color mosaic screen process and the principal color photography method until subtractive color film was introduced in the late 1930s. Autochrome plates were easy to use in existing cameras, but they were very insensitive requiring exposures of 1-second or more even in bright sunlight. The Autochrome process and other competing processes at that time were based on the concept of screens of microscopic color filters deposited on the photographic plate with its photosensitive emulsion.

The additive color process works well for making transparencies (i.e., traditional slides). It has the disadvantage of having to use filters which blocks light and increases exposure time, often producing dense transparencies. To view these color images transmitted light is necessary, which means using a projector or a special viewing device.

3.1.2 Subtractive Color

The primary colors are considered red, green, and blue (RGB, "natural color"). White is the result of adding red, green, and blue together in the right amount. A complementary color absorbs a primary color. For example, cyan (blue-green) absorbs red light and is thus a complementary, subtractive color to red. Magenta (blue-red) is complementary to green and yellow is complementary to blue. Superimposing complementary colors in various proportions can be used to reproduce any range of other colors. In the additive process images through red, green, and blue filters are added in some fashion. In the subtractive process color comes from dyes or pigments rather than colored filters. A cyan image is like a red filter used in an additive

process. In a subtractive system white is represented by clear glass or white paper rather than light going through three primary color filters. Subtractive colors work with reflected light not transmitted light allowing them to be used for color photographs on paper.

Commercial color photographic print photography became widely available in the 1930s. A commercially popular system was the Vivex process invented in 1928 by Douglas A Spencer (1901–1979). The Vivex process produced high quality standardized color prints from color-separation negatives. The Vivex system required the color separation negatives to be made on three separate photographic plates. Many attempts were made to combine them into a single unit or tripack, obviating the need for specialized color cameras or repeating backs fitted with different filters.

The most important color photography breakthrough was the development of Kodachrome which went on sale in 1935 for use in 16 mm cine cameras, and in 1936 35 mm Kodachrome film became available. Kodachrome was a black and white film to which colored dyes were added during the development of the film, which involved repeated use of a developing solution, dyeing, and selective bleaching, a complex system that could only be performed in a Kodak laboratory. No one could develop their own film. It had to be sent back to Eastman Kodak laboratories in Rochester, New York (Science+Media Museum 2020).

Agfa, a German company also introduced a multilayered color film Agfacolor-Neu in 1936. Color anchoring couplers were present in the individual emulsion layers making Agfacolor film easier to process. It could even be processed by the user at home. In 1942 Kodak introduced the Kodacolor brand a negative-positive color film (negatives which when printed produced standard color prints). This became the most popular color film as Kodak improved its quality, speed, and price over the next 20 years (Touche 2017).

By the 1970's the sensitivity and pricing of color films was comparable to black and white films somewhat putting black and white films out of use. Instant color film was also popular having been introduced by Polaroid in 1963.

A color astrophotograph obtained digitally is a composite image derived from three monochromatic images taken through filters for different wavelengths, such as traditional red, green, and blue filters. Single shot color (SSC) cameras whether used for astrophotography or ordinary daytime photography work similarly. In the case of single shot color cameras, a Bayer array is used with the camera's imaging chip to essentially combine images through different filters.

Most astronomical objects like nebulae, star clusters, and galaxies are simply too faint to show much if any color when viewed visually even

though very large telescopes. Our faint vision uses the rods in the retina which give us no color sense. Our color sense comes from the retinal cones which need considerable signal to be triggered. When we see a color image of an astronomical object, is that how it looks? What is true color? This is more a philosophical issue rather than a scientific issue.

Many astrophotographers try to produce images that show an object how it might look if we could view it close-by or if we had super enhanced color vision (Markuse 2022). That is, we show the image with RGB, so-called natural color. What is color vision for one person may not represent exactly the colors seen by another, though most of us probably see colors approximately the same. Color is the result of the eye brain system and relies on the brain interpreting signals from the eye. Someone who is "color blind" sees the world differently than someone who is not color blind. There may be a small group of individuals that have enhanced color sense compared to the average, and it is certainly true we do not see the world in the same fashion as an eagle or a dog.

Many professional and amateur color images use coloration that shows an object not as it would look to the human eye. For example, the famous "Pillars of Creation" image of a portion of the Eagle Nebula (NGC 6611, M16) taken with the Hubble Space Telescope (HST) is a composite image through filters with wavelengths of 673 nm, 657 nm, and 502 nm mapped to the red, green, and blue color channels, respectively (Markuse 2022). 673 nm is a red color as is 657 nm, but the latter was mapped to the green channel. 502 nm is greenish, but it was mapped to the blue channel. The resulting image is stunning but not as we would see the nebula with our own eyes with enhanced color vision. Yet, it is not a fake image as it represents the chemical makeup within the object.

Professional astronomers use "color" images to study the chemistry and physical properties of an object and do not worry about the color being "real." It is quite common for Hubble Space Telescope images and images from many planetary probes to use color in this way. Processes astronomers want to study may be more evident, and the resulting images may be more spectacular, not a small consideration for NASA and ESO who are always looking to enhance their public image. In addition, many of these images contain information obtained from exposures taken through ultraviolet or infrared filters, wavelengths not visible to the human eye. The James Webb Space Telescope (JWST) promises to produce stunning never before images of the early Universe, and it only images in the infrared and far-red visual wavelengths.

Most color digital astronomical images have three color channels representing red, green, and blue. More than one data set can be assigned in varying combinations to those channels, and the resultant image often pro-

duces an unnatural color with respect to human vision but color that is helpful for understanding the composition and processes affecting the astronomical object being imaged. Astronomers are interested in the energy an object emits or absorbs and by using the ranges of colors, these physical properties can be detected and analyzed.

The Hubble palette uses color assignments that do not reflect the natural colors visualized by most persons. This is for two reasons. First, the image is often more aesthetically pleasing. Second, it better represents the data collected by the telescope (AstronomyMark 2020).

The following wavelengths are commonly used in professional images and sometimes the Hubble palette:

Wavelength	Natural color	Assigned color
673 nm ionized sulfur S-II	Red	White
568 nm ionized nitrogen	Red	Orange
656 nm hydrogen alpha, Ha	Red	Brown
502 nm doubly ionized oxygen O-III	Blue/Green	Cyan
469 nm ionized helium	Blue	Blue
373 nm ionized oxygen	Not visible	Violet

The Hubble Palette or Hubble Colors usually refers to ionized sulfur S-II which is assigned to red, hydrogen Ha which is assigned to green, and doubly ionized oxygen O-III which is assigned to blue, the so-called "SHO Hubble Palette" (Hubblesite 2022). These filters are used because nebular colors result mainly from various gases which glow or reflect light at specific narrow band wavelengths, like hydrogen alpha at 656 nm or doubly ionized oxygen at 502 nm. Narrowband filters centered around these specific wavelengths enhance the features of these gases in each astronomical body.

The wide field color images in this book were taken with a Takahashi Epsilon 180 f/2.8 astrograph (180 mm diameter, 504 mm focal length) or a telephoto lens combined with a digital single shot color camera, usually a Canon 60 Da or a Canon EOS Ra camera. Multiple images (10 to 20) with exposures of 300–600-seconds were combined for each object most often using median combination of the images to reduce or limit satellite and airplane trails and to increase the signal to noise ratio.

The more detailed images taken with a PlaneWave CDK 24-inch f/6.5 telescope or an ASA20 20-inch f/3.6 astrograph were obtained with a Finger Lakes Instrumentation Proline KAF9000 CCD on each telescope using a LRGB (Luminance Red, Green, and Blue) processing technique. LRGB is a the most popular technique used by amateur astronomers for color astrophotography. It combines a luminance (white or clear) exposure with R, G, B exposures for a final color image.

The luminous exposure is typically through a "clear" ultraviolet-infrared blocking filter which allows transmission of most of the visible spectrum onto the imaging chip. Ultraviolet and near-infrared are blocked as these may be picked up by the imaging chip and cause color shift and focusing issues. Considerably greater light strikes the chip with this filter than through the individual R, G, and B filters. The clear or luminance filter has a bandpass width of around 300 nm (from approximately 400–700 nm, deep blue to deep red, respectively) while the R, G, and B filters typically have a bandpass width of approximately 100–150 nm centered around 650 nm (Red) 550 nm (Green), and 450 nm (Blue).

In most cases multiple exposures are taken through each filter with master luminous, red, green, and blue images being made prior to combining them into a final color image. Bias, dark, and flat-field images are commonly obtained for most astrophotographic applications and are used in the processing routine. Also, if one wants to have a "natural" coloration for their astrophotographic images, color calibrations against a standard is another feature that must be considered in the processing routine (DSLR Astrophotography). A detailed discussion of astrophotographic imaging and image processing is not the focus of this book. There are multiple web sources and excellent reference publications covering these subjects (Clark R, Gender R, Lodriguss J, Markuse P, Wright RS).

3.2 UBV and Other Photometric Systems

The R, G, B filters used in many color imaging applications in astronomy are not well defined and are varying in their bandpass and transmission efficiency depending on the manufacturer. They are generally not accepted for accurate astronomical photometry applications, such as measuring stellar magnitudes. The UBV (Ultraviolet, Blue, Visual) photometric system is a well-defined metric for classifying stars according to their colors. It was the first widely accepted standardized photometric system. The choice of the colors favoring the blue portion of the spectrum was motivated by its introduction in the 1950's during the photographic era of astronomical imaging where blue sensitive photographic plates prevailed.

Harold Lester Johnson (1921–1980) and William Wilson Morgan (1906–1994) developed the UBV system at McDonald Observatory in Texas introducing it in the early 1950's first using it to produce a color-magnitude diagram of the Pleiades (M45) (Johnson and Morgan 1951). The filters are centered around wavelengths 366 nm for U, 436 nm for B, and 545 nm for V with broadband widths of U 65 nm, B 89 nm, and V 84 nm (Bessel, 2022), though there is slight variation in these numbers depending on the

reference cited. In the development of the UBV system, B was devised to approximate the raw photographic magnitude (less the ultraviolet), while the V band was to approximate the visual magnitude system.

The photographic magnitude is centered around 425 nm, and the peak sensitivity of the human eye is around wavelength 550 nm (Hawaii, 2002). The fluxes in the Johnson system are normalized to Vega which is defined as having a V magnitude of 0.0 (Bessell 2005a, b). This also assumes there is no significant interstellar absorption of starlight by intervening dust and gas. The U band provided additional information between the B band and the short wavelength cutoff of ultraviolet radiation by the atmosphere (Bessell 2022). Bandwidths are usually expressed as the full width at half maximum (FWHM). This assumes a symmetric spectral curve around a maximum value with equal distribution of the curve on either side of the maximal value.

The original UBV system did not cover the red and near-infrared portions of the spectrum as most scientific films and early photomultiplier tube systems for measuring stellar magnitudes were insensitive or completely unresponsive to that portion of the spectrum. The UBV system was later extended to the UBVRI system. This extension was motivated by the work of Alan William James Cousins (1903–2001) who used a newly available red sensitive photomultiplier tube in the 1990's and the extensive stellar photometric work of Gerald Kron (1913–2012) who was the first astronomer to describe a starspot on another star. Kron later became the Director of the United States Naval Observatory in Flagstaff, Arizona.

The UBVRI system is now the main standard photometric system in astronomy where visual wavelength imaging is the focus. It carries a variety of names, such as the Johnson/Bessel, the Kron/Cousins, the Johnson Cousins and the Cousins-Johnson system, the latter being the most common. These systems are not identical, though quite similar, but the filter specifications for R (red) and I (near-infrared) vary a bit. In general, the U, B, and V filters are the same, the difference being in the specifications for the R and I filters. Some may be better suited for use with a photomultiplier tube and others better suited for use with silicon CCD and CMOS chips.

The R, G, B images obtained at the Grasslands Observatory with the Finger Lakes Instrumentation Proline KAF9000 CCD uses Cousins-Johnson R, V, B, and I filters, as well as a narrowband 5 nm hydrogen alpha filter. Images from these filters are combined in similar fashion to more traditional R, G, B filters to produce color images. The "photometric" VBRI filter set was chosen in lieu of a more traditional (and less expensive) R, G, B set, because any resultant image could be more easily used for photometric applications as the filter set is accepted for use in professional astronomical circles.

The UBV system uses broadband filters with passbands wider than 30 nm. Intermediate band filters usually have passbands 10–30 nm, and narrowband filters are less than 10 nm wide.

Common narrowband filters used in professional astronomy are the hydrogen alpha filter centered at 656.3 nm, the Oxygen III filter centered at 500.7 nm, and the Sulfur II filter centered at 672.4 nm as noted above in the discussion of the Hubble Palette.

Another widely used system is the Stromgren intermediate band *uvby* system. The JHKLM system is an extension of the UBV system into the infrared. These band are matched to the same named windows in which the atmosphere is transparent to infrared wavelengths (Hawaii, 2002). Many observatories have their own photometric systems that are tuned to their instrumentation, atmospheric conditions, and their lines of research. There are also ultra-broad band systems used mainly by surveys such as the Sloan Survey and the Hipparcos Satellite (Bessell 2005a, b).

In addition, there is a hydrogen beta filter which isolates the hydrogen beta line at 486 nm. This filter is for visual use for viewing the Horsehead Nebula (Barnard 33, IC 434) and the California Nebula (NGC 1499). There are several types of light pollution or deep sky filters designed to eliminate the background glow of street lighting either for visual observing or for astrophotography. Many amateur astrophotographers uses these filters in light polluted condition for urban and suburban skies. Such filters reduce the amount of light reaching the imaging chip. Their main advantage is they increase contrast and highlight nebular emission regions significantly. They may highlight reflection nebulosity and galaxies but are less effective in that regard. They may also highlight the contrast between faint stars and the background sky. Light pollution filters do require increased exposures to image fainter stars, and they will shift the color somewhat, usually producing a more pleasant image with better contrast.

3.3 Imaging the Barnard Objects at the Grasslands Observatory

The Grasslands Observatory (http://www.GrasslandsObservatory.com) is located on 20 acres in rural southeastern Arizona halfway between Sonoita and Elgin, Arizona. This region is mainly rolling grasslands at 5000-foot altitude with distant mountains in all directions. The observatory was established in 1987 with a 24-inch f/5 Newtonian fork mounted telescope contained inside a 20 × 20-foot roll-off roof building. The original 24-inch telescope was mainly used for visual observation at the Newtonian focus. Later imaging was performed at the Newtonian focus.

Since 2015, the observatory complex has upgraded dramatically now being designed for remote imaging using three main telescopes: (1) PlaneWave CDK24 24-inch f/6.5 telescope fitted with a Finger Lakes Instrumentation Proline KAF9000 CCD and Cousins-Johnson B, V, R, I, and hydrogen alpha filters; (2) ASA20 20-inch f/3.6 astrograph fitted with a Finger Lakes Instrumentation Proline KAF9000 CCD and Cousins-Johnson B, V, R, I, and hydrogen alpha filters; and (3) Takahashi Epsilon 180 f/2.8 astrograph currently fitted with a Canon EOS Ra full 35 mm frame astronomical single shot color camera.

Most images displayed on the Grasslands Observatory website and most of the illustrations in this book show astronomical objects with north to the top and east to the left, the standard astronomical orientation. This is to provide consistency in image display and orientation from object to object and from year to year. Barnard oriented all his images similarly making direct comparison of our current images with his images considerably easier.

In 2016 a project was started at the Grasslands Observatory to image all the Barnard Objects listed in *A Photographic Atlas of Selected Regions of the Milky Way (1927)* in color using modern digital imaging techniques and to compare these images with those of Barnard and his colleagues from 100 years ago. Barnard's collection of objects in his 1927 *Atlas* is extremely eclectic. The dark objects he listed range in size from approximately 1 arcminute to 270 arcminutes in greatest dimension. Most are 30 arcminutes or smaller. The opacity of the objects was not specifically assigned by Barnard, but others have assigned a relative density value to them ranging from 1 least dense to 6 most dense.

It is not known specifically what photographic plates and emulsions Barnard used for the images illustrated in the *Atlas*. Many of them were obtained when he temporarily set up the Yerkes Bruce Telescope at Mount Wilson in 1905. He often listed the date, negative number, and exposure times for his published photographic illustrations, but he rarely listed which specific photographic plate and emulsion he used for a particular image.

It is reasonable to assume Barnard used high-contrast commercial plates that had sensitivity to near-ultraviolet and blue light with minimal or no sensitivity to the green, yellow, orange, and red portions of the spectrum. Also, any available published or online images derived from the *Atlas* were obtained by digitization of the prints in a one of the original printed copies of the *Atlas*. There are no known digital images from direct digitation of his Milky Way wide-field glass plates. Therefore, Barnard's images that we presently have for study are bound to suffer considerably from these limitations. The objects he identified would appear to us darker and more contrasted against the starry background than would be shown if we could examine his original glass plates.

When comparing historic and modern images, one can look for different presentations of astronomical objects due to changes in technology and differing spectral sensitivities as has been discussed. It is probably more important to look for changes in astronomical objects from a prior image whether that image is from last week, last year, or a century ago. Such changes would include novae, supernovae, variable stars, asteroids, comets and change in nebular structure. A more important aspect is the astrometry, the proper motion of stars. These are more easily detected and measured over longer periods of time. As such, Barnard's images provide astronomers with a wealth of data that truly needs to be harnessed.

Barnard often compared current images with previous images of the same region with a blink comparator which is how he discovered the close, rapid proper motion red dwarf star in Ophiuchus now known as Barnard's star. He also made the first photographic discovery of a comet on the night of October 12, 1892, when he noticed a "…narrow hazy streak…" on a photographic plate he took near Altair which had not been present on a plate of the same region on September 26th (Barnard 1892).

Barnard's friend Max Wolfe made the first photographic discovery of an asteroid in 1891, and he advocated photographic surveys for asteroid discovery. They could be noted by the streak they made against background stars if the exposure were long enough to streak their motion versus background stars that remained rounded dots due to the compensating clock drive motion of the telescope during the exposure. Comparison of images of the same region on different times of the night or on different days could also show a "star", i.e., the asteroid that had changed positions between the exposures. Wolf also "…was one of the first to use the stereoscopic method for detecting proper motions of stars, by comparison of plates taken some years apart" (Nature, 1933). The ongoing modern effort to digitize and make available online as many photographic plates as possible from observatories around the world emphasizes the utility of easily having prior, possibly decades old, images for comparison with recent images.

Most of the Barnard Objects imaged in color at the Grasslands Observatory were obtained with wide-field techniques, mainly with a Takahashi Epsilon 180 f/2.8 telescope using a Canon EOS Ra camera (field size 4.1 × 2.7°, 2.2 arcseconds/pixel) or a Canon 60 Da camera (field size 2.6 × 1.7°, 1.8 arcseconds/pixel). The exposure techniques varied with the sky conditions, object size and brightness, and object azimuth and altitude. Generally, exposures of 500–800 seconds can be obtained without obvious sky glow degradation. ISO 1600 produces images with the least noise.

Telephoto images with a Canon 200 mm lens and a Canon EOS Ra camera give good coverage of a field of 10.3 × 6.8° not too dissimilar to most of Barnard's wide-field work with the Yerkes Bruce Telescope using 12 × 12-inch glass plates. Barnard obtained exquisite star definition over a 7-degree field

and fairly good stellar definition over 9°. In our case multiple median combined 180–300-second exposures with the 200 mm telephoto lens and the Canon EOS Ra camera set at ISO 1600 produced images with a fainter limiting magnitude than those of Barnard displaying much nebulosity not evident on Barnard's plates (Figs. 6.3, 6.4, and 6.5; **see also figures in** Chap. 7).

Fig. 6.3 (**a**) Digitized version of Plate 7-Region of the Cluster Messier 37 in Auriga from *A Photographic Atlas of Selected Regions of the Milky Way* edited by Edwin B Frost and Mary R Calvert, reprinted under the direction of Gerald Orin Dobek, 2011, Cambridge University Press, Cambridge, UK. Permission granted for use of image by Gerald Orin Dobek. (**b**) 200 mm f/3.2 telephoto lens image with Canon EOS Ra camera, ISO 1600, 420-second exposure obtained to resemble Plate 7-Region of the Cluster Messier 37 in Auriga as shown in *A Photographic Atlas of Selected Regions of the Milky Way*. Barnard 34 is the large vacant area to the west (right) of M37. M36 is the cluster along the right edge of the image with Barnard 226 below M36. Image by James McGaha and Tim Hunter. (© Tim B Hunter, 3towers, LLC, 2022. All Rights Reserved)

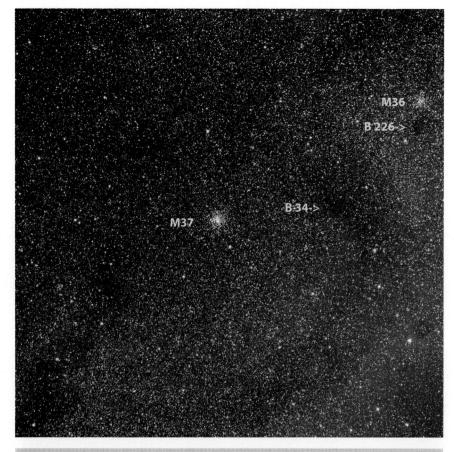

Fig. 6.3 (continued)

Higher resolution images of selected Barnard Objects were taken with PlaneWave CDK24 24-inch f/6.5 telescope and the ASA20 20-inch f/3.6 astrograph as noted above. Several of these images are displayed and discussed elsewhere in the book, particularly in Chap. 7-Selected Important Barnard Objects and Chap. 9-Conclusions: the Barnard Objects Now. All images of the Barnard Objects obtained at the Grasslands Observatory are available at the Grasslands Observatory website: https://www.grasslandsobservatory.com/Grasslands_Content/BarnardObjects/BarnardMain.html.

Processing of modern digital astronomical images is a rapidly evolving field with many imagers spending as much or more time on processing of the images as is spent obtaining them. There are several excellent publications and web sources for help and information on how best to process one's images for a desired result (Clark, Gendler, Lodriguss, Markuse, Wright).

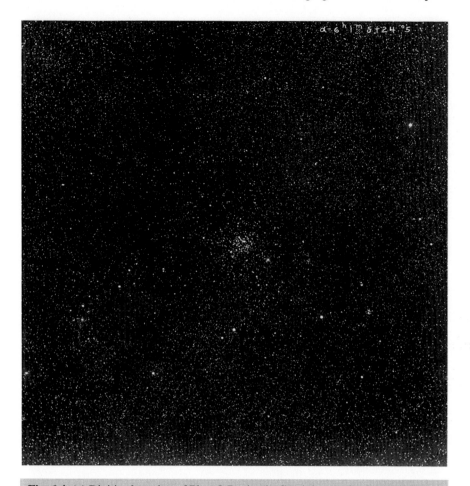

Fig. 6.4 (**a**) Digitized version of Plate 8-Region in Gemini, near the Cluster Messier 35 from *A Photographic Atlas of Selected Regions of the Milky Way* edited by Edwin B Frost and Mary R Calvert, reprinted under the direction of Gerald Orin Dobek, 2011, Cambridge University Press, Cambridge, UK. Permission granted for use of image by Gerald Orin Dobek. (**b**) 200 mm f/2 telephoto lens image with Canon EOS Ra camera, ISO 1600, twelve 120-second exposures median combined to resemble Plate 8- Region in Gemini, near the Cluster Messier 35 as shown in *A Photographic Atlas of Selected Regions of the Milky Way*. Image by James McGaha and Tim Hunter. (© Tim B Hunter, 3towers, LLC, 2022. All Rights Reserved). The bright nebulosity in the lower left-hand corner is IC 443 (the Jellyfish Nebula). This is not evident on Barnard's plate in Fig. 6.4a . (Mars was in the field of view when these exposures were obtained March 25, 2023)

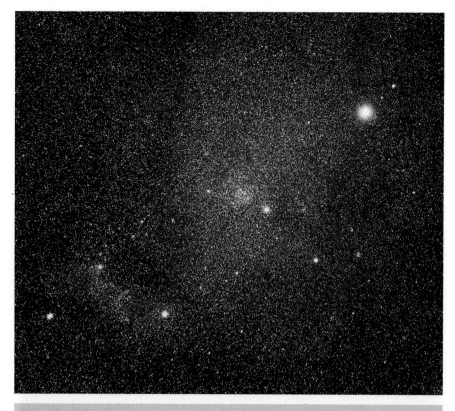

Fig. 6.4 (continued)

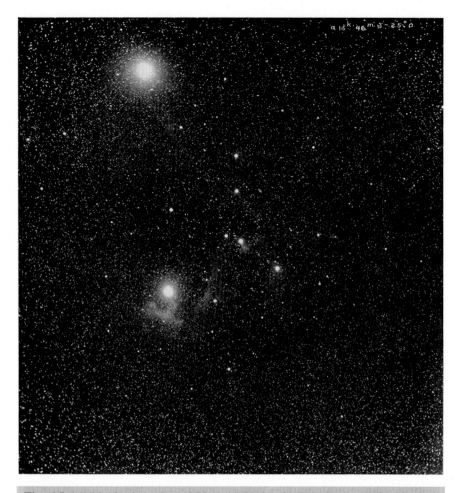

Fig. 6.5 (**a**) Digitized version of Plate 11-Region in Scorpius and Libra from *A Photographic Atlas of Selected Regions of the Milky Way* edited by Edwin B Frost and Mary R Calvert, reprinted under the direction of Gerald Orin Dobek, 2011, Cambridge University Press, Cambridge, UK. Permission granted for use of image by Gerald Orin Dobek. (**b**) 200 mm f/2 telephoto lens image with Canon EOS R modified camera, ISO 1600, ten 180-second exposures medium combined to obtain a modern color image resembling Plate 11- Region in Scorpius and Libra as shown in *A Photographic Atlas of Selected Regions of the Milky Way*. Image by James McGaha and Tim Hunter. (© Tim B Hunter, 3towers, LLC, 2022. All Rights Reserved). There is no Barnard Object on Plate 11. The bright star near the top is Dschubba 7-Delta Scorpii. The red emission nebulosity near Dschubba is Sharpless 2–7. Scattered red emission nebulosity and blue reflection nebulosity is in the center of the image and around Pi Scorpii the bright star below the center of the image. Sharpless 2–1 is the emission nebulosity about Pi Scorpii

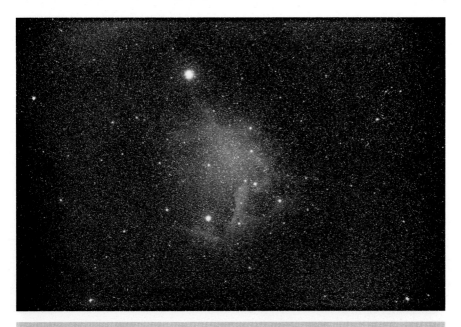

Fig. 6.5 (continued)

References and General Bibliography

Astronomy Mark. 2020. The Hubble Palette: http://www.astronomymark.com/hubble_palette.htm.

Barnard EE. Photographic discovery and visual observations of a comet. Astron J. 1892;12:102.

Barnard EE. Some abnormal stars in the cluster of M 13 Herculis. Astrophys J. 1900;12:170–81.

Barnard EE. On the colors of some of the stars in the globular cluster M 13 Herculis. Astrophys J. 1909;29:72–9.

Barnard EE. Photographic determination of the colors of some of the stars in the cluster M 13 (Hercules). Astrophys J. 1914;40:173–81.

Barnard EE. In: Frost EB, Calvert MR, editors. A Photographic Atlas of Selected Regions of the Milky Way. Washington: Carnegie Institution of Washington; 1927. Online Version at Georgia Institute of Technology: Barnard's Photographic Atlas of Selected Regions of the Milky Way (gatech.edu).

Barnard EE. A Photographic Atlas of Selected Regions of the Milky Way. In: Edwin B Frost, Mary R Calvert, editors, reprinted under the direction of Gerald Orin Dobek. Cambridge: Cambridge University Press; 2011.

Bessell MS. UBVRI Photometry II. The Cousins VRI System, Its Temperature and Absolute Flux Calibration, and Relevance for Two-Dimensional Photometry. Publ Astron Soc Pac. 1979;91(#543):589–607.

Bessell MS. Standard Photometric Systems. Australian National University. 2005a.: araapaper_rev.dvi (anu.edu.au).

Bessell M. Standard photometric systems. Annu Rev Astron Astrophys. 2005b;11(43):293–336. https://doi.org/10.1146/annurev.astro.41.082801.100251.

Carpenter EF, Jepperson R. Color photography of faint objects with special fast film. Astron J. 1959;64:49–50. https://doi.org/10.1086/107859.

Clark R. ClarkVision.com: Astrophotography, Color and Critics Clarkvision.com.

DSLR Astrophotography. Getting the colors right in your astrophotos. October 30, 2016.: Getting the colors right in your astrophotos I DSLR Astrophotography (dslr-astrophotography.com).

Gendler R, editor. Lessons from the masters, The Patrick Moore practical astronomy series. New York: Springer; 2013.

Gendler R. The Universe in Color: index.html (robgendlerastropics.com).

Hubblesite. 2022: The Meaning of Light and Color: https://hubblesite.org/contents/articles/the-meaning-of-light-and-color.

Hunter TB, Knauss D. A photographic Messier Marathon: March 19–20, 1988. https://www.3towers.com/Grasslands_Content/PhotographicMessierMarathon/Marathon.html.

Illuminated Universe: Are hubble images real? Part II: a brief history of astrophotography: Are Hubble Images Real? Part II: A Brief History of Astrophotography – Illuminated Universe.

Johnson HL, Morgan WW. On the color-magnitude diagram of the Pleiades. Astrophys J. 1951;114:522–43.

Kodak. Chronology of Film: https://www.kodak.com/en/motion/page/chronology-of-film.

Lodriguss J. 2021. AstroPix: Astrophotography and Image Processing Tips and Techniques by Jerry Lodriguss (astropix.com).

M.A. Seed Dry Plate Co. St. Louis. The art of negative making. Circa; 1890.

Mallas JH, Kreimer E. The Messier Album. Cambridge: Sky Publishing Corporation; 1978, fourth printing 1997.

Markuse P. 2022. The Thing with Colors in Astrophotography. Photographing Space: The Thing with Colors in Astrophotography PhotographingSpace.com.

Miller WC. First color portraits of the heavens. Natl Geogr. 1959:670–9.

Miller WC. Color photography in astronomy. Publ Astron Soc Pac. 1962;74(#441):457–73.

Pennell WE. Kodak 103a-f spectroscopic 35 mm film. Listed on SAO/NASA Astrophysics Data System (ADS). 2022.: https://adsabs.harvard.edu/full/1975Astr...12....3.

Science+Media Museum: A Short History of Colour Photography. Published 7 July 2020.: https://www.scienceandmediamuseum.org.uk/objects-and-stories/history-colour-photography#:~:text=The%20first%20processes%20for%20colour,as%20'additive'%20colour%20processes.

The CCD Photometric Calibration Cookbook. University of Hawaii. Photometric Systems (hawaii.edu).

Touche A.. A Quick History of Color Photography (for Photographers) June 8, 2017.: A Quick History of Color Photography (for Photographers) (tutsplus.com).

Wallis BD, Provin RW. A manual of advanced celestial photography. Cambridge University Press; 1988. ISBN 0 521–25553 8

Wolf M. Obituary. Nature. 1933;131:353.

Wright RS Jr. An astrophotographer's gentle introduction to noise. April 15, 2018a.: Astrophotography: A Gentle Introduction to Noise – Sky & Telescope (skyandtelescope.org).

Wright RS Jr. Choosing the best (good enough) ISO for astrophotography. September 15, 2018b.: Choosing the Best (Good Enough) ISO for Astrophotography – Sky & Telescope – Sky & Telescope (skyandtelescope.org).

Chapter 7

Selected Barnard Objects

The Barnard Objects compiled in the 1927 Frost and Calvert edition of Barnard's *A Photographic Atlas of Select Regions of the Milky Way* comprise 349 dark objects numbered 1–370 with several sub numbers. There are no Barnard Objects 52, 131a, and 172, as Frost and Calvert felt they were erroneous duplications of other objects. There are also no Barnard Objects 176 to 200. In Dobek's 2011 edition of Barnard's *Atlas* he included Barnard Objects 52, 131a, and 172 (Barnard 2011). Dobek felt these were genuine, non-duplicated objects Barnard had noted in probably the most crowded fields in the sky making it easy for Frost and Calvert to assume they were duplicate entries. Thus, Dobek feels there are a total of 352 Barnard Objects which is the convention we are following in this book. In Chap. 8 we propose and illustrate 25 dark nebular objects for numbers 176–200 based on our interpretation of notes and comments left by Barnard about adding additional dark objects to his catalogue. In the present chapter we have selected what we feel are some of the finest dark nebulae and other objects photographed and described by Barnard.

The Barnard plates displayed herein originate from exquisite digitization by Dobek of prints selected for quality from six copies of the original *1927 Atlas* as well as other selected prints from Barnard's extensive plate collection in the Yerkes Observatory archives. The subsequent TIFF images were downsized to 1400 dpi for printing. "The finest possible print for publication is currently 1200 dpi. This closely matches the original silver-tipped

T. B. Hunter et al., *The Barnard Objects: Then and Now*, The Patrick Moore Practical Astronomy Series, https://doi.org/10.1007/978-3-031-31485-8_7

gelatin photographs that were produced in the 700 volumes published [in 1927]" (Barnard 2011).

Contrasted against the Barnard images are current color digital images of portions of the same regions found on the selected Barnard plates (Figs. 7.1, 7.2, 7.3, 7.4, 7.5, 7.6, 7.7, 7.8, 7.9, 7.10, 7.11, 7.12, 7.13). It would be ideal to show all the Barnard Objects in color in this book, but that is not practical. The online version of Barnard 1927 Photographic Atlas is available from the Georgia Institute of Technology at https://exhibit-archive.library. gatech.edu/barnard/intro.html. Color images of all the Barnard Objects are

Fig. 7.1 (a) Plate 1. Region of the Double Cluster in Perseus. Superimposed white rectangle shows region illustrated in Fig. 7.1b. **(b)** Double cluster (NGC884 and NGC869), NGC957, and Barnard 201. Takahashi Epsilon 180 f/2.8 telescope with Canon EOS Ra single shot color camera. (© Tim B Hunter, 3towers, LLC, 2022. All Rights Reserved)

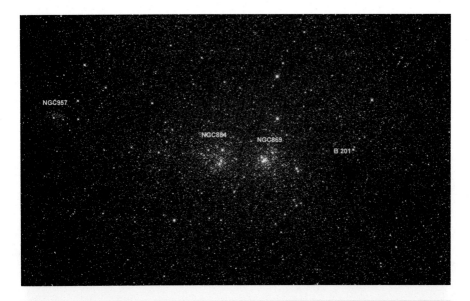

Fig. 7.1 (continued)

Fig. 7.2 (**a**) Plate 3. In Perseus and Taurus. Superimposed white rectangle shows region illustrated in Fig. 7.2b. (**b**). Barnard 1, 2, 3, 4, 5, and IC 1985/348. Takahashi Epsilon 180 f/2.8 telescope with Canon EOS Ra single shot color camera. (© Tim B Hunter, 3towers, LLC, 2022. All Rights Reserved)

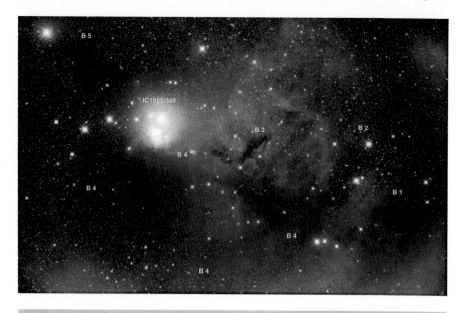

Fig. 7.2 (continued)

available at the Grasslands Observatory website: https://www.3towers.com/ Grasslands_Content/BarnardObjects/BarnardMain.html.

The image scale used by Barnard with the Yerkes Observatory Bruce telescope 10-inch Brashear doublet lens is approximately 9 × 9° for a photographic plate 12 × 12 inches cropped down somewhat for printing the final photograph. The 6 ¼ doublet on the Bruce Telescope used 8 × 10-inch plates to verify findings taken with the larger telescope. The color images presented in this book were mainly taken with a Takahashi Epsilon 180 f/2.8 astrograph which has a focal length of 504 mm. When used with a Canon EOS Ra full frame (36 × 24 mm) single shot color camera, there is a field of view of 4.1 × 2.7° which has a scale 6.8 arcminutes per mm, while Barnard's large plates have a scale of approximately 2.5 arcminutes per mm. This varies a bit depending on how much Barnard cropped the final image for printing.

An image scale like Barnard's largest plates can be obtained with a 200 mm lens coupled with the Canon EOS Ra camera. The resulting image has a field of 10.3 × 6.8°, a roughly comparable field of view in width to a 12 × 12-inch Barnard plate cropped to approximately 9 × 9 inches for printing. It is only approximately ¾ the field of view in length due to the rectangular 36 × 24 mm configuration of the CMOS chip in the Canon Camera.

The Canon EOS Ra camera has 5.36-micron pixels. The Canon 60 Da single shot color camera has 4.3-micron pixels. Barnard rarely mentioned the specific photographic plates he employed, and their grain size is unknown. Silver halide particles in undeveloped modern film average 0.2–2.0 microns (Vitale 2010). The Takahashi 180 astrograph Canon EOS Ra combination has a resolution of approximately 2.2 arcseconds/pixel.

Plate 26 "Great Star Clouds in Sagittarius" was originally printed 9 × 9 inches with 67.5 arcminutes per inch giving a field of 10.1 × 10.1°. Assuming the "grain" size for the photographic plates used by Barnard is 2 microns, the potential resolution on Plate 26 is 0.2 arcsecond per "pixel."

Fig. 7.3 (**a**) Plate 4. Region of the Pleiades. Superimposed white rectangle shows region illustrated in Fig. 7.3b. (**b**) The Pleiades (M45). Takahashi Epsilon 180 f/2.8 telescope with Canon EOS Ra single shot color camera. (© Tim B Hunter, 3towers, LLC, 2022. All Rights Reserved)

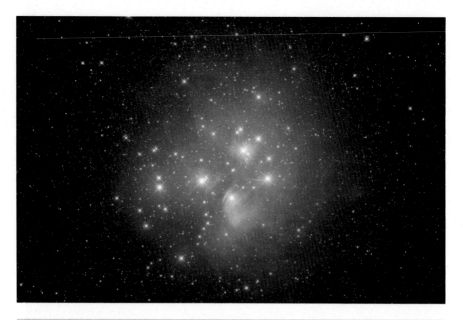

Fig. 7.3 (continued)

However, the resolution is limited to the 1200 dpi for high quality photographic printing. This gives an apparent print resolution of approximately 3.4 arcseconds per pixel, which gives less resolution than the Takahashi 180 astrograph Canon EOS Ra combination (Figs 7.9a–f). If a 200 mm lens is used with the Canon EOS Ra, the image resolution is 5.5 pixels per arcsecond, considerably poorer spatial resolution than potentially available on Barnard's photographic prints (Barnard 1913, 2011).

Barnard was passionate about his photographic study of the Milky Way(Frost 1923) As early as 1890 he realized it was groundbreaking providing an examination of the Milky Way that was heretofore unavailable. "One very important feature, and one which must not be overlooked, is that these are the only photographs ever made, here or elsewhere, which show all the true Milky Way...The photography...of the true Milky Way must be confined to instruments of medium dimensions-with large apertures and small focal lengths-until our plates can be made much more sensitive, or the exposures extended through several nights...In the photographs made with the six-inch portrait lens [Willard Lens at Lick Observatory], besides myriads of stars, there are shown, for the first time, the vast and wonderful cloud forms, with all their remarkable structure of lanes, holes and black gaps and sprays of stars" (Barnard 1890).

The Barnard Objects range in size from 1 arcminute to several degrees. They have a magnificent variation in density in both black and white and color images, ranging from tiny ink spots (Barnard 86 Figs 7.9c–f, and Barnard 92 Figs 7.10b–c) with no visible stars to dusty regions barely distinguishable from surrounding star fields (Barnard 304, Fig. 7.10b).

Detailed comparison of Barnard's plates with modern images of the same regions would no doubt show many subtle changes in some of the objects studied by Barnard. When you examine many of Barnard's plates and compare them to modern images, it becomes apparent that his selection of dark

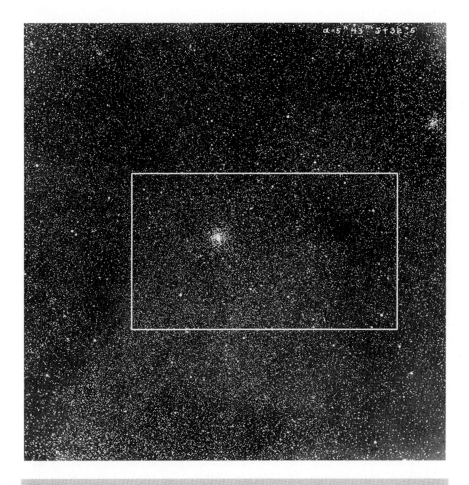

Fig. 7.4 (**a**) Region of the Cluster Messier 37 in Auriga. Superimposed white rectangle shows region illustrated in Fig. 7.4b. (**b**) M37 and Barnard 34. Takahashi Epsilon 180 f/2.8 telescope with Canon EOS Ra single shot color camera. (© Tim B Hunter, 3towers, LLC, 2022. All Rights Reserved)

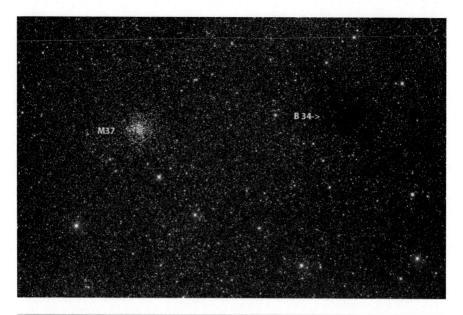

Fig. 7.4 (continued)

objects was at best inconsistent, sometimes noting a small somewhat dense area while seemingly omitting to mention several large dark lanes on the same plate. Plate 1, the region of the Double Cluster in Perseus notes Barnard 201 east of the clusters, while the large dark nebular lanes north and east of the clusters were not specifically noted by Barnard. Much of this area has been noted in other catalogs.

Barnard's numbering system for the Barnard Objects is confusing and seemingly without a defined approach based on size, location, or date of discovery. If he had an orderly method for numbering his objects, he did not specify that in any of his publications. One can look at many of the plates in the *1927 Atlas* to find Barnard Objects of greatly varying size and numbers in the same roughly 9 × 9-degree field of view, such as Plate 3 in Perseus and Taurus.

Barnard struggled for many years over whether these dark areas, "dark nebulae," represented holes in the sky where there were no stars or whether they represented varying degrees of obscuring material obliterating the background stars or some combination of these two (Frost 1923). Near the end of his career, Barnard concluded that most dark nebulae represented obscuring material (Sheehan 1995). This evolution of Barnard's thinking is superbly detailed in Sheehan's wonderful biography of Barnard.

Several lines of evidence for noting these dark nebulae are obscuring material in front of a starry background can be gleaned by examining the simple color images presented in this book. Several of the Barnard Objects are barely discernible from the starry background on long expo-

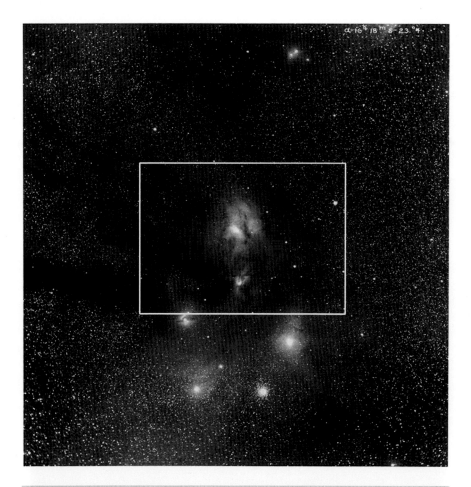

Fig. 7.5 (**a**) Plate 13. Region of the Great Nebula of Rho Ophiuchi. Superimposed white rectangle shows region illustrated in Fig. 7.5b. (**b**) Region of Rho Ophiuchus nebula [IC 4604], IC 4603, Barnard 42, and M80. Takahashi Epsilon 180 f/2.8 telescope with Canon EOS Ra single shot color camera. (© Tim B Hunter, 3towers, LLC, 2022. All Rights Reserved). (**c**) Plate 13. Region of the Great Nebula of Rho Ophiuchi. Superimposed white rectangle shows region illustrated in Fig. 7.5d. (**d**) Western portion of Barnard 44 with Antares. Takahashi Epsilon 180 f/2.8 telescope with Canon EOS Ra single shot color camera. (© Tim B Hunter, 3towers, LLC, 2022. All Rights Reserved)

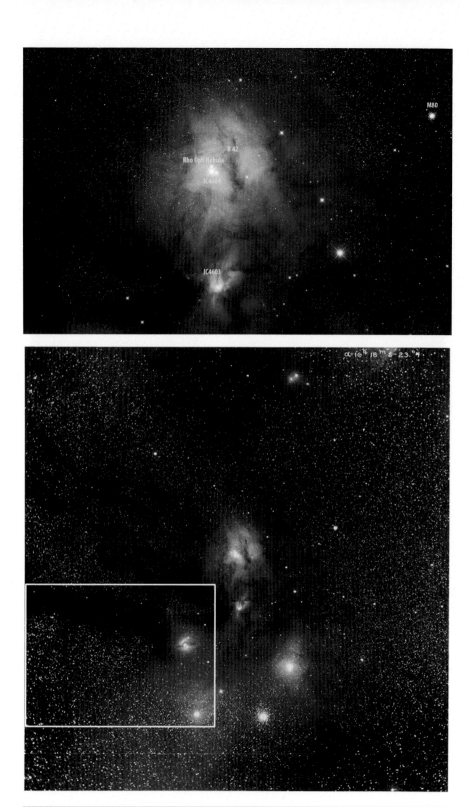

Fig. 7.5 (continued)

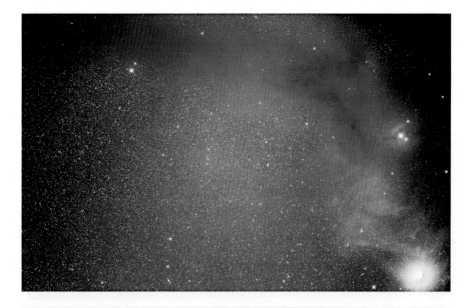

Fig. 7.5 (continued)

Fig. 7.6 (**a**) Plate 14. Region of Dark Lanes in Ophiuchus. Superimposed white rectangle shows region illustrated in Fig. 7.6b. (**b**) Eastern portion of Barnard 44. Takahashi Epsilon 180 f/2.8 telescope with Canon EOS Ra single shot color camera. (© Tim B Hunter, 3towers, LLC, 2022. All Rights Reserved)

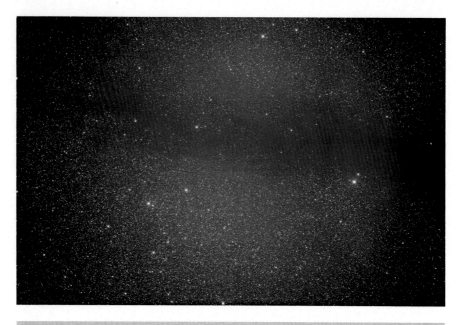

Fig. 7.6 (continued)

sures. The longer the exposure, the more stars appear in the nebulous regions. Many of the dark nebulae have sharp margins in some portion of their periphery while blending imperceptibly into the starry background on other portions of their periphery. Many of the nebulae show a mixture of colors, mainly brown, red-brown, and grays as well as having areas of emission nebulae or reflection nebulae (Fig. 7.5b). These effects are much more apparent on modern color images than on the black and white images from Barnard's era.

The selected plates and adjoining color images are a good representation of the range of wide field stellar photographic work performed by Barnard. Barnard was also a pioneer in comet photography and clearly demonstrated that photographic techniques available to astronomers even in the 1880s' far exceeded the reproducibility and information conveyed by visual observations(Barnard 1913, Frost 1923)

Fig. 7.7 (**a**) Plate 18. Region of Ophiuchus and Scorpius. Superimposed white rectangle shows region illustrated in Fig. 7.7b. Superimposed black rectangle shows region illustrated in Fig. 7.7c. (**b**) Barnard 260, 65, 66, 67, and 59 (Pipe Nebula). Image by James McGaha with Canon 300 mm f/3.8 lens on Canon 20Da single shot color camera. (© Tim B Hunter, 3towers, LLC, 2022. All Rights Reserved). (**c**) Barnard 78 and environs. Image by James McGaha with Canon 300 mm f/3.8 lens on Canon 20Da single shot color camera. (© Tim B Hunter, 3towers, LLC, 2022. All Rights Reserved)

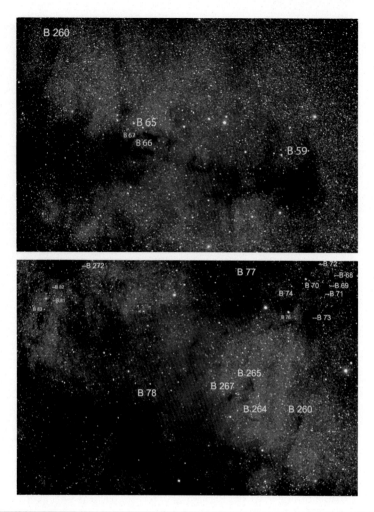

Fig. 7.7 (continued)

Fig. 7.8 (**a**) Plate 19. Region North of Theta Ophiuchi. Superimposed white rectangle shows region illustrated in Fig. 7.8b. Superimposed top black rectangle shows region illustrated in Fig. 7.8c. Superimposed lower black rectangle shows region illustrated in Fig. 7.8d. (**b**) Barnard 268 and environs. Takahashi Epsilon 180 f/2.8 telescope, Canon EOS Ra single shot color camera. (© Tim B Hunter, 3towers, LLC, 2022. All Rights Reserved). (**c**) Barnard 62 and 63. Takahashi Epsilon 180 f/2.8 telescope, Canon 20Da single shot color camera. (© Tim B Hunter, 3towers, LLC, 2022. All Rights Reserved). (**d**) Barnard 72 (Snake Nebula) and environs. Takahashi Epsilon 180 f/2.8 telescope, Canon EOS Ra single shot color camera. (© Tim B Hunter, 3towers, LLC, 2022. All Rights Reserved)

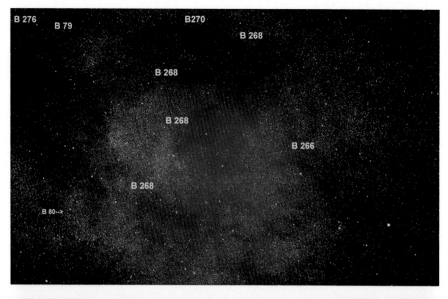

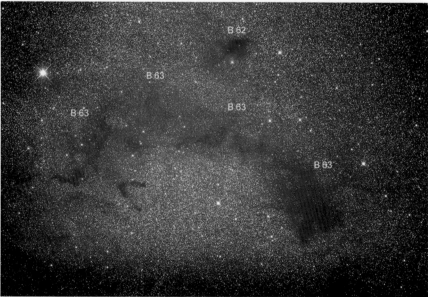

Fig. 7.8 (continued)

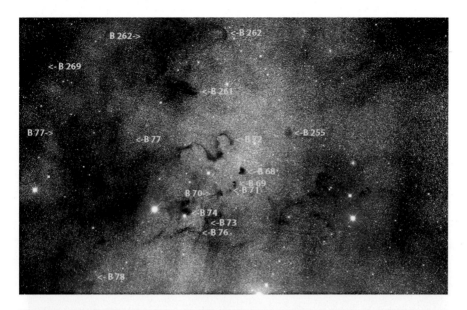

Fig. 7.8 (continued)

Fig. 7.9 (**a**) Plate 26. Great Star Clouds in Sagittarius. Superimposed white rectangle shows region illustrated in Fig. 7.9b. Superimposed black rectangle shows region illustrated in Fig. 7.9c. (**b**) Barnard 300, 87, 292, and 291. Takahashi Epsilon 180 f/2.8 telescope, Canon 60Da single shot color camera. (© Tim B Hunter, 3towers, LLC, 2022. All Rights Reserved). (**c**) Wide angle view of Barnard 86 and NGC 6520 and environs. Takahashi Epsilon 180 f/2.8 telescope, Canon EOS Ra single shot color camera. (© Tim B Hunter, 3towers, LLC, 2022. All Rights Reserved). (**d**) Barnard 86 and NGC 6520. ASA20 20-inch telescope with Finger Lakes Instrumentation KAF9000 CCD, combined luminous, Cousins-Johnson photometric B, photometric V, and photometric R images. (© Tim B Hunter, 3towers, LLC, 2022. All Rights Reserved). (**e**) Cropped portion of Fig. 7.9c centered on Barnard 86 and NGC 6520. Compare this to Fig. 7.9f. (© Tim B Hunter, 3towers, LLC, 2022. All Rights Reserved). (**f**) Cropped portion of Plate 26 Great Star Clouds in Sagittarius centered on Barnard 86 and NGC6520. This was cropped from an ultrahigh resolution scan of the original Barnard print by Dobek (2011).

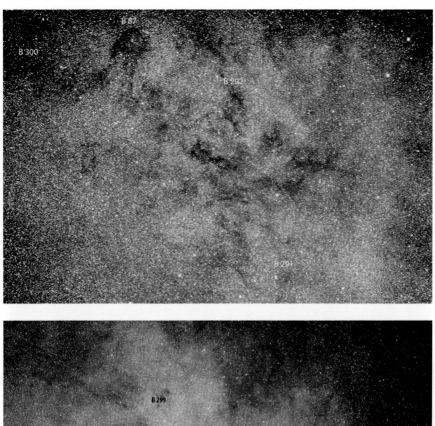

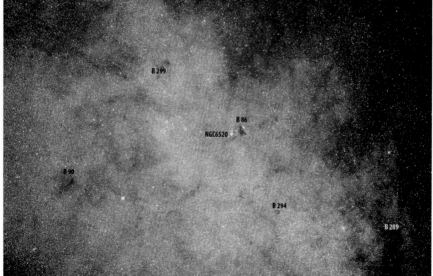

Fig. 7.9 (continued)

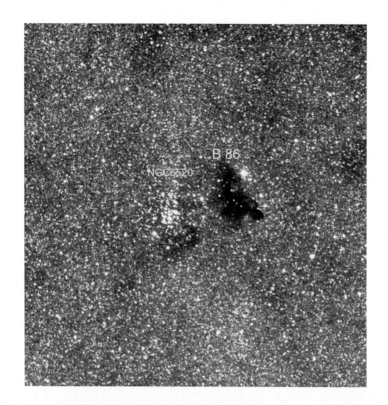

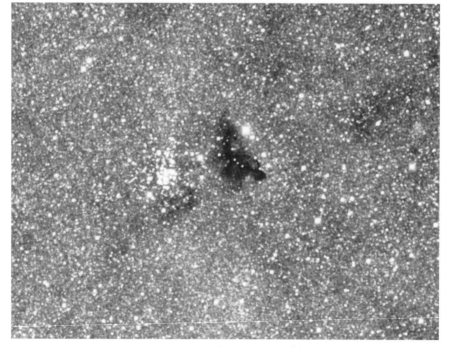

Fig. 7.9 (continued)

Fig. 7.9 (continued)

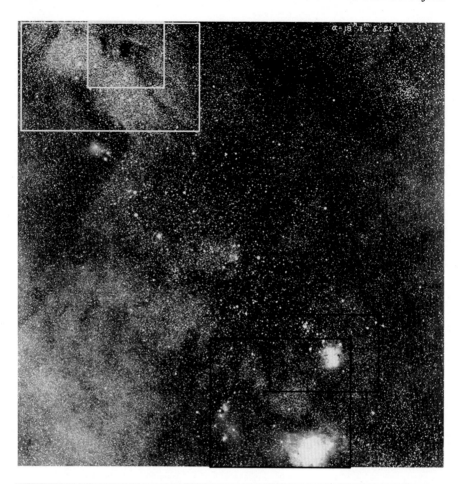

Fig. 7.10 (**a**) Plate 29. Region in Sagittarius, North of the Great Star Cloud. Superimposed large white rectangle shows region illustrated in Fig. 7.10b. Superimposed smaller white rectangle shows region illustrated in Fig. 7.10c. Superimposed smaller black rectangle shows region illustrated in Fig. 7.10d. Superimposed larger black rectangle shows region illustrated in Fig. 7.10e. (**b**) NGC6603, IC 1283, Barnard 307, 93, 92, and 304. Takahashi Epsilon 180 f/2.8 telescope, Canon EOS Ra single shot color camera. (© Tim B Hunter, 3towers, LLC, 2022. All Rights Reserved). (**c**) Barnard 92 (center) and Barnard 93 (left of center). ASA20 20-inch f/3.6 astrograph with Finger Lakes Instrumentation KAF9000 CCD, combined luminous, Cousins-Johnson photometric B, photometric V, and photometric R images. (© Tim B Hunter, 3towers, LLC, 2022. All Rights Reserved). (**d**) M20 (Trifid Nebula, NGC6514) with Barnard 85. Also, M21 (NGC6531). Explore Scientific 102 mm f/7 refractor with Canon 60Da single shot color camera. © Tim B Hunter, 3towers, LLC, 2022. All Rights Reserved. (**e**) M8, M20 and environs with associated Barnard Objects: Barnard 85, 88, 89, 296, 303, 302, and 91. Takahashi Epsilon 180 f/2.8 astrograph with Canon EOS Ra single shot color camera. (© Tim B Hunter, 3towers, LLC, 2022. All Rights Reserved)

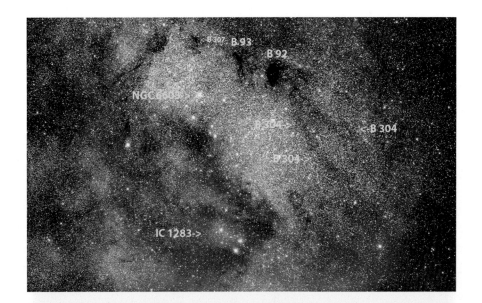

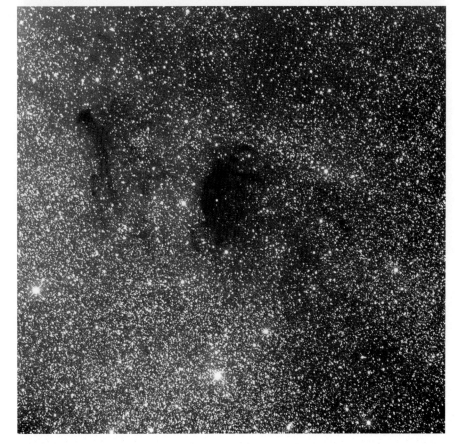

Fig. 7.10 (continued)

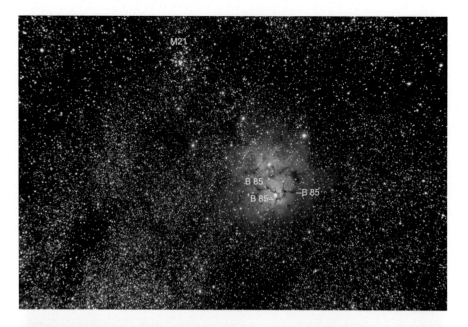

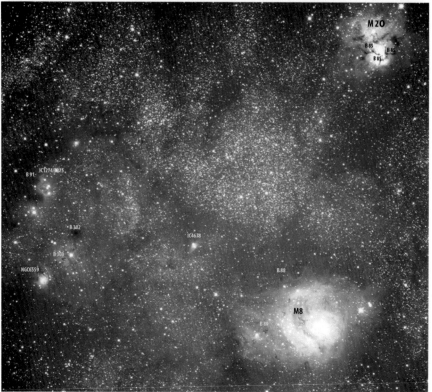

Fig. 7.10 (continued)

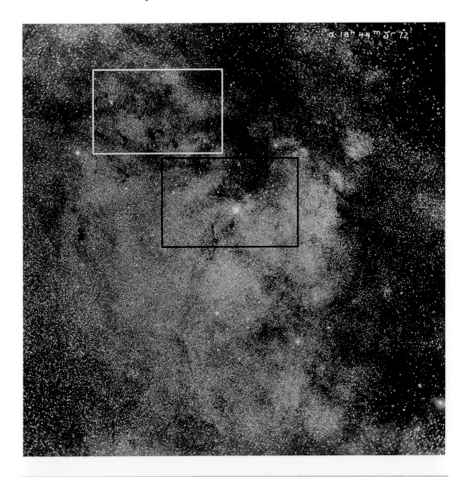

Fig. 7.11 (**a**) Plate 37. The Great Star Cloud in Scutum. Superimposed white rect-angle shows region illustrated in Fig. 7.11b. Superimposed black rectangle shows region illustrated in Fig. 7.11c. (**b**) Barnard 325 and environs. Takahashi Epsilon 180 f/2.8 telescope, Canon EOS Ra single shot color camera. (© Tim B Hunter, 3towers, LLC, 2022. All Rights Reserved). (**c**) M11 (NGC 6705) and environs. Takahashi Epsilon 180 /2.8 telescope, Canon EOS Ra single shot color camera. (© Tim B Hunter, 3towers, LLC, 2022. All Rights Reserved)

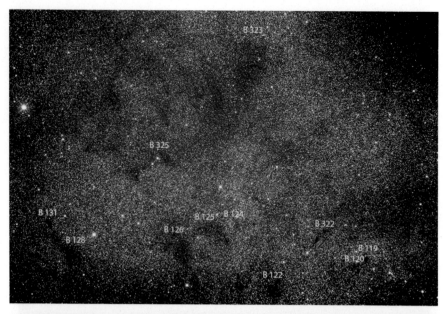

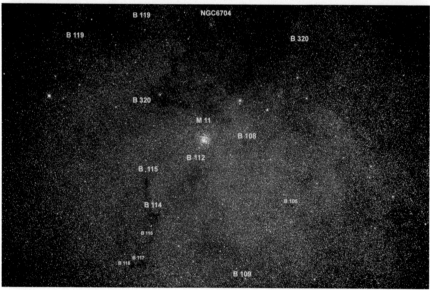

Fig. 7.11 (continued)

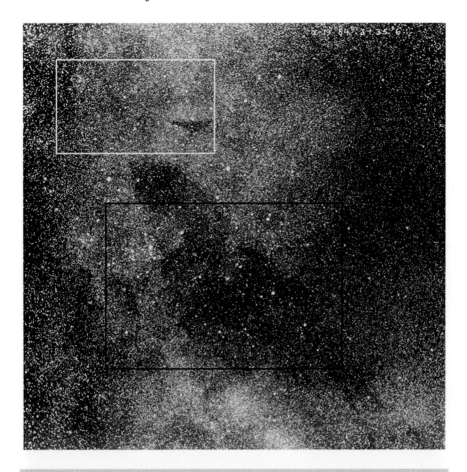

Fig. 7.12 (**a**) Plate 43. Region in Cygnus, Southern Part. Superimposed white rectangle shows region illustrated in Fig. 7.12b. Superimposed black rectangle shows region illustrated in Fig. 7.12c. (**b**) Crescent Nebula (NGC 6888 in upper left corner) and Barnard 145 (lower right-hand corner). Takahashi Epsilon 180 f/2.8 telescope, Canon 60Da single shot color camera. (© Tim B Hunter, 3towers, LLC, 2022. All Rights Reserved). (**c**) Barnard 144 and environs. Takahashi Epsilon 180 f/2.8 telescope, Canon EOS Ra single shot color camera. (© Tim B Hunter, 3towers, LLC, 2022. All Rights Reserved). (**d**) Wide-angle color image with comparable scale to Plate 43 in Fig. 7.12a. 200 mm f/2 Canon lens with Canon EOS Ra single shot color camera. Image obtained by James McGaha and Tim Hunter. (© Tim B Hunter, 3towers, LLC, 2022. All Rights Reserved)

Fig. 7.12 (continued)

Fig. 7.12 (continued)

Fig. 7.13 (**a**) Plate 46. Region of the North America Nebula. Superimposed white rectangle shows region illustrated in Fig. 7.13b. (**b**) North America and Pelican Nebulae. Takahashi Epsilon 180 f/2.8 telescope, Canon EOS Ra single shot color camera. (© Tim B Hunter, 3towers, LLC, 2022. All Rights Reserved)

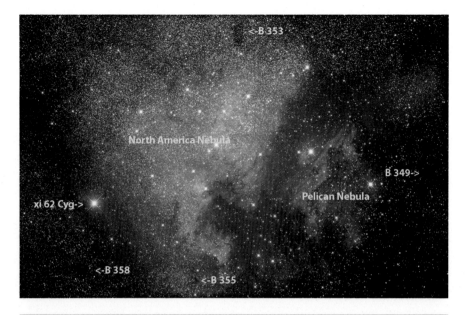

Fig. 7.13 (continued)

References

Barnard EE. On the photographs of the milky way made at the lick observatory in 1889. Publ Astron Soc Pac. 1890;2:240–4.

Barnard EE. Photographs of the milky way and comets. Publ Lick Obs. 1913;11

Barnard EE. In: Frost EB, Calvert MR, editors. A Photographic atlas of selected regions of the Milky Way. Washington: Carnegie Institution of Washington; 1927. Online Version at Georgia Institute of Technology: Barnard's Photographic Atlas of Selected Regions of the Milky Way (gatech.edu).

Barnard EE. A Photographic Atlas of Selected Regions of the Milky Way. In: Edwin B Frost, Mary R Calvert, editors, reprinted under the direction of Gerald Orin Dobek. Cambridge: Cambridge University Press; 2011.

Frost EB. Edward Emerson Barnard. Astron J. 1923;LVIII(#1):1–35.

Sheehan W. The immortal fire within: The life and work of Edward Emerson Barnard. Cambridge University Press; 1995. ISBN 0 521 44489 6

Vitale T. Film grain, resolution and fundamental film particles. Version 24. August 2010. Digital Image File Format and Storage (culturalheritage.org).

Chapter 8

The Missing Barnard Objects

1 Introduction

Barnard published the first version of his catalog of dark markings in 1919 with 182 objects (Barnard 1919). He stated therein "For some time I have hoped to make a catalogue of the dark markings shown on my photographs of the sky. The exact location of these objects is desirable so that their study with powerful photographic telescopes may be possible. There seems to be no question that some of them are real objects which are either entirely devoid of light or so feebly luminous when seen against the Milky Way as to appear black...This catalogue is necessarily incomplete; it is constantly being added to. Later, a more complete list will be printed. The places [object coordinates] are closely approximate."

Barnard's 1919 publication numbered objects from 1 to 175 with the addition of 44a, 67a, 83a, 84a, 117a, 119a, and 131a, giving a total of 182 objects. It is unclear as to why 44a, 67a, 83a, 84a, 117a, 119a, and 131a were not given separate numbers. It has previously been noted Barnard's numbering system and his criteria for including an object were not defined and seem widely inconsistent. The objects numbered with the subscript "a" are close in right ascension to their non-subscript companions a half-degree or somewhat more directly north or south of their non-subscript companion except for B 44 and B 44a whose declinations differ by >16 degrees. It may be that Barnard added these as an afterthought, especially if the next object number had already been assigned.

© The Author(s), under exclusive license to Springer Nature Switzerland AG 2023

T. B. Hunter et al., *The Barnard Objects: Then and Now*, The Patrick Moore Practical Astronomy Series, https://doi.org/10.1007/978-3-031-31485-8_8

Table 8.1 Table of contents for *A Photographic Atlas of Selected Regions of the Milky Way* (as collated by Dobek in 2011)

Title Page:	*A Photographic Atlas of Selected Regions of the Milky Way*
	By Edward Emerson Barnard
	Edited By Edwin B Frost Director, and Mary R Calvert, Assistant of the Yerkes Observatory of the University of Chicago
	Part I and Part II Photographs and Descriptions Charts and Tables
Preface	Edwin B Frost, 31 May 1927
Introduction Book I	Edward Emerson Barnard
Introduction Book II	Edwin B Frost and Mary R Calvert
Catalogue of 349 Dark Objects in the Sky	
	First Catalogue [B 1–175] Second Catalogue [B 201 – B 370] Notes on the Catalogue
Charts, notes, and Plates 1–50 and Accompanying Tables [for each chart and Plate]	
In the original 1927 publication Volume I had the photographs and descriptions, and Volume II had the Charts and Tables.	

Barnard's health unfortunately precluded him from completing his catalogue of dark objects. He had it partially in place and by 1917 had the 35,700 specially chosen photographic prints completed for the 700 anticipated printed copies of his future catalog. After Barnard's death in early 1923, Frost and Calvert collected Barnard's work and assembled it as best they could in a form, they hoped corresponded reasonably well to Barnard's original plan. Frost and Calvert's work resulted in the 1927 publication of Barnard's *Atlas*. Table 8.1 gives an overview of this publication. A new edition of Barnard's *Atlas* was published by Gerald Orin Dobek in 2011, and a scanned version of the *Atlas* is available on the Georgia Tech website as listed in the references (Barnard 2011).

Edwin B Frost and Mary R Calvert divided Barnard's work into Book I Photographs and Descriptions, and Book II Charts and Tables. They also divided his lists of dark objects into two catalogue's: *First Catalogue* and

Second Catalogue. These two catalogues were given the grand title *Catalogue of 349 Dark Objects in the Sky* with the following preface: "In his article in the *Astrophysical Journal* for January 1919 (**49**, 1–23) Professor Barnard gave a list of 182 dark objects in the sky. Three of the objects in that list have been omitted here, viz., Nos 52, 131a, and 172, because by inadvertence the same object had been listed twice. Mr. Barnard had begun a second list, most of the objects for which he had himself selected. The positions were determined by Miss Calvert. It seemed best to begin the second list with No. 201; accordingly, there are no objects having the numbers from 176 to 200."

The *First Catalogue* lists Barnard's original 182 objects described in his 1919 publication omitting B 52, B 131a, and B172 as noted. The *Second Catalogue* starting with number 201 lists another 170 objects Barnard had contemplated for his atlas. The two catalogs are then followed by *Notes on the Catalogue* which were collected from Barnard's published writings and his office notes for each object listed.

Mary Calvert drew 50 charts to go with the 50 photographic plates selected by Barnard for the *Atlas*. Each of Calvert's Charts 1–50 is a high-quality sketch of the respective photographic plates 1–50. The charts show the dark objects identified by Barnard as well as important bright stars, Messier, NGC, or IC Objects, and some asteroids, comets, or planets. There are informative tables accompanying the 50 charts and 50 photographic plates as well as detailed notes for each plate. Calvert used a dotted line with vague outlines to indicate dark nebulae and a solid line to imply a more definite border. Many additional dark regions were outlined without a number assigned to them implying that Barnard had identified a dark object in that location but had not gotten around to numbering it or further classifying it.

Dobek's 2011 edition of Barnard's *Atlas* includes B 52, B 131a, and B 172. Dobek's research led him to believe these were not erroneous duplicate entries. Following Barnard's notation and description, the three objects were located on the plates of the *Atlas* and their size and co-ordinates added to the 2011 republication of Barnard's *Atlas*. We include them in our summary table of Barnard Objects at the end of the book, and they are included in the Grasslands Observatory website (https://www.3towers.com/Grasslands_Content/BarnardObjects/BarnardMain.html).

Frost and Calvert's compilation and publication of the 1927 edition of *A Photographic Atlas of Selected Regions of the Milky Way* is today considered an astronomical classic and frequently referenced. It does have some peculiarities. There are six of Barnards plates (#'s 2, 4, 8, 10, 11, and 42) showing no Barnard Object. In fact, on these six plates no dark nebulae are

marked with dotted or solid lines. A couple of these plates are of special interest. Plate 4 is the "Region of the Pleiades" which was obtained on September 7.937, 1905, at Mount Wilson with a 3 hour 48-minute exposure (Fig. 7.3a). This plate was included to show the remarkable nebulosity associated with the Pleiades and the noteworthy ability of photography to display nebulosity otherwise not appreciated. Plate 8 is "Region in Gemini, Near the Cluster Messier 35" (Fig. 6.4a). While there are elaborate notes for this plate the notes for it state: "This is not an especially interesting region." This plate was taken at Mount Wilson March 22.642, 1905, with a short exposure of 50 minutes.

2 The Missing Barnard Objects

Frost and Calvert did not elaborate on why they omitted numbering objects from 176 to 200. If you examine all the 50 charts drawn by Mary Calvert, there are at least 52 unlabeled regions with dotted or solid lines indicating unnumbered but identified areas of dark nebulosity. These were placed on the charts by Mary Calvert drawing on notes and publications by Barnard indicating he had identified dark regions in these areas but had not yet labeled them or studied them further. In the 2011 edition of the Atlas, Dobek notes in the Addendum "There remain several dark objects that are clearly seen on the plates, outlined by Barnard and Calvert, but which were never catalogued by Professor Barnard. … Perhaps these regions could be added to Professor Barnard's catalogue to "fill in" the numbers from 176 through 200, thus completing the listing with these objects." Examining these regions and working on scattered publications by Barnard or notes in his 1927 publication, we have identified and labeled 25 dark nebular regions, "The Missing Barnard Objects," and given them designations B 176–200 (Table 8.2). We cannot claim Barnard would have given these the same number or bothered to have numbered them if he could have completed this project during his life. All but one object, B 200, were catalogued by using the outlined regions on the charts drawn by Calvert and noted by Barnard in his descriptions. We do think these are dark nebular regions worthy of noting and studying.

Table 8.2 The missing barnard objects (Barnard 176–200)

Object	Chart number	Coordinates (epoch J2000.0)	Size (arcminutes)	Comments
Barnard 176	13, 14, Figs. 8.1 and 8.2	16 41.0 −21 32	145 × 15	Large dark lanes west of Barnard 45 and south of Barnard 43
Barnard 177	13,14, Fig. 8.1 and 8.2	16 37.0 −23 30	75 × 20	Large irregular dark lane, part of the complex nebulous region east of Rho Ophiuchi and north of Barnard 44
Barnard 178	14, Fig. 8.2	17 09.5 −22 41	30	Ill-defined region contiguous to Barnard 57, Barnard 60, and Barnard 246
Barnard 179	16, Fig. 8.3	16 44.8 −34 56	15	Near but probably separate from Barnard 233
Barnard 180	17, Fig. 8.4	17 02.0 −34 37	11	South of Barnard 50 and less opaque than the central portion of Barnard 50
Barnard 181	18, Fig. 8.5	17 21.1 −25 45	72	Long thin somewhat opaque lane in a complex region of stars and dark nebulosity
Barnard 182	33, Fig. 8.6	18 33.3 −25 59	50 × 9	A dark lane nearly 1° in length. Contains the small black 'planetary nebula object' B 98.
Barnard 183	26, Fig. 8.7	18 08.0 −25 52	60	Large, amorphous dark region in the middle of a star cloud. Appears like a 'long-sleeved shirt'. Less opaque than smaller nearby dark regions like Barnard 90, 299, and 86
Barnard 184	28, Fig. 8.8	18 03.7 −30 36	18 × 4	Poorly defined but distinct dark region north and separate from large Barnard 295
Barnard 185	29, Fig. 8.9	18 18.3 −20 03	168	Dark, wall like structure south of NGC 6603
Barnard 186	34, Fig. 8.10	18 34.9 −12 42	240	Very large distinct but poorly defined upside-down V-shaped dark region east of Barnard 95
Barnard 187	34, Fig. 8.10	18 31.4 −17 35	45 × 15	Poorly defined less opaque region surrounding small dense Barnard 311

(continued)

Table 8.2 (continued)

Object	Chart number	Coordinates (epoch J2000.0)	Size (arcminutes)	Comments
Barnard 188	36, Fig. 8.11	18 40.1 − 06 15	60	Very large, irregular dark wall like area contiguous to and north of Barnard 103
Barnard 189 Barnard 189a	41, Fig. 8.12	19 20.6 + 08 26 19 21.3 + 08 43	22	Two regions north and slightly east of Barnard 330. The larger region is B 189, and the strip north is B 189a.
Barnard 190	47, Fig. 8.13	21 08.2 + 56 24	3 × 1.5	Distinct small dark lane contiguous to Barnard 360
Barnard 191	48, Fig. 8.14	21 32.1 + 54 24	14	Large, irregular poorly defined opaque region separate from but contiguous to small Barnard 157 and very large, very poorly defined Barnard 364
Barnard 192	48, Fig. 8.14	21 31.7 + 53 45	12 × 5	Small dark region separate from but near Barnard 364
Barnard 193	48, Fig. 8.14	21 00.5 + 48 37	15 × 4	Small well-defined dark region in an area with larger more obvious dark areas.
Barnard 194	49, Fig. 8.14	21 32.3 + 54 49	8 × 4	Barnard 194, 195, and 196 are small fairly opaque regions near but separate from Barnard 157, and Barnard 191
Barnard 195	49, Fig. 8.14	21 32.5 + 55 02	8 × 4	Barnard 194, 195, and 196 are small fairly opaque regions near but separate from Barnard 157, and Barnard 191
Barnard 196	49, Fig. 8.14	21 33.3 + 54 56	4	Barnard 194, 195, and 196 are small fairly opaque regions near but separate from Barnard 157, and Barnard 191
Barnard 197	49, Fig. 8.14	21 41.4 + 56 37	2.5	Small irregular dark region in the large nebulosity comprising IC 1396
Barnard 198	49, Fig. 8.14	21 56.3 + 59 01	4	Small, rounded distinct dark region separate from several nearby Barnard Objects. Separate from B 170.
Barnard 199	49, Fig. 8.14	21 40.1 + 58 02	120	Three large, separate irregular dark lanes in the nebulosity comprising IC 1396
Barnard 200	13, Fig. 8.1	16 25.8 − 24 17	8	Well delineated dark lanes resembling a trident in the middle of IC 4603.

Chart 13 – Region of the Great Nebula of Rho Ophiuchi
Barnard 176, 177, and 200

There are three large unnumbered dark regions on this chart as well as a small dark region resembling what Dobek is naming "Neptune's Trident," which we have labeled Barnard 176, 177, and 200 respectively (Fig. 8.1). Barnard 176 are two dark irregular lanes quite evident on Barnard's Plate 13, while Barnard 178 is a single long, irregular dark lane just north of Barnard 44. Color images of these regions including Barnard 45 and Barnard 43 as well as Barnard 44 show these dark regions have faint reddish brown coloration consistent with obscuring material, more of which is present around and north of Antares.

Barnard 200 is a small, irregular "trident," or lower case omega (ω) shaped dark region amid reflection and emission nebulosity which enhances its appearance. It is a small part of the stringy, complex thin dark lanes running through this region and must be foreground obscuring material made visible by the background bright nebulosity which is mainly reflection nebulosity with areas of emission. One of the more interesting questions about this dark nebulosity is how closely attached is it to the bright regions? Is it a much closer foreground object or is it part of a large region of mixed emission, reflection, and dark nebulosity? It is most interesting that this object appears to 'stand-out' so prominently near the center of Plate 13 in the *Atlas*, yet Barnard neither outlined this dark 'trident' nor noted the object in his descriptions of this region. The Rho Ophiuchi region (Rho Ophiuchi Cloud Complex) is discussed in further detail in Chap. 9.

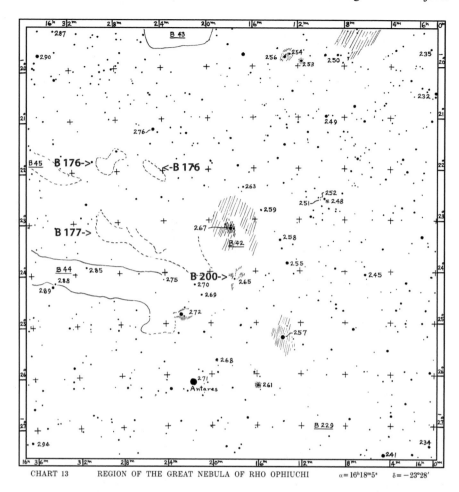

CHART 13 REGION OF THE GREAT NEBULA OF RHO OPHIUCHI α=16ʰ18ᵐ5ˢ δ=−23°28′

Fig. 8.1 (**a**) Chart 13 from EE Barnard *A Photographic Atlas of Selected Regions of the Milky Way* with Barnard 176, 177, and 200 labeled. (**b**) Cropped and enlarged image from Barnard's Plate 13 from *A Photographic Atlas of Selected Regions of the Milky Way.* Barnard 200 (Neptune's Trident) is marked as well as other important objects in the region. Note how first magnitude Antares does not appear very bright due the plates used by Barnard being mainly sensitive to blue and near ultraviolet light. (**c**) Wide angle image of the region around Rho Ophiuchi centered to provide a modern color digital image showing the region depicted in Chart 13 as illustrated in Fig. 8.1a. This is a composite image obtained by James McGaha and Tim Hunter from multiple exposures with a Canon 200 f/2 lens and Canon EOS Ra camera. (© Tim B Hunter, 3towers, LLC, 2022. All Rights Reserved). (**d**) Cropped and enlarged image showing "Neptune's Trident" Barnard 200. Takahashi Epsilon 180 f/2.8 astrograph with Canon EOS Ra camera. (© Tim B Hunter, 3towers, LLC, 2022. All Rights Reserved)

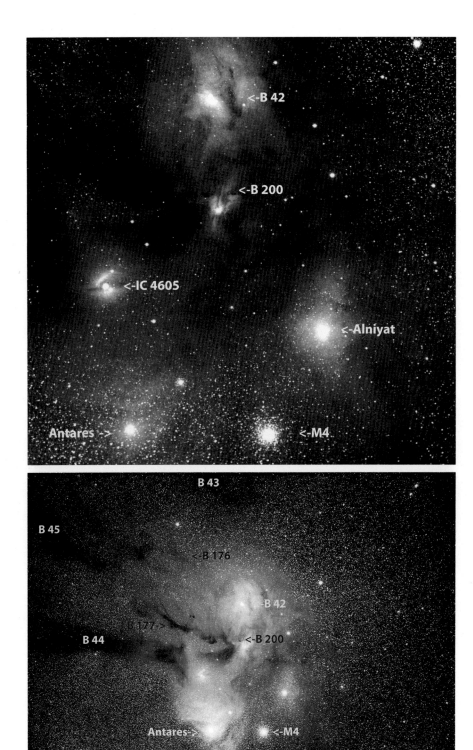

Fig. 8.1 (continued)

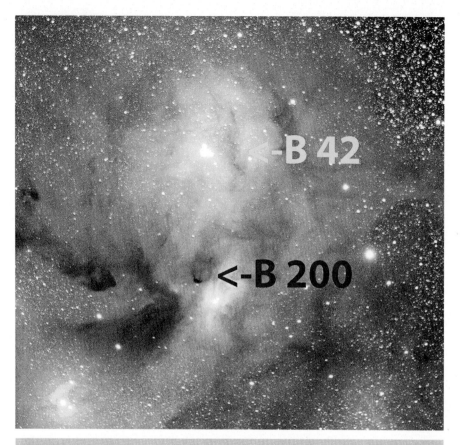

Fig. 8.1 (continued)

Chart 14 – Dark Lanes in Ophiuchus
Barnard 178

Barnard 178 is a poorly defined dark region contiguous to Barnard 57, Barnard 60, and Barnard 246 (Fig. 8.2). On Barnard's published photograph for Plate 14 these areas tend to blend, and it is unclear as to why an unnumbered region, which we have called Barnard 178, was distinguished from the other regions. If the original plate [negative, No. 209, obtained at Mount Wilson June 3.771, 1905, with an exposure of 3 hours], could be obtained and examined closely, these regions might be seen to be somewhat separate objects.

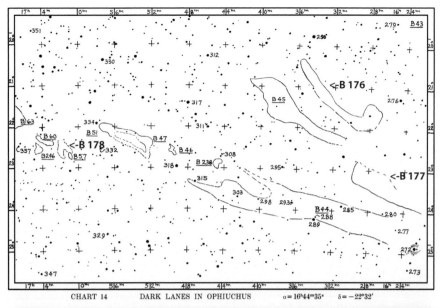

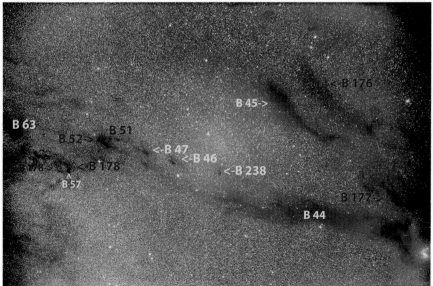

Fig. 8.2 (**a**) Chart 14 from EE Barnard *A Photographic Atlas of Selected Regions of the Milky Way* with Barnard 176, 177, and 178 labeled. (**b**) Wide angle image centered to provide a modern color digital image showing the region depicted in Chart 14 as illustrated in Fig. 8.2a. Also, Dobek's revised positions for Barnard 51 and 52 are noted based on Barnard's original descriptions for these objects. This is a composite image obtained by James McGaha and Tim Hunter from multiple exposures with a Canon 200 f/2 lens and Canon EOS Ra camera. (© Tim B Hunter, 3towers, LLC, 2022. All Rights Reserved). (**c**) Barnard 253, 246, 63, 60, 57, and Barnard 178. Takahashi Epsilon 180 f/2.8 astrograph with Canon 60 Da. (© Tim B Hunter, 3towers, LLC, 2022. All Rights Reserved)

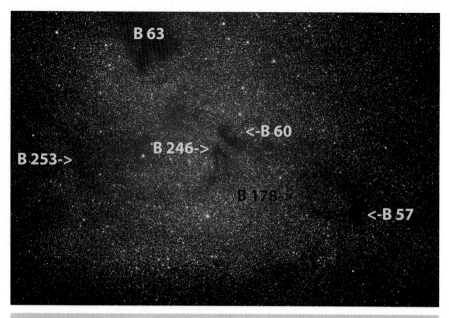

Fig. 8.2 (continued)

Chart 16 – In the Southern Part of Scorpius
Barnard 179

Barnard 179 is marked on Chart 16 as being contiguous to or an extension of Barnard 233 (Fig. 8.3). If you examine Plate 16 or a modern image of this area, you will see that Barnard 233 is somewhat separate from the dark region we are naming Barnard 179. To the west of Barnard 233 and 179 is Barnard 231, an irregular area with significant opacity in its northern portion.

Near Barnard 231 is the bright star H (Eta) Scorpii which is also known as NSV7844 (a new suggested variable). The listed V magnitude (Cousins-Johnson photometric system) is 4.18. This is a very red star shown in Fig. 8.3b by its listed B-V photometric value of 1.535 (Guide, Project Pluto 2015). Curiously, it is noted on Chart 16 drawn by Mary Calvert, but is not prominent on the drawing. It has marginal visibility on Barnard's Plate 16 due to the relative insensitivity to red light of the plates used by Barnard.

This is a good illustration of how modern imaging will show different results than the images produced by Barnard. His photographic plates were relatively slow by modern standards, perhaps having the equivalent sensitivity of ISO 1-2. They were mostly sensitive to blue and near ultraviolet light, producing somewhat greater contrast between nebular areas and surrounding star fields than are often evident on more modern photographs or digital

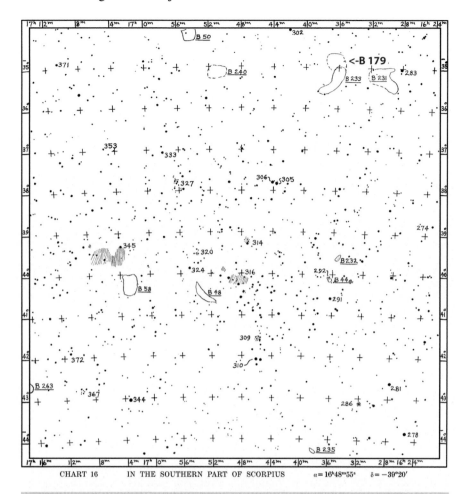

Fig. 8.3 (**a**) Chart 16 from EE Barnard *A Photographic Atlas of Selected Regions of the Milky Way* with Barnard 179 marked. (**b**) Barnard 233 and 231 with Barnard 179 marked. Note the bright red star (Eta Scorpii) near Barnard 231. It is shown as star #283 on Chart 16 in Fig. 8.3a. Takahashi Epsilon 180 f/2.8 astrograph with Canon EOS Ra camera. (© Tim B Hunter, 3towers, LLC, 2022. All Rights Reserved)

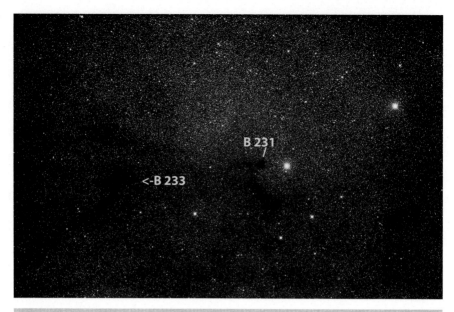

Fig. 8.3 (continued)

images which have a wider spectral range as well as considerably greater sensitivity. Many of the wide field digital images illustrated in this book were taken with single shot digital color cameras using an ISO of 1600 and total exposures of ½ to 1½ hours.

Barnard was quite aware of the spectral sensitivity of his plates as noted in Chap. 4 in discussing his photographic plates showing amazing cometary detail often not evident to the visual observer. Barnard also noted that there was sometimes a mismatch between what his photographic plate showed versus his visual observations: "In comparing photographs with the actual sky one is often struck with the relative smallness of certain stars on the photographs that are bright in the sky. This peculiarity is due to more or less color in these stars which produces a smaller photographic image. This is sometimes so pronounced that it is troublesome to identify the individual stars" (Barnard 1900).

Chart 17 – Region in Scorpius, Near Messier 62
Barnard 180, 239a and 239b

Barnard 180 is a dark region close to but distinct from Barnard 50 which is a bit larger and somewhat more opaque (Fig. 8.4a–b). On wide field color imaging Barnard 180 is not as well defined as shown on Calvert's Chart 8.17 and on Barnard's Plate 17. Also outlined on this chart are two tiny dark areas

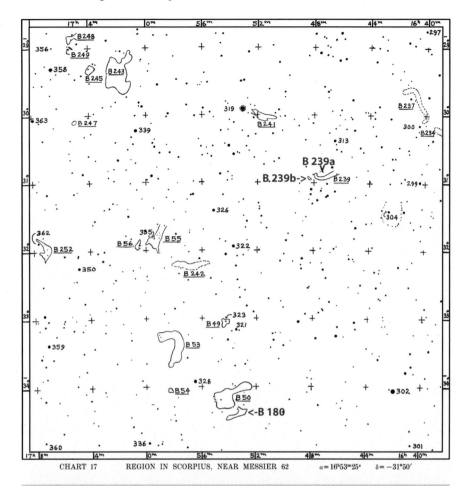

CHART 17 REGION IN SCORPIUS, NEAR MESSIER 62 $\alpha = 16^h53^m25^s$ $\delta = -31°50'$

Fig. 8.4 (**a**) Chart 17 from EE Barnard *A Photographic Atlas of Selected Regions of the Milky Way* with Barnard 180 and 239a and 239b marked. (**b**) Barnard 49, 50, 53, 54, and Barnard 180. Takahashi Epsilon 180 f/2.8 astrograph with Canon EOS Ra camera. (© Tim B Hunter, 3towers, LLC, 2022. All Rights Reserved). (**c**) Barnard 237, 234, 239, and 239a and 239b. Takahashi Epsilon 180 f/2.8 astrograph with Canon EOS Ra camera. (© Tim B Hunter, 3towers, LLC, 2022. All Rights Reserved)

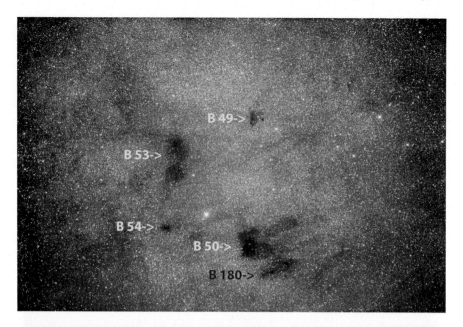

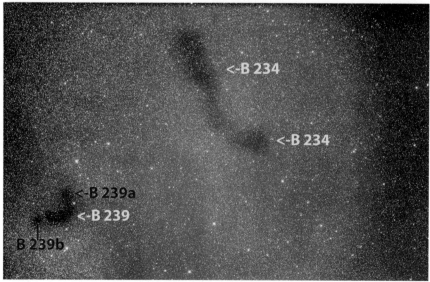

Fig. 8.4 (continued)

near Barnard 239 (Fig. 8.4a and c). One of the areas blends in with Barnard 239. These two small 'spots' are listed as Barnard 239a and Barnard 239b. The top (northern) area chosen as part of Barnard 239a does not exactly correspond to the dark area marked by Mary Calvert on Chart 8.17. Both Barnard 239a and Barnard 239b are not part of the 'missing objects' but are added to the Barnard catalogue in similar fashion to Barnard's additions by sub-numbering adjacent dark regions. Figure 8.4c and Barnard's Plate 17 shows this tiny dark area (Barnard 239a) with its southwest corner touching a star now known as WDS1 577 (Washington Double Star Catalog, with two very close companions 0.9 arcseconds apart) with combined magnitude of 8.39. Calvert slightly misplaces this area to the east.

Chart 18 – Region in Ophiuchus and Scorpius
Barnard 181

Barnard 181 is in one of the most complex regions of the Milky Way with many dark nebulae identified by Barnard (Fig. 8.5). This area is fairly evident on Barnard's Plate 18. It appears separate from other dark regions. Why it was not labeled by Barnard is unknown. It was probably on his long list of projects that he was never able to complete.

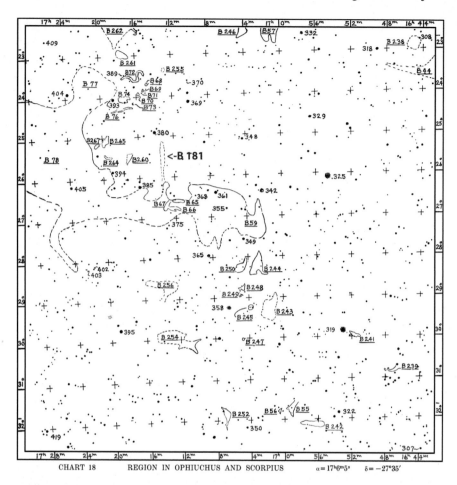

CHART 18 REGION IN OPHIUCHUS AND SCORPIUS $\alpha = 17^h 6^m 5^s$ $\delta = -27°35'$

Fig. 8.5 (**a**) Chart 18 from EE Barnard *A Photographic Atlas of Selected Regions of the Milky Way* with Barnard 181 marked. (**b**) Wide angle image centered to provide a modern color digital image showing the region depicted in Chart 18 as illustrated in Fig. 8.5a. This is a composite image obtained by James McGaha and Tim Hunter from multiple exposures with a Canon 200 f/2 lens and Canon EOS Ra camera. (© Tim B Hunter, 3towers, LLC, 2022. All Rights Reserved)

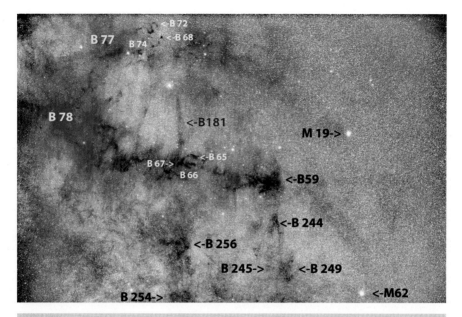

Fig. 8.5 (continued)

Chart 33 – Region in Sagittarius
Barnard 182

Barnard 182 contains the small dark object Barnard 98 inside a dark lane (Fig. 8.6). E. E. Barnard described Barnard 98 as an "object that looks like a dark planetary nebula" (Barnard 1919). Barnard 182 he described as "…, a rather broad dark pathway in the Milky Way." This region contains numerous dark lanes and areas, but only this dark strip was outlined by Barnard and Calvert. The area is approximately 2 degrees south and slightly west of Messier 22.

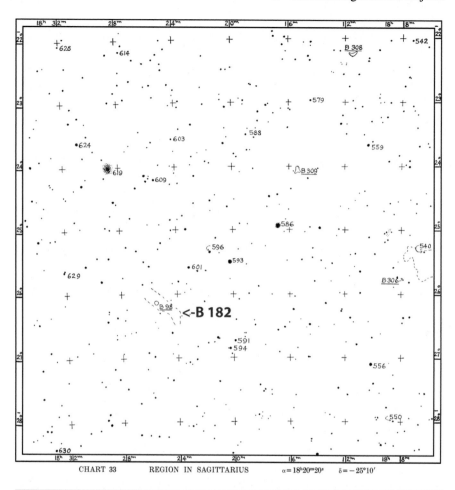

CHART 33 REGION IN SAGITTARIUS $\alpha = 18^h20^m20^s$ $\delta = -25°10'$

Fig. 8.6 (**a**) Chart 33 from EE Barnard *A Photographic Atlas of Selected Regions of the Milky Way* with Barnard 182 marked. It surrounds the smaller darker region Barnard 98. (**b**) Barnard 98 and Barnard 182. Barnard 182 surrounds the smaller darker region Barnard 98. Takahashi Epsilon 180 f/2.8 astrograph with Canon EOS Ra camera. (© Tim B Hunter, 3towers, LLC, 2022. All Rights Reserved).

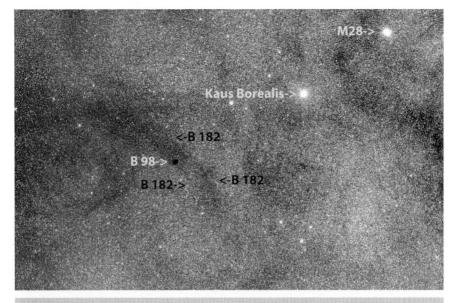

Fig. 8.6 (continued)

Chart 27 – Great Star Clouds in Sagittarius-2
Barnard 183

Barnard 183 is a large amorphous somewhat darkened area nearly a degree in its greatest extent (Fig. 8.7). It is dark compared to the surrounding star fields, but it is star filled and not nearly as opaque as Barnard 90, 299, 86, 294, and 289, which are nearby. This dark region resembles a long-sleeved shirt.

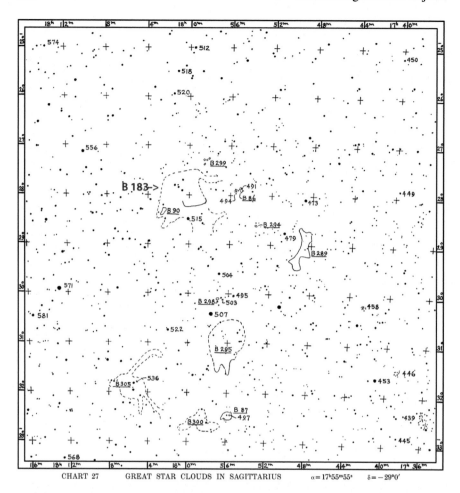

CHART 27 GREAT STAR CLOUDS IN SAGITTARIUS $\alpha = 17^h55^m55^s$ $\delta = -29°0'$

Fig. 8.7 (**a**) Chart 27 from EE Barnard *A Photographic Atlas of Selected Regions of the Milky Way* with Barnard 183 marked. (**b**) Barnard 183 ("the shirt") and its environs in the Sagittarius star clouds. Takahashi Epsilon 180 f/2.8 astrograph with Canon EOS Ra camera. (© Tim B Hunter, 3towers, LLC, 2022. All Rights Reserved)

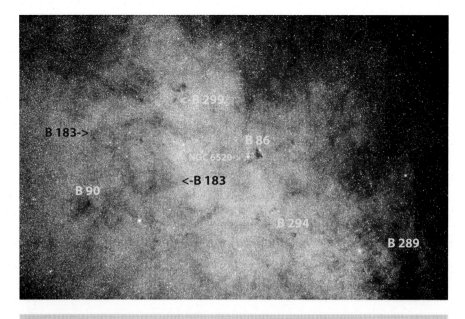

Fig. 8.7 (continued)

Chart 28 – Region South of the Great Star Cloud in Sagittarius Barnard 184

Barnard 184 is southwest of Alnasi magnitude 2.98 (Fig. 8.8). It is north of the large dark region Barnard 295, and like Barnard 295 it is poorly defined but relatively opaque.

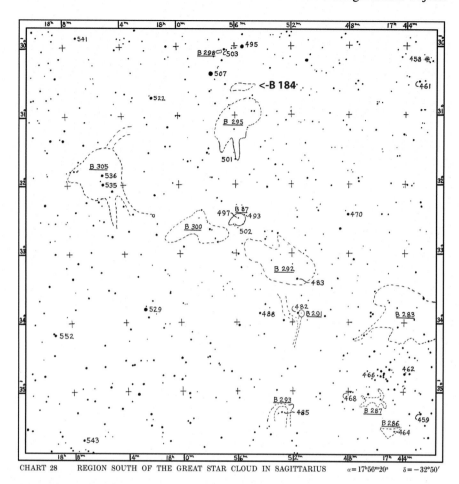

Fig. 8.8 (**a**) Chart 28 from EE Barnard *A Photographic Atlas of Selected Regions of the Milky Way* with Barnard 184 marked. (**b**) Barnard 184 and its environs in the Sagittarius star clouds. Takahashi Epsilon 180 f/2.8 astrograph with ZWO ASI071 camera. (© Tim B Hunter, 3towers, LLC, 2022. All Rights Reserved)

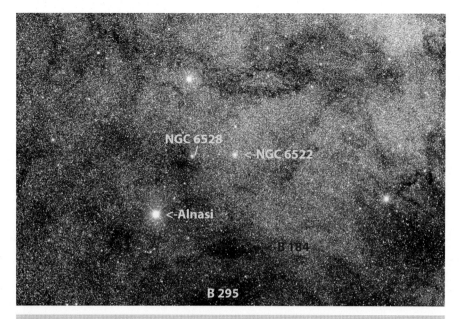

Fig. 8.8 (continued)

Chart 29 – Region in Sagittarius, North of the Great Star Cloud Barnard 185

Barnard 185 is a long ill-defined linear area of darkening about 1 ½ degrees in greatest dimension. It is moderately opaque and south of NGC 6603 in the middle of M24 (the Sagittarius Small Star Cloud) and not far from Barnard 307, 93, 92, and 304 (Fig. 8.9).

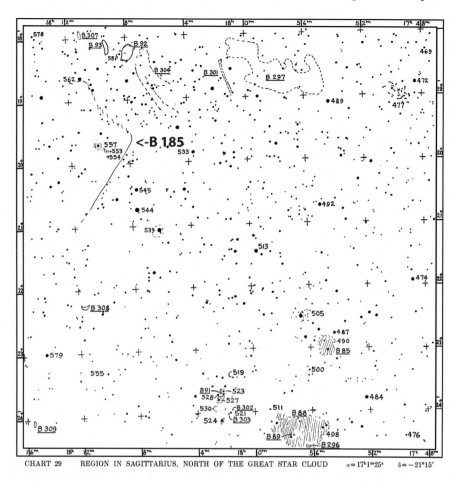

CHART 29 REGION IN SAGITTARIUS, NORTH OF THE GREAT STAR CLOUD $\alpha = 17^h1^m25^s$ $\delta = -21°15'$

Fig. 8.9 (**a**) Chart 29 from EE Barnard *A Photographic Atlas of Selected Regions of the Milky Way* with Barnard 185 marked. (**b**) M24 (the Small Sagittarius Star Cloud) and environs with the open cluster NGC 6603, Barnard 307, 93, 92, 304, and Barnard 185. Takahashi Epsilon 180 f/2.8 astrograph with Canon EOS Ra camera. (© Tim B Hunter, 3towers, LLC, 2022. All Rights Reserved)

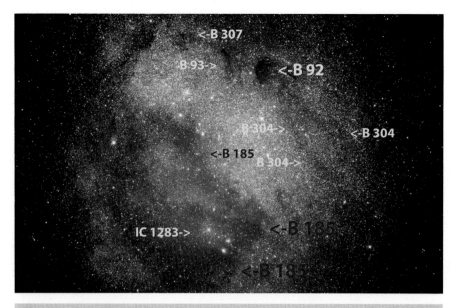

Fig. 8.9 (continued)

Chart 34 – In Aquila and Sagittarius
Barnard 186, 187

Barnard 186 is a rather large upside-down V shaped area spanning more than 3 degrees in greatest north-south and east-west extent (Fig. 8.10). It touches on Barnard 317 on its eastern limb and Barnard 97 on its northwestern region. It is south of NGC 1287, a prominent bright mixed emission reflection nebulous region. Barnard 186 is very prominent on Barnard's Plate 34.

Barnard 187 is south of the large dark area Barnard 312 and the open cluster NGC 6645. It surrounds Barnard 311 (Fig. 8.10d). Barnard described B 311 as a "Black elliptical:...in a semi-vacant strip..." (Barnard 1919). The 'strip' was outlined but never catalogued.

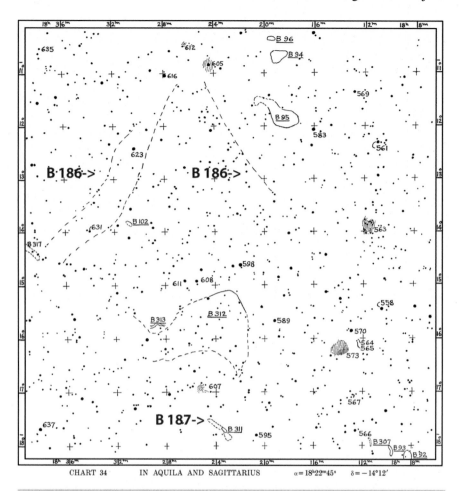

CHART 34 IN AQUILA AND SAGITTARIUS $\alpha = 18^h22^m45^s$ $\delta = -14°12'$

Fig. 8.10 (**a**) Chart 34 from EE Barnard *A Photographic Atlas of Selected Regions of the Milky Way* with Barnard 186 and 187 marked. (**b**) Barnard 95 and most of Barnard 186. Takahashi Epsilon 180 f/2.8 astrograph with Canon EOS Ra camera. (© Tim B Hunter, 3towers, LLC, 2022. All Rights Reserved). (**c**) Barnard 317, 102, and the eastern wing of Barnard 186. Takahashi Epsilon 180 f/2.8 astrograph with Canon EOS Ra camera. (© Tim B Hunter, 3towers, LLC, 2022. All Rights Reserved). (**d**) Barnard 311, 310, and Barnard 187. Takahashi Epsilon 180 f/2.8 astrograph with Canon EOS Ra camera. (© Tim B Hunter, 3towers, LLC, 2022. All Rights Reserved)

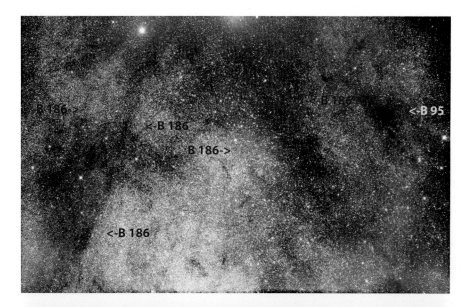

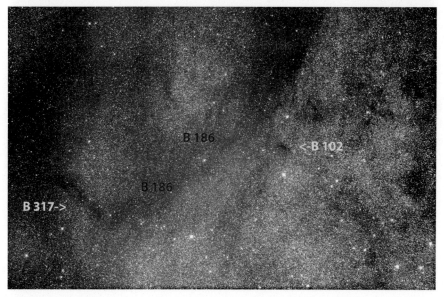

Fig. 8.10 (continued)

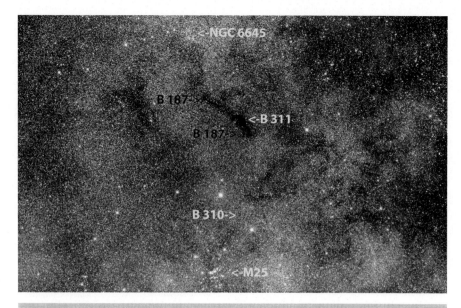

Fig. 8.10 (continued)

Chart 36 – Region of the Star Cloud in Scutum, Northern Part
Barnard 188

Barnard 188 is distinct large area contiguous to Barnard 103 on Barnard's Plate 36 (Fig. 8.11). It is evident on modern color digital imaging but not as contrasted with the starry background and not as contrasted with Barnard 103 as shown on Barnard's black and white plate.

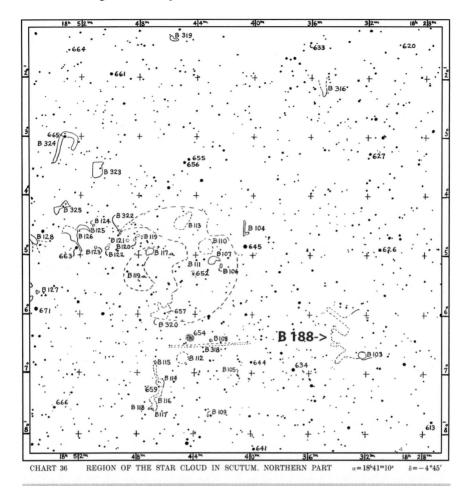

CHART 36 REGION OF THE STAR CLOUD IN SCUTUM. NORTHERN PART $\alpha = 18^h41^m10^s$ $\delta = -4°45'$

Fig. 8.11 (**a**) Chart 36 from EE Barnard *A Photographic Atlas of Selected Regions of the Milky Way* with Barnard 188 marked. (**b**) Barnard 103 and Barnard 188. Takahashi Epsilon 180 f/2.8 astrograph with ZWO ASI071 camera. (© Tim B Hunter, 3towers, LLC, 2022. All Rights Reserved)

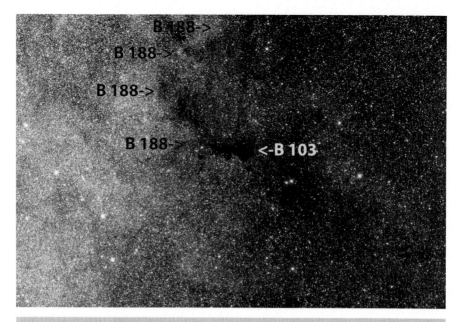

Fig. 8.11 (continued)

Chart 41 – In Aquila, Northwest of Altair
Barnard 189, 189a

Barnard 189 is an irregularly opaque region near but separate from the defined, large Barnard 330. Barnard 189a is a dark strip on the northern edge, but clearly separated from Barnard 189. It seems appropriate to use the same numbering notation similar to other related Barnard dark objects (Fig. 8.12).

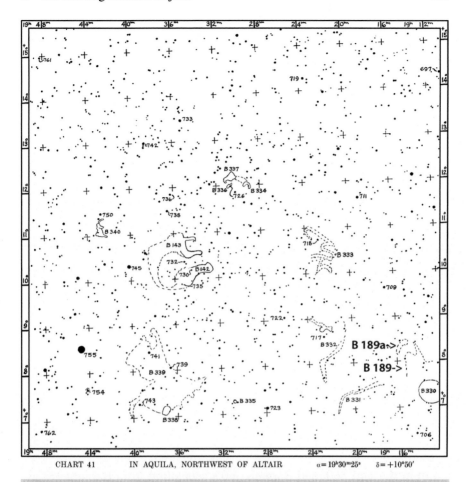

CHART 41 IN AQUILA, NORTHWEST OF ALTAIR α = 19ʰ30ᵐ25ˢ δ = +10°50′

Fig. 8.12 (**a**) Chart 41 from EE Barnard *A Photographic Atlas of Selected Regions of the Milky Way* with Barnard 189 and 189a marked. (**b**) Barnard 332, 331, and 330 with Barnard 189 and 189a. Takahashi Epsilon 180 f/2.8 astrograph with Canon EOS Ra camera. (© Tim B Hunter, 3towers, LLC, 2022. All Rights Reserved)

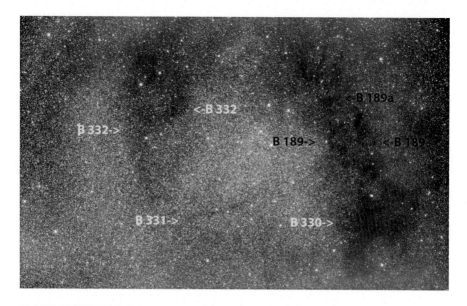

Fig. 8.12 (continued)

Chart 47 – Region in Cepheus
Barnard 190

Barnard 190 is a readily evident, small dark lane just north of Barnard 360 (Fig. 8.13). It is one of those areas so evident that one wonders why it was not originally labeled by Barnard. On deep digital color imaging its separation from Barnard 360, and Barnard 360's separation from Barnard 151 is harder to discern (Fig. 8.13).

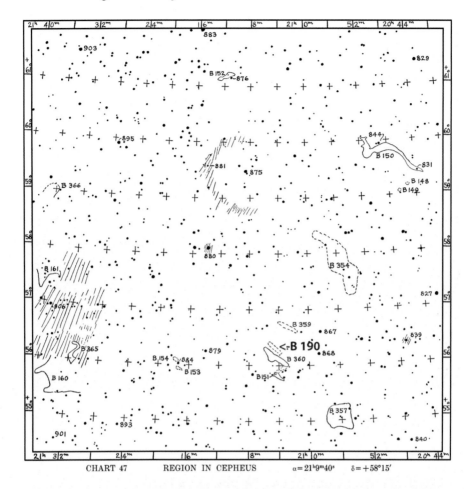

CHART 47 REGION IN CEPHEUS $\alpha = 21^h 9^m 40^s$ $\delta = +58°15'$

Fig. 8.13 (**a**) Chart 47 from EE Barnard *A Photographic Atlas of Selected Regions of the Milky Way* with Barnard 190 marked. (**b**) Cropped and enlarged image showing Barnard 360, 359, 151, and Barnard 190. Takahashi Epsilon 180 f/2.8 astrograph with Canon EOS Ra camera. (© Tim B Hunter, 3towers, LLC, 2022. All Rights Reserved)

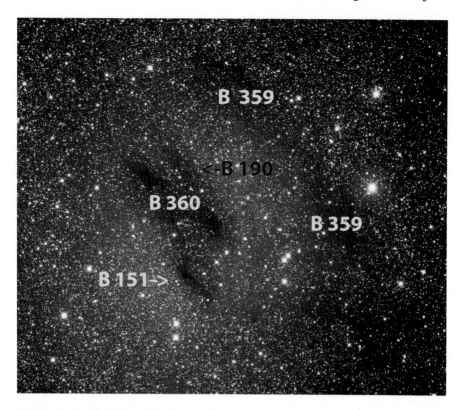

Fig. 8.13 (continued)

Chart 48 – Region in Cygnus, Northeastern Part
Barnard 191, 192, 193

Chart 49 – Region in Cepheus

Barnard 191, 192, 194, 195, 196, 197, 198, 199

Barnard 191, 192, and 193 can be see with difficulty on Barnard's Plate 48, probably showing the limitations of web display of a digitized photograph. However, Barnard 191, 192, 194, 195, 196, 197, 198, and 199 are quite well seen and are quite opaque on Barnard's Plate 49 (Fig. 8.14).

Figure 8.14f shows many original Barnard Objects as well as Barnard 172 added by Dobek in his 2011 edition of Barnard's *Atlas* and our suggested Barnard 198. In, addition a large 40 × 20 arcminute region of dark nebulosity southeast of nu Cephei is marked. This nebulosity is visible on Barnard's Plate 49, but it was not circled or otherwise noted on Calvert's

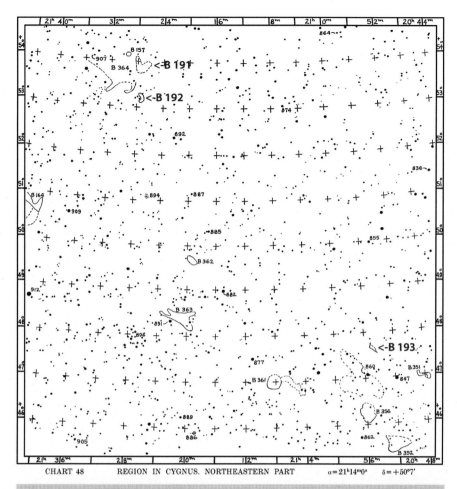

CHART 48 REGION IN CYGNUS. NORTHEASTERN PART $\alpha = 21^h14^m0^s$ $\delta = +50°7'$

Fig. 8.14 (**a**) Chart 48 from EE Barnard *A Photographic Atlas of Selected Regions of the Milky Way* with Barnard 191, 192, and 193 marked. (**b**) Chart 49 from EE Barnard *A Photographic Atlas of Selected Regions of the Milky Way* with Barnard 191, 192, 194, 195, 196, 197, 198, and 199 marked. (**c**) Cropped and enlarged image showing Barnard 364 and 157 with Barnard 191, 192, 194, 195, and 196. Takahashi Epsilon 180 f/2.8 astrograph with Canon EOS Ra camera. (© Tim B Hunter, 3towers, LLC, 2022. All Rights Reserved). (**d**) IC 1396 (Elephant Trunk Nebula as well as large area of surrounding nebulosity) plus Barnard 161, 163, 365, 367, and Barnard 197 and 199. Takahashi Epsilon 180 f/2.8 astrograph with Canon 60 Da camera. (© Tim B Hunter, 3towers, LLC, 2022. All Rights Reserved). (**e**) Barnard 351, 356, IC 5076, and Barnard 193. Takahashi Epsilon 180 f/2.8 astrograph with Canon EOS Ra. (© Tim B Hunter, 3towers, LLC, 2022. All Rights Reserved). (**f**) Wide angle view showing Barnard 173, 174, 171, 169, 170, 368, 167, 166, and 165. Barnard 172 is marked in red as well as Barnard 198. Barnard 172 is listed in Dobek's 2011 edition of *A Photographic Atlas of Selected Regions of the Milky Way*. Barnard 198 is a selection for one of the "Missing Barnard Objects." Note the large nebulous area marked by?? southeast of nu Cephei. It is quite apparent in this image, and it is apparent on Barnard's Plate 49 though not outlined or otherwise noted on Calvert's Chart 49. It does not correspond to a listed dark nebula in one of the modern nebular catalogs

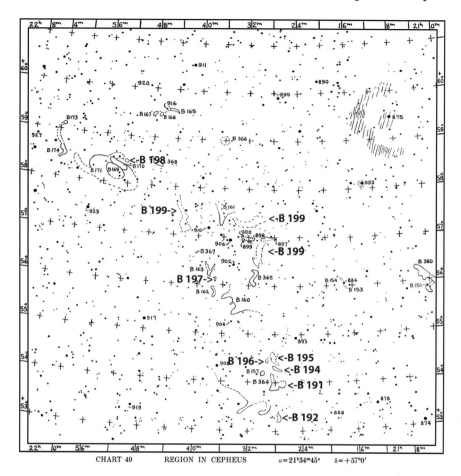

CHART 49 REGION IN CEPHEUS $\alpha = 21^h34^m45^s$ $\delta = +57°0'$

Fig. 8.14 (continued)

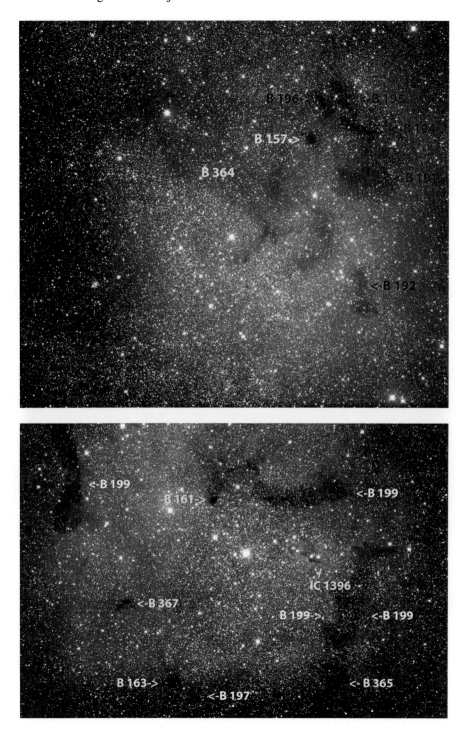

Fig. 8.14 (continued)

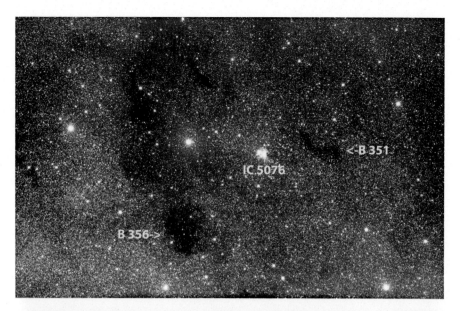

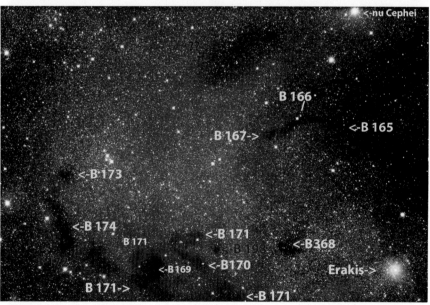

Fig. 8.14 (continued)

Chart 49. A SIMBAD database search shows no known nebular object for this region. No doubt there are many such regions tucked in various portions of the Milky Way. Barnard's survey of dark regions was done visually examining his photographic plates off and on. As noted, he never defined his criteria for including or excluding dark regions in his catalog.

A more detailed discussion of catalogs of dark nebulae is found in Section III of Chap. 9. Modern catalogs of dark nebulae have better defined criteria for including a dark region in the catalog. Even so, such criteria are bound to overlook areas casual observers, such as ourselves, may consider a dark region as illustrated in Fig. 8.14f.

3 Conclusions

Barnard's glass photographic plates which are the basis for his *Atlas* and for his research on dark nebulae have not been scanned and are not available for study. The wonderful George Tech website with digital access to Barnard's 1927 *Atlas* scanned his photographic prints at 600 dots per inch (dpi) with camera software settings of 600 dpi, 4096 × 4096 scan size. For more specific details see: https://exhibit-archive.library.gatech.edu/barnard/project_info.html. Dobek scanned the photographic prints for his 2011 Edition of Barnard's *Atlas* at 2400 dpi, a bit depth of 16, with an average scan size of 24,000 × 24,000.

A hoped-for future project is to track down Barnard's original glass photographic plates, most of which are stored at Yerkes Observatory in Williams Bay, Wisconsin, and digitize at high resolution (1200 dpi or higher) those plates comprising his *Atlas* and other well-known plates of interest. Until that is accomplished, we must live with the limited dynamic range shown by the digitized images of the photographic prints in his *Atlas*. This does limit discussion as to what was evident to Barnard as he visually studied his glass plates.

Our reconstruction of Barnard Objects 175–200 is based on those areas indicated by Barnard for further study. There is no way to know that if he had the time and lived long enough whether he would have included these regions in future publications. There is certainly no way to know what numbers he would have assigned these areas.

Several of our newly designated Barnard Objects may represent Bok globules. Bok globules are small, rounded dark nebular regions thought to contain star formation or be a precursor to star formation. They are named after Bart Bok (1906–1983) who called attention to them. He always credited Barnard with having first called attention to these small dark nebular

areas. Bok globules are extensively discussed in Chap. 9 where we look at the modern study of Barnard Objects. Several of Barnard's dark nebulae are now considered Bok globules and show regions of star formation. Our newly designated Barnard 182, 193, 196, 197, and 198 may be Bok globules.

We cannot pretend our assignments for "The Missing Barnard Objects" may carry any official recognition. They simply clean up a gap in the Barnard Object numbering system and point out overlooked dark regions of note. They were clearly outlined by Barnard and Calvert, so one may presume that Barnard viewed these regions as having some significance. Perhaps these additions to Barnard's catalogue may one day be added to the astronomical database. At the very least, these regions warrant some degree of future study.

With the addition of the "Missing Barnard Objects", comprising of 25 outlined regions and 1 prominent dark object, along with 3 outlined regions that are most likely associated with catalogued Barnard Dark Objects, the final total of Dark Objects in Barnard's catalogue is 380.

References

Barnard EE. Some abnormal stars in the cluster M 13 Herculis. Astrophys J. 1900;12:179–81.

Barnard EE. On the dark markings of the sky with a catalogue of 182 such objects. Astrophys J. 1919;XLIX(#1):1–28.

Barnard EE. In: Frost EB, Calvert MR, editors. A Photographic atlas of selected regions of the Milky Way. Washington: Carnegie Institution of Washington; 1927. Online Version at Georgia Institute of Technology: Barnard's Photographic Atlas of Selected Regions of the Milky Way (gatech.edu).

Barnard EE. A Photographic atlas of selected regions of the Milky Way. In: Edwin B Frost, Mary R Calvert, editors, reprinted under the direction of Gerald Orin Dobek. Cambridge: Cambridge University Press; 2011.

Project Pluto: *Guide*, version 9.15, December 2015.

Chapter 9

The Barnard Objects Now

1 Introduction

What is the importance of the Barnard Objects today? Are they merely of historical interest? Yes, in the sense that Barnard's list was not comprehensive only including selected portions of the Milky Way. No, in the sense that Barnard's list led to an important branch of astrophysical research – the formation, structure, and evolution of nebular regions in our Galaxy and in other galaxies. These dark nebulae are the "birth places" for new stars.

Barnard's list contains objects ranging in size from 1 arcminute to 270 arcminutes. He offered no definition for the opacity of an object, and his list had no consistent numbering system with no specific criteria defined for inclusion in the list. Many of the Barnard Objects are known to be regions of active star formation. All the larger and more prominent Barnard Objects are under active study today by professional astronomers using visual, infrared, microwave, and radio wave techniques. Most of the Barnard Objects are still referred to by their original Barnard Object number.

Quite a few of the Barnard Objects are gorgeous visually through binoculars or a small telescope (3–10 inches) (Franks 1930). Several of them are quite interesting when viewed under high power with a large amateur or small professional telescope (12–36-inches). Many of Barnard's publications describe his experience viewing these dark objects with the Yerkes 40-inch refractor (Barnard 1913b). It was his observation that some of the

T. B. Hunter et al., *The Barnard Objects: Then and Now*, The Patrick Moore Practical Astronomy Series, https://doi.org/10.1007/978-3-031-31485-8_9

small dark areas on his photographs had an "…over-spreading feeble nebulosity…" which helped convince him of their nebulous nature rather than being voids in the sky (Franks 1930).

Almost all of the Barnard Objects are quite interesting with modern color digital imaging, particularly if the right image scale is used for the object (see https://www.3towers.com/Grasslands_Content/BarnardObjects/BarnardMain.html). Quite a few of the Barnard Objects are extraordinarily spectacular when imaged in color using long exposures and sophisticated image processing techniques.

Barnard's work was the first organized study of dark nebulae. He had an enormous data set of visual observations and photographs taken over almost four decades far exceeding that of anyone else. It was not known in Barnard's time there were galaxies separate from the Milky Way. Most of the faint "nebulae" he and others discovered visually were in fact distant galaxies. Even so, he did recognize that many "nebulae" which we now know are galaxies had dark regions like those he discovered photographically in the Milky Way.

2 Interstellar Medium (ISM)

Stars are the fundamental units of the Universe. They host planetary systems and form the building blocks of galaxies. Understanding how stars form supports our understanding of astrophysics from the molecular to the galactic scale. There is a close connection between molecular gas and star formation. Cold, dense molecular gas collapses gravitationally to form stars. Observing molecular clouds in the Solar neighborhood facilitates detailed studies of their physical properties and enables a better understanding of star-formation in general (Zucker et al. 2019).

Interstellar space, the region between stars in a galaxy, contains clouds of gas and dust. This space is called the interstellar medium (ISM) and presumably contains primordial material from the early formation of a galaxy, materials from stars and star formation, and material that is the raw ingredients for future star-formation and planet formation (Cfa, ISM). Hydrogen and helium together make up 98% of the mass of the interstellar medium, while 2% is heavier elements like carbon and oxygen. Any element that is not hydrogen or helium is called a "metal" by professional astronomers. About half of the heavier elements are in the form of gas and about half of the heavier elements are in a solid form called *interstellar dust*.

The interstellar medium on average is emptier than the best vacuums that can be made on Earth. Because of its enormous volume in the Milky Way,

it contains a significant amount of mass. The Milky Way is a typical large spiral galaxy which has a 4 million solar mass black hole in its center. It has a barred galactic bulge and a disk with spiral arms. Modeling the structure and mass of the Milky Way is quite difficult since we are inside the Milky Way in a spur of one of its spiral arms.

Modeling of the Milky Way was done by Li (2016) using the recently released Gaia billion-star map (Lindegren et al. 2016). Li obtained a flat rotation curve for the Milky Way with no need for a dark halo (Li 2016). His mass estimate for the Galactic bulge with its black hole is $Mb=1.69 \pm 0.12 \times 10^{10} M_\odot$, where M_\odot is the mass of the Sun. His estimate for the mass of the stellar disk of the Milky Way is $Ms=2.32 \pm 0.24 \times 10^{11} M_\odot$. He estimates the gas (HI and H2, non-ionized atomic and molecular hydrogen, respectively), in the Milky Way at $Mg=8.43 \pm 0.84 \times 10^9 M_\odot$ and the mass of the low-density areas as $Ml=2.93 \pm 0.57 \times 10^{10} M_\odot$. The total mass of the Milky Way is estimated at $Mtotal=2.57 \pm 0.23 \times 10^{11} M_\odot$. While non-ionized gas is probably less than 4% of the Milky Way's mass, it is still an enormous total mass of nearly 10 billion times the mass of the Sun.

About half of interstellar gas by mass in the Milky Way is spread out through an estimated 98% of the space between stars. This gas is of very low density, but it is heated by light from stars. In its hottest parts the ISM can reach temperatures of millions of degrees, even the coolest parts of this hot gas are hotter than the surface of the Sun. This very low-density hot gas emits some visible light, and the hottest ISM produces a diffuse X-ray glow (CfA, ISM).

One-half of the interstellar gas by mass is compressed into 2% of its volume which exists in the form of interstellar clouds. These regions are cold and still relatively low in density forming hydrogen clouds or HI regions where hydrogen exists as non-ionic single H molecules. Neutral hydrogen clouds are detected by their 21 cm radio wave emissions. If there is a nearby hot star, ultraviolet radiation from the star can ionize the neutral hydrogen to produce free electrons and H^+ ions (protons) giving rise to HII regions where there is emission of a dominant spectral line at 656.3 nm (H-alpha line) from light emitted when a H^+ ion momentarily captures an electron.

The densest interstellar clouds are the *molecular clouds* which are very dense and very cold compared to most of the interstellar medium. The hydrogen in these clouds mainly exists in the form of H_2 molecules. The very largest dark clouds, known as *giant molecular clouds*, contain more than a million solar masses of material. Since a giant molecular cloud can span 150 light years, its average density is very low 100–300 molecules/cc. Generally, molecular clouds are quite cold at only 7–15 Kelvin.

Molecular clouds are where star formation takes place. It does not occur elsewhere, though most molecular clouds do not seem to contain stars and often do not show star formation. Molecular clouds can contain stars which may be completely or partially hidden by the dust in the clouds. The energy from the stars will heat portions of the clouds giving rise to emission nebulae and reflection nebulae. Far infrared thermal emission from dust grains and microwave emission from constituent molecules allow detection of stars and regions of star formation in many molecular clouds that would otherwise be hidden from view. There is much clumping of material in molecular clouds, and the clouds themselves can range greatly in size and mass. The smallest clouds and the smallest clumps in larger clouds that we can detect are around a light year in size.

2.1 Dust Clouds (Molecular Clouds)

Dust makes up about 1% of the interstellar medium and is good at absorbing visible light, particularly toward the blue end of the spectrum (CfA, ISM). Starlight shining through the ISM or through a more concentrated dust cloud appears redder and may be completely obscured. Infrared, microwave, and radio wavelengths pass through these regions more easily, and the modern study of the ISM and dust clouds is via these wavelengths.

The terms molecular cloud, dark nebula, and dust cloud are used loosely and interchangeably by most astronomers. For our purposes a molecular cloud is an interstellar clump of material that is opaque to visible light because of internal dust grains. These are the objects studied by Barnard and which he called dark nebulae, dark regions, dark zones, dark lanes, and dark markings. The largest dark nebulae or molecular clouds visible are nearest to us, and a few are even visible to the naked eye on a Moon free night at a dark site. As noted by Barnard and others, they appear as dark patches against the brighter Milky Way background. Star formation takes place only in molecular clouds which are located primarily in the disks of spiral galaxies. They are also located in active regions of star formation in irregular galaxies.

Dark nebulae are mainly molecular H_2, but they also contain other gases like helium and carbon monoxide CO as well as dust. For every 10,000 hydrogen molecules there is a carbon monoxide CO molecule. Unfortunately, molecular hydrogen is very difficult to detect because of its weak spectral lines. Carbon monoxide molecules have strong microwave emission at 115,267.2 MHz allowing radio telescope detection (Wilson et al. 1970). Carbon monoxide is far easier to detect than molecular hydrogen and is

often used to trace molecular hydrogen (Cosmos, Molecular Cloud). Water H_2O, HCN, and other molecules "glow" at microwave radiofrequencies and are also used as tracers for molecular hydrogen. Well over 100 molecules have been found in dense molecular clouds.

HI clouds (atomic hydrogen) can form on the outer edges of molecular clouds if there is enough energy for some of the molecular hydrogen to dissociate into atomic hydrogen. As you go deeper into a molecular cloud, it becomes darker and colder. At the low densities and temperatures in major portions of molecular clouds there is exotic chemistry with unstable chemical species existing because there is not enough energy to convert them to more stable forms.

The densest and most opaque molecular clouds can give rise to star formation when the cloud is "disturbed" causing the gas and dust to collapse under its own gravity. The interstellar medium is known for being turbulent, the cause of which is debated. It may be from star formation as new stars and their supernovae drive winds in the ISM. It may be from the influence of gravity as it induces supersonic motions in the gas moving through a rotating galaxy (CfA, ISM).

As a localized dense region of gas collapses, its density rapidly increases as does its temperature sometimes reaching high enough densities and temperatures to start nuclear reactions leading to star formation. Why some clouds harbor star formation and why other do not is an area of intense research. Some clouds have very active star formation, others have slight star formation. Many show no star formation. The star formation in some clouds leads to massive stars, while the star formation in other clouds produces solar sized and smaller stars.

3 Catalogs of Dark Nebulae; Lynds Catalogues (LDN and LBN); Sandqvist and Lindroos Catalogues (SL, Sa); Bernes Catalogue (Be)

The first comprehensive attempt to catalog dark areas in the Milky Way was that of Barnard. He and Max Wolf are responsible for starting a systemic study of these regions. Barnard's catalog is still the most cited and the most known in amateur astronomy. Lynds Catalogues of Bright and Dark Nebulae are probably the most cited and well-known nebular catalogs used in professional astronomy along with Barnard's work. Dutra and Bica in 2002 studied 21 catalogues of dust clouds in the Milky Way. They noted dust clouds are fundamental to understanding the structure and evolution of the Milky Way. Their summary of dust cloud catalogues is an excellent

overview of this field of study and confirms that Barnard's work and subsequent work by Lynds are the primary sources for studying dark regions in the Milky Way (Dutra 2002).

Beverly T Lynds (1929-) published a *Catalogue of Dark Nebulae* in 1962 (Lynds 1962). In her 1962 publication she noted general surveys of the distribution of dark nebulae were undertaken by relatively few astronomers. The National Geographic Society - Palomar Sky Survey (NGS-POSS) was completed by the end of 1958. Lynds felt this provided a wealth of material for a detailed survey of dark nebulae. "These photographs have the advantage of enabling the surveyor to cover the entire sky visible from Mount Palomar. In addition, the availability of photographs of each region, in both red and blue light, makes the detection and classification of nebulae more accurate" (Lynds 1962).

Lynds examined red and blue photographs for 879 fields obtained from (NGS-POSS) for the presence of a dark nebula. She measured its area in square degrees with a planimeter after determining its outline as traced from the prints. She measured the celestial coordinates for the center of each dark nebula she identified. Lynds also developed a scale for the opacity of each cloud from 1 to 6. "These estimates were based on a comparison of the neighboring fields for the particular Palomar photograph on which the cloud appeared. Both the red and blue prints were used in this comparison. The clouds just detectable on both prints, as evidenced by a slight decrease in surface intensity of the general field, were designated opacity 1. The darkest clouds, of opacity 6, were those within which the star density, on the average amounted to 120 stars per square degree, down to the limiting magnitude of the red photograph. In addition to the minimum number of stars per square degree, the opacity 6 clouds are those which *appear* to be the darkest-many seem darker than the general background in the neighboring clear regions" (Lynds 1962).

The range in declination for Lynds catalog was +90° to −33°. She only listed those dark clouds that were visible on both red and blue photographs. In this regard she noted "It is therefore very probable that the more tenuous clouds which may be transparent in the red are not included in this survey. It is often difficult to detect a cloud which absorbs less than 0.75 mag." (Lynds 1962). Lynds also noted many small dark nebulae, globules described by Bok and Reilly in 1947, were not included in her catalog, because she did not include bright nebulae in her survey. Many of the globules first described by Bok and Reilly appear as dark objects projected against the bright background of bright emission nebulosity.

The galactic coordinate system locates objects withing the Milky Way by galactic longitude and latitude somewhat analogous to Right Ascension

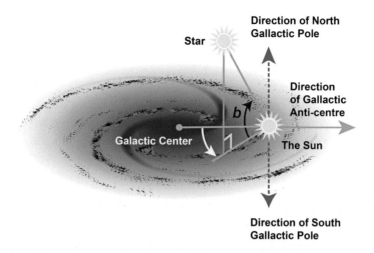

Fig. 9.1 Galactic coordinate system. (Drawing by Debra Bowles)

(RA) and Declination (Dec) in the equatorial coordinate system used for everyday observing. The definition of the galactic coordinate system was finalized by the International Astronomical Union in 1959. The galactic equator or galactic plane is like the celestial equator in the equatorial coordinate system and is the great circle on the projected celestial sphere made by the plane of the disk of the Milky Way. The Sun is at the center of a sphere that encloses the Milky Way on to which the galactic latitude (b) and longitude (l) are projected (Fig. 9.1).

The galactic latitude ranges from +90° to −90° above and below the galactic plane. Galactic longitude ranges from 0° to 360°. Galactic longitude $l = 0$ is that direction pointing to the center of the Galaxy which is Sagittarius A*. Galactic longitude increases in the counterclockwise direction as viewed down from the north galactic pole which is defined as RA = 12 h 51.4 min, Dec = +27° 07′ in 2000.0 coordinates. The galactic equator is inclined 63° to the Earth's equator (Cosmos 2022).

The galactic coordinate system is used by those studying the Milky Way, particularly in the infrared, microwave, and radio portions of the spectrum. It is difficult to appreciate and use for most amateurs and professionals not specifically working with the Milky Way. Most of the Barnard Objects are at "low" galactic latitude °($|b|$ <25°) in such regions as Aquila, Scutum, Ophiuchus, Sagittarius, and Scorpius.

Lynds catalog had 1802 listings which included all the objects listed in Barnard's 1927 *Atlas*. In her Table I her objects were listed in increasing order by galactic longitude. In Table II she lists Barnard Objects in her

catalogue from Barnard 1 to Barnard 269 with their corresponding number in her catalog. The smallest objects measured in her survey had an area of "2 square minutes of arc." Small objects like this need a thick stellar background to become apparent. "In fact, the minimum detectable size of a dark nebulae increases rapidly with increasing [galactic] latitude, to such an extent that clouds covering areas of the order of 0.1 square degree may not be noticeable at sufficiently great distances from the galactic plane" (Lynds 1962). This may be less true today with more sensitive color digital imaging where long exposures show considerable background "cirrus" nebulosity in many portions of the sky away from the Milky Way. Small dark clouds may be more apparent on this imaging contrasted against the background "cirrus." There is a tendency of dark nebulae to lie below the galactic plane in longitudes of the order of 180° and above the galactic plane at longitudes around 0° .

Lynds also made a survey of the bright diffuse areas (LBN) detectable on the Palomar Sky Survey prints in a manner like her survey of dark nebulae (Lynds 1965). All known planetary nebulae were excluded, but the survey included known supernova remnants, reflection nebulae, and standard HII emission nebulae. Objects appearing brighter on the blue plate versus the red plate are considered reflection nebulae. Those that have nearly the same brightness on the blue and red plates may be transition objects or weaker emission regions. Those very bright on the red plates are usually HII regions. Red nebulae (emission nebulae) are mostly confined to low galactic latitudes. Many low surface-brightness features are found at large distances from the galactic plane. Blue and mixed color nebulosity dominates in galactic latitudes greater than 30° .

In 1976 Aage Sandqvist and KP Lindroos published a catalogue (SL) of 42 dark dust clouds of high visual opacity compiled from a study of the Whiteoak Fields of the POSS I (−33° > declination > − 46°), and in 1977 Sandqvist published a further catalogue (Sa) of an additional 95 dark dust clouds of high visual opacity. The latter catalogue was compiled from the ESO (B) Atlas covering declinations −42.5° and greater (Sandqvist and Lindroos 1976; Sandqvist 1977).

Formaldehyde (H_2CO) was detected in 33 of the original 42 dark areas cataloged by Sandqvist and Lindroos. In fact, "…the ultimate purpose of [their] project was to survey clouds for formaldehyde, only the darker clouds (and therefore those more likely to contain detectable formaldehyde) were chosen…[and]…a serious attempt was made to follow [Lynds opacity] scale as closely as possible" (Sandqvist 1976).

"Formaldehyde is an important molecule as a precursor of methanol, which in turn is a starting point for the formation of more complex organic

species" (Potapov et al. 2017). Twelve Barnard Objects (B 228, B 235, B 44a, B 48, B 231, B 263, B 58, B 233, B 50, B 49, B 53, and B 257) were among the 42 dark clouds in the Sandqvist Lindroos catalog. The second catalog of 95 additional dark dust clouds published by Sandqvist in 1977 completed southern sky coverage for high opacity dark areas in a fashion similar to Lynds large survey covering the northern sky down to declination −33 degrees (Sandqvist 1977).

Claes Bernes in 1977 published an interesting catalog of "...160 bright nebulosities seen in or at the edges of well-defined dark clouds with an opacity, as defined by Lynds (1962), of at least 4" (Bernes 1977). These objects were derived by examination of the POSS red and blue plates, the Whiteoak Extension of the POSS I (red plates) and ESO (B) atlas (blue plates) available in September 1976. Bernes felt emission or reflection nebulae or other bright nebulosities, like Herbig-Haro objects, in a dark cloud may be an indication of recent or ongoing star formation. He further felt "Searches in these regions at infrared and radio wavelengths for obscured protostellar or stellar objects and compact HII regions may therefore be useful." This has since been proven to be true as noted in the below discussion of the current research on dark nebulae.

There are several other catalogs of dust (dark nebulae) which extend the sky surveyed to below declination −33° (Feitzinger and Stuwe 1984). Much of this later work was based on European Southern Observatory (ESO) photographic surveys, particularly the ESO(B) Atlas and the ESO/SERC plates. For example, Hartley et al. (1986) published a catalogue of 1101 dark clouds compiled from visual inspection of the ESO/SERC Southern J survey plates for declinations south of −33 degrees. This survey agreed with work by Lynds that dark clouds are concentrated along the galactic equator and more toward the galactic center. For the southern clouds there is no overt connection with Gould's Belt.

Dobashi and colleagues in 2005 presented an atlas and catalog of dark clouds based on the Digitized Sky Survey I (DSS). They noted prior catalogs were qualitative and did not offer in most cases what they called the visual extinction (A_v) of individual dark clouds. They also felt some dark clouds escaped detection in earlier catalogs because searches of dark clouds were carried out by eye inspection. Dobashi and colleagues presented a new atlas and catalog of dark clouds based on computer surveying of the DSS deriving an "...A_v map covering the entire region in the galactic latitude range |b| <- 40°...Based on the A_v map...[they] identified 2448 dark clouds and 2841 clumps located inside them" (Dobashi et al. 2005). This was done by applying a traditional star-count technique to the 1043 plates contained in the DSS database.

The 2 Micron All-Sky Survey (2 MASS) is a survey of the whole sky in the infrared. It took place from 1997 to 2001 in both the Northern Hemisphere and the Southern Hemisphere and was conducted in the short wavelength infrared in the J, H, and K frequency bands near 2 microns (2 Mass). Using data from the 2 MASS, Dobashi in 2011 published an atlas and catalog of dark clouds. He correlated his 2005 atlas and catalog based on the optical DSS 1 with the 2 Micron infrared data (Dobashi 2011). In this process he identified 7614 dark clouds and noted the infrared data "… mainly trace relatively dense regions in dark clouds, revealing a number of dense cloud cores leading to star formation, while those presented…based on the optical database are more suited to trace less-dense regions and to reveal the global extents of dark clouds. These two datasets are complementary, and all together, they are useful to picture the structures of dark clouds in various density ranges" (Dobashi 2011).

Dobashi's methodology uniquely combined optical and infrared observations. However, the correlation between optical and infrared observations may not be as straightforward as originally thought. In 2013 Dobashi and colleagues published a correction to their earlier work giving new color excess and extinction maps corrected for the background. The corrections and the inferred correlations may evolve further, but there is no doubt that combing optical data with data from other wavelengths is a necessity for studying dark nebulae.

4 Gould's Belt; Radcliffe Wave; Local Bubble

In 1879 Benjamin Gould (1824–1896) described a collection of bright, massive stars forming a partial ring when plotted against the background sky. This partial ring or Gould Belt is an expanding ring containing young stars, gas, and dust in a local region of the Milky Way where there is prominent star formation. This area is about 3000 light years long and tilted with respect to the galactic plane up to 20 degrees (Fig. 9.2). It intersects the galactic equator in rich starfield regions of Scorpius and Centaurus on one side of the sky and rich areas in Orion on the other side of the sky (Ventrudo 2023). The Sun is contained in Gould's Belt, and Gould's Belt contains many O and B-type stars with some of the nearest star-forming regions in the local (Orion) spiral arm.

Gould's Belt is an area of intense study, and its contents and relationships to other parts of the Milky Way must be further defined. The physical relation between local gas clouds has been quite difficult to determine. Unfortunately, the distance accuracy to the clouds is of the same order or

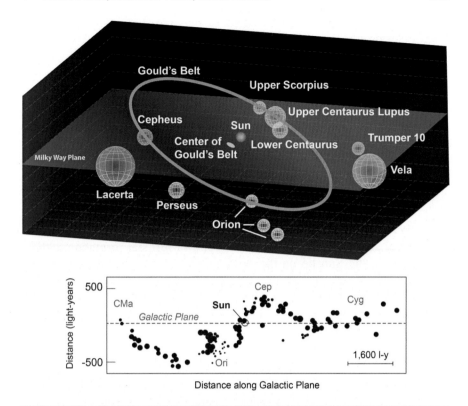

Fig. 9.2 Gould's Belt. B. Radcliffe Wave. (Drawings by Debra Bowles)

larger than the clouds actual size. To overcome this limitation Alves et al. (2020) reported a 3-D structure of the local cloud complexes using large photometric surveys and data from the Gaia satellite astrometric survey.

Alves found a narrow 2.7 kiloparsec long arrangement of dense gas in the Solar neighborhood that contains many of the clouds thought to be part of Gould's Belt. This finding disputes the notion these clouds are part of a ring (Alves et al. 2020). The new structure which is named the Radcliffe Wave after the Radcliffe Institute for Advance Study at Harvard University where this work was developed is felt to contain most nearby star-forming regions. Its length is 20 times its width, and it has an estimated 3 million solar masses. It appears to be undulating, with its 3-D structure like a long narrow damped sinusoidal wave on the Galactic plane. The maximum height of a wave front is 160 parsecs, and the waves are about 2 kiloparsecs apart. Most star clouds along its length formed 50 million years ago, and the star-forming regions are less than 30 million years old (Ventrudo 2023).

Swiggum et al. (2022) used catalogs of massive stars and young open clusters based on Gaia astrometry in conjunction with kiloparsec-scale 3D dust maps to look at the distribution of gas and young stars. Massive stars and clusters appear to be "…inside and downstream from the Radcliffe Wave" (Swiggum et al. 2022). They hypothesized the Radcliffe Wave is the gas reservoir of the Orion (local) arm of the Galaxy. Ventrudo (2023) nicely summarized the latest thinking on the Radcliffe Wave and lists multiple deep sky nebulae and clusters that are associated with the Radcliffe wave. There appears to be a physical connection among many deep sky objects – the North America Nebula, the Taurus Dark (Molecular) Cloud, and the bright nebulae of Orion and Canis Major.

The Sun lies within a region called the Local Bubble or Local Cavity. It is a cavity of low-density, high temperature plasma surrounded by a shell of cold, neutral gas, and dust (Zucker et al. 2022). Most star formation within 200 parsecs of the Sun lie on the surface of the Local Bubble, and these young stars show outward expansion perpendicular to the bubble's surface. Backward tracing of these stars' motion suggests there was a burst of star formation and then death from supernovae taking place near the bubble's center 14 million years ago.

As the Local Bubble expanded from supernovae creation, it swept up the interstellar medium into an extended shell which fragmented and collapsed into prominent nearby molecular clouds, like the Taurus Molecular Cloud (Zucker et al. 2022). Toward the galactic center the Local Bubble abuts up against the Ophiuchus and Lupus Molecular Clouds. Toward the Orion arm of the Milky Way, it abuts up against the Radcliffe Wave. The specific arrangements of these regions is still being studied, and it is likely our understanding of them will change somewhat as more data is acquired. Datasets from the Gaia satellite have provided a much more detailed understanding of the nearby Milky Way structure.

4.1 Handbook of Star Forming Regions

The Handbook of Star Forming Regions was published in 2008 (Reipurth 2008a, b). It is divided into two volumes, one for the northern sky and one for the southern sky. It contains sixty of the most important star-forming regions within 2 kiloparsecs of the Sun. As summarized by Zucker et al. (2020) the handbooks were composed by a team of 105 authors and include "the most comprehensive discussion of individual low-and high-mass star forming regions published to date." These clouds are close enough for high-resolution observations across the electromagnetic spectrum.

Unfortunately, the distances to the clouds listed in the ***Handbook*** are not well constrained. According to Zucker et al. (2020): "Several clouds in the Handbook have distance estimates in the literature that vary by at least a factor of two (e.g. Circinus Molecular Cloud, North America Nebula, Coalsack Nebula, NGC 2362, IC 5146), while many others (e.g. Lagoon Nebula, Pipe Nebula, IC 2944, NGC 2264) show better agreement, but with large distance uncertainties (>30%)." Because of these ranges in reported distances to the various dark clouds, Zucker and colleague produced a supplementary catalog of distances to molecular clouds listed in the Handbook with a typical distance uncertainty of approximately 5% (Zucker et al. 2020).

The North America Nebula is shown on Plate 46 (Region of The North America Nebula) in Barnard's ***Atlas*** (Fig. 7.13). On that plate are shown Barnard 352, Barnard 353, Barnard 349, Barnard 358, and Barnard 355, that latter of which is in the southern portion of the nebula. Barnard 168 is a large dark lane that on its eastern end surrounds IC 5146 (Cocoon Nebula) (Fig. 9.3). The Lagoon Nebula (M8, NGC 6523, NGC 6530) contains

Fig. 9.3 (**a**) Barnard 168 is the large dark lane surrounding the Cocoon Nebula (IC 5146) and extending westward. Takahashi E180 f/2.8 astrograph and Canon EOS Ra camera. (© Tim B Hunter, 3towers, LLC, 2022. All Rights Reserved). (**b**) Early image of the Cocoon Nebula by Max Wolf of Heidelberg, Germany using the Brashear 16-inch Bruce Telescope on July 10, 1904, 240-minute exposure. "This work made use of the HDAP which was produced at Landessternwarte Heidelberg-Königstuhl under grant No. 00.071.2005 of the Klaus-Tschira-Foundation". (HDAP – Heidelberg Digitized Astronomical Plates (uni-heidelberg.de))

Fig. 9.3 (continued)

Barnard 88, Barnard 89, and Barnard 296 (Fig. 9.4). It is shown on Plate 29 (Region in Sagittarius, North of the Great Star Cloud) and Plate 30 (A Region in Sagittarius) in Barnard's *Atlas*. The Pipe Nebula is a combination of Barnard 59, 65–67, and 78 (Fig. 7.7). They are shown on Plates 15 (In Scorpius and Ophiuchus), 18 (Region in Ophiuchus and Scorpius), 20 (Dark Markings Near Theta Ophiuchi), and 21 (Region of Theta Ophiuchi and Eastward). NGC 2264 is part of a large stellar complex with nebulosity (Fig. 9.5). The nebulosity is associated with 15 Monocerotis. Barnard found the nebulosity visually in 1888 with the 12-inch refractor at Lick Observatory and later photographed it.

Stars behind a dust cloud appear redder. The amount of reddening can be used to estimate stellar distances. Stellar counts can also be used to approximate dust cloud distances as dust clouds obscure a fraction of the background stars. Max Wolfe was one of the first astronomers to measure distances to molecular clouds. He used the apparent magnitudes of stars in a "Wolf Diagram" in which he plotted the number of stars per unit solid angle versus their apparent measured magnitudes in regions toward the nebulae where there was extinguishing of starlight by the nebulosity and in regions where there was not. He assumed all the stars had the same absolute magnitude and determined the distance to a dark nebula by characterizing

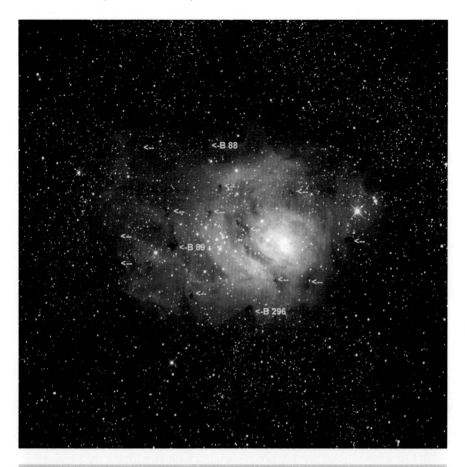

Fig. 9.4 M8 (the Lagoon Nebula; NGC 6523 and NGC 6530). Modern digital image taken with a 20-inch f/3.6 astrograph and a Finger Lakes Instrumentation KAF Proline CCD with Cousins-Johnson photometric B, V, R filters. Potential Bok globules are marked with arrows. There are three Barnard Objects (B 88, B 89, and B 296) which are also considered Bok globules. (© Tim B Hunter, 3towers, LLC, 2022. All Rights Reserved)

the apparent magnitude at which there is a drop in stellar numbers toward the nebula (Zucker et al. 2020).

For these methods to produce accurate distances there has to be good modeling of stars and their types. Zucker combined Gaia DR2 [Gaia Data Release 2] parallax measurements with stellar photometry to "...infer the distance, extinction, type, and Rv [radial velocity] of stellar sources in sight-lines toward local molecular clouds...we require stars to be detected both in front of and behind the cloud, and we fit a simple line-of-sight dust model to the set of *Gaia*-constrained stellar distance and extinction estimates to

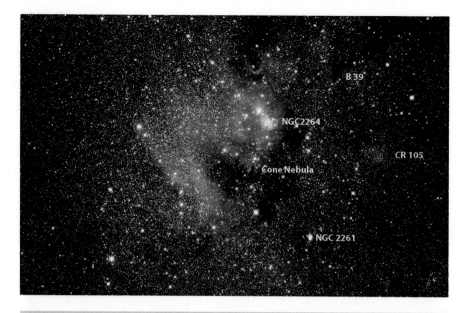

Fig. 9.5 NGC 2264 and environs, including the Cone Nebula. Modern digital image taken with Takahashi E180 f/2.8 astrograph and Canon EOS Ra camera. (© Tim B Hunter, 3towers, LLC, 2022. All Rights Reserved)

infer the distance at which we observe a 'break' in stellar reddening "(Zucker et al. 2020).

The update in distances to dust clouds has several exceptions. Open clusters or OB associations that are not associated with significant dust emission are not suitable for the technique used by Zucker and colleagues. Star formation in Bok globules and small clouds were not targeted as the objects were too small with not enough angular resolution to provide enough background stars to be seen through the globules. The Perseus, Hercules, Aquila South, Spider, Draco, and Maddalena clouds were not mentioned in the **Handbook** but were studied by Zucker in 2019.

5 Structure of the Milky Way; Great Star Clouds

The structure of the Milky Way is difficult to determine since we lie inside the Milky Way and looking along its thin disk and are not able to view it "from above." Also, direct distances to astronomical subjects rely on parallax measurements which limit measurements to nearby objects, a few hundred light years, particularly if stars are being measured by optical telescopes. Large radio telescopes, like the Very Long Baseline Array

(VLBA), can produce parallax measurements for distances in the range of a few kiloparsecs or further. Continental or larger arrays of radio telescopes like the Very Long Baseline Interferometry (VLBI) array can produce even more precise parallax measurements measuring more distant objects. Radio observations also have the advantage of peering through interstellar dust which is opaque to optical wavelengths.

The Bar and Spiral Structure Legacy Survey (BeSSeL) is a Key Project on the Very Long Baseline Array (VLBA). It measures trigonometric parallaxes and proper motions of methanol and water masers associated with hundreds of high mass forming regions in the Milky Way. Radio-astrometric measurements are complementary to the high precision Gaia satellite optical measurements.

The current view of the Milky Way is that of a barred spiral galaxy with four arms with some extra arm segments and spurs (Fig. 9.6). The Solar System sits in the Orion Spur 8.15 +/− 0.15 kiloparsecs (~27,000 light) years from the Galactic center, R_0 (Reid et al. 2019). When we look toward the Milky Way, we are seeing it on edge, viewing thousands of stars seemingly piled on top of one another, thus giving the illusion of milk spilled (*via lactea* in Latin) across the sky. The central bulge of the Milky Way is best observed from the southern hemisphere where it is high in the sky. The northern portion of the central bulge is brighter than the southern portion indicating the Solar System sits above the central plane of the Milky Way (Wilds 2017).

Our view of the Milky Way is bound to change, not because the Milky Way is changing very much on a human time frame, but because our understanding of it and our ability to measure it is constantly changing and improving.

5.1 Great Star Clouds

Barnard often referred to the "Great Star Cloud" in Sagittarius, the "Small Star Cloud in Sagittarius," and the "Great Star Cloud in Scutum." These are commonly used terms regarding the Milky Way and often cited without specifying any definition for these clouds or for their location.

The Small Star Cloud in Sagittarius (also called the Small Sagittarius Star Cloud) is generally regarded as M24 as originally described by Charles Messier, a star filled nebulous region 1.5 degrees across and centered roughly at right ascension 18 hours 17 minutes, declination −18 degrees 29 minutes (2000 coordinates). The open cluster NGC 6603 is sometimes referred to as M24 instead of the large star cloud which contains this cluster

and other objects like Barnard 92 and 93 (Figs. 5.4a–b, 7.10a–c, 8.9b, and 9.7).

The Great Star Cloud in Sagittarius (Large Sagittarius Star Cloud) lies 10 degrees south of the Small Sagittarius Star Cloud. The Great Star Cloud is considered the brightest visible region of the Milky Way, a portion of the central bulge of the Milky contiguous to the Great Rift. The star cloud has an apparent size of 6 × 4 degrees and is centered at approximately 18 hours right ascension and − 29 degrees declination (2000 coordinates). Barnard was fascinated by this region and spent much of his photographic effort

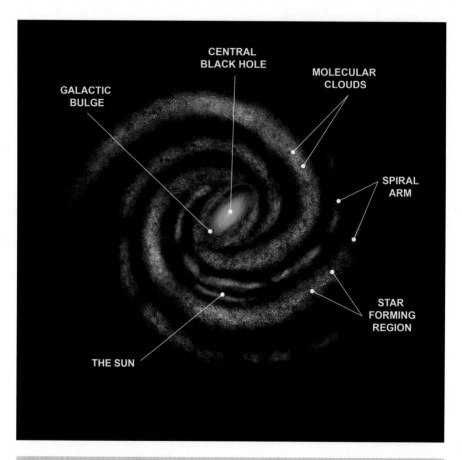

Fig. 9.6 (**a**) Simple top-down overview of the Milky Way. (**b**) Top-down view of the Milky Way and its spiral arms. The galactic bulge contains the Milky Way's spiral bar and is the expanded area of the Milky Way with a massive black hole at its center. The distances of the spiral arms from the center of the Milky Way are only approximate. Drawings by Debra Bowles

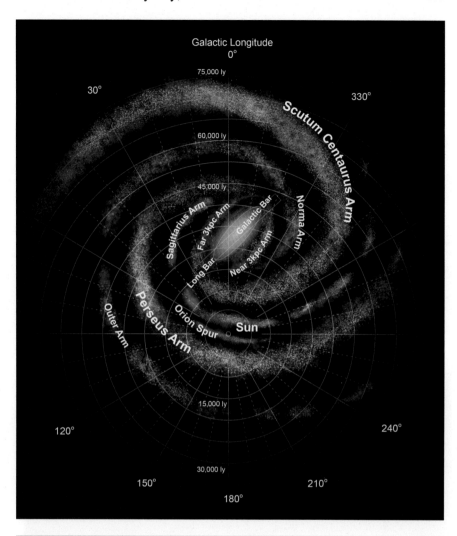

Fig. 9.6 (continued)

here. He started his Milky Way photography at Lick Observatory in 1889 photographing a portion of the Great Star Cloud (**see** Fig. 1.2).

The Great Rift in the Milky Way is a long irregular dark lane or band that stretches from Sagittarius to near Deneb (Figs. 5.4a–b, 9.8). The Scutum Star Cloud is a bright region of the Milky Way about 5 degrees in diameter centered in Scutum just below the tail of Aquila (King 2015) (Figs. 5.4a–b). Along the cloud's northern edge is the large dark area Barnard 111 which has Barnard 110 and Barnard 113 within its bounds (Fig. 9.9). East of Barnard 111 is Barnard 119a. In the central and southern part of the Scutum

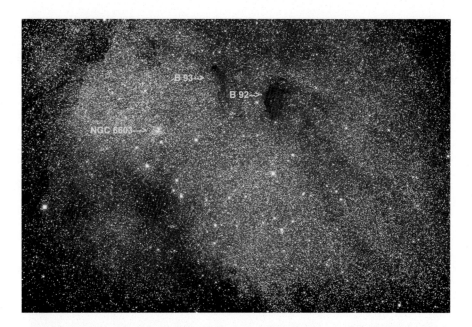

Fig. 9.7 Small Star Cloud in Sagittarius. Takahashi E180 f/2.8 astrograph and Canon 60 Da camera. (© Tim B Hunter, 3towers, LLC, 2022. All Rights Reserved)

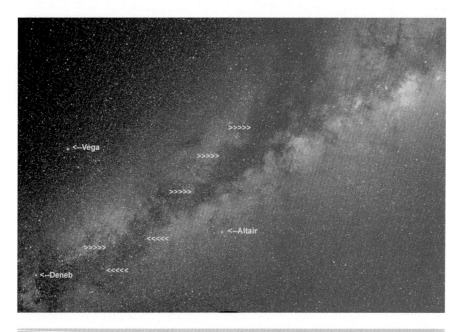

Fig. 9.8 Summer Milky Way overhead with Vega, Deneb, and Altair noted (the Summer Triangle). The arrows (>>>>>) denote the Great Rift of the Milky Way. Canon 5D Mark II camera 15 mm f/3.5 lens. Image by James McGaha and Tim Hunter. (© Tim B Hunter, 3towers, LLC, 2022. All Rights Reserved)

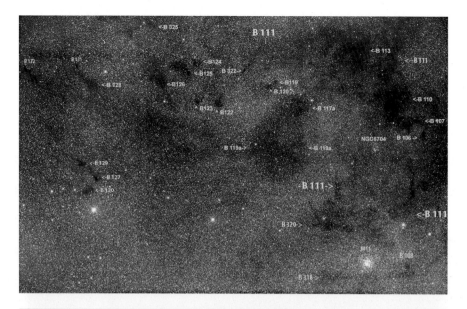

Fig. 9.9 A portion of the Scutum Star Cloud featuring the large Barnard Objects B 111, B119a, and M 11 (NGC 6705; the Wild Duck Cluster). Takahashi Epsilon 180 f/2.8 astrograph with Canon EOS Ra camera. (© Tim B Hunter, 3towers, LLC, 2022. All Rights Reserved)

Star Cloud is M11 (the Wild Duck Cluster, NGC 6705) and several other objects of interest (see Figs. 7.11a–c). Many of these Barnard Objects are visible in dark skies with large binoculars or a wide-field telescope (King 2015). The Scutum Cloud was another remarkable area of interest for Barnard.

5.2 *Theta Ophiuchi (θ Ophiuchi)*

Theta Ophiuchi (Ɵ Ophiuchi) is a naked eye star in Ophiuchus. It has a visual magnitude of 3.27 and is probably a triple star system with its component too close to be visible telescopically. This star sits near many objects of interest to Barnard, and three of the plates in his *Atlas* were oriented with respect to Theta Ophiuchi: Plate 19, Region North of Theta Ophiuchi; Plate 20, Dark Markings near Theta Ophiuchi; and Plate 21, Region of Theta Ophiuchi and Eastward (**see** Figs. 7.8a–c and Fig. 9.10). It lies at approximately 436 +/−10 light years away.

5.5.1 Rho Ophiuchi Cloud Complex (Also Known as Ophiuchus Molecular Cloud or Ophiuchus Dark Cloud)

The Rho Ophiuchi region is an extremely complex area of stars and nebulae, bright and dark. Throughout his career Barnard photographed and visually observed this region writing many papers about it. Rho Ophiuchi (P Ophiuchi) is 3 degrees north of Antares, and while it can be seen visually in

Fig. 9.10 (a) Plate 21 from the *Atlas*. Region of Theta Ophiuchi and Eastward. Superimposed white rectangle shows region illustrated in (**b**). (**b**) Modern digital image centered on the main portion of Barnard 78 (western portion of the Pipe Nebula). Note several smaller scattered Barnard Objects, many of which might represent Bok globules. Theta Ophiuchus is the bright star on the right edge of the image. Canon 200 mm f/2 lens, Canon EOS Ra digital camera, image cropped and enlarged. Image by James McGaha and Tim Hunter. (© Tim B Hunter, 3towers, LLC, 2022. All Rights Reserved)

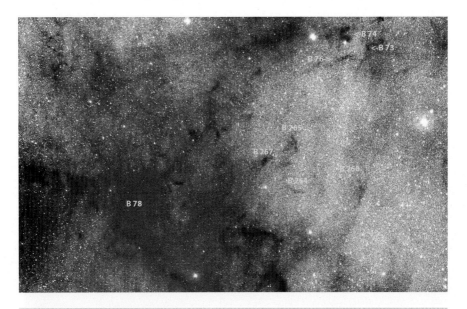

Fig. 9.10 (continued)

a dark sky (magnitude 4.63), it is usually overlooked due to the nearby brighter stars in Scorpius. Rho Ophiuchi is located about 395 light years away. It is a multiple star system consisting of two blue subgiants Rho Ophiuchi A and Rho Ophiuchi B separated by 3.1 arcseconds. They are typical hot B stars, rotating over 300 kilometers per second at the equator. Rho Ophiuchi A has a luminosity 4900 times that of the Sun and is 9 times more massive. Rho Ophiuchi B has a luminosity 2100 times that of the Sun and is 8 times more massive (Kaler 2021).

On photographs of the region Rho Ophiuchus appears as a single bright star. North of Rho Ophiuchi 2.5 arcminutes is HIP 80474 (Rho Ophiuchi C) and west 2.82 arcminutes is HIP 80461 (Rho Ophiuchi DE, a close binary star). These stars lie farther away than Rho Ophiuchi at 408 and 440 light years respectively. These three stars are readily evident on historic and modern images forming a right triangle with Rho at the right angle (Figs. 7.5b and 9.11) . They are surrounded by IC 4604 a large area of reflection and dark nebulosity. West of these stars approximately 10 arcminutes is the long linear dark region Barnard 42 amid IC 4604. IC 4604 is also known as the Rho Ophiuchi Nebula. Two degrees to the west of Rho Ophiuchi is M80 (NGC 6093).

Rho Ophiuchi is embedded in the Rho Ophiuchi Cloud Complex, a vast region of dust and gas that probably dims Rho Ophiuchi up to 2 magnitudes (**see** Figs. 5.3, 7.5, and 7.6). This is one of the nearest star forming regions

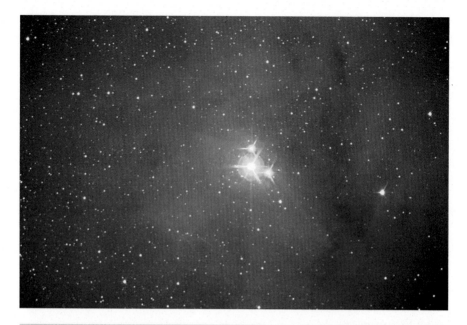

Fig. 9.11 Modern digital image of Rho Ophiuchi. The bright center star is Rho Ophiuchi which forms the right angle of a right triangle with HIP 80474 at the top of the triangle and HIP 80461 at the base of the triangle. Meade LXD75 8-inch f/4 telescope, QSI CCD with images through clear, red, green, and blue filters combined to produce a final color image. (© Tim B Hunter, 3towers, LLC, 2022. All Rights Reserved)

to the Sun and encompasses an area about 4.5 × 6.5 degrees containing IC 4604, IC 4603 one degree south of Rho Ophiuchi, and IC 4605 two degrees southwest of Rho Ophiuchi. IC 4603 is a bright reflection nebula centered around the 7.87 magnitude star HIP 80462. IC 4605 is a bright reflection nebula centered around 22 Scorpii magnitude 4.78. The Rho Ophiuchus complex is contiguous to the nebulosity surrounding Antares to the south as well as continuing west toward M4 and considerably east of Antares encompassing Barnard 44, though these regions are generally not listed as part of the Rho Ophiuchus complex.

5.3 Taurus Dark Cloud

The Taurus Dark Cloud is better known as the Taurus Molecular Cloud and is also called the Taurus-Auriga complex or the Taurus star forming region. It is a molecular cloud in the constellations of Taurus and Auriga and is an

active star forming region, one of the nearest star formation regions to the Earth. The Taurus Molecular Cloud is approximately 140 parsecs (430 light years) away. It is a roughly 450 × 300 arcminute patch of the sky about 10° east of a line joining the Hyades and the Pleiades and centered near the complex dark nebular region Barnard 22. Visual observations of this region are usually unremarkable unless one has a very dark sky with steady seeing. Then the dark cloud complex is silhouetted against the brighter starry regions. Photographically many complex nebular areas are present with dark nebulae, emission nebulosity, and reflection nebulosity (Fig. 9.12).

Near-infrared surveys of the Taurus Dark Cloud shows recently formed stars are spread throughout the cloud. They are primarily T Tauri stars or T Tauri-like stars. Luminous objects are present in the dark cloud like the reflection nebula IC 2087 (Barnard 14) (Elias 1978). The cloud contains many complex molecules including large amounts of molecular hydrogen. The cloud has no luminous O or B stars and is considered an excellent place

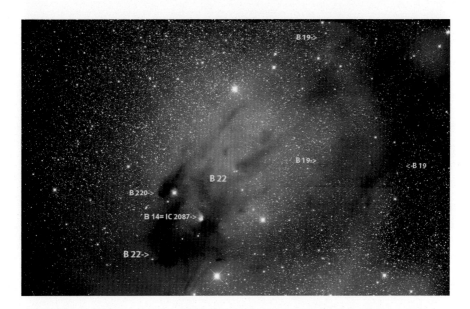

Fig. 9.12 (a) Barnard 22 (Taurus Dark Cloud Complex). This region is near the center of the Taurus Dark (Molecular) Cloud. It is an area of active star formation. Takahashi Epsilon 180 f/2.8 astrograph with Canon EOS Ra camera. (© Tim B Hunter, 3towers, LLC, 2022. All Rights Reserved). (**b**) Barnard 14 (IC 2087) and environs. Barnard 14 is a reflection nebula surrounded by dark nebulosity. Image taken with a 20-inch f/3.6 astrograph and a Finger Lakes Instrumentation KAF Proline CCD using luminous and Cousins-Johnson photometric B, V, R filters. The extraneous light at the bottom of the image is from nearby Mars. (© Tim B Hunter, 3towers, LLC, 2022. All Rights Reserved)

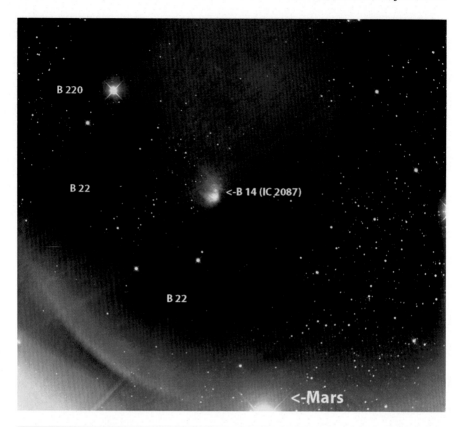

B 220

B 22

<-B 14 (IC 2087)

B 22

<-Mars

Fig. 9.12 (continued)

to study the formation of low mass stars like the Sun (Kenyon et al. 2008). There are 28 Barnard Objects that lie in the Taurus-Auriga complex [B 7, 10, 14, 18, 19, 22, 23, 24, 26, 27, 28, 29, 207, 208, 209, 210, 211, 212, 213, 214, 215, 216, 217, 218, 219, 220, 221, and 222] (Kenyon et al. 2008).

5.4 *Perseus Dark Cloud*

The Perseus Dark Cloud located mainly in Perseus is better known as the Perseus Molecular Cloud which contains the Perseus OB2 Association, a loosely organized group of mainly young, hot OB stars moving together. They are in the Perseus spiral arm of the Milky Way in the opposite direction from the center of the Milky Way in Sagittarius. The Perseus Molecular Cloud comprises a roughly $12° \times 12°$ area and is the most active region of star formation within 1000 light years of the Sun. Some of the OB stars in

this region are visible to the naked eye including Menkib 46-Xi Persei (magnitude 3.98) and Atik 44-Zeta Persei (magnitude 2.84). Menkib is just south of the California Nebula (NGC 1499) which was discovered visually by Barnard in 1885 using the 6-inch Cooke Telescope at Vanderbilt University (Fig. 5.1).

Menkib is colliding with a cloud of dense interstellar matter and illuminates and ionizes a portion of an expanding shell of hydrogen from probable supernova explosions. This creates the California Nebula which may itself be a molecular cloud complex. Atik lies 4 degrees south of Menkib. Near Atik is IC 348, an open cluster which illuminates the reflection nebulosity Van den Bergh 19. There are numerous Herbig-Haro objects in the region. NGC 1333 is a bright cluster and reflection nebula at the western border of the Perseus Molecular Cloud 3 ¼ ° southwest of Atik. This is the most active star forming region in the molecular cloud (O'Meara 2020). Barnard 1–5 is part of the Perseus Molecular Cloud as an extension of the Taurus Dark Cloud to the northwest (Fig. 7.2).

5.5 Lupus Dark Cloud

The Lupus Dark Cloud is a complex region of low mass star-formation. It consists of six molecular clouds named Lupus 1 to 6 (the Lupus clouds). It is one of the largest low mass star-forming regions in the sky with an angular extent of approximately 20° × 20° containing a rich association of T Tauri stars (Marti et al. 2011). There is probably an association with the Scorpius-Centaurus OB association which lies approximately 140 parsecs from the Sun. The estimated distance to the Lupus clouds is 140–220 parsecs. The Lupus clouds are projected against the Scorpius-Centaurus OB association which is one of the main structures of the Gould Belt.

6 Bok Globules

Bart Bok and Edith Reilly in 1948 drew attention to "small, round, dense, dark nebulae with diameters varying between 5" and 10'" (Bok and Reilly 1947). These small dark nebulae are felt to represent the evolutionary stage preceding star formation. They called such regions "globules" to distinguish them from other sorts of dark nebular regions. Since then, such globules have generally been called Bok globules, though Bok prominently noted Barnard had originally called attention to such small, dark, dense nodular regions in his writings about dark nebulae.

Bok globules are most easily recognized being projected against the bright background of much larger diffuse nebulosity. M8 (the Lagoon Nebula; NGC 6523 and NGC 6530) is the prime example of this phenomenon in which Bok and Reilly stated: "Published photographs show at least sixteen of them [Bok globules] projected against the bright background of the diffuse nebula." (Bok and Reilly 1947) (Fig. 9.4).

Most globules are small on the order of 1/25 parsec, less than 10,000 astronomical units. Such small globules can only be noted projected against the luminous background of emission nebulae, such as NGC 2244 (Rosette Nebula), M8, IC 2944, and NGC 3603, the latter two objects being visible only in the southern hemisphere. Larger isolated globules are evident along the band of the Milky Way, especially in Taurus and Ophiuchus. These larger globules have radii of 0.1 to 1 parsec. The largest dark nebulae of this type have radii up to 4 parsecs (Bok in Lynds 1970).

Bok, Cordwell, and Cromwell (in Lynds 1970) listed 16 objects that either contained nebular globules or were themselves stand-alone nebular globules. Ten of these globules are Barnard Objects (Table 9.1). Bok globules are contained in M8 and M20 [Trifid Nebula; NGC 6514] (Figs. 9.4 and

Table 9.1 Barnard Objects Considered "Bok" Globules

Object	Comments (from Bok in Lynds 1970)
Barnard 34	Large, isolated globule, with about 3 mag absorption. [Near M37 (NGC 2099). (See Fig. 7.4.)
Barnard 227	Isolated globule with 5 mag absorption.
Barnard 255	Fairly transparent, round globule.
Barnard 68	Very opaque, smaller Barnard object found in region of Theta Ophiuchi. (See Figs. 7.7c and 7.8d)
Trifid Nebula [M20, NGC 6514]	Small emission region containing several globules. (See Fig. 7.10e)
M8 [Lagoon Nebula; NGC 6523]	Emission nebula where globules were first pointed out. (See Fig. 9.4)
Barnard 87	More transparent object with streamers. South of the great star cloud in Sagittarius. (See Figs. 7.9a and 7.9b)
Barnard 92	Opaque, elliptical object with projecting threaded filaments. Region in Sagittarius north of the great cloud. (See Fig. 7.10)
Barnard 133	Opaque elliptical globule found in Scutum.
Barnard 335	Fairly opaque and round.
Barnard 367	One of several small condensations in a nebulous region [IC 1396].

7.10d–e). Barnard 34 is an isolated globule near M37 (NGC 2099) (Fig. 7.4). The large complex nebular region IC 1396 near Mu Cephei (Erakis, Herschel's Garnet Star) contains several condensations one of which is Barnard 367 (Fig. 6.1). Barnard 227 and Barnard 255 are isolated globules, while tiny Barnard 68 is associated with the complex Theta Ophiuchi nebular region (Fig. 7.7c and 7.8d). Barnard 87 is south of the great star cloud in Sagittarius (Fig. 7.9a). Barnard 92 is north of the great star cloud in Sagittarius and is close to similarly sized but less defined Barnard 93 (Figs. 7.10a–c).

High mass stars, like OB stars, and low mass stars forming in large numbers, such as in an open cluster, are formed in giant molecular clouds. Isolated low mass stars seemingly are found in dark clouds with less mass, lower temperatures, and less density. These clouds are on the verge of converting their gas and dust into none or one or two stars. These types of clouds are Bok globules, which as noted can be found in larger nebular complexes or may be an isolated small nebular region.

Moore defines a Bok globule as "...roundish dark clouds that may have diameters as small as 0.1 ly...Dust makes up only a small fraction of the globule and molecular hydrogen is its main constituent, though there may be many other types of molecules present as well. Their masses range from 0.1 Solar to 2000 Solar and at their upper range they blend in with other "dark" nebulae (Moore 2002). They are very cold and often associated with T-Tauri stars and Herbig-Haro objects.

T-Tauri stars are a type of variable star named after T-Tauri, a young star in the Taurus star forming region. These stars are less than 10 million years old and are in the earliest stage of star formation. They have less than 3 solar masses are often binary and have circumstellar disks which may lead to planet formation. A Herbig-Haro object (HH) is a patch of bright nebulosity associated with newborn stars caused by jets of ionized gas ejected by young stars colliding at high speed with nearby clouds of dust and gas. They are a distinct type of emission nebulosity first studied in detail by George Herbig (1920–2013) and Guillermo Haro (1913–1988).

Infrared, millimeter, and visual observations in star-forming cores in Bok globules shows at least 40% of the globules studied by Launhardt and Sargent (2000) "contain double or multiple condensations in their cores when observed at angular resolutions of ~10 [arcseconds]...Together, these observations indicate that the usual star formation product of a simply-structured Bok globule is a small group of stars, a hierarchical stellar system or a binary system rather than a single stars..."

Bok globules have been discovered in the Large Magellanic Cloud (LMC) as small, isolated dust clouds silhouetted against diffuse H-alpha emission with the Wide Field Planetary Camera 2 on the HST. They are of

a typical size (0.25 pc) and optical density to those in the Milky Way (Garnett et al. 1999). Bok globules which have IRAS satellite observations showing no central infrared sources are starless molecular clouds (Clemens et al. 1996). Thus, star formation is common in Bok globules but probably not universal.

7 Barnard Objects Listed But Not Shown in *a Photographic Atlas of Selected Regions of the Milky Way* (1927)

The 1927 *Atlas* was the culmination of Barnard's professional lifetime's work on dark regions of the Milky Way. It is one of the classics of professional astronomy. Due to Barnard's deteriorating health, he was unable to complete his work on dark regions in the sky. *A Photographic Atlas of Selected Regions of the Milky Way* was published posthumously in 1927, 4 years after Barnard's death in 1923. Edwin Frost and Mary Calvert edited this work reprinting Barnard's 1919 list of dark nebulae and including a second list which Barnard had started prior to his death. In the process of putting together completed and partially completed work by Barnard, Frost and Calvert deliberately omitted having Barnard Objects with numbers from 176 to 200 as noted previously. Additionally, there are 31 Barnard dark objects listed with descriptions in the *Atlas* but not shown on any of its photographic plates or charts (Table 9.2).

The objects listed but not shown in a few cases are well-known, like the Horsehead Nebula (IC 434; Barnard 33), the complex nebulous region around the star cluster NCC 2264 near 15 Monocerotis (region of Christmas Tree Cluster and Nebula and the Cone Nebula), and the dark region Barnard 168 surrounding and extending westward from the Cocoon Nebula (IC 5146) (Figs. 1.2, 4.1, 9.3, and 9.5).

Barnard's descriptions for these dark objects often but not always correspond to what we discern with modern color digital imaging (Table 9.2; Figs. 9.13, 9.14, 9.15, 9.16, 9.17, 9.18, 9.19, 9.20, 9.21, 9.22, 9.23, 9.24, 9.25, 9.26, 9.27, 9.28, and 9.29). Many of these objects are small, close together and easily included in the same field on images covering 2 degrees or more. Some of these objects were discovered or first photographed by Barnard, and no doubt images of all of them were obtained by Barnard and often cited as being on his photographic plates in his 1913 and 1919 publications. Unfortunately, those images are not available since most of Barnard's photographic plates have not been digitized and are not available for researchers.

Table 9.2 Barnard Objects listed but not shown in the 1927 *Atlas*

Object	Comments (quotes are from Barnard 1919; current star data are from Guide 9.1)
6	Barnard 6 is the only dark region in a field filled with stars and is easy to identify. Fig. 9.13
8, 9, 11, 12, 13	Barnard 12 and 13 are distinct and easy to identify. Barnard 8, 9, and 11 are portions of the same dark lane. Fig. 9.14.
15, 16, 17	Barnard 15 is distinct and easy to identify. It is not possible to identify Barnard 16 and 17 from the coordinates and descriptions given for them. Fig. 9.15.
20	Large, irregular dark area near a small open cluster Berkeley 67 and NGC 1624. Originally discovered visually by the Rev. TE Espin probably using a 17 ¼ in Newtonian reflector at his Wolsingham Observatory in Tow Law, England (Espin 1898). Fig. 9.16.
21	Barnard described B 21 as "Indefinite, irregularly round; diam. 10′." This correlates well with a modern image of it (Fig. 9.17).
25	Barnard described this object as "Irregularly round; a good example of a dark or more or less starless region." Figure 9.18 shows long exposure color imaging of this region. It is very irregular and contains many stars, though fewer are evident compared to the background starry regions.
26, 27, 28	"B-26, 27, 28 are close NW of BD +30,741 (mag 6.8), which is involved in feeble nebulosity." Figure 9.19.
29, 222	Barnard 29 is a distinct, well defined dark region. Barnard 222 is an elongated, somewhat poorly distinguishable region. Barnard listed it as "Round, indefinite, diam 10′." The seeming arbitrary numbering system used by Barnard is illustrated by the juxtaposition of these two objects with large differences in their numbers. Figure 9.20.
33	IC 434 (Horsehead Nebula) see Figs. 1.1 and 4.1. This is such an iconic object it is strange it was not illustrated in Barnard's *Atlas*. **However, in his 1919 Catalogue Notes he states, "See Astrophysical Journal, 38, 496, 1913, Plate XX." (Barnard** 1919)
37, 38, 39	These objects are northwest of 15 Monocerotis which is embedded in the nebulosity surrounding NGC 2264 (the Christmas Tree Cluster). Figures. 9.5 and 9.21.
140	This is a "Semi-vacant region; diam. 1 deg" as described by Barnard. Figure 9.22.
155, 156	Barnard described B 155: "There are four small stars in a line crossing this object east and west." He also described it as "Round; diam. 13′; indefinite." Figure 9.23 is an image of B 155 and B 156. On this image Barnard 155 looks elongated N-S and not round. It is hard to distinguish the four stars noted by Barnard. Barnard described B 156 as "Diam. 8′; sharp-pointed to north." He also noted B 156 surrounded 73-Rho Cygni. On Fig. 9.23 Barnard 156 is hard to discern.

(continued)

Table 9.2 (continued)

Object	Comments (quotes are from Barnard 1919; current star data are from Guide 9.1)
158,159	Figure 9.24. Barnard 158 is a dark spot Barnard estimated as 3 arcminutes in diameter. He also noted there were others north and west of it but did not further identify them. Barnard 159 was described as"…the center of an irregular, partially vacant region 25′ in diameter…there are several darker spots in it." Barnard noted B 159 is extended east to west and listed by their BD numbers three stars involved in it which are now described as 75 Cyg magnitude 5.090, UU Cyg magnitude 8.895, and SAO 51127 magnitude 7.581.
168	This large dark lane on its eastern end surrounds IC 5146 (Cocoon Nebula). One of the first images of this region was obtained by Max Wolf with the 16-inch Brashear Telescope at Heidelberg on July 10, 1904, with a 2-hour 40 minute exposure (Fig. 9.3b).
175	This is dusty region running north-south bordering a 7.6 magnitude star SA0 1287 which is surrounded by reflection nebulosity vdB 152. Figure 9.25. See discussion in text.
228	Barnard's description for this nebulous region is very consistent with modern imaging: "Large vacant region about 4 degrees long NW and SE…Its average width is about ½ degree. It is strongest mark at north end. There are fragments of other dark markings several degrees west of this." This area is sometimes called the Lupus Dark Cloud or Dark Wolf Nebula in Lupus. Figure 9.26.
230	Poorly defined, somewhat round 1° dark region. Figure 9.27
315	Barnard called this object "Round, dark, diam. 5′." Figure 9.28 shows it is small and dark, though not particularly round.

Barnard 175 is an interesting case (Fig. 9.25). Barnard described it as "…
a large dark spot, extended north to south, 62′ in its largest diameter. In its
upper part is the star B.D. +69° 1231 ($8^m.8$) [SAO 10287 magnitude 9.28]
which is nebulous. This is apparently a large dark nebula, the brightest part
of which forms the star B.D. +69° 1231." Barnard may have misspoken as
the star he cites is at the lower, southern end of the nebulosity. It is also
interesting to note Barnard 175 is misplaced on common charting programs
from where it appears on modern images.

Barnard also contests the discovery of Barnard 175: "In *Monthly Notices*,
69 (December) 1908, Dr. Max Wolf gives a photograph of the nebula, stat-
ing that the object was discovered by Dr. Kopff at Heidelberg on October
12, 1908. It is conspicuous on a photograph of mine made with the Willard

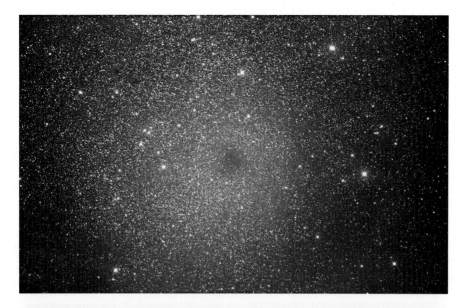

Fig. 9.13 Barnard 6. Takahashi Epsilon 180 f/2.8 astrograph with Canon EOS Ra camera. (© Tim B Hunter, 3towers, LLC, 2022. All Rights Reserved)

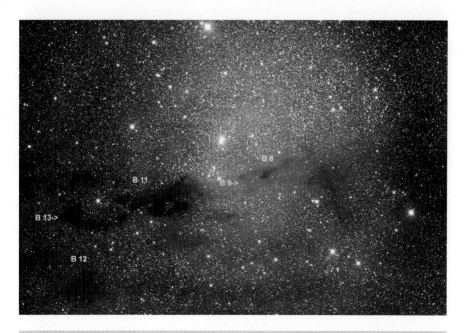

Fig. 9.14 Barnard 8, 9, 11, 12, and 13. Takahashi Epsilon 180 f/2.8 astrograph with Canon EOS Ra camera. (© Tim B Hunter, 3towers, LLC, 2022. All Rights Reserved)

lens at Lick Observatory, September 24, 1895, with 5hr0m exposure. It is also shown on a photograph of mine with the Bruce telescope, July 20, 1904, with exposure of 3h1m. By inadvertence reference to this object was omitted in *Lick Observatory Publications*, 11, when it is cut out by the matting in Plate 83."

Barnard incorrectly listed the date for Kopff's discovery plate as October 12 when it was October 21, 1908, as noted in the *Monthly Notices [of the Royal Astronomical Society (MNRAS)]* December 1908 article cited by Barnard. The photograph published by Max Wolf in that article was obtained with the Heidelberg Waltz 28-inch reflector on November 16, 1908, with a 2 ½ hour exposure (Fig. 9.25b). Wolf's image clearly shows Barnard 175, and it resembles modern digital images of the object (Fig. 9.25c). Unfortunately, the September 24, 1895, and the July 10, 1904, images of this object taken by Barnard are not available for inspection unless one has an original copy of the publications where he published those images not the PDF versions available online. Most of Barnard's photo-

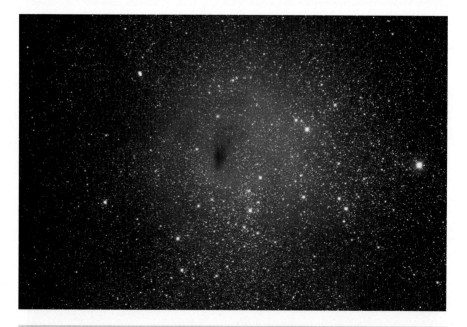

Fig. 9.15 (a) Barnard 15, 16, and 17. Takahashi Epsilon 180 f/2.8 astrograph with Canon EOS Ra camera. (© Tim B Hunter, 3towers, LLC, 2022. All Rights Reserved). **(b)** Barnard 15 and environs close-up image with PlaneWave CDK24 24-inch f/6.5 telescope, Finger Lakes Instrumentation Proline KAF9000 CCD and exposures through Cousins-Johnson B, V, R filters coupled with luminous exposures to produce a final color image. It is impossible to distinguish Barnard 15 from Barnard 16 and 17. (© Tim B Hunter, 3towers, LLC, 2022. All Rights Reserved)

Fig. 9.15 (continued)

graphic plates at Lick Observatory or at Yerkes Observatory have not been digitized.

Barnard has an extraordinary number of discoveries to his credit. There are also many other objects first observed and logged by Barnard but not attributed specifically to him as he often did not publish all the findings from his observing runs, particularly faint nebulous objects. He was most interested in comet discovery in his early observing days or later involved in a specific observing project during which he noted many incidental findings not following up on them or claiming discovery. These were often noted by other visual observers years later or discovered anew on photographic surveys in the twentieth century. Many of Barnard's unattributed discoveries were galaxies. Gottlieb in 2020 documented some 50 unknown discoveries of Barnard's during Barnard's first 2 ½ years at Lick Observatory. These include galaxies, open clusters, globular clusters, reflection, and

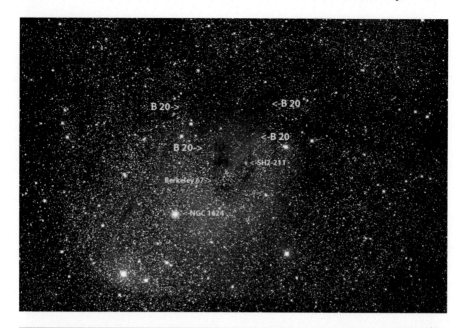

Fig. 9.16 Barnard 20 and environs. Takahashi Epsilon 180 f/2.8 astrograph with Canon EOS Ra camera. (© Tim B Hunter, 3towers, LLC, 2022. All Rights Reserved)

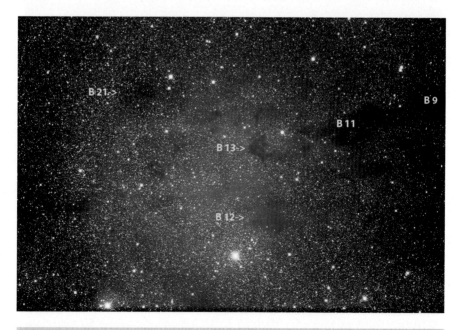

Fig. 9.17 Barnard 21 and environs. Takahashi Epsilon 180 f/2.8 astrograph with Canon EOS Ra camera. (© Tim B Hunter, 3towers, LLC, 2022. All Rights Reserved)

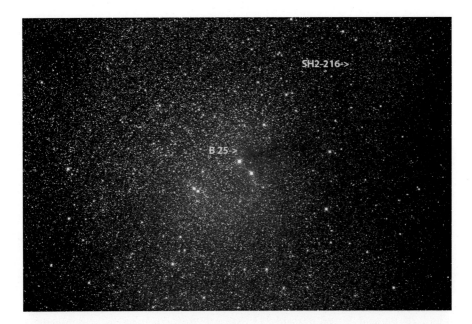

Fig. 9.18 Barnard 25 and environs. Takahashi Epsilon 180 f/2.8 astrograph with Canon EOS Ra camera. (© Tim B Hunter, 3towers, LLC, 2022. All Rights Reserved)

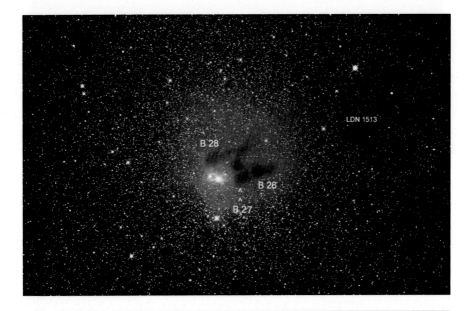

Fig. 9.19 Barnard 26, 27, and 28. Takahashi Epsilon 180 f/2.8 astrograph with Canon EOS Ra camera. (© Tim B Hunter, 3towers, LLC, 2022. All Rights Reserved)

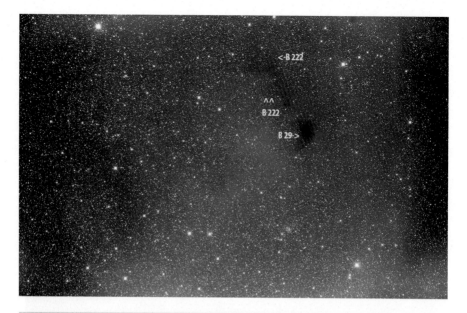

Fig. 9.20 Barnard 29 and Barnard 222. Barnard 29 is a well-defined dark region, while Barnard 222 is larger, more amorphous and harder to distinguish from the stratum of stars. Takahashi Epsilon 180 f/2.8 astrograph with Canon EOS Ra camera. (© Tim B Hunter, 3towers, LLC, 2022. All Rights Reserved)

emission nebulae. How many more such unknown discoveries were made by Barnard may never be known.

Barnard 236 is another interesting case. This object is listed in the 1927 *Atlas* in Tables 15 and 17 as shown on (photographic) Plates 15 and 17, respectively, but Charts 15 and 17, the drawings done by Mary Calvert outlining Barnard Objects do not have Barnard 236 shown. This minor error probably was overlooked by Mary Calvert as she finalized the charts for the *Atlas*. Barnard called B 236 a "Center of system of indistinct lanes." It seems to be a poorly defined and poorly distinguishable dark region north of Barnard 237 (Figs. 8.4c and 9.29).

8 The Barnard Objects Today

Where are the Barnard Objects today? The same place they have always been. Are they still important? Yes, for many reasons. First, they are of supreme historical interest. The catalog of dark nebulae collected by Barnard was a forceful demonstration of photography replacing most visual astronomy. Second, they have not been forgotten. They are probably as well

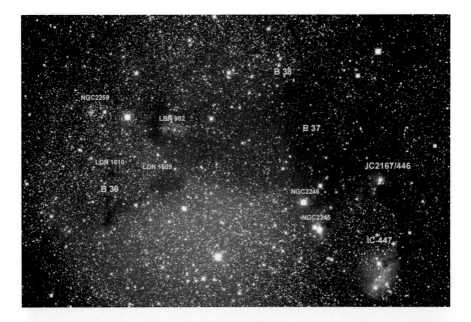

Fig. 9.21 Barnard 37, 38, 39 and environs. Takahashi Epsilon 180 f/2.8 astrograph with Canon EOS Ra camera. (© Tim B Hunter, 3towers, LLC, 2022. All Rights Reserved)

Fig. 9.22 Barnard 140. Takahashi Epsilon 180 f/2.8 astrograph with Canon EOS Ra camera. (© Tim B Hunter, 3towers, LLC, 2022. All Rights Reserved)

Fig. 9.23 Barnard 155 and 156. Barnard 156 is vague dark area surrounding the bright star 73-Rho Cygni magnitude 4.0. Takahashi Epsilon 180 f/2.8 astrograph with Canon EOS Ra camera (cropped and enlarged image). (© Tim B Hunter, 3towers, LLC, 2022. All Rights Reserved)

known today as they were 100 years ago. Amateur astronomers love them for their photographic beauty and for their observing delights and observing challenges. Some Barnard Objects otherwise famous in their own right are: B 22 (Taurus Dark Cloud); B 33 (Horsehead Nebula; IC 434); B 42 (Rho Ophiuchi complex); B 59 (Pipe Nebula); B 72 (Snake Nebula); B 78 (Pipe Nebula); B 86 (Ink Spot Nebula); B 142 and B 143 (E-Nebula; Triple Cave Nebula); B 144 (Fish on the Platter); B 150 (Seahorse Nebula); B 168 surrounding the Cocoon Nebula (IC 5146); B 207 (Vulture Head Nebula); B 228 (Dark Wolf Nebula in Lupus); and Barnard 298 (Region of Baade's Window).

Many Barnard Objects are on the front line of professional astronomical research (Table 9.3). They are being studied across the electromagnetic spectrum- X-ray, ultraviolet, visual, infrared, microwave, and radio wave-

Fig. 9.24 Barnard 158 and 159. The three stars just above B 159 are left to right 75 Cyg magnitude 5.090, UU Cyg magnitude 8.895, and SAO 51127 magnitude 7.581. Takahashi Epsilon 180 f/2.8 astrograph with Canon EOS Ra camera. (© Tim B Hunter, 3towers, LLC, 2022. All Rights Reserved)

lengths. These are being looked at for the formation of massive stars as well as for the formation of small mass stars and brown dwarfs. The nature of their nebular composition, their magnetic field properties, and their polarization of light effects are important areas of research. An especial area of active research is the detection and characterization of organic compounds, particularly polycyclic aromatic hydrocarbons (PAHs), in the interstellar medium and in more concentrated molecular clouds.

Barnard's *A Photographic Atlas of Selected Regions of the Milky Way* was the first recognized systematic collection of dark regions in the Milky Way. It is still being used today and has only been partially supplanted by Lynds' work and by other catalogs almost all of which refer to Barnard. Unfortunately, the ***Photographic Atlas*** is incomplete and suffers from several problems. It was published 4 years after Barnard's death being compiled by Edwin B Frost and Mary R Calvert from uncompleted work left by Barnard. It does not cover most of the Milky Way visible from the Southern Hemisphere. It also does not cover all the Milky Way visible from the Northern Hemisphere. Barnard recognized it was important to photograph as much of the southern Milky Way as possible, and his time at Mount Wilson with the Yerkes Bruce Telescope was an important effort in that

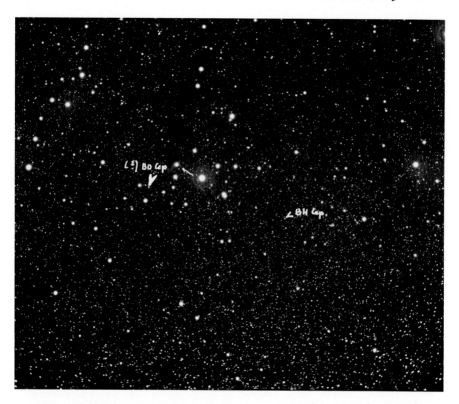

Fig. 9.25 (**a**) Discovery image of the dark nebulosity later known as Barnard 175. Image taken by Dr. Kopf with the 16-inch f/5 Heidelberg Bruce Telescope on October 21, 1908, 15,600 second exposure. This image was rotated so north is at top and east is to the left. "This work made use of the HDAP which was produced at Landessternwarte Heidelberg-Königstuhl under grant No. 00.071.2005 of the Klaus-Tschira-Foundation". (HDAP – Heidelberg Digitized Astronomical Plates (uni-heidelberg.de)). (**b**) Image of the dark nebulosity later known as Barnard 175. This image was taken by Max Wolf with the 28-inch Waltz reflector at Heidelberg Observatory on November 16, 1908, 2.5-hour exposure. This image was rotated so north is at top and east is to the left. "This work made use of the HDAP which was produced at Landessternwarte Heidelberg-Königstuhl under grant No. 00.071.2005 of the Klaus-Tschira-Foundation". (HDAP – Heidelberg Digitized Astronomical Plates (uni-heidelberg.de)). (**c**) Modern digital image of Barnard 175 taken with a 20-inch f/3.6 astrograph and a Finger Lakes Instrumentation KAF Proline CCD with Cousins-Johnson photometric B, V, R filters. The reflection nebula vdB-152 is contiguous to southern end of Barnard 175 and surrounds B.D. +69° 1231 [SAO 10287 magnitude 9.28]. (© Tim B Hunter, 3towers, LLC, 2022. All Rights Reserved)

Fig. 9.25 (continued)

regard. Barnard never had the time or funding to travel to the Southern Hemisphere to extend his photographic work.

In the original 1927 edition of Barnard's *Atlas*, Plate 51 contains 'Nine Selected Areas…' that he chose to depict the connectivity of the stratum in the Milky Way and the dark regions. Barnard stated that this was not meant to provide a wholistic view of the Milky Way, "This would have been impossible." (Barnard 1927). Using the photographic process of that time would have been a daunting task if at all possible. Using the modern technology of today, Dobek in his republication of the Atlas in 2011, provides a mosaic of the 50 plates. Barnard's selection of photographs were focused on the central regions of the Milky Way, and the interesting areas between lower Cygnus and upper Cepheus. Although the mosaic is only 10.5 × 30 inches (6 × 29 inches plotted), the plates are overlaid in their corrected scale and positions. This shows the true connectivity of the plates Barnard chose for inclusion in his Atlas (Barnard 2011).

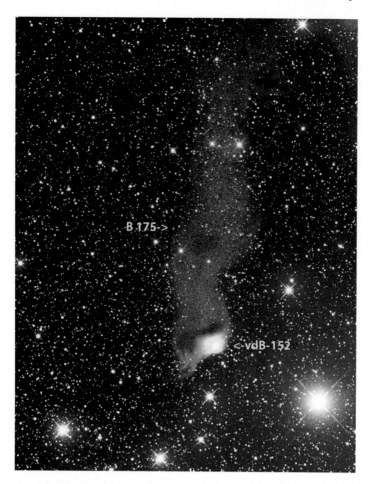

Fig. 9.25 (continued)

Barnard did not define his criteria for including a dark region in his cata-
log. Chapter 8 is our attempt to fill in some Barnard Objects that we feel he
intended to include in his catalog but never got around to it. There are innu-
merable examples where he draws marks around a dark area but does not
give it a number or numbers. In some instances, Barnard numbers and
describes what appears to be a small region and excludes a nearby larger
and possibly darker region, such as ignoring LDN 1513 near B 26, 27, and
28 (Fig. 9.19).

Barnard listed no criteria for estimating the opacity of a dark object, and
his numbering system is seemingly arbitrary and capricious. For example,
B 6 is separate from B 8, 9, 11, 12, 13, which are separated from B 10
(Figs. 9.13 and 9.14). On Chart 25 (Region in Serpens and Sagittarius) B 84

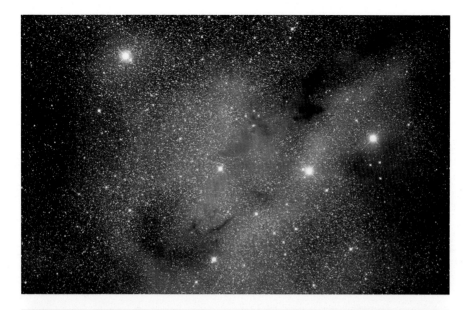

Fig. 9.26 Barnard 228 (Lupus Dark Cloud; Dark Wolf Nebula in Lupus). Takahashi Epsilon 180 f/2.8 astrograph with Canon EOS Ra camera. (© Tim B Hunter, 3towers, LLC, 2022. All Rights Reserved)

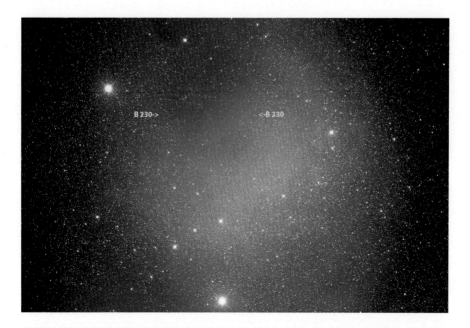

Fig. 9.27 Barnard 230. Takahashi Epsilon 180 f/2.8 astrograph with Canon EOS Ra color camera. (© Tim B Hunter, 3towers, LLC, 2022. All Rights Reserved)

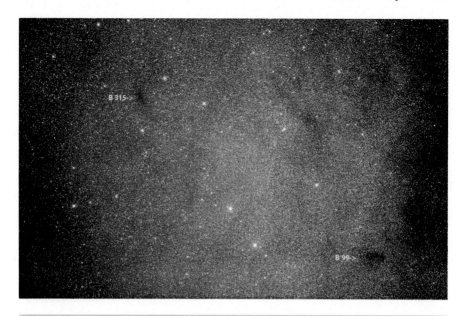

Fig. 9.28 Barnard 315 and Barnard 99. Takahashi Epsilon 180 f/2.8 astrograph with Canon EOS Ra camera. Barnard 315 was listed but not shown in Barnard's *Atlas*. Barnard 99 was listed and shown on Plate 32 Region in Sagittarius, Southeast of the Small Star Cloud. (© Tim B Hunter, 3towers, LLC, 2022. All Rights Reserved)

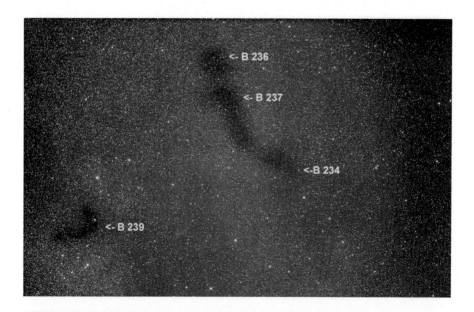

Fig. 9.29 Barnard 234, 236, 237, and 239. Takahashi Epsilon 180 f/2.8 astrograph with Canon EOS Ra camera. (© Tim B Hunter, 3towers, LLC, 2022. All Rights Reserved)

Table 9.3 Selected Listing of Barnard Objects Actively Researched 2011–2021

Barnard 1	Fuente A et al. Ionization fraction and the enhanced sulfur chemistry in Barnard1. *A&A* 2016. DOI: 10.1051/0004-6361/201628285
Barnard 5	Taquet ES. Chemical complexity induced by efficient ice evaporation in the Barnard 5 molecular cloud. *A&A* 2017; DOI: 10.1051/0004-6361/201630023
Barnard 30	Huelamo N et al. A search for pre-and proto-brown dwarfs in the dark cloud Barnard 30. *A&A* 2017. DOI: 10.1051/0004-6361/201628510
Barnard 33 (Horsehead Nebula)	Bally J et al. Kinematics of the Horsehead Nebula and IC434 ionization front in CO and C+. *AJ* 2018. https://doi.org/10.3847/1538-3881/aaa248
Barnard 35	Perotti G et al. Linking ice and gas in the λ Orionis Barnard 35A cloud. *A&A* 2021; https://doi.org/10.1051/0004-6361/202039669
Barnard 59	Dzib SA et al. Deep VLA Observations of nearby star forming regions I: Barnard 59 and Lupus. *Revista Mexicana de Astronomia and Astropfisica* 2016; 52: 317–327.
	Redaelli E. The Green Bank Ammonia Survey: unveiling the dynamics of the Barnard 59 star-forming clump. *ApJ* 2017. https://doi.org/10.3847/1538-4357/aa9703
Barnard 68	Kandori R et al. Distortion of magnetic fields in Barnard 68. *Publ Astron Soc Japan* 2020; doi: 10.1093/pasj/psz127.
Barnard 86	Odell AP. A new look at open cluster NGC 6520. *AJ* 2014; doi:10.1088/0004-6256/147/1/7
Barnard 175	Rector TA, Schweiker H. A search for Herbig-Haro objects in NGC 7023 and Barnard 175. *AJ* 2013; doi:10.1088/0004-6256/145/2/35
Barnard 207	Togi A et al. Dust properties of the cometary globule Barnard 207 (LDN 1489). *A&A* 2017; DOI: 10.1051/0004-6361/201629414
Barnard 335	Kandori R et al. Distortion of the magnetic fields in Barnard 335. *ApJ* 2020; https://doi.org/10.3847/1538-4357/ab6f07
Barnard 361	Boyle RP et al. Dust cloud LDN 970: extinction and distance. Abstracts of the 235th AAS Meeting (Honolulu, HI). January 2020.

and B 83 are just north of B 280. B 276 abuts against B 79. B 84a is in the center of the chart. At its top is B 285. The numbering is not based on right ascension, declination, constellation, size, opacity, or some other recognizable criterion. Most probably, Barnard would examine a plate and number a couple of objects and then not come back to this same plate for months or

years. He would then find other areas on the plate that he wanted to include in his catalog and simply used whatever number was next on his list.

Areas that appear dark on his plates often are not very impressive on modern color images, and he apparently had no size limits for including an object in his list. Despite these criticisms Barnard's work on dark regions of the sky was groundbreaking. He created this field of study, and he literally worked himself to death. In all probability Barnard worked on the project intermittently getting drawn to more immediate projects, comets, eclipses, planetary observations, micrometer measurements of stars in clusters, travel, and other writing commitments. He started to organize the work formally late in his career when his health had a rapid decline precluding him from completing the work.

Barnard was also hindered by the slow photographic plates of his era which were only sensitive to ultraviolet and blue portions of the spectrum. These plates show blue areas and blue stars well but are poor at displaying yellow, orange, or red stars or nebular regions. Interstellar dust tends to absorb blue light producing brownish or reddish areas that are not very apparent on Barnard's plates, often making them appear darker and more contrasted against the rest of the sky then apparent on digital color images. Additionally, most of his original glass plates have not undergone modern scanning and digitization. The images we have are those produced by digitizing his photographic prints, another factor that tends to poorly display what was actually evident if one could examine the plates themselves.

Has modern color digital imaging changed our view of the Barnard Objects? Yes, with a few exceptions. Modern color images of the Barnard Objects show most are not that dark, and it is apparent they contain much obscuring "dark" matter. This obscuring matter is dark in the visual spectrum but not necessarily dark in other spectral regions like in the infrared and microwave frequencies. It also shows varying coloration from gray, to red, to red brown, to dark gray, and sometimes dark black. The coloration and absorption of light is presumably due to the dust in these regions.

One of the most important questions concerning dark clouds and star formation is the composition of interstellar dust. Dust as we ordinarily think about it, atmospheric dust or household dust, is not the same as interstellar dust. Ordinary atmospheric dust is particles of soil lifted by the wind, particles emitted by volcanic eruptions, and pollution. Dust in homes may be as much as 20–50% dead cells. There is also plant pollen, human hair particles, textile fibers, animal fur particles, minerals like silicon dioxide from sand, and even burnt meteorite particles. These dust particles range greatly in size from those visible floating in the air to those that are submicron in size.

AGB stars and supernovae are the main producers of cosmic dust. Their dust is distributed into the interstellar medium and some eventually becomes part of cold molecular clouds where star formation takes place. Interstellar dust is exposed to destruction by supernova induced shock waves, and only a few per cent of the total mass of star dust may survive this destruction. Interstellar dust grains range in size from 0.005—0.25µm. In denser interstellar environments like molecular clouds and Bok globules smaller grains may agglutinate to produce larger grains, and there may be ice mantle formation about the grains. Small grains scatter short wavelengths, while larger grains can scatter mid-infrared light (3.6–4.5µm wavelength). Dense cores of molecular clouds are often optically thick enough to prevent ultraviolet photons from exciting polycyclic aromatic hydrocarbons (PAHs) (Togi et al. 2017).

The dust in the diffuse interstellar medium is a mixture of amorphous silicates, amorphous carbon, PAHs, graphite, and refractory organic compounds. Icy grain mantles are important inside molecular clouds.

As far back as 1982 Hoyle, proposed three main types of interstellar dust grains: "graphite spheres of radii ~0.02µm making up ~10% of the total grain mass, small dielectric cylinders containing metallic iron with diameters of ~2/3µm making up ~45% of the mass. The remaining 20% consists of other metals and metal oxides. The main dielectric component of the grains appears to be comprised of organic material" (Hoyle and Wickramasinghe 1982).

Dielectric materials are insulators or poor conductors of electric current. Organic compounds are thought to exist in the interstellar medium and to be constituents in the colder, denser portions of molecular clouds. They are hard to identify, and many research project are actively studying the interstellar medium and molecular clouds looking for organic compounds, particularly polycyclic aromatic hydrocarbons. These are hard to detect due to the stable nature of their molecules, but they may contribute to the anomalous microwave emissions (AME) found in the Milky Way and other galaxies (Hensley et al. 2022). Also of note is that dust grains in general have non-spherical elongated shapes and are aligned with the magnetic field of their environment as shown by starlight polarization and polarization of thermal dust emission. Grain growth involves magnetically aligned grains rather than randomly oriented grains.

In the Local Cloud around the Sun the major constituents of the interstellar dust are organic materials, magnesium silicates, and iron alloys. Spinel crystal and iron sulfides are also present. No organic materials have been detected in the dust grains that penetrate into the Solar System. The

organic materials may have been lost en route to the inner Solar System (Kimura 2015).

We now know the Milky Way is a large spiral galaxy, one of innumerable galaxies in the Universe. We also have a fair idea of the Milky Way's structure with its spiral arms, central bulge, and large poorly defined massive halo. The spiral arms from our perspective are seen in tangent and overlap each other to produce a disk. In the disk are star clusters, bright, and dark nebulae, and the dark clouds studied by Barnard. Barnard did not know many of the other "nebulae" he noted were actual galaxies separate from the Milky Way. We now know his dark clouds are important features of the Milky Way and other galaxies. These regions are where star formation takes place, and they tell us much about the Milky Way and other similar galaxies. The Barnard Objects now are even more interesting and important than they were in Barnard's time. Our knowledge and understanding of these dark nebulous regions have grown in the past century and will only increase exponentially in the future.

References and General Bibliography

Alves J, Zucker C, Goodman AA, Speagle JS, Meingast S, et al. A galactic-scale gas wave in the solar neighborhood. Nature. 2020;578:237–9.

Astro DSLR Cameras Come of Age - Sky & Telescope - Sky & Telescope (skyandtelescope.org).

Astrophotography and Image Processing Tips and Techniques by Jerry Lodriguss (astropix.com).

Barnard EE. Photographs of the milky way and comets. Publ Lick Obs. 1913a;11

Barnard EE. Dark regions in the Sky suggesting an obscuration of light. Astrophys J. 1913b;38:496–501.

Barnard EE. On the dark markings of the sky with a catalogue of 182 such objects. Astrophys J. 1919;XLIX(#1):1–28.

Barnard EE. In: Frost EB, Calvert MR, editors. A Photographic atlas of selected regions of the Milky Way. Washington: Carnegie Institution of Washington; 1927. Online Version at Georgia Institute of Technology: Barnard's Photographic Atlas of Selected Regions of the Milky Way (gatech.edu).

Barnard EE. A Photographic Atlas of Selected Regions of the Milky Way. In: Edwin B Frost, Mary R Calvert, editors, reprinted under the direction of Gerald Orin Dobek. Cambridge: Cambridge University Press; 2011.

Bernes C. A catalogue of bright Nebulosities in opaque dust clouds. Astron Astrophys Suppl Ser. 1977;29:65–70.

Bok BJ, Reilly EF. Small dark nebulae. Astrophys J. 1947;105:255–7.

Center for Astrophysics (CfA). Harvard & Smithsonian. Interstellar Medium and Molecular Clouds: Interstellar Medium and Molecular Clouds | Center for Astrophysics (harvard.edu).

Clemens D, Byrne A, Yun J, Kane B. ISO observations of starless Bok globules: usually no embedded stars. Technical Report. Boston: Boston University; 1996.

Cosmos. The SAO Encyclopedia of Astronomy. Galactic Coordinates System. 2022. https://astronomy.swin.edu.au/cosmos/G/Galactic+Coordinate+System.

Cosmos. The SAO Encyclopedia of Astronomy. Molecular Cloud: https://astronomy.swin.edu.au/cosmos/m/Molecular+Cloud

Covington's DSLR Astrophotography Procedures (covingtoninnovations.com) .

Dobashi K. Atlas and catalog of dark clouds based on the 2 micron all sky survey. Publ Astron Soc Jpn. 2011;63:S1–S362.

Dobashi K, Uehara H, Kandori R, Sakurai T, Kaiden M. Atlas and catalog of dark clouds based on digitized sky survey I. Publ Astron Soc Jpn. 2005;57:S1–S386.

Dobashi K, Marshall DJ, Shimoikura T, Bernard J-P. Atlas and catalog of dark clouds based on the 2 micron all sky survey. II. Correction of the background using the Besancon Galaxy Model. Publ Astron Soc Jpn. 2013;65(31):1–16.

Dutra CM, Bica A. A catalogue of dust clouds in the galaxy. Astron Astrophys. 2002;383:631–5. https://doi.org/10.1051/0004-6361:20011761. https://www.aanda.org/articles/aa/full/2002/08/aah3306/aah3306.html

Elias JH. A study of the Taurus dark cloud complex. Astrophys J. 1978;224(September 15):857–72.

Espin TE. A remarkable object in Perseus. Mon Not R Astron Soc. 1898;58:334–5.

Feitzinger JV, Stuwe JA. Catalogue of dark nebulae and globules for galactic longitudes 240 to 360 degrees. Astron Astrophys. 1984;58:365–86.

Franks WS. Visual observations of dark nebulae. Mon Not R Astron Soc. 1930;90:326–8.

Garnett DR, Walsh JR, Chu YH, Lasker BM. Bok globules in the Large Magellanic Cloud. Astron J. 1999;117(3):1285–91.

Gendler R, editor. Lessons from the Masters, The Patrick Moore Practical Astronomy Series. New York: Springer; 2013.

Gottlieb S. The lost discoveries of E.E. Barnard. Sky Telescope. 2020:34–40.

Hartley M, Manchester RN, Smith RM, Tritton SB, Goss WM. A catalogue of southern dark clouds. Astron Astrophys Suppl Ser. 1986;63:27–48.

HEASARC: LDN-Lynds Catalog of Dark Nebulae: https://heasarc.gsfc.nasa.gov/W3Browse/nebula-catalog/ldn.html.

Heidelberg Digitized Astronomical Plates (HDAP): Information on resource 'HDAP – Heidelberg Digitized Astronomical Plates' (uni-heidelberg.de)

Hensley BS, Murray CE, Dodici M. Polycyclic aromatic hydrocarbons, anomalous microwave emission, and their connection to the cold neutral medium. Astrophys J. 2022;929:23. https://doi.org/10.3847/1538-4357/ac5cbd.

Hoyle F, Wickramasinghe NC. A model for interstellar extinction. Astrophys Space Sci. 1982;86:321–9.

Hunter TB, Knauss D. A photographic Messier Marathon: March 19–20, 1988. https://www.3towers.com/Grasslands_Content/PhotographicMessierMarathon/Marathon.html.

Kaler J. 2021. Stars. Stars (illinois.edu).

Kenyon SJ, Gomez M, Whitney BA. Low Mass Star Formation in the Taurus-Auriga Clouds. Handbook of Star Forming Regions Vol I. Astronomical Society of the Pacific; 2008, Bo Reipurth, ed.

Kimura H. Interstellar dust in the local cloud surrounding the sun. Mon Not R Astron Soc. 2015;449:2250–8.

King B. Dive into Scutum's Dark Nebulae. Sky Telescope. July 15, 2015: Dive Into Scutum's Dark Nebulae – Sky & Telescope – Sky & Telescope (skyandtelescope. org).

Launhardt R, Sargent AI. Binary and multiple star formation in Bok globules. Poster Proceedings of IAU Symposium No. 200 on The Formation of Binary Stars, held 10–15 April, 2000 in Potsdam, Germany, page 103.

Li E. Modelling mass distribution of the Milky Way galaxy using Gaia's billion-star map; 2016. https://doi.org/10.48550/arXiv.1612.07781.

Lindegren L, Lammers U, Bastian U, Hernandez J, Klioner S, et al. Astrometry: one billion positions, two million proper motions and parallaxes. Astron Astrophys. 2016;595:A4. https://doi.org/10.1051/0004-6361/201628714.

Lodriguss J. AstroPix: Astrophotography and Image Processing Tips and Techniques by Jerry Lodriguss (astropix.com).

Lynds BT. Catalogue of dark nebulae. Astrophys J Suppl Ser. 1962;7:1–52.

Lynds BT. Catalogue of bright nebulae. Astrophys J. 1965;12:163–85.

Lynds BT, editor. Dark nebulae, globules, and protostars. Tucson: University of Arizona Press; 1970. Chapter 4: Bok BJ, Cordwell CS, Cromwell RH. Globules, pp 33–55

Mallas JH, Kreimer E. The Messier Album. Cambridge: Sky Publishing Corporation; 1978, fourth printing 1997.

Marti BL, Jimenez-Esteban F, Solano E. A proper motion study of the lupus clouds using virtual observatory tools. Astron Astrophys. 2011;529:A108. https://doi.org/10.1051/0004-6361/201016377.

MASS: The two micron all sky survey at IPAC: https://www.ipac.caltech.edu/2mass/.

Moore, Sir Patrick, General Editor. Oxford Astronomy Encyclopedia. New York: Oxford University Press; 2002, pages 125; 394–395; 198.

O'Meara SJ. Explore the Perseus molecular cloud. Astronomy. 2020.: https://astronomy.com/magazine/2020/01/inside-the-perseus-molecular-cloud.

Pennell WE. Kodak 103a-f spectroscopic 35 mm film. Listed on SAO/NASA Astrophysics Data System (ADS). 2022.: https://adsabs.harvard.edu/full/1975Astr...12....3

Potapov A, Jager C, Henning T, Jonusas M, Krim L. The formation of formaldehyde on interstellar carbonaceous grain analogs by O/H atom addition. Astrophys J. 2017;846:1–5. https://iopscience.iop.org/article/10.3847/1538-4357/aa85e8/pdf

Guide 9.1: Project Pluto. Project Pluto

Reid MJ, Menten KM, Brunthaler A, Zheng XW, Dame TM, et al. Trigonometric parallaxes of high mass star forming regions: our view of the Milky Way. the structure and kinematics of the Milky Way. Astrophys J. 2019; 885: 131 (18pp). https://doi.org/10.3847/1538-4357/ab4a11.

Reipurth B. Handbook of star forming regions, volume I: The Northern Sky, vol. 4. San Francisco: Astronomical Society of the Pacific Monographs; 2008a.

Reipurth B. Handbook of star forming regions, volume II: The Northern Sky, vol. 5. San Francisco: Astronomical Society of the Pacific Monographs; 2008b.

Sandqvist A. More southern dark clouds. Astron Astrophys. 1977;57:467–70.

Sandqvist A, Lindroos KP. Interstellar formaldehyde in southern dark dust clouds. Astron Astrophys. 1976;53:179–89.

Swiggum C, Alves J, Onghia ED, Benjamin RA, Thulasidharan L, Zucker C, Poggio E, Drimmel R, Gallagher JS III, Goodman A. The Radcliffe wave as gas spine of the Orion arm. Letter to the Editor Astron Astrophys April 14. 2022.

Togi A, Witt AN, St John D. Dust properties of the cometary globule Barnard 207 (LDN 1489). Astron Astrophys. 2017;605:A99. https://doi.org/10.1051/0004-6361/201629414.

Ventrudo B. Riding the Radcliffe Wave. Sky Telescope. 2023;145:26–33.

Wallis BD, Provin RW. A manual of advanced celestial photography. Cambridge University Press; 1988. ISBN 0 521-25553 8.

Wilds RP. Bright & Dark Nebulae: an observers guide to understanding the clouds of milky way galaxy. CreateSpace; 2017.

Wilson RW, Jefferts KB, Penzias AA. Carbon Monoxide in the Orion Nebula. Astrophys J 1970 161: L43–L44.

Wright RS Jr. An astrophotographer's gentle introduction to noise. April 15, 2018a.: Astrophotography: A Gentle Introduction to Noise - Sky & Telescope (skyandtelescope.org)

Wright RS Jr. Choosing the best (good enough) ISO for astrophotography. September 15, 2018b: Choosing the Best (Good Enough) ISO for Astrophotography – Sky & Telescope – Sky & Telescope (skyandtelescope.org).

Zucker C, Speagle JS, Schlafly EF, Green GM, Finkbeiner DP, Goodman A, Alves J. A large catalog of accurate distances to local molecular clouds: the *Gaia* DR2 edition. Astrophys J. 2019;879:125 (20pp).

Zucker C, Speagle JS, Schlafly EF, Green GM, Finkbeiner DP, Goodman A, Alves J. A compendium of distances to molecular clouds in the star formation handbook. Astron Astrophys. 2020;633:A51.

Zucker C, Goodman AA, Alves J, Bialy S, Foley M, et al. Star formation near the sun is driven by expansion of the local bubble. Nature. 2022;601:334–7.

Correction to: The Barnard Objects: Then and Now

Tim B. Hunter, Gerald O. Dobek, and James E. McGaha

Correction to:
T. B. Hunter et al., *The Barnard Objects: Then and Now*,
The Patrick Moore Practical Astronomy Series,
https://doi.org/10.1007/978-3-031-31485-8

The original version of this book was inadvertently published with few errors in Chapters 1, 2, and 5, and index. The errors have now been updated in the mentioned chapters in this version.

(Page 3) Fig. 1.1 after the word Vega in figure legend there should be **(V)**
(Page 110) Second paragraph second sentence Cook should be **Cooke**

The updated version of these chapters can be found at
https://doi.org/10.1007/978-3-031-31485-8_1
https://doi.org/10.1007/978-3-031-31485-8_2
https://doi.org/10.1007/978-3-031-31485-8_5

Table of Barnard Objects

Barnard object number	Right Ascension α J2000.0	Declination δ J2000.0	Size Arcminutes
1	03 33.0	+31 10	30
2	03 33.5	+32 19	20
3	03 40.0	+31 59	20
4	03 44.0	+31 48	
5	03 47.9	+32 53	60
6	03 56.4	+56 07	
7	04 17.4	+28 34	
8	04 17.8	+55 15	
9	04 18.9	+55 04	
10	04 18.7	+28 17	8
11	04 26.6	+55 02	
12	04 29.8	+54 15	24
13	04 31.3	+54 54	11
14	04 40.0	+25 45	3
15	04 31.9	+46 37	13
16	04 32.4	+46 36	
17	04 32.5	+46 31	
18	04 31.2	+24 21	60
19	04 33.7	+26 16	60
20	04 37.1	+50 59	60
21	04 38.0	+55 21	10
22	04 38.7	+26 03	120
23	04 40.6	+29 53	5

T. B. Hunter et al., *The Barnard Objects: Then and Now*, The Patrick Moore Practical Astronomy Series, https://doi.org/10.1007/978-3-031-31485-8

Barnard object number	Right Ascension α J2000.0	Declination δ J2000.0	Size Arcminutes
24	04 42.9	+29 44	8
25	04 52.1	+46 01	8
26	04 54.6	+30 37	5
27	04 55.1	+30 33	5
28	04 55.9	+30 38	4
29	05 06.4	+31 35	10
30	05 30.3	+12 46	67
31	05 32.0	+12 46	30
32	05 32.1	+12 26	
33	05 40.9	−02 28	4
34	05 43.5	+32 39	20
35	05 45.5	+09 03	15
36	05 49.8	+07 25	120
37	06 32.9	+10 29	175
38	06 33.7	+11 05	60
39	06 38.0	+10 20	
40	16 14.6	−18 58	15
41	16 22.3	−19 38	45
42	16 25.5	−23 26	
43	16 30.3	−19 47	
44	16 40.6	−24 05	
44a	16 44.8	−40 20	5
45	16 46.4	−21 36	120
46	16 57.2	−22 44	
47	16 59.7	−22 39	15
48	17 01.7	−40 41	40
49	17 02.7	−33 16	
50	17 02.9	−34 23	15
51[b]	17 03.7	−22 23	20
52[a]	17 04.7	−22 13	13[c]
53	17 06.2	−33 35	60
54	17 06.6	−34 15	5
55	17 07.6	−32 00	16
56	17 08.8	−32 06	3
57	17 08.4	−22 50	5
58	17 11.2	−40 25	30
59	17 11.4	−27 29	60
60	17 11.9	−22 26	13
61	17 15.0	−20 29	
62	17 16.2	−20 53	19
63	17 16.5	−21 29	60
64	17 17.3	−18 29	
65	17 19.6	−26 42	12

Barnard object number	Right Ascension α J2000.0	Declination δ J2000.0	Size Arcminutes
66	17 20.0	−26 54	8
67	17 21.0	−26 52	
67a	17 22.5	−21 53	13
68	17 22.6	−23 47	4
69	17 22.9	−23 55	4[d]
70	17 23.5	−24 02	4
71	17 23.0	−24 00	1
72	17 23.6	−23 37	
73	17 24.1	−24 17	1
74	17 25.1	−24 12	5[d]
75	17 25.3	−22 02	
76	17 25.6	−24 25	30[d]
77	17 28.6	−23 51	60
78	17 32.7	−25 36	180
79	17 37.4	−19 37	30
80	17 37.7	−21 17	2
81	17 38.5	−23 56	
82	17 38.6	−23 47	
83	17 39.0	−24 11	7
83a	17 45.3	−20 00	4
84	17 46.4	−20 15	
84a	17 57.6	−17 40	16
85	18 02.4	−23 01	
86	18 03.0	−27 52	5
87	18 04.2	−32 30	
88	18 04.6	−24 07	2
89	18 05.0	−24 22	0.5
90	18 10.2	−28 17	3
91	18 10.1	−23 42	5
92	18 15.6	−18 14	12
93	18 16.9	−18 04	2
94	18 25.9	−10 40	15
95	18 25.6	−11 45	30
96	18 26.4	−10 18	
97	18 29.1	−09 55	60
98	18 33.3	−26 04	3
99	18 33.3	−21 29	7
100	18 32.7	−09 09	16
101	18 32.7	−08 49	8
102	18 37.7	−13 45	5
103	18 39.4	−06 40	4
104	18 47.3	−04 32	16
105	18 47.7	−06 55	0.5

Barnard object number	Right Ascension α J2000.0	Declination δ J2000.0	Size Arcminutes
106	18 48.8	−05 05	2
107	18 49.5	−05 01	5
108	18 49.6	−06 19	3
109	18 49.6	−07 34	0.7
110	18 50.1	−04 48	11
111	18 50.6	−04 57	120
112	18 51.1	−06 40	18
113	18 51.4	−04 19	16
114	18 53.2	−06 57	6
115	18 53.3	−06 40	6
116	18 53.5	−07 11	
117	18 53.7	−07 25	1
117a	18 53.7	−04 51	7
118	18 53.9	−07 27	2
119	18 54.6	−04 33	
119a	18 54.7	−05 11	30
120	18 54.9	−04 36	
121	18 55.4	−04 37	
122	18 56.8	−04 45	4
123	18 57.7	−04 43	1.5
124	18 57.7	−04 21	3
125	18 58.4	−04 23	9
126	18 59.0	−04 32	8
127	19 01.5	−05 27	4.5
128	19 01.7	−04 34	10
129	19 02.1	−05 18	5
130	19 01.9	−05 34	7
131	19 02.3	−04 22	0.7[c]
131a[a]	19 03.1	−04 20	3
132	19 04.5	−04 26	16
133	19 06.2	−06 54	
134	19 06.9	−06 15	6
135	19 07.5	−03 55	13
136	19 08.8	−04 00	8
137	19 16.0	−01 20	
138	19 16.4	+00 13	180
139	19 18.0	−01 25	
140	19 19.8	+05 14	60
141	19 20.2	+01 54	20
142	19 39.7	+10 31	40
143	19 41.4	+11 00	30
144	19 58.7	+35 20	270
145	20 02.8	+37 41	45

Barnard object number	Right Ascension α J2000.0	Declination δ J2000.0	Size Arcminutes
146	20 03.5	+36 01	
147	20 06.8	+35 23	11
148	20 47.7	+59 38	3
149	20 49.0	+59 32	2
150	20 50.7	+60 18	60
151	21 08.2	+56 19	60
152	21 14.5	+61 44	9
153	21 21.1	+56 27	60
154	21 21.4	+56 37	8
155	21 32.1	+44 58	13
156	21 34.0	+45 35	8
157	21 33.7	+54 40	5
158	21 37.2	+43 25	3
159	21 38.4	+43 14	25
160	21 38.0	+56 14	31
161	21 40.4	+57 49	3
162	21 41.2	+56 19	13
163	21 42.2	+56 42	
164	21 46.5	+51 06	20
165	21 48.9	+60 13	18
166	21 51.1	+60 05	5
167	21 52.0	+60 04	5
168	21 53.3	+47 16	10
169	21 58.9	+58 46	60
170	21 58.0	+58 58	15
171[b]	22 01.8	+58 52	19[c]
172[a]	22 06.9	+59 13	
173	22 07.5	+59 41	4
174	22 07.3	+59 05	19
175	22 14.0	+69 56	60
176	16 41.0	−21 32	145 x 15
177	16 37.0	−23 30	75 x 20
178	17 09.5	−22 41	30
179	16 44.8	−34 56	15
180	17 02.0	−34 37	11
181	17 21.1	−25 45	72
182	18 33.3	−25 59	50 x 9
183	18 08.0	−25 52	60
184	18 03.7	−30 36	18 x 4
185	18 18.3	−20 03	168
186	18 34.9	−12 42	240
187	18 31.4	−17 35	45 x 15
188	18 40.1	−06 15	60

Barnard object number	Right Ascension α J2000.0	Declination δ J2000.0	Size Arcminutes
189	19 20.6	+08 26	22
189a	19 21.3	+08 43	10 x 3
190	21 08.2	+56 24	3 x 1.5
191	21 32.1	+54 24	14
192	21 31.7	+53 45	12 x 5
193	21 00.5	+48 37	15 x 4
194	21 32.3	+54 49	8 x 4
195	21 32.5	+55 02	8 x 4
196	21 33.3	+54 56	4
197	21 41.4	+56 37	2.5
198	21 56.3	+59 01	4
199	21 40.1	+58 02	120
200[e]	16 25.8	−24 17	8
201	02 13.0	+57 05	10
202	03 25.6	+30 17	22
203	03 25.8	+30 47	
204	03 28.5	+30 11	14
205	03 28.5	+31 06	15
206	03 29.2	+30 11	5
207	04 04.6	+26 21	
208	04 11.5	+25 10	
209	04 12.4	+28 20	
210	04 15.6	+25 04	
211	04 17.2	+27 49	
212	04 19.2	+25 18	
213	04 21.2	+27 03	
214	04 21.9	+28 33	5
215	04 23.6	+25 03	
216	04 24.0	+26 38	
217	04 27.6	+26 07	
218	04 28.2	+26 17	15
219	04 34.9	+29 36	120
220	04 41.5	+26 00	7
221	04 44.0	+31 44	45
222	05 08.4	+32 10	10
223	05 21.5	+08 20	8
224	05 23.9	+10 37	20
225	05 29.0	+11 36	
226	05 36.6	+33 42	17
227	06 07.4	+19 39	12
228	15 45.0	−34 31	240
229	16 17.7	−27 19	45
230	16 27.2	−16 47	60

Barnard object number	Right Ascension α J2000.0	Declination δ J2000.0	Size Arcminutes
231	16 38.4	−35 25	30
232	16 43.7	−39 49	10
233	16 44.8	−35 24	37
234	16 46.4	−30 29	18
235	16 47.1	−44 29	7
236	16 48.9	−29 48	
237	16 48.9	−29 58	37
238	16 52.4	−23 08	13
239	16 55.0	−31 07	15
239a[a]	16 54.9	−31 05	0.3
239b[a]	16 55.2	−31 06	0.4
240	16 59.3	−35 22	20
241	16 59.5	−30 12	12
242	17 05.1	−32 26	19
243	17 09.8	−29 35	25
244	17 10.9	−28 25	25
245	17 11.9	−29 24	8
246	17 12.0	−22 39	15
247	17 13.1	−30 15	4
248	17 13.1	−28 59	10
249	17 13.1	−29 09	13
250	17 13.0	−28 24	15
251	17 13.8	−20 09	13
252	17 15.3	−32 09	20
253	17 15.5	−22 34	60
254	17 20.5	−30 08	40
255	17 20.6	−23 28	5
256	17 22.2	−28 50	50
257	17 22.8	−35 38	15
258	17 23.0	−34 43	40
259	17 22.0	−19 18	30
260	17 24.8	−25 37	10
261	17 25.1	−23 02	10
262	17 25.5	−22 37	30
263	17 26.9	−42 47	30
264	17 27.2	−25 32	10
265	17 27.6	−25 12	12
266	17 28.1	−20 56	30
267	17 28.5	−25 13	4
268	17 31.4	−20 31	75
269	17 32.2	−22 46	60
270	17 32.7	−19 36	11
271	17 34.3	−34 15	120

Barnard object number	Right Ascension α J2000.0	Declination δ J2000.0	Size Arcminutes
272	17 37.6	−23 25	45
273	17 38.5	−33 21	15
274	17 38.1	−22 44	18
275	17 39.0	−32 20	13
276	17 39.6	−19 49	45
277	17 40.7	−23 04	18
278	17 42.7	−32 19	15
279	17 44.6	−22 33	60
280	17 45.0	−20 43	60
281	17 46.8	−23 43	
282	17 48.6	−23 28	18
283	17 51.3	−33 52	75
284	17 50.1	−14 22	25
285	17 51.5	−12 52	15
286	17 53.1	−35 37	15
287	17 54.4	−35 12	30
288	17 57.1	−37 05	2
289	17 56.6	−29 01	25
290	17 59.3	−37 09	3
291	17 59.7	−33 54	5
292	18 00.6	−33 21	60
293	18 01.2	−35 21	18
294	18 01.5	−28 36	3
295	18 04.1	−31 10	50
296	18 04.1	−24 32	4
297	18 04.3	−18 45	75
298	18 05.2	−30 06	4
299	18 06.3	−27 18	3[d]
300	18 07.0	−32 39	
301	18 08.8	−18 42	30
302	18 09.2	−23 58	30
303	18 09.5	−24 00	1
304	18 13.3	−18 43	
305	18 14.6	−31 48	13
306	18 15.7	−25 43	4
307	18 18.6	−17 57	6
308	18 19.1	−22 14	6
309	18 23.1	−24 01	5
310	18 30.2	−18 35	2
311	18 30.5	−17 40	6
312	18 32.2	−15 35	75
313	18 35.9	−15 41	15
314	18 37.1	−09 43	35

Barnard object number	Right Ascension α J2000.0	Declination δ J2000.0	Size Arcminutes
315	18 42.3	−20 02	5
316	18 41.8	−02 08	6
317	18 45.8	−14 12	20
318	18 49.7	−06 24	60
319	18 52.0	−01 16	7
320	18 52.8	−05 51	15
321	18 54.0	−11 18	13
322	18 55.8	−04 28	2
323	18 57.6	−03 25	17
324	18 59.4	−03 00	30
325	18 59.9	−04 04	15
326	19 03.4	−00 23	20
327	19 04.4	−05 08	25
328	19 04.8	−04 15	4
329	19 07.0	+03 11	6
330	19 19.6	+07 34	30
331	19 26.1	+07 35	40
332	19 28.0	+08 45	
333	19 28.9	+10 40	60
334	19 35.1	+12 19	3
335	19 36.9	+07 37	6
336	19 36.7	+12 21	2
337	19 37.0	+12 24	3
338	19 43.0	+07 28	8
339	19 44.0	+08 18	60
340	19 48.7	+11 25	7
341	19 50.0	+34 17	30
342	20 09.5	+41 12	4
343	20 13.4	+40 17	13
344	20 16.2	+40 13	7
345	20 21.0	+46 34	15
346	20 26.8	+43 45	10
347	20 28.5	+39 55	1
348	20 34.4	+42 06	60
349	20 47.4	+43 58	6
350	20 49.1	+45 53	3
351	20 52.5	+47 24	20
352	20 57.2	+45 54	22
353	20 57.4	+45 29	9
354	20 58.2	+58 09	60
355	20 59.6	+43 11	5
356	21 00.0	+46 41	24
357	20 59.9	+55 34	30

Barnard object number	Right Ascension α J2000.0	Declination δ J2000.0	Size Arcminutes
358	21 05.7	+43 17	20
359	21 06.8	+57 10	20
360	21 07.9	+56 30	54
361	21 12.8	+47 26	20
362	21 24.0	+50 12	15
363	21 24.9	+48 56	40
364	21 34.1	+54 33	75
365	21 34.9	+56 43	22
366	21 40.4	+59 34	10
367	21 44.4	+57 10	5
368	21 50.9	+58 59	14
369	22 15.9	+56 01	5
370	22 34.8	+56 39	

[a]Dark object added to this list
[b]Corrected position for this object
[c]Corrected size for this object
[d]Added size based upon Barnard's papers
[e]Object not charted by Barnard, added by Dobek

Glossary[1]

2MASS Two Micron All-Sky Survey, a survey of the whole sky in the infrared. It took place from 1997 to 2001 in both the Northern Hemisphere and the Southern Hemisphere. It was conducted in the short wavelength infrared in the J, H, and K frequency bands near 2 microns.

A A spectral classification for hot, white stars, such as Sirius. See stellar spectral classification.

AAS American Astronomical Society: https://aas.org/

AAT Anglo-Australian Telescope, a 3.9-meter telescope situated at Siding Springs Observatory, New South Wales, Australia, also known as the **Anglo-Australian Observatory (AAO).**

AAVSO American Association of Variable Star Observers: https://www.aavso.org/

A&A *Astronomy & Astrophysics*, a professional astronomical journal.

Absolute Magnitude The apparent magnitude of a star if it were 10 parsecs distant.

Absolute Zero The temperature (-273^0 C) where all molecular motion stops, 0 on the Kelvin scale.

[1] The terms selected for this Glossary are somewhat arbitrary as are all glossaries. Professional and amateur astronomers are very eclectic in their use of eponyms, acronyms, and abbreviations with little consistency from one source to another concerning the abbreviation, capitalization, and even the spelling of common astronomical terms. Hopefully, the copyeditor for this book will standardize the astronomical terms used herein so they are presented in a consistent manner throughout the book. The Glossary tries to define as much as possible all the numerous abbreviations, acronyms, and eponyms that appear in the book.

© The Editor(s) (if applicable) and The Author(s), under exclusive license to Springer Nature Switzerland AG 2023

297

T. B. Hunter et al., *The Barnard Objects: Then and Now*, The Patrick Moore Practical Astronomy Series, https://doi.org/10.1007/978-3-031-31485-8

Absorption Line Spectrum Dark lines on an otherwise continuous spectrum. Hot glowing gas emits lines of light specific to its composition (emission spectrum), whereas absorption lines refer to the tendency of cool often dense atmospheric gas to absorb the same lines.

Accretion Dust and gas accumulating into larger bodies eventually forming planets and stars.

Accretion disk A disk of gas and accumulating around a center of gravity, such as a forming star or a black hole.

Acetate negative Any photographic negative on a cellulose acetate film base (cellulose diacetate, cellulose acetate propiarate, cellulose acetate butyrate, and cellulose triacetate). These started replacing highly flammable nitrate base films in the mid 1920's and were known as "safety film."

Achromatic Doublet A compound lens with two elements, often in contact. The lenses are composed of different glasses with slightly differing focal lengths. Doublets are designed to correct lens aberrations. In the case of achromatic doublets chromatic (color) aberration is corrected so most visible colors are focused on the same point reducing red, yellow, or blue coloration around bright stars and planets. For common achromatic doublets a concave lens of flint glass is combined with a convex lens of crown glass.

Achromat Achromatic doublet. This usually refers to a refractor telescope with a doublet objective lens.

Actinic Short wavelength blue or ultraviolet light able to cause photochemical reactions.

ADS SAO/NASA Astrophysics Data System, "...a digital library portal for researchers in astronomy and physics, operated by the Smithsonian Astrophysical Observatory (SAO) under a NASA grant." See: https://ui.adsabs.harvard.edu/

ADS Aiken Double Star Catalogue.

AGB star Asymptotic giant branch star, a period of stellar evolution where low to intermediate mass stars (0.5-8 solar masses) late in their lives appear as a bright red giant star.

AGN Active galactic nucleus, a young galaxy with a highly energetic core producing a bright central region of the galaxy dominated by dust and gas falling into a central black hole.

AGN Abbreviation sometimes used for *Atlas of Galactic Nebulae* by German astronomers Hans Vehrenberg and Thorsten Nickel published in three volumes from 1985-1990.

Airglow The brightest part of natural skyglow. It is caused by oxygen atoms emitting radiation at 557.7 nm in the upper atmosphere from being excited by ultraviolet radiation. Airglow is stronger at solar maximum and at a dark sky site adds a faint green or red color to the sky background.

AJ *The Astronomical* Journal, a professional astronomical journal owned by the American Astronomical Association (AAS).

Albedo The fraction of sunlight a planet, asteroid, or comet reflects.

ALMA The Atacama Large Millimeter/submillimeter Array, sixty-six high precision antennas located in Northern Chile at 5000 meters altitude. See: https://www.almaobservatory.org/en/home/

Almagest A second century Greek-language mathematical and astronomical treatise written by Claudius Ptolemy (circa 100 AD-circa 170 AD). It proposed a geocentric model of the Universe and is a key source of information about ancient Greek astronomy. The Almagest star catalog is the oldest extant catalog in which there are tables of stellar coordinates and magnitudes.

Altitude Altitude and azimuth are part of the *horizontal coordinate system*. *Altitude* is a measure of the angular distance of an object above or below the horizon. Objects located on the horizon have 0 degrees altitude and at the *zenith (directly overhead)* 90 degrees altitude. In formal astronomical circles objects below the horizon have negative altitudes.

AN See *Astronomische Nachricten*.

Analog [data] A string of continuously variable data; i.e., raw data from an electronic device.

Angstrom (A) A unit of length 10^{-10} meter. Named after the Swedish physicist Anders Jonas Angstrom (1814-1874) who expressed the wavelengths of electromagnetic radiation in multiples of one ten millionth of a millimeter (10^{-7} mm). Angstrom is widely used in physics and chemistry but is not a formal part of the International System of Units (SI). Nanometer (10^{-9} m) is more commonly used to express wavelengths of the visible portion of the electromagnetic spectrum.

Angular Diameter The angle subtended by the diameter of an object being observed or measured.

Angular Velocity The speed measured in angular units with which an object rotates around an axis.

Angular Resolution The angular diameter of the smallest feature that can be resolved with a telescope or the human eye.

Annual Solar Eclipse A solar eclipse in which the Moon passes directly in front of the Sun but does not completely cover the Sun's entire disk. This leaves a "ring of fire" or annulus around the Moon.

ANSI American National Standards Institute, a nongovernmental, voluntary federation of trade associations, professional societies, and individuals. ANSI organizes and publishes national standards.

Anomalous microwave emission (AME) A component of diffuse galactic radiation observed at frequencies in the 10-60 GHz range. It spatially correlates with far infrared thermal dust emission, but its source is unknown and is an area of intense study.

APASS The American Association of Variable Star Observers (AAVSO) all sky photometric survey from ~10th-17th magnitude. See: APASS: The AAVSO Photometric All-Sky Survey | aavso

Aperture The diameter of an opening or the diameter of the primary lens or mirror of a telescope.

APEX Atacama Pathfinder Experiment, an ESO 12-meter diameter telescope operating at millimeter and submillimeter wavelengths. It is located on the Chajnantor plateau in Chile's Atacama region at 5100 meters altitude.

Aphelion The point at which the Earth or other body is farthest from the Sun on its orbit around the Sun. The Earth's aphelion occurs in early July.

ApJ *The Astrophysical Journal*, a research astronomical journal owned by the American Astronomical Association (AAS).

Apochromatic lenses (APO) A triple lens design with three air-spaced lenses first introduced by Peter Dolland (1731-1820) in 1763 to mitigate the effects of chromatic aberration seen in the two-lens achromatic design.

Apogee The point at which a body orbiting the Earth is furthest from the Earth. This is usually applied to the Moon or an artificial satellite of the Earth.

Apparent (brightness) magnitude The brightness (magnitude) of a star or other object as measured from the Earth.

APS-C camera (cropped-sensor camera) A digital 35 mm camera with an imaging chip less than the full frame size of 36 mm x 24 mm. Nikon, Pentax, and Sony cameras have 23.6 mm 15.8 mm cropped sensors. Canon cameras have 22.3 x 14.9 mm cropped sensors.

Arcminute (') An angular distance 1/60th of a degree or 60 arcseconds.

Arcsecond (") An angular distance 1/60th of an arcminute. Sixty arcseconds equal one arcminute. Sixty arcminutes equal one degree.

Array A grid or rectangular arrangement of picture elements (pixels) with respect to digital imaging. An array is described by the number of pixels in the x and y dimensions and by the pixel size.

arXiv An open-access repository of preprints and postprints approved for posting after some inspection, but not prior to formal peer review.

ASAS-SN All Sky Automated Survey for Supernovae, 24 telescopes distributed around the world: ASAS-SN's Homepage (ohio-state.edu)

ASKAP Australian Square Kilometre Array Pathfinder: https://www.atnf.csiro.au/projects/askap/index.html

ASP Astronomical Society of the Pacific, American scientific and educational organization founded in San Francisco, CA, February 7, 1889. It is the largest general astronomy education society in the world.

Asterism A pattern of stars, such as a triangle or rectangle of stars, that are not a formally recognized constellation.

ASA In reference to film speed the American Standards Association scale which has been replaced by the ISO standard for film and digital imaging speed.

Asteroid A small rocky body orbiting the Sun. Known asteroids number in the hundreds of thousands with many smaller ones yet to be discovered. They range in size from Vesta the largest with a diameter of 525 kilometers (326 miles) to bits of rock only a few meters in diameter. Ceres is now classified as a Minor Planet. The largest number of asteroids by far lie in the "asteroid belt" between Mars and Jupiter.

Astrometry The measurement of the position and movement of celestial bodies.

Astronomical League (AL) The national organization for amateur astronomers. It consists of more than 240 local amateur astronomical societies from across the United States. See: https://www.astroleague.org/

Astronomical Unit (AU) The average distance between the Earth and the Sun, approximately 150 million kilometers.

Astronomische Nachricten **(Astronomical Notes)** An astronomical journal founded in 1821. It is the oldest astronomical journal still being published. It has been one of the premier astronomical journals since the mid-19th century.

ASKAP Australian Square Kilometre Array Pathfinder radio telescope. See: https://www.atnf.csiro.au/projects/askap/index.html

ASP Astronomical Society of the Pacific: https://astrosociety.org/

ATLAS-REFCAT-MAST An all-sky reference catalog containing close to one billion stars down to magnitude 19. It includes star data from several large catalog, including Tycho-2 and the Yale Bright Star Catalog.

Aurora An electrical glow in a planet's atmosphere caused by the interaction of the planet's magnetic field and charged particles from the Sun. Regarding the Earth, auroras are most common in high northern and southern latitudes where the Earth's magnetic field is more concentrated. In the northern hemisphere they are named *Aurora Borealis* or *the Northern Lights*. In the southern hemisphere they are named *Aurora Australis* or the *Southern Lights*. They may be quite bright and display a multitude of quickly changing forms, streamers, arcs, curtains, and rays with a variety of colors, most often green and red.

Azimuth Altitude and azimuth are part of the *horizontal coordinate system*. Azimuth is based on the 360 degrees of a traditional compass with due north 0 degrees, due east 90 degrees, due south 180 degrees, and due west 270 degrees azimuth.

BAA British Astronomical Association, founded in 1890, the most prominent amateur astronomy association in the United Kingdom: https://britastro.org/

Balmer Series A series of spectral emission lines of the hydrogen atom. They result from electron transitions from higher levels down to the energy level with principal quantum number 2. See: Balmer series | COSMOS (swin.edu.au)

Bandpass (Band) A specification for the range of wavelengths allowed through a filter that cuts off high and low wavelengths beyond the limits of the bandpass.

Barnard Object A dark nebula listed in EE Barnard's *A Photographic Atlas of Selected Regions of the Milky Way* edited by Edwin B Frost and Mary R Calvert. Washington: Carnegie Institution of Washington, 1927.

Background (Fixed) Stars All stars (except for the Sun) are so distant they appear fixed in place and do not move relative to each other compared to "foreground" objects like the Moon and planets which move with respect to the background stars.

Barred spiral galaxy A spiral galaxy with a central bar like structure made of stars. The Milky Way is thought to be barred spiral galaxy.

Bayer Array (also known as a Color Filter Array).

Bayer Star Designation Johann Bayer (1572–1625) in 1600 introduced a system of ranking stars in a constellation by brightness using lower case Greek letter names, alpha, beta, gamma, and so forth.

BD or B.D See **Bonner Durchmusterung**.

BeSSeL Survey The Bar and Spiral Structure Legacy Survey is a Key Project on the Very Long Baseline Array (VLBA). It measures trigonometric parallaxes and proper motions of methanol and water masers associated with hundreds of high-mass forming regions in the Milky Way.

Binary Star A double star. Two stars close together, usually gravitationally bound to each other and revolving around each other.

Black body A theoretical body that absorbs and reemits all radiation striking it. Stars are often regarded as comparable to black bodies with their "color" representative of a spherical black body at the star's temperature.

Black hole The collapsed core of a massive star with so much mass compressed into such a tiny region nothing can escape from it including light.

Blink Comparator A viewing apparatus invented in 1904 by Carl P Pulfrich (1858-1927) to enhance differences between two photographic plates of the same portion of the sky taken at different times. By rapidly viewing (blinking) from one plate to the other, change in position or brightness of an object was more easily discernible than examining each plate individually.

Bok Globule A small, rounded dark nebular region thought to contain star formation or be a precursor to star formation. Named after Bart Bok (1906-1983) who called attention to these regions in his writings. He always credited EE Barnard with having first called attention to these small dark nebular areas.

Bonner Durchmusterung (**B.D. or BD**) An astrometric star catalogue and atlas of the sky compiled from the north celestial pole to just south of the celestial equator by the Bonn Observatory in Germany. It was first published in its entirety in 1863 and was later periodically updated. The catalogue was initiated by Friedrich Argelander (1799-1875) and mainly carried out by his assistants. When first published it had positions and apparent magnitudes of approximately 324, 188 stars down to magnitude 9-10. There were charts plotting the positions of the stars, and it was the basis of the ***Smithsonian Astrophysical Observatory Star Catalog (SAO)*** of today. BD star numbers were frequently used by Barnard and are still sometimes used today. BD was the last great star atlas to be compiled prior to photography superseding visual observations in astronomy.

Bright Nebula A cloud of dust and gas emitting light either from internal stellar emissions (*emission nebulae*) and/or from reflection of emission from nearby bright stars reflected off particulate matter (dust particles and ice particles) in the nebular cloud (*reflection nebulae*).

Bright Star Catalogue A catalog of naked eye stars, 9000 stars down to magnitude 7.1 with stellar coordinates, proper motion, photometric data, and stellar spectral type.

Bruce Telescopes Catherine Wolf Bruce (1816-1900) a patron of astronomy donated the funds for a 24-inch photographic doublet for Harvard College Observatory, two 16-inch portrait lenses for a doublet telescope at Heidelberg University for

Max Wolf, and a 10-inch photographic doublet at Yerkes Observatory for EE Barnard. The **Bruce Medal** of the Astronomical Society of the Pacific is named in her honor and is given to a recipient in recognition of lifetime achievements and contributions to astrophysics. It is one of the most prestigious awards in astronomy.

Camera Obscura A darkened room with a small pinhole or lens on a wall projecting an image on the opposite wall. This concept has been known since antiquity. The first recorded built camera obscura is attributed to Abu Ali Al-Hasan Ibn al-Haytham (965-1039). Some attribute Johannes Vermeer's (1632–1675) beautifully detailed paintings to the use of a camera obscura.

CARMA The Combined Array for Research in Millimeter-Wave Astronomy, a Caltech operated interferometer encompassing 23 antennas used in combination to image the sky at millimeter wavelengths. It is in the Inyo Mountains of California. See: https://sites.astro.caltech.edu/research/carma/

Carte du Ciel An international star mapping project initiated in 1887 by Amedee Mouchez (1821-1892) at the Paris Observatory. It consisted of an Astrographic Catalogue in which the entire sky was to be photographed to 11th magnitude and a fainter survey (Carte due Ciel) to 14th magnitude. Different observatories around the world were assigned to survey specific declination zones. The entire project was only partially successful and never fully completed.

CCD Charged-coupled device. Electronic sensor invented in 1969. CCD's and later CMOS "chips" replaced film imaging in astronomy due to their 10-fold increased quantum efficiency, wider spectral sensitivity, lack of reciprocity failure, and a linear signal to exposure response over a very wide exposure range.

CCO Central compact object, a tiny hot source that emits X-rays and found close to the center of a supernova remnant. It may be a subclass of neutron stars.

CD *Cordova Durchmusterung* star catalog.

CDS In reference to astronomy, Strasbourg astronomical Data Center: https://cdsweb.u-strasbg.fr/

Ced Cederblad Catalog of bright diffuse galactic nebulae.

Celestial Coordinate System Astronomers use an *equatorial coordinate system* to define the position of an object in the sky. *Right ascension* is the equivalent of longitude, and *declination* is the equivalent of latitude. This system is more confusing and uses somewhat different units than the familiar longitude and latitude system.

Celestial Equator The projection of the Earth's equator into space dividing the sky into the north celestial hemisphere and the south celestial hemisphere.

Celestial Poles The projection of the north and south poles of the Earth into the sky. Polaris is close to the north celestial pole and is called the "pole star" in the northern hemisphere. The sky appears to rotate about the celestial poles like the Earth rotating about its poles.

Cepheid variable star A special type of supergiant, pulsating variable star whose intrinsic brightness can be derived from its period of variability. Cepheid variables are important candlesticks allowing determination of galactic distances.

Ceres Now classified as a Minor Planet, it was largest and the first asteroid to be discovered.

CFA Also known as Bayer array. A system where out of each four-pixel group two will be green, one red, and one blue. The final color displayed for each pixel is determined by a complex mathematical algorithm using information from the color pixels surrounding it.

CGCG Catalogue of Galaxies and Clusters of Galaxies.

Chandra X-Ray Observatory NASA's flagship mission for X-ray astronomy. See: https://chandra.harvard.edu/

Chromatic aberration See achromatic doublet.

CIERA Center for Interdisciplinary Exploration and Research in Astrophysics: Center for Interdisciplinary Exploration and Research in Astrophysics (CIERA) (northwestern.edu)

Circumpolar Refers to stars and constellations near enough to the north or south celestial pole for one's latitude that they never dip below the horizon as the Earth rotates. They never rise or set.

Classical Planet (as opposed to a dwarf planet). Mercury, Venus, Earth, Mars, Jupiter, Saturn, Uranus, and Neptune are the classical planets. Pluto was demoted from being a classical planet to being defined as a dwarf planet.

CLASSy CARMA Large Area Star-formation Survey, a CARMA key project.

CMD Color magnitude diagram.

CMOS Complementary metal-oxide sensor. An electronic sensor analogous to the CCD but less costly and less effected by electronic noise. CMOS chips have replaced most CCD applications for astronomical imaging.

Coelostat A device with a flat mirror that is pointed at a selected portion of the sky and is turned slowly by motor so that its light from the selected area is continuously reflected on to a second fixed mirror, the combined effects of which is to send light into a fixed telescope. A heliostat produces an image of the Sun reflecting light into a fixed telescope. A siderostat is similar to a heliostat but observes stars.

Collodion A solution of nitrocellulose (guncotton) in alcohol and ether. After the solvents evaporate a clear film is formed which is impervious to water.

Collotype A process for making prints from a sheet of light sensitive gelatin exposed photographically.

Color Filter Array (CFA) See Bayer array.

Color Magnitude Diagram (CMD) A plot showing the spectral type of a star or its temperature (color equivalent) versus its luminosity for an open cluster or globular cluster. This is often referred to as the Hertzsprung-Russell (HR) diagram after Ejnar Hertzsprung and Henry Norris Russell who independently introduced this concept in 1905 and 1913, respectively.

Comet Comets are large "dirty snowballs" consisting of various ices of frozen water, carbon monoxide, carbon dioxide, ammonia, and methane mixed with dust and rocky debris. This icy dusty mixture is the "nucleus" of the comet which is stable in the cold outer reaches of the Solar System. When a comet travels into the inner portion of the Solar System to where the Earth lies or closer, the nucleus is heated by the Sun and gives off large volumes of thin gas as its ices vaporize through a process called sublimation.

Conjunction A situation in which two astronomical objects are close to each other in the sky.

Constellation A specific identifiable grouping of stars, traditionally representing a mythical hero or creature. The modern definition of constellations with demarcation of their borders was established by the International Astronomical Union (IAU) in 1930. There are 88 currently recognized constellations.

Corona The Sun's outer atmosphere which has a very high temperature and low density. It is best observed during solar eclipse totality and was not thought to be a real phenomenon until the mid and latter part of the 19th century when early total eclipse photographs demonstrated its presence.

Cousins Johnson Photometric System An extension of the UBV (Ultraviolet, Blue, Visual) photometric system introduced in the 1950's by Harold Lester Johnson (1921-1980) and William Wilson Morgan (1906-1994). William James Cousins (1903-2001) and others suggested a system for adding R (Red) and I (near-infrared) to the original UBV system. The latter is now known as the UBVRI system.

Cr Collinder Catalogue of open clusters.

Crown glass Glass made without lead or iron, originally made in a circular plate from which windows were cut. It is also used as an optical glass.

CSA Canadian Space Agency: https://www.asc-csa.gc.ca/eng/

CSIRO Australia's National Science Agency: https://www.csiro.au/

CSPN Central star planetary nebula.

CTIO Cerro Tololo Inter-American Observatory, a program of NOIRLab. CTIO is a complex of telescopes and instruments located 500 km (310 miles) north of Santiago and 80 km (50 miles) to the east of La Serena, Chile, at altitude of 2200 meters (7200 feet): https://noirlab.edu/public/programs/ctio/

Cyanogen Chemical compound $(CN)_2$, a colorless, toxic gas.

Cygnus X A diffuse radio source in Cygnus from clouds of ionized interstellar gas. It is one of the richest star formation regions in the Milky Way.

Cygnus X-1 A source of X-rays discovered in Cygnus. It is the first suspected black hole, the X-rays coming from a disk of gas spiring into a black hole which causes a companion blue supergiant star to bulge toward it with its gas flowing into the black hole.

Dark adaptation The process in which the eye adapts to vision under low light conditions. It is a requirement for deep sky observing of faint celestial objects.

Dark current Small electrical current that flows through an electronic device, such as a CCD or CMOS chip, even though no photons strike the chip. This is a source of noise that must be controlled in modern digital imaging.

Dark Lanes Regions of dark nebulae which are elongated with finger-like shapes.

Dark Nebula A contained region of the sky where there is reduced light emission compared to the starry background from obscuring dust and gas.

Darkroom An enclosed room allowing no entrance of outside light used for the developing of photographic films and plates. It usually has running water hot and cold and good ventilation to remove chemical fumes from the photographic processes.

Declination δ The celestial equivalent of terrestrial latitude.

Deep Sky Object (DSO) A classification used in amateur astronomy for any celestial object that is not an individual star or a member of the Solar System. The term usually refers to faint galaxies, nebulae, and star clusters.

Degree (0) The basic unit of angular measurement in the sky. The distance from one celestial pole to the other is 180^0. The distance from the horizon in any direction to the zenith is 90^0.

Digitalize Process of administering digitalis to a patient with congestive heart failure. This term should not be confused with the term *digitize*.

Distance modulus The difference between the apparent magnitude (m) and the absolute magnitude (M) of a celestial object (m-M). It provides a measure of the distance to the object through the formula $m-M=5\log_{10}(r/10)$, where r is the distance to the object in parsecs.

Digitize Conversion of analog data to digital information.

DOI Digital Object Identifier, a system designed to provide persistent identification which is commonly associated with publication citations complementing or replacing the traditional printed citation. The International DOI Foundation (IDF) is the registration authority for the ISO standard (ISO 26324) for the DOI system. According to IDF: "The DOI system provides a technical and social infrastructure for the registration and use of persistent interoperable identifiers, called DOIs, for use on digital networks."

Double Star A pair of stars close to each other from our viewpoint. They may be rotating around a common center of gravity and are technically a binary star system. Or they may be unrelated to each other and simply lie along the same line of sight from the Earth.

Doublet See achromatic doublet.

DSLR Digital single lens reflex camera.

DSS *Digitized Sky Survey.* DSS-N are images from the Palomar Sky Survey, and DSS-S are images from the U.K. Schmidt telescope. DSS1 and DSS2 surveys were produced at the Space Telescope Science Institute for the Guide Star Catalog. On online version of DSS is available from the ESO. See https://archive.eso.org/dss/dss

Dusk The transition from day to night as the sky gets darker in the evening. See twilight.

Earthshine A glow on the unlit part of the Moon. It is best seen a few days prior to or a few days after new Moon. Leonardo da Vinci was the first person to realize earthshine is light from the Sun reflected off the Earth onto the Moon and back to the Earth.

Ecliptic The plane of the Earth's orbit around the Sun. It is the path in the sky the Sun follows on its apparent yearly movement. Most of the planets and major asteroids lie with a few degrees of the ecliptic.

ED air-spaced triplet APO refracting telescope A refractor telescope with an apochromatic objective of three air-spaced lens having enhanced coatings to reduce all but the most residual effects of chromatic aberration. They use high-

quality ED (Extra-Low Dispersion) glass. Such refractors if well-made have minimal chromatic aberration, producing high definition, high contrast viewing.

Electromagnetic radiation The "scientific" term for light. Light waves are created by fluctuations of electric and magnetic fields in space.

Electromagnetic spectrum The range of wavelengths from very long (radio waves) to progressively shorter wavelengths (microwave, infrared) to short wavelengths (visible light, ultraviolet) to ultrashort wavelengths (X-rays, gamma rays).

Elongation Distance east or west of the Sun as viewed from the Earth. This term is commonly used to describe the elongation of Mercury or Venus from the Sun in the morning or evening sky.

Emission Line Bright line or lines on top of a continuous spectrum or individual lines against a black background. These lines are produced when a neutral atom, ion, or molecule is in an excited state and returns to a lower state emitting photons at specific wavelengths unique to the atom, ion, or molecule.

Emission Line spectrum A spectrum consisting of emission lines. In astronomy an emission lines spectrum is usually associated with emission nebulae consisting of glowing gas at high temperatures and low density.

Emission Nebula See bright nebula.

Entrance pupil The aperture of an optical device like a telescope or pair of binoculars.

Ephemeris A table of data, usually arranged by date and time listing the position of a celestial body, such as the Sun, Moon, planets, and comets.

Epoch In reference to the celestial coordinate system epoch denotes the date for which an object's Right Ascension and Declination are based. These coordinates gradually change due to the slow wobble of the Earth's polar axis. Epoch 1875.0 was commonly used in Barnard's time. Today, Epoch 2000.0 is commonly used and stated as J2000.0, which is 12 noon on January 1, 2000.

Equinox The instant in time when the Sun appears to cross the equator from south to north (spring or vernal equinox around March 21st) or from north to south (fall or autumnal equinox around September 21st). The day upon which the equinox occurs if often referred to the "equinox" though the equinox is technically a moment in time. These dates are for the Northern Hemisphere. Dates and Sun movement are reversed in the Southern Hemisphere.

ESA European Space Agency: European Space Agency (esa.int)

ESO European Southern Observatory: ESO.

ESO(B) Atlas (Quick Blue Survey) The ESO(B) Atlas used the ESO 1-meter Schmidt telescope at La Silla, Chile, to photograph 606 fields from -90 to -20 degrees declination using unsensitized IIa-O plates with a 2 mm GG385 filter to give a bandpass similar to the Johnson B color. The field size and scale are similar to those in the Palomar Sky Survey. The Atlas was completed in 1979.

ESO Red Survey This ran from 1978-1990. The ESO-Schmidt telescope at Ls Silla, Chile, produced 606 photographic red plates of the sky from -15 degrees declination to -90 degrees declination. The UK Schmidt Telescope in Coonabarabran, Australia, took corresponding 606 blue/green J-plates. This ran from 1974-1987.

ESO/SRC Atlas of the Southern Sky A catalog containing the coordinates of the plate centers and observation dates of the plates composing the ESO(B) Survey, the ESO Red Survey, and the SRC-J Survey.

ESOUPPSALA-ESO-Uppsala ESO(B) Survey A joint project with the European Southern Observatory (ESO) and the Uppsala Observatory in which an object listing was compiled from studying the ESO(B) Atlas (Quick Blue Survey).

Exit pupil Small circle of light just behind the eyepiece of a telescope or binoculars through which all the light rays diverge. For the best viewing one's pupil size should match the exit pupil of the optical device.

Extinction The dimming of distant objects like stars due to the presence of dust in the interstellar medium along the line of sight.

Evening Star A morning star or an evening star is a bright planet, usually Venus, that is prominent in the twilight morning sky or the twilight evening sky.

Falling Star A meteor.

Fixed (Background) Stars Except for the Sun, all other stars are so far away they appear fixed in place and do not move relative to each other compared to "foreground" objects like the Moon and planets which move with respect to the background stars.

(Filar) micrometer Device used with a telescope to measure small angular distances. It uses knife blades or crosshairs in the eyepiece of a telescope. The observer sights on one of the knife blades or crosshairs and turns a screw which moves the other knife blade or crosshair. The amount of screw turning can be used to calculate the angular distance between two objects, typically a double star.

Film A generic term used in this book for either photographic roll film or a photographic plate. In the earliest days of photography prior to the 1890's photographic emulsions were placed on large glass plates. Eastman Kodak introduced the concept of a flexible smaller roll with photographic emulsion coating, thus introducing the concept of photographic film as opposed to a photographic (glass) plate. Roll film allowed the widespread adoption of photography by the public and by professional photographers. Professional astronomers mainly still used 8 x 10-inch or large photographic plates until modern digital imaging became widespread. Most other photographic applications used smaller roll film, such as 35 mm film, which is still available today. When discussing photography using a photographic emulsion versus digital imaging the term film is often used to represent any type of photographic medium, roll film or plates.

FIR Far infrared. A subdivision of the infrared portion of the electromagnetic spectrum with wavelength (λ) 15 micrometers to 1 mm.

FITS Flexible Image Transport System, open standard digital image file format commonly used in astronomy. Its filename extensions are: .fits .fit .fts.

Flamsteed Star Numbers John Flamsteed (1646–1719) in 1712 published an atlas listing 54 constellations. He numbered the stars in each constellation in order of their Right Ascension.

Flint glass A type of optical glass. In its manufacture powdered flint [a type of mineral quartz] was originally used as an additive to improve the quality of blown glass.

Forbidden spectral lines Spectral lines in nebulae not observed in laboratory spectra of the same gases, because the gases on Earth are too dense even in manmade vacuums. Such lines are evident in HII nebular regions where there are very rarified, low temperature conditions.

f/ratio, f/number The ratio of the focal length of a lens or mirror to its diameter. Fast f/ratios are found in large lenses or mirrors with short focal ratios, roughly f/1-f/5. Slow f/ratios range from approximately f/10-f/20.

Fluorescence The property of a substance absorbing light at a short wavelength and re-emitting it as light with a longer wavelength.

Fixator (hypo) A solution to give permanence to the developed image on a plate or print once it has been removed from the developing solution and washed. A photographic plate that has been exposed, developed, and washed will show an image, but that image quickly fades with time. Plate fixation was introduced by John Herschel in 1839 when he proposed sodium hyposulfite (hypo) as a fixating agent.

FWHM Full width at half maximum.

Gaia (spacecraft) Space observatory of the European Space Agency launched in 2013. It is designed for ultra-precision astrometry and is a follow-on mission to the earlier Hipparcos mission.

Galactic Center (Galactic Centre) The point about which the Milky Way rotates. This is located in Sagittarius 8 kiloparsecs (26,000 light years) away and is probably the complex radio source Sagittarius A (SgrA*) which is a supermassive black hole.

Galactic coordinates A celestial coordinate system with the Sun at its center, the primary direction aligned with the approximate center of the Milky Way, and the fundamental plane parallel to the plane of the Milky Way. This is a system designed to more accurately designate an object's location in the Milky Way as opposed to the common celestial coordinates using right ascension and declination.

Galaxy A large collection of millions or billions of stars, dust, and gas. When the term is capitalized (Galaxy), it refers to the Milky Way, our parent galaxy. In Barnard's lifetime (1857-1923) the Milky Way was presumed to comprise most of the Universe. Most galaxies were classified as "nebulae" and placed in the same category as dust and gaseous nebulae in the Milky Way. Some astronomers felt these 'galactic' nebulae were galaxies similar to our Milky Way, a concept now fully accepted by professional astronomers.

Gegenschein "Countershine," a faint spot in the night sky centered at the antisolar point (180 degrees opposite the Sun). It is the backscatter of sunlight by interplanetary dust.

Gelatin Animal protein with gel-forming properties. It is derived from collagen, protein in animal skin, bone, and tissues.

Gelb effect The illusory effect of a black surface appearing white or grey when it is lit by a white light and surrounded by a dark background, such as the dark surface of the Moon appearing grey or white against the dark background of the sky. It is named after the Russian born German psychologist Adhemar Maximillian Maurice Gelb (1887-1936).

GISS NASA Goddard Institute for Space Studies: https://www.giss.nasa.gov/

GMC Giant molecular cloud. Giant molecular clouds contain more than one million solar masses and can be as large 150 light years in diameter.

Gould's Belt A local partial ring of bright stars in the Milky Way about 3000 light years in length. It is tilted with respect to the galactic plane up to 20 degrees. Gould's Belt contains many star forming regions in the Milky Way and contains the Sun. Benjamin Gould (1824-1896), an American astronomer, noted this feature in the Milky Way in 1877.

Great Rift (of the Milky Way) A long irregular dark lane or band of clouds of dark material that stretches from Cygnus near Deneb through Aquila and Sagittarius.

GSC Guide Star Catalog. "The Catalogs and Surveys Branch of the Space Telescope Science Institute has digitized the photographic Sky Survey plates from the Palomar and UK Schmidt telescopes to produce the 'Digitized Sky Survey'. These images were then processed and calibrated to produce the Guide Star Catalogs in support of HST operations." From: http://gsss.stsci.edu/Catalogs/Catalogs.htm

H1 region A region of neutral hydrogen H in interstellar space.

HII region A region of ionized hydrogen H^+ in interstellar space. Large HII regions are common in many star forming galaxies and emit a dominant spectral line at 656.3 nm (H-alpha line) from a hydrogen electron going from excitation state n=3 to n=2.

Halation The spreading of light beyond where it is wanted with it forming a fog around the edges of a bright image in a photograph. Anti-halation backing is commonly a coating at the back of a film base or photographic plate.

Half-tone (or halftone) A photographic reproduction technique that uses dots varying in size or spacing to produce a gradient like continuous effect. The image produced is sometimes called a halftone.

Harvard Sky Patrol The world's first photographic sky survey. It was started by Edward C Pickering (1846-1919), director of Harvard College Observatory, in 1882. It used telescopes in both the Northern and Southern Hemispheres and ran until 1992 producing over 500,000 images. Pickering in 1882 also stared a spectral program at Harvard College Observatory using objective prisms obtaining several stellar spectra on a single plate.

HD Henry Draper Catalogue. An astronomical catalogue published between 1918 and 1924 giving spectroscopic classifications for 225,300 stars. It has been updated and expanded since then. The catalogue is named after Henry Draper (1837-1882), whose widow Mary Anna Draper (1839-1914) donated the money to finance it. The catalogue covers the entire sky down to photographic magnitude 9. HD catalogue numbers are a common way used to identify stars.

HDR High-dynamic-range image.

HEASARC High Energy Astrophysics Science Archive Research Center (NASA). "…HEASARC is the primary archive for NASA's (and other space agencies') missions studying electromagnetic radiation from extremely energetic cosmic phenomena ranging from black holes to the Big Bang" (https://heasarc.gsfc. nasa.gov/).

Heliometer An optical instrument designed for measuring the variation in the Sun's diameter at different times of the year. It can also be used to measure the angular separation of two nearby stars.

Herbig-Haro object (HH) A patch of bright nebulosity associated with newborn stars caused by jets of ionized gas ejected by young stars colliding at high speed with nearby clouds of dust and gas. They are a distinct type of emission nebulosity and first studied in detail by George Herbig (1920-2013) and Guillermo Haro (1913-1988).

Herschel Space Observatory A European Space Agency (ESA) infrared space telescope active from 2009 to 2013.

Hertzsprung-Russell diagram (HR diagram, H-R diagram, or HRD) A plot of stars showing their luminosity (absolute magnitude) versus their temperature (spectral type). This was created independently by Ejnar Hertzsprung (1873-1967) in 1911 and Henry Norris Russel (1877-1957) in 1913.

HH Herbig-Haro object.

HIRF High intensity reciprocity failure. Film reciprocity (image density being proportional to exposure length) breaks down with very high levels of light and very short exposures, usually less than a millisecond. This rarely applies to astrophotography or general photography.

HIP (number) The Hipparcos Catalogue running number, a number assigned to stars in order of right ascension as derived by Hipparcos observations. The HIP number is a common way of naming stars.

Hipparcos Acronym for High Precision PARallax COllecting Satellite, a satellite of the European Space Agency devoted to precision astrometry. It was named for the Greek astronomer Hipparchus of Nicaea (c. 190-120 BC), founder of trigonometry and discoverer of the precession of the equinoxes. The Hipparcos Catalogue, a high-precision listing of 118, 200 stars was published in 1997. The lower-precision Tycho Catalogue based on Hipparcos contains more than a million stars, and the Tycho-2 Catalogue contains 2.5 million stars.

HOS Palette A color palette system for a color image produced by combining monochromatic images taken with Ha, O-III, and S-II filters where Ha is assigned to red, O-III is assigned to green, and S-II is assigned to blue.

HST Hubble Space Telescope.

Hubble Palette or Hubble Colors A color palette system for a color image produced by combining monochromatic images taken with S-II, Ha, and O-III filter where S-II is assigned to red, Ha is assigned to green, and O-III is assigned to blue.

Hypersensitization (of film) A method of increasing the sensitivity of a photographic emulsion on a roll of film or glass plate by baking the film or plate in nitrogen or hydrogen gas or exposing it to a low temperature. These processes often increased film sensitivity by reducing low light level reciprocity failure.

Hypo (see fixator) A solution to give permanence to the developed image on a plate or print once it has been removed from the developing solution and washed. A photographic plate that has been exposed, developed, and washed will show an image, but that image quickly fades with time. Plate fixation was introduced by John Herschel in 1839 when he proposed sodium hyposulfite (hypo) as a fixating agent.

IAU International Astronomical Union.

IC Index Catalogue of Nebulae and Clusters of Stars A catalog published by John Louis Emil Draper (1852-1926) in 1895 and 1908 as a two-part update of his original *New General Catalogue of Nebulae and Star Clusters (NGC)* published in 1888. NGC and IC are the standard references used by astronomers worldwide.

ICRF International Celestial Reference Frame. See Gaia Early Data Release 3: 2204.12574.pdf (arxiv.org)

ICRS International Celestial Reference System. See Gaia Early Data Release 3: 2204.12574.pdf (arxiv.org)

(astronomical) Interferometer [telescope array] Using a set of separate telescopes, either optical telescopes or radio telescopes, working together as a single telescope to provide higher resolution images.

IPAC Infrared Processing and Analysis Center (JPL/Caltech): https://www.ipac.caltech.edu/

IRAM Institut de Radioastronomie Millimetrique, an international research institute for radio astronomy: https://www.iram-institute.org/

IRAS Infrared Astronomical Satellite, the first mission to put a telescope in space to survey the sky in infrared. IRAS detected about 350,000 infrared sources. "IRAS was a technical and scientific precursor to future infrared space missions including the Spitzer Space Telescope, James Webb Space Telescope, the Infrared Space Observatory, and the Herschel observatory" (https://www.jpl.nasa.gov/missions/infrared-astronomical-satellite-iras).

IRDC Infrared dark cloud, a cold dense region of a giant molecular cloud made visible against bright diffuse mid-infrared radiation from the plane of the Milky Way.

ISM Local interstellar medium.

ISO International Organization for Standardization. ISO is a **network** of the national standards institutes of **165 countries**, one member per country, with a Central Secretariat in Geneva, Switzerland, that coordinates the system [see **http://www.iso.org/iso/about.htm**.]. ISO also refers to a camera setting which adjusts the relative sensitivity of the camera. It is also a number that corresponds to the relative sensitivity of a photographic film or plate, the higher the number the greater the sensitivity.

JPEG (JPG) Joint Photographic Expert's Group. A method for lossy (loss of some data) compression of digital images. The degree of compression can be adjusted for a tradeoff between image size and image quality. File extension: .jpg

Johnson-Morgan system The UBV (Ultraviolet, Blue, Visual) photometric system introduced in the 1950's by Harold Lester Johnson (1921-1980) and William

Wilson Morgan (1906-1994). William James Cousins (1903-2001) and others suggested a system for adding R (Red) and I (near-infrared) to the original UBV system. The latter is now known as the UBVRI system.

Julian year and J2000 A Julian year is the mean length of a year in the Julian calendar, 365.25 days. J2000 refers to 12 noon on January 1, 2000. The International Astronomical Union (IAU) decided in 1976 that a new standard epoch of J2000.0 should be used starting in 1984.

JWST James Webb Space Telescope.

LAC or Lacaille Nonstellar object noted by Nicholas Louis de Lacaille (1713-1762).

Lanes See dark lanes.

Lantern lens A lens used to project an image from a "magic lantern," the forerunner of the slide projector. At first a bright candle was enclosed in small box with a lens (the lantern lens) used to project the image from a transparency between the candle and the lens onto a wall or a screen for audience viewing. Later arc lamps and eventually electric bulbs replaced the candle. The lantern lens used by Barnard for his astrophotography had a diameter of 1 ½ inches and a 5.3-inch focal length.

Lantern slide (magic lantern slide) Positive transparent photographs made on glass and viewed with a magic lantern, an early form of a slide projector.

Large Magellanic Cloud (LMC) A satellite galaxy of the Milky Way at approximately 50 kiloparsecs (160,000 light years) distance. It is best viewed in the Southern Hemisphere.

LBN Lynds bright nebula from *Lynds Catalogue of Bright Nebulae*.

LCO Las Cumbres Observatory: https://lco.global/observatory/

LDN Lynds dark nebula from *Lynds Catalogue of Dark Nebulae*.

LEDA The Lyon-Meudon Extragalactic Database. A database of galaxies created in 1983 at the Lyon Observatory. This evolved into the Catalogue of Principal Galaxies (PGC) published in 1989. It later became HyperLEDA or PGC2003 containing information on over 3 million objects, 1 million are galaxies.

LENR Long exposure noise reduction, a feature in many digital cameras designed to automatically subtract a dark frame from an exposure frame to reduce noise.

Light Pollution A pervasive glow in the night sky dimming faint stars and celestial objects. It is caused by artificial nighttime lighting and is a significant problem in most urban and suburban regions of the world.

Light Trespass Light shining where it is not wanted, such as a neighbor's floodlight shining in your bedroom window.

Light Year The distance light traveling through a vacuum covers in a year, approximately 9.46 trillion kilometers or 5.88 trillion miles.

LIRF Low intensity reciprocity failure.

Lithograph A printing process in which a design or image is drawn onto a flat prepared stone or metal plate and affixed with ink onto paper from the stone or metal plate.

Local Bubble All young stars and star-forming regions within 500 light years of the Earth sit on the surface of a giant 1000 light year wide bubble, probably

formed by a series of supernovae that went off ~ 14 million years ago pushing interstellar gas outward and forming a "bubble," the surface of which is ideal for star formation.

Local Interstellar Cloud (LIC) or Local Fluff Interstellar cloud roughly 30 light years in diameter through which the Sun is currently moving. The LIC is located inside the Local Bubble.

LSST See Vera Rubin Observatory.

Luminance The intensity of light emitted from a surface per unit area in a given direction, often measured in candela per square meter (cd/m^2) when discussing ordinary lighting applications. With respect to the darkness of the night sky luminance is stated in magnitude per square arcsecond.

Luminosity The amount of energy emitted by a star.

Magnitude The astronomical term for star brightness. In 1856 Norman R Pogson (1829-1891) of Oxford proposed the modern system of magnitudes in which five magnitude steps correspond to an exact difference in brightness of a factor of 100. Each magnitude is ~2.512 times dimmer than the preceding magnitude. Very bright objects, such as the Sun (-26.8), the full Moon (-12.6), Venus (-4.9), Jupiter (-2.64), and Sirius (-1.46) have negative magnitudes. The first magnitude stars range from Sirius to Regulus (magnitude 1.35). The second magnitude stars range from 1.51 to 2.5 magnitude and so forth.

Main Sequence The grouping of most stars on the Hertzsprung-Russell diagram. It extends diagonally from at top very hot, very luminous giant stars to very cool, dwarf stars at the bottom. Stars on the main sequence have nuclear fusion of hydrogen into helium.

Maser (microwave amplification by stimulated emission of radiation) In astronomy a naturally occurring source of stimulated spectral line emission in the microwave portion of the electromagnetic spectrum. Masers occur in molecular clouds and other astronomical phenomena.

MASH The Macquire/AAO/Strasburg Hα Planetary Nebula Catalogue.

MATLAS Mass Assembly of early-Type GaLAxies with their fine Structures. See: MATLAS – a deep imaging survey of massive galaxies and their surroundings (unistra.fr)

MCG Morphological Catalogue of Galaxies.

MeerKAT A South African radio telescope which is stated to be a precursor to the Square Kilometre Array (SKA) telescope: https://www.sarao.ac.za/gallery/meerkat/

Messier Object French Comet hunter Charles Messier (1730-1817) compiled a list of 103 bright celestial objects that at first look resembled comets but were fixed celestial objects. Most of the brightest star clusters, nebulae, and galaxies are Messier objects and are listed as M1 to M103. Another seven were added to the list in modern times as they were described by Messier in his writings but not on his published list.

Metallicity In astronomy the abundance of elements present in a star of elements heavier than hydrogen and helium. If a star has more "metals" relative to their abundance in the Sun, the star is said to be metal rich.

Meteor (Falling Star or Shooting Star) The visible passage of small piece of rock or dust from outer space as it heats up and vaporizes while traveling through the atmosphere. If it survives to reach the ground, it is a **meteorite.**

Meteorite A meteor that has reached the ground.

Meteor Shower A series of meteors that radiate from a localized area of the sky. A meteor shower is named after the constellation in which its radiant is located. Famous meteor showers include the Perseids in August, the Leonids in November, and the Geminids in December.

Micrometer Also called a micron, it is an SI unit of linear measurement equal to one millionth of a meter (10^{-6} m) symbolized by μm.

Milky Way Our parent galaxy. When we look toward the Milky Way, we are seeing our parent galaxy on edge, viewing thousands of stars seemingly piled on top of one another, thus giving the illusion of milk spilled (*via lactea* in Latin) across the sky.

Minor Planet Another name for an asteroid.

MNRAS *Monthly Notices of the Royal Astronomical Society,* one of the world's leading astronomical journals used frequently by Barnard for his publications.

Molecular cloud A dark nebular region containing molecular hydrogen H_2 and internal dust grains. Giant molecular clouds contain more than one million solar masses and can be as large 150 light years in diameter.

Morgan Keenan Kellman (MK or MKK) system A system of classifying stellar spectra. It was developed at Yerkes Observatory by WW Morgan (1906-1994), Philip Childs Keenan (1908-2000), and Edith Marie Kellman (1911-2007) and first published in 1943.

Mount Wilson Catalogue of Photographic Magnitudes in Selected Areas (MWC) A photographic catalog that was a leading reference for celestial photometry in the first half of the 20th century.

Nanometer (nm) Nanometer (10^{-9} m) is commonly used to express wavelengths of the visible portion of the electromagnetic spectrum.

NASA National Aeronautics and Space Administration: NASA

Nebula A region of indistinctness brighter than the background sky. In Barnard's time nebular regions could represent any poorly defined region, either from an actual "nebula" of gas and dust or from a galaxy which until the middle third of the 20th century was not recognized as a separate "island universe" analogous to the Milky Way. There are multiple overlapping categories of nebulae, including bright nebulae, emission nebulae, reflection nebulae, planetary nebulae, and dark nebulae.

NED Extragalactic Database, "…a master list of extragalactic objects for which cross-identification of names have been established, accurate positions and redshifts entered to the extent possible, and some basic data collected" (NASA: https://science.nasa.gov/astrophysics/astrophysics-data-centers/nasa-ipac-extragalactic-database-ned)

Neutron star Very dense star composed almost entirely of neutrons, presumably the result of a supernova collapse of a massive star.

NGC *New General Catalogue of Nebulae and Clusters, Being the Catalogue of Sir John Herschel, Revised, Corrected and Enlarged*, more commonly known as the New General Catalogue or NGC. It was compiled from published work of John Herschel (1792-1871) and others by John Louis Emil Draper (1852-1926) and first published in 1888. The catalog as originally published contained the positions and descriptions of 7,840 objects for the epoch 1860. Draper later added two supplements, the *Index Catalogs (IC)* in 1895 and 1908. The NGC has been somewhat updated and revised many times by several authors, but it and the IC remain the standard reference for astronomers worldwide.

ngVLA Next generation Very Large Array: https://ngvla.nrao.edu/

NIR Near infrared. A subdivision of the infrared portion of the electromagnetic spectrum with wavelength (λ) 700-1400 nm.

NOIRLab United States National Science Foundation (NSF) NOIRLab was formally named the National Optical-Infrared Astronomy Research Laboratory. It is the US national center for ground based nighttime optical and infrared astronomy: https://noirlab.edu/public/about/

Nova A "new" star that appears where none was visible previously or a known star that flares in brightness for some while before returning to its original brightness.

NRAO National Radio Astronomy Observatory of the United States.

NSF National Science Foundation of the United States.

NSV New Catalogue of Suspected Variable Stars: www.sai.msu.su/groups/cluster/gcvs/gcvs/nsv/readme

OB star, OB association Hot massive stars of spectral type O or type B that form in a loose group known as an OB association. Such stars are short lived and emit much ultraviolet radiation which ionizes surrounding interstellar gas forming an HII region.

O-III Doubly ionized oxygen which emits light at 502 nm.

O3 star O stars are large, very hot blue-white giant stars with temperatures in excess of 30,000 Kelvin. They are rare but amongst the brightest stars. O-type stars are classified by the strength of certain spectral lines. O3 is one of several luminosity classes of O stars.

Orthochromatic film A black and white film sensitive not only to ultraviolet and blue light but also having sensitivity to green and orange. Orthochromatic film is not sensitive to red wavelengths and can be developed in the dark room with a low-level red safety light making it easier for a darkroom worker to watch a plate or print being developed and to control darkroom processing.

PAH Polycyclic aromatic hydrocarbon, a subclass of polycyclic organic matter (POM), a broad class of compounds generally including organic structures with three or more fused aromatic (benzene) rings. POMS can contain oxygen, nitrogen, and sulfur in addition to carbon and hydrogen. PAHs contain only carbon and hydrogen and have two or more aromatic rings. Several PAHs have been found in the interstellar medium.

Palomar Sky Survey (National Geographic Society-Palomar Sky Survey) (NGS-POSS) A photographic survey of the entire sky visible from Mount Palomar Observatory in Southern California. The First Palomar Sky Survey

(POSS I) was completed in 1958 and was followed later by a second extensive survey from Mount Palomar as well as a Southern Sky Survey from Siding Springs Observatory in Australia.

Panchromatic film A black and white film sensitive to most of the visible light spectrum from blue to red producing more natural and accurate landscape images and potentially more accurate astronomical images. Panchromatic film can only be developed in a totally light free environment.

Parallax The apparent change in position of a foreground object against a distant background when one changes position. Distances to nearby stars are measured by noting the angular shift in arcseconds of a star's position against background more distant stars as the Earth orbits around the Sun.

Parsec A unit of length used by professional astronomers for large distances. It is the distance at which a star would show a parallax shift of one arcsecond (1") as observed from the Earth's orbit. It represents 3.26 light years.

PASJ *Publications of the Astronomical Society of Japan.*

PASP *Publications of the Astronomical Society of the Pacific*, monthly peer-reviewed scientific journal owned by the Astronomical Society of the Pacific (ASP).

PDF Portable Document Format developed by Adobe in 1992 as a file format for text and images that is independent of application software.

Perseus Molecular Cloud (Perseus Dark Cloud) A roughly 12^0 x 12^0 area mainly in Perseus that contains the Perseus OB2 Association, a loosely organized group of mainly young, hot OB stars moving together. It is the most active star forming region within 1000 light years of the Sun.

Petzval (doublet) lens The first photographic portrait objective lens. It was developed by Joseph Petzval (1807-1891) in 1840. It was the first lens designed based on optical laws and consisted of a front doublet lens separated by a back doublet lens with an aperture stop in between. The first Petzval lenses were built by the Voigtlander company and were widely used as "portrait" lens as they could be made with large apertures and focal lengths as short as f/3.6.

PGC Catalogue of Principal Galaxies. See also LEDA.

Photoelectric photometry (PEP) The use of a photoelectric photometer containing a photomultiplier tube to measure stellar magnitudes. When photomultiplier tubes became widespread after World War II, Harold Lester Johnson (1921-1980), William James Cousins (1903-2001), Gerald Kron (1913-2021) and others used them to establish the photometric standards used today.

Photoengraving A photomechanical process in which a photo-resistant substance is applied to a surface to be engraved. This creates a mask that protects some areas during a subsequent process which etches and dissolves some of the surface from the areas that were free of the photo-resistant substance. Photoengraving can be applied to metals, glass, or plastic surfaces.

(Photographic) Negative An image with the ordinary black and white relationships reversed. All astronomical photographic plates produce a "negative" image with black stars and a white sky background. The term negative is more commonly used for negative images on a roll of black and white film after its development.

(Photographic) Positive An image with normal black and white relationships as opposed to a photographic negative.

(Photographic) Print An everyday image printed on photographic paper.

Photoheliograph A solar telescope designed to observe and photograph the Sun in a particular wavelength of light.

Photometry (astronomy) The measurement of the flux or intensity of light from an astronomical object, typically that of a star.

Photomultiplier An instrument containing a photomultiplier tube (PMT) which consists of a photosensitive cathode, several dynodes which increase signal detection, and a collecting anode. Electrons are emitted off the cathode in relation to the light striking it. The number of electrons is amplified by the dynodes, and they are collected at the anode which reads out an electrical signal that can be converted to a measurement of the light signal striking the cathode. Photomultiplier tubes are the essential part of photoelectric photometers which are used for precise measurement of stellar magnitudes.

Planck Space Telescope Europe's first mission to study the cosmic microwave background. It was launched in 2009, and its mission ended October 23, 2013. See: https://www.esa.int/Enabling_Support/Operations/Planck

Planetary Nebula (PN, PNe pleural) A shell of gas surrounding a small star. The gas is illuminated by the star and is given off by star near the end of its active nuclear life. The gas has a variety of shapes and colors and often has an appearance suggesting a planet, though a planetary nebula and stellar planet have no relation to each other.

Plate. Photographic plate A transparent glass or sometimes plastic plate coated with photographic emulsion. See also the discussion for film.

PMT Photomultiplier tube.

Popular Astronomy An American magazine published from 1893 to 1951. Barnard often published review articles in this journal which was read by both professional and amateur astronomers.

Portrait lens Any lens that has the right combination of focal length and aperture to take exceptional portrait photographs. They usually have a focal length of 70-135 mm with maximum aperture for low light level and shallow depth of field to blur the background.

POSS Palomar Sky Survey.

PRIMOS The Prebiotic Interstellar Molecular Survey, a Green Bank Observatory (GBO) Large Program that was conducted from 2007-2011. PRIMOS targeted Sgr B2(N), a star-forming region toward the galactic center, a chemically rich source of molecular species. PRIMOS was used in the detection of nearly a dozen new molecular species.

Proper Motion The angle motion of a star or other celestial object against background more distant stars.

Pulsar A rapidly rotating neutron star emitting a pulsating radio signal.

QE Quantum efficiency.

Quantum efficiency (QE) Regarding CCD or CMOS imaging the ratio between the number of charges produced compared to the number of photons striking the

imaging chip. It is often measured over a range of wavelengths of light to characterize an imaging device's sensitivity.

Radcliffe Wave A narrow 2.7 kiloparsec area of dense gas in the Solar neighborhood that contains molecular clouds thought to be part of Gould's Belt. The Radcliffe Wave is purposed to contain most of the nearby star-forming regions. It is named after the Radcliffe Institute for Advanced Study at Harvard University where its proponents did their research.

RAS Royal Astronomical Society: https://ras.ac.uk/

RASC Royal Astronomical Society of Canada, the main amateur astronomy organization in Canada: https://www.rasc.ca/

Raw image file or format The proprietary native image file produced by a digital camera. It contains minimally processed data and is usually processed and converted into a standard file format, such as FITS, JPG, or TIFF.

RSA Revised Shapley-Ames Catalog by Sandage and Tammann.

RC3 *Third Reference Catalogue of Bright Galaxies* by G de Vacouleurs, A de Vacouleurs, HG Corwin, RJ Buta, P Fouque, and G Paturel, Springer-Verlag, 1991. See: https://heasarc.gsfc.nasa.gov/W3Browse/all/rc3.html

Read out (Read) noise Noise that is created within a digital camera during the readout process as the electrons produced by photons striking the imaging chip are subjected to analog to digital conversion.

Reciprocity failure Usually refers to low light (low intensity) reciprocity failure a significant issue for astronomical photography in those situations where long exposures (minutes to hours) are required for faint astronomical objects. Most photographic emulsions become less and less sensitive as the exposure is lengthened reaching a point beyond which further exposure is not warranted.

Recombination (physics) A combining of charges or transfer of electrons in a gas that neutralizes ions such as a proton capturing an electron to become a neutral hydrogen atom H.

Reflection Nebula See bright nebula.

Rich field telescope A short focal length (f4 or less) telescope, typically 4-6 inches in diameter whether reflector or refractor, providing a wide-field (one degree or more) view of the sky for observing nebulae and star clusters while sweeping through the Milky Way.

Right Ascension α The equivalent of longitude in the celestial coordinate system. Declination is the equivalent of latitude in the celestial coordinate system.

ROSAT The Roentgen Satellite, a German/United States/United Kingdom X-ray satellite launched June 1, 1990 and operating until February 12, 1999.

Rosetta A space probe built by the European Space Agency launched in 2004. It produced a detailed study of 67/P Churyumov-Gerasimenko in 2014 with its lander Philae being the first successful probe to land on a comet.

Rosette Nebula A large cloud of dust, gas, and stars in Monoceros extending more than one degree across. Its parts have been assigned different NGC numbers, including NGC 2237, 2238, 2239, 2246, as well as open cluster NGC 2244 which is in the central part of the Rosette Nebula.

Sagittarius A (SgrA*) A complex radio source almost exactly at the center of the Milky Way. It is located 8 kiloparsecs (26,000 light years) away and is probably a 3-4 million solar mass black hole.

SAO *Smithsonian Astrophysical Observatory Star Catalog*, a whole sky catalog published by the Smithsonian Astrophysical Observatory in 1966 and revised and updated several times since then. It compiles the positions and proper motions of 258, 977 stars down to a limiting magnitude of 9.

Schmidt camera or telescope A catadioptric optical system (reflection and refraction elements are combined in the same system) introduced by Bernhard Schmidt (1879-1935) in 1930. It has a front corrector lens which sends light to a back spherical mirror that reflects the light onto a curved photographic or digital imaging plate. This system produces wide field images with limited distortion.

SDSS Sloan Digital Sky Survey. 1SDSS. Sloan Digital Sky Survey, 1st release. https://www.sdss.org/

SEDS Students for the Exploration and Development of Space, "…an international student organization whose purpose is to promote space exploration and development through educational and engineering projects." SEDS has many astronomical references and links. See: SEDS USA

Seeing An astronomical term describing the steadiness of the atmosphere. This depends on many factors including one's location and the local weather. Good seeing represents a steady atmosphere enabling easier telescopic viewing or imaging of small details. When the seeing is especially poor, even the best telescope may show the Moon and planets as nothing more than blurry blobs. When the seeing is exceptionally good, even a mediocre telescope may show especially good detail on the Moon and planets.

Sh 2 or SH 2 A catalogue of 313 HII regions north of declination -27 degrees complied by Stewart Sharpless (1926-2013) and published in 1959 as an update and addition to his earlier catalog of 1953 of 142 objects.

SHO The SHO Hubble Palette. A color palette system for a color image produced by combining monochromatic images taken with S-II, Ha, and O-III filters where S-II is assigned to red, Ha is assigned to green, and O-III is assigned to blue. This is frequently used for color rendition of Hubble Space Telescope images.

S-II Singly ionized sulfur which emits light at 673 nm.

SI The International System of Units, the modern form of the metric system, and the world's most widely used system of measurement. See: https://www.bipm. org/en/

SIMBAD (Set of identification Measurements and Bibliography for Astronomical Data) A reference database for identification and bibliographic reference for astronomical objects. See: https://simbad.u-strasbg.fr/simbad/

Single lens reflex camera (SLR) A camera using a mirror and prism system that allows the photographer to view through the lens and see what will be captured on the photograph. The mirror typically flips out of the light path when the exposure button is pressed.

SKA Square Kilometre Array project, an international effort to build the world's largest radio telescope with over one square kilometer of collecting space: https://www.skatelescope.org/the-ska-project/

SMA Submillimeter Array. An 8-element radio interferometer located near the summit of Maunakea (Mauna Kea) in Hawaii: https://lweb.cfa.harvard.edu/sma/

Small Magellanic Cloud (SMC) A dwarf irregular satellite galaxy of the Milky Way. It lies at a distance of 200,000 light years and is best viewed from the Southern Hemisphere.

SOFIA Stratospheric Observatory for Infrared Astronomy: https://www.sofia.usra.edu/

Spectral Classification See Stellar (Spectral) Classification.

Spectrum The range of "color" [different wavelengths] of light spread out along a continuum from short to longer wavelength as shown by the light passing through a prism or diffraction grating [a hard surface with multiple thin linear grooves engraved upon it to reflect light of differing wavelengths in slightly different directions].

Spectroscopy The observation or photography of light from an object to determine its composition, temperature, density, and possibly speed of approach or retreat of a celestial body from the Earth.

Spectroheliograph Instrument designed to capture a photographic image of the Sun at a single wavelength of light.

Spitzer Space Telescope, formerly Space Infrared Telescope (SIRTF) An infrared space telescope launched in 2003 with operations ending January 30, 2020. See: https://www.spitzer.caltech.edu/mission/the-solar-panel-assembly/

SQM Sky Quality Meter. An instrument to measure the luminance of the night sky using the unit of magnitudes per square arcsecond favored by professional astronomers.

SRC United Kingdom Research Council

SRC-J Survey The southern sky survey analogous to the Palomar Sky Survey (POSS) of the northern sky using Kodak IIIa-J plates with the 1.24 UK Schmidt Telescope at Siding Springs Observatory, New South Wales, Australia.

SSC Singled shot color camera.

SSO Siding Springs Observatory, New South Wales, Australia now part of the **Anglo-Australian Observatory (AAO).**

Star Large collection of gas which has enough mass to contract upon itself generating intense internal temperatures through nuclear reactions which heat up the gas further until it emits large amounts of radiation, mostly in the visible portion of the electromagnetic spectrum. The Sun is the nearest star. Stars are distant suns.

Star cloud A large grouping of stars within a galaxy sometimes containing individual star clusters within them.

Star Cluster A collection of stars which are usually gravitationally bound to each other and traveling through space together. The Pleiades are an example of a bright loose collection of stars known as an open cluster. **Open clusters** contain a few hundred to a few thousand stars. **Globular clusters** are very compact collections of hundreds of thousands of stars.

Stellar (Spectral) Classification Classification of stars based on their spectral characteristics. Since stars can be considered black bodies, their spectral characteristics mainly represent their temperature. The most common classification is

the Morgan Keenan Kellman (MK) system using the letters O, B, A, F, G, K, and M, from the hottest (O) to the coolest (M). O, B, and A stars are blue to white with temperatures from 30,000 K to 10,000 K. F and G stars are yellow white to yellow with temperatures 7,500 to 5,000 K. The Sun is a G star. K and M stars are orange to red with temperatures of 5200 to 2200 K. O, B, and A stars are more massive than the Sun. F and G stars have masses similar to the Sun, and K and M stars are less massive than the Sun.

Stratum (of the Milky Way) The myriad of stars making up the wash of light or milky stream in the Milky Way.

STScI Space Telescope Science Institute. See: STScI Home

SuperCosmos An advanced photographic plate digitizing machine used to systematically digitize sky survey plates taken with the UK Schmidt telescope (UKST), the ESO Schmidt telescope, and the Palomar Schmidt telescope. This data (SuperCosmos Sky Surveys [SSS]) is publicly available. See: http://www-wfau.roe.ac.uk/sss/index.html

Supernova A cataclysmic "explosion" of a massive star at the end of its life as it exhausts its nuclear fuel. The radiation given off by a supernova lasts days to weeks at its maximum and can exceed the energy output from the rest of the stars in its parent galaxy during this interval.

Supernova Remnant (SNR) The expanding shell of gas ejected at high speed during a supernova explosion. These remnants often form visible diffuse gaseous nebulae.

TESS Transiting Exoplanet Survey Satellite. A NASA satellite launched April 18, 2018, aboard a SpaceX Falcon 9 rocket to look for exoplanets transiting their parent stars: https://www.nasa.gov/tess-transiting-exoplanet-survey-satellite

TIFF (TIF) Tag Image File Format. An image file format for raster graphic computer images or digital camera images. A raster graphic is a two-dimensional image consisting of a rectangular matrix or grid of square pixels (picture elements). Filename extensions: .tiff .tif

Transient Name Server (TNS) The official International Astronomical Union (IAU) mechanism for reporting new astronomical transients (Ats) such as supernova candidates.

T Tauri stars A type of variable star named after T-Tauri, a young star in the Taurus star forming region. These stars are less than 10 million years old and are in the earliest stage of star formation. They have less than 3 solar masses are often binary and have circumstellar disks which may lead to planet formation.

TTS T Tauri stars.

Twilight After sunset, there is a period in which the sky gradually darkens, and before sunrise there is a period of time during which the sky gradually brightens. *Twilight*, the time between day and night, is caused by scattered sunlight in the atmosphere which illuminates the sky and the ground when the Sun is not far below the horizon. *Civil Twilight* is the time when the center of the Sun's disk is less than 6^0 below the horizon. During this time, the brightest stars and planets appear. At *Nautical Twilight* the Sun is between 6^0 and 12^0 below the horizon. Prior to modern electronic equipment, sailors used this time for reliable sightings

of well-known stars for navigation. *Astronomical Twilight* takes place when the center of the Sun is more than 12^0 and less than 18^0 below the horizon. The sky appears nearly fully dark, but very faint objects may still be hidden by the dim sunlight in the atmosphere.

Tycho Catalogue See Hipparcos.

UBV, UBVRI The UBV (Ultraviolet, Blue, Visual) photometric system introduced in the 1950's by Harold Lester Johnson (1921-1980) and William Wilson Morgan (1906-1994). William James Cousins (1903-2001) and others suggested a system for adding R (Red) and I (near-infrared) to the original UBV system. The latter is now known as the UBVRI system.

UKST United Kingdom Schmidt Telescope, a 1.24 meter Schmidt telescope with Schmidt camera at Siding Springs Observatory in Australia.

Ultraviolet Electromagnetic radiation at wavelengths shorter than the violet deep blue portion of the visible light spectrum. The astronomical photographic plates used during Barnard's lifetime were most sensitive to blue and ultraviolet light. Even though the atmosphere effectively blocks transmission of most ultraviolet light, some does reach Earth from hot, energetic stars emitting intense radiation from the ultraviolet and blue portion of the visible spectrum making such stars and associated nebular regions appear brighter on photographic plates than they appear to visible observation through a telescope.

VizieR A sophisticated search engine provided by the Strasbourg astronomical Data Center: https://vizier.u-strasbg.fr/index.gml

Voigtlander lens Any lens made by the Voigtlander lens and camera manufacturing company of Austria. It existed from 1756 to 1972 and produced the first Petzval lens for portrait photography starting in 1840.

Wet-plate (collodion) photography An early (1850's-1880's) photographic process where wet photographic emulsion was coated on glass plates, sensitized, exposed, and developed in a short several minute time. It required access to a darkroom for plate preparation and immediate plate development after exposure.

WHIM Warm-hot intergalactic medium between galaxies.

White Dwarf star A stellar core remnant composed of electron-degenerate matter thought to be the final evolutionary state of stars whose mass is not high enough to form a neutron star or black hole.

WISE Wide-field Infrared Survey Explorer. WISE was launched in 2009 and is repeatedly mapping the entire sky in infrared light (https://www.jpl.nasa.gov/missions/wide-field-infrared-survey-explorer-wise).

Wolf-Rayet stars (WR stars) Stars with unusual spectra showing prominent broad emission lines of ionized helium and highly ionized nitrogen or carbon on an otherwise continuous spectrum. They are depleted of hydrogen and have extremely high surface temperatures from 20,000-210,000 Kelvin. Wolf-Rayet stars differ from spectral class O stars of a similar temperature by having their strong emission lines as opposed to most O stars, although there are many stars with mixed spectral features of Wolf-Rayet and O stars. The first three Wolf-Rayet stars were discovered at the Paris Observatory in 1867 by Charles Wolf (1827-1918) and Georges Rayet (1839-1906).

Varnish (the negative) Application of a sealing liquid to a glass plate negative. When the liquid dries, it forms a hermetical seal that preserves the plate emulsion from atmospheric deterioration for several decades.

VERA VLBI Exploration of Radio Astrometry.

Vera C Rubin Observatory (VRO), formerly Large Synoptic Survey Telescope (LSST) A wide-field 8.4-meter reflecting telescope that will image the entire sky every few nights. See: https://www.lsst.org/

Visible light That portion of the electromagnetic spectrum visible to the human eye.

VLBA Very Long Base Line Array. A system of radio telescopes operated remotely from an operations center in Socorro, New Mexico. The array operating as one large radio telescope allows significantly greater resolution and sensitivity than a single radio telescope.

VLBI Very Long Baseline Interferometry. Interferometry used in radio astronomy. Individual radio telescopes may be arrayed across a continent or even across a hemisphere.

VLT Very Large Telescope. ESO observatory in Cerro Paranal, Chile.

VSX International Variable Star Index (VSX) VSX : About (aavso.org)

WDS The Washington Double Star Catalog, a catalog maintained by the United States Naval Observatory, "...is the world's principal database of astronomic double and multiple star formation": Washington Double Star Catalog - Current Version (gsu.edu)

Wolf Diagram A graph of star counts at various apparent magnitudes plotted for a dark nebula and for a companion field on the same graph. Max Wolf used the magnitude at which the counts started to diverge to calculate the distance at which the obscuring dark matter started.

XMM-Newton The European Space Agency X-ray Multi-Mirror Mission launched on December 10, 1999: https://www.cosmos.esa.int/web/xmm-newton

YSO Young stellar object, a star in its early stage of formation.

Zodiacal Band A portion of the zodiacal light that extends as a band in the center of the zodiacal light from one horizon to the next and is visible only in the darkest of skies.

Zodiacal Light Large, faint cone of light visible in the east prior to sunrise or in the west after sunset. It is caused by sunlight reflecting off tiny dust grains and ice particles in the plane of the Solar System.

ZTF Zwicky Transient Facility, a survey of the entire northern sky every two days using a wide field of view to look for transient events like supernovae: Zwicky Transient Facility Website (caltech.edu)

References

Cosmos. The SAO Encyclopedia of Astronomy.

Freedman RA, Kaufmann WJ III. Universe. 6th ed. New York: W.H, Freeman and Company; 2002.

Gear F.. A glossary of astronomical terms or what every student of astronomy should know. AstroGlossary1.pdf (eagleseye.me.uk).

Lodriguss J. AstroPix (2021). Glossary: Glossary (astropix.com).

Sea and Sky Astronomy Reference Guide.: http://www.seasky.org/astronomy/astronomy-glossary.html#A.

Seeds MA. Foundations of Astronomy. 7th ed. Pacific Grove: Thomson. Brooks/Cole; 2003.

Sky & Telescope Astronomy Terms.: https://skyandtelescope.org/astronomy-terms/.

Swinburne University. Cosmos – The SAO Encyclopedia of Astronomy: https://astronomy.swin.edu.au/cosmos/.

timeandate.com.: https://www.timeanddate.com/astronomy/explanation-terms.html.

Wikipedia – Glossary of astronomy.: https://en.wikipedia.org/wiki/Glossary_of_astronomy.

General Bibliography

APASS. American Association of Variable Star Observers (AAVSO) all sky photometric survey: APASS: The AAVSO Photometric All-Sky Survey | aavso.

APPLAUSE, Archives of Photographic PLates for Astronomical USE: https://www.plate-archive.org/applause/.

Ashbrook J. In: Robinson LJ, editor. The Astronomical Scrapbook. Cambridge, MA/Cambridge, UK: Sky Publishing Corporation/Cambridge University Press; 1984.

© The Editor(s) (if applicable) and The Author(s), under exclusive license to Springer Nature Switzerland AG 2023
T. B. Hunter et al., *The Barnard Objects: Then and Now*, The Patrick Moore Practical Astronomy Series, https://doi.org/10.1007/978-3-031-31485-8

Astronomy Mark. The Hubble Palette: http://www.astronomymark.com/hubble_palette. htm.

Barnard EE. Photographs of the Milky Way and Comets. Publ Lick Observatory. 1913;11

Barnard EE. On the dark markings of the sky with a catalogue of 182 such objects. Astrophys J. 1919;XLIX(#1):1–28.

Barnard EE. In: Frost EB, Calvert MR, editors. A Photographic atlas of selected regions of the Milky Way. Washington: Carnegie Institution of Washington; 1927. Online Version at Georgia Institute of Technology: Barnard's Photographic Atlas of Selected Regions of the Milky Way (gatech.edu).

Barnard EE. A Photographic Atlas of Selected Regions of the Milky Way. In: Edwin B Frost, Mary R Calvert, editors, reprinted under the direction of Gerald Orin Dobek. Cambridge: Cambridge University Press; 2011.

Belkora L. Minding the heavens. The story of our discovery of the milky way. Philadelphia, Bristol: Institute of Physics Publishing; 2003.

Bessell MS. Standard photometric systems. Australian National University: araapa-per_rev.dvi (anu.edu.au)

Bessell MS. UBVRI photometry II. The cousins VRI system, its temperature and absolute flux calibration, and relevance for two-dimensional photometry. Publ Astron Soc Pac. 1979;91(#543):589–607.

Bessell M. Standard photometric systems. Annu Rev Astron Astrophys. 2005;11(43):293–336. https://doi.org/10.1146/annurev.astro.41.082801.100251.

Bortle JE. Gauging Light Pollution: The Bortle Dark-Sky Scale. Sky Telescope, July 18, 2008: https://skyandtelescope.org/astronomy-resources/light-pollution-and-astronomy-the-bortle-dark-sky-scale/

California Institute of Technology. National Geographic Society Palomar Observatory Sky Atlas (PDF), 1954.

Carpenter EF, Jepperson R. Color photography of faint objects with special fast film. Astron J. 1959;64:49–50.

CDS (Centre de Donnees astronomiques de Strasbourg, Strasbourg astronomical Data Center): https://cdsweb.u-strasbg.fr/

Clark R. ClarkVision.com: Astrophotography, Color and Critics Clarkvision.com

Cooke A. Dark nebulae, dark lanes, and dust belts. New York: Springer; 2012.

DSLR Astrophotography. Getting the colors right in your astrophotos. October 30, 2016: Getting the colors right in your astrophotos I DSLR Astrophotography (dslr-astrophotography.com)

ESO online Digitized Sky Survey. https://archive.eso.org/dss/dss

Flanders T. Astronomy, hiking, and travel. Urban and suburban stargazing. Surface brightness. 2017. https://tonyflanders.wordpress.com/surface-brightness/.

Frommert H. The Interactive NGC Catalog Online: The Interactive NGC Catalog Online (seds.org).

Franks WS. Visual observations of dark nebulae. Mon Not R Astron Soc. 1930;90:326–9.

Frost EB. Edward Emerson Barnard. Astrophys J. 1923;LVIII(#1):1–35.

Gendler R, editor. Lessons from the masters, The Patrick Moore Practical Astronomy Series. New York: Springer; 2013.

Gendler R. The Universe in Color: index.html (robgendlerastropics.com).

Gottlieb S. Restoring order to the deep sky. Sky Telescope. 2003;106:113–20.

Gottlieb S. The lost discoveries of E.E. Barnard. Sky Telescope. 2020:34–40.

Grasslands Observatory website: http://3towers.com.

German Astronomical Virtual Observatory (GAVO). Heidelberg Digitized Astronomical Plates. Full plate access to Heidelberg Digitized Astronomical Plates (uni-heidelberg.de).

Hunter TB. The Sky at Night: easy enjoyment from your backyard. Tucson, Arizona: University of Arizona Press; 2023.

Hynes SJ. Planetary nebulae. A practical guide and handbook for amateur astronomers. Richmond, VA: Willman-Bell, Inc; 1991.

International Comet Quarterly: The 1892/3 and 2007 Outbursts of Comet 17P/Holmes: The 1892/3 and 2007 Outbursts of Comet 17P/Holmes (harvard.edu).

Jones KG. Messier's nebulae and star clusters. 2nd ed. Cambridge: Cambridge University Press; 1991.

Kaler J. Stars. Stars (illinois.edu).

Kenyon SJ, Gomez M, Whitney BA. Low mass star formation in the Taurus-Auriga clouds. In: Handbook of star forming regions Vol I. Astronomical Society of the Pacific; 2008, Bo Reipurth, ed.

King B. Dive into Scutum's Dark Nebulae. Sky & Telescope July 15, 2015: Dive Into Scutum's Dark Nebulae – Sky & Telescope – Sky & Telescope (skyandtelescope.org).

Kodak. Chronology of Film: https://www.kodak.com/en/motion/page/chronology-of-film.

The Lick Observatory Historical Collections. The Lick Observatory Collections Project: Home (ucolick.org).

List of astronomical catalogues: List of astronomical catalogues – Wikipedia.

Lodriguss L. AstroPix. The Brightness of the Night Sky: https://www.astropix.com/html/observing/skybrite.html.

Luginbuhl C, Skiff BA. Observing handbook and catalogue of deep-sky objects. Cambridge: Cambridge University Press; 1990.

Lynds BT. Catalogue of dark nebulae. Astrophys J. 1962;S7:1–52.

Lynds BT. Catalogue of dark nebulae. Astrophys J. 1965;12:163–85.

Lynds B, editor. Dark nebulae, globules, and protostars. Tucson: University of Arizona Press; 1970.

Machin K. Dark nebulae observing program. The astronomical league: Dark Nebula Observing Program | The Astronomical League (astroleague.org).

Mallas JH, Kreimer E. The Messier album. Cambridge: Sky Publishing Corporation; 1978, fourth printing 1997

MATLAS (Mass Assembly of early-Type GaLAxies with their fine Structures). MATLAS – a deep imaging survey of massive galaxies and their surroundings (unistra.fr).

McHenry L. E. E. Barnard and his Dark Nebula. PDF: https://www.stellar-journeys.org/EE%20Barnard%20and%20His%20Dark%20Nebula.pdf.

Mitchell L. Texas Star Party-Advanced Observing Program-2018. https://texasstarparty.org/wp-content/uploads/2018/04/tspcluba_s.pdf.

Metcalf JH. Publications of the lick observatory, volume XI: photographs of the Milky Way and of Comets; by E.E. Barnard: a review. Publ Astron Soc Pac. 1914;26(#156, December):241–5.

Miller WC. First color portraits of the heavens. Natl Geogr. 1959;115:670–9.

Modern Star Maps and Catalogs. Britannica (2022): https://noirlab.edu/public/programs/ctio/.

NASA's HEASARC: Archive. Access to the catalogs and astronomical archives of the HEASARC: https://heasarc.gsfc.nasa.gov/docs/archive.html.

The NGC/IC Project. https://ngcicproject.observers.org/.

Newhall B. The history of photography. New York: The Museum of Modern Art; 1992.

Don O. Who discovered the Gegenschein? Sky & Telescope. 2021;142(4):34–40.

O'Meara SJ. Deep-sky companions. The messier objects. Cambridge University Press, Cambridge; 1998.

PhotoBlog: Photography Tutorials & Gear Reviews | PhotoBlog. First photograph ever taken and 20 more historical figures.

Precession Coordinator: https://www.bbastrodesigns.com/precession.html.

Ridpath I. Star tales. James Clarke & Co.; 1988.

Salman D. The best of the sharpless catalog. http://www.sharplesscatalog.com/default.aspx.

SAO/NASA Astrophysics Data System: https://ui.adsabs.harvard.edu/.

Schaefer BE. Old Astrophotos: Averting a lost legacy. Sky Telescope. 2003;105:42–6.

Sharpless S. A catalogue of HII regions. Astrophys J Suppl Ser. 1959;4:257–79.

Sheehan W. The immortal fire within: the life and work of Edward Emerson Barnard. Cambridge University Press; 1995, ISBN 0 521 44489 6

SIMBAD. https://simbad.u-strasbg.fr/simbad/.

Sinnott RW. Ngc 2000.0: the complete new general catalogue and index catalogues of nebulae and star clusters by Jl.L.E. Dreyer. Cambridge: Sky Publishing Corporation; 1988.

SkyMapper. Southern Sky Survey. https://skymapper.anu.edu.au/.

Sloan Digital Sky Survey (SDSS). https://www.sdss.org/.

Space Telescope Science Institute (STScI). STScI Home.

Star Catalogue. 2022. https://en.wikipedia.org/wiki/Star_catalogue.

Steinicke W. Observing and cataloguing nebulae and star clusters. Cambridge: Cambridge University Press; 2010.

Steinicke W. Hans Vehrenberg, Thorsten Neckel. Atlas of Galactic Nebulae (DVD). 2022. http://www.klima-luft.de/steinicke/Artikel/Atlas%20of%20Galactic%20Nebulae.pdf.

Sulentic JW, Tiff WG. The revised new general catalogue of nonstellar astronomical objects. Tucson: The University of Arizona Press; 1973.

Teets B. Vanderbilt University Dyer Observatory Osher Lifelong Learning Institute. Edward Emerson Barnard-Nashville Astronomer Extraordinare. Edward Emerson Barnard – Nashville Astronomer Extraordinaire (vanderbilt.edu).

The University of Chicago Photographic Archive. Browse Yerkes Observatory: http://photoarchive.lib.uchicago.edu/browse-yerkes.html.

UC Santa Cruz. University Library. Digital Collections. Lick Observatory photographs // Digital Collections Online (ucsc.edu).

Vanderbilt University. Special Collections and University Archives. Edward Emerson Barnard Papers: Collection: Edward Emerson Barnard Papers | Collection Guides (vanderbilt.edu).

Vera C. Rubin Observatory. https://www.lsst.org/.

VizieR. https://vizier.cfa.harvard.edu/viz-bin/VizieR.

Wallis BD, Provin RW. A manual of advanced celestial photography. Cambridge University Press; 1988. ISBN 0 521-25553 8

Wide-Field Astronomy Unit (WFAU) Institute for Astronomy. https://www.roe.ac.uk/ifa/wfau/ukstu/.

Wide-Field Plate Database WFPDP at: http://dc.zah.uni-heidelberg.de/wfpdb/q/cone/form.

Wilds RP. Bright and dark nebulae: an observers guide to understanding the clouds of the milky way galaxy. CreateSpace; 2017.

Index